# THE ARCIMBOLDO EFFECT

## TRANSFORMATIONS OF THE FACE FROM THE 16TH TO THE 20TH CENTURY

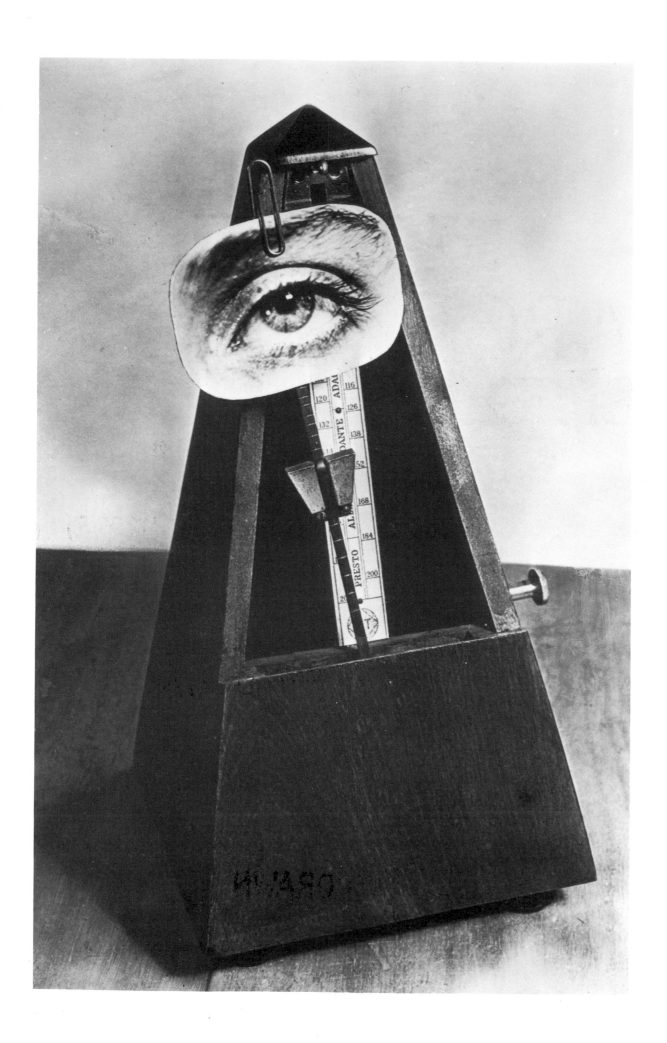

# THE ARCIMBOLDO EFFECT

## TRANSFORMATIONS OF THE FACE FROM THE 16TH TO THE 20TH CENTURY

ABBEVILLE PRESS PUBLISHERS NEW YORK

*In homage to Alfred H. Barr, Jr.,*
*who fifty years ago*
*introduced Giuseppe Arcimboldo*
*into the history of modern art*

Opposite to title page: *Object*
*to be destroyed - Indestructible Object*,
object and photo by Man Ray

Copyright © 1987 Gruppo Editoriale
Fabbri S.A., Milano. Published in the
United States by Abbeville Press, New
York. All rights reserved under
International and Pan-American
Copyright Conventions. No part of this
publication may be reproduced or
transmitted in any form or by any means,
electronic or mechanical, including
photocopying, recording, or any other
information storage and retrieval system,
without prior permission in writing from
the publisher. Inquiries should be
addressed to Abbeville Press, 488
Madison Avenue, New York, NY 10022.

**Library of Congress Cataloging
in Publication Data**

The Arcimboldo effect.

  Bibliography: p.
  Includes index.
  1. Arcimboldi, Giuseppe, 1527?–1593
—Exhibitions. 2. Painting, Italian—
Exhibitions. 3. Painting—16th century
—Italy—Exhibitions. 4. Mannerism
(Art)—Italy—Exhibitions. 5. Grotesque
in art—Exhibitions. I. Hulten,
Karl Gunnar Pontus, 1924–.
ND623.A7A4  1987  759.5  87-1002
ISBN 0-89659-769-5

Printed in Italy
by Gruppo Editoriale Fabbri, Milan

# CONTENTS

PALAZZOGRASSI

Palazzo Grassi S.p.A.
San Samuele 3231, Venice

With this exhibition Palazzo Grassi resumes activity after the show "Futurismo & Futurismi".

But this time the intention is different.

Then the aim was to show all the expressions of a movement that was primarily cultural rather than artistic, a movement centred on a relatively momentary idea which allowed aspects of the life of a certain period to be identified. The model here is completely different.

Here as well, of course, the aim is to throw light on a form of art with motivations rooted in a ground of culture, but this is not the culture of a limited period, which may completely lack any logical, and therefore artistic continuity.

This exhibition on the contrary attempts to follow a cultural path extracted from history almost by force — that is, by forcing history as it were to say something which at the time was thought rather than enacted; something which appeared like a flash of memory and found a complete fulfilment only in one case, that of Arcimboldo. Lovers of *Kulturgeschichte* will appreciate the importance of this attempt, which rather than following the singleness of a thought, follows a singleness of thought through different situations in time — almost as though there did exist something permanent that fascinates and arouses man's interest, and can take on an artistic form with an autonomous value fo its own.

Although approaches of this sort have already been attempted in the past, they have rarely been given such a wide, full development as in this exhibition.

It is Palazzo Grassi's conviction that this new initiative and the approach used, besides representing a novelty for the Italian public, can also contribute significantly to transforming the way we look at art and "make culture" — seen in a new light, without the attempted objectivity that positivism counted on, but rather imbued with the subjectivity that seems to be the sign of our times.

*Feliciano Benvenuti*

*Scientific and Executive*
*Committe for the Exhibition*

*General Commissioner*
Pontus Hulten

*Exhibition Commissioner*
Yasha David

*Coordination*
Pierre Astier

*Technical consultancy*
*for the setting*
Daniela Ferretti

*Secretariat*
Clarenza Catullo
Francesca Pattaro

*Related Activities*
Agnes Kohlmeyer

*Press relations*
Lauro Bergamo

*Homage to Arcimboldo*
by Mario Merz

*Video computer*
by Woody and Steina Vasulkas

*Scientific Committee*

Sven Alfons
Jurgis Baltrušaitis
Per Bjurström
Massimo Cacciari
Jean Clair
R.J.W. Evans
Paolo Fabbri
Eliška Fučíková
Thomas DaCosta Kaufmann
Michel Laclotte
Robert Lebel
František Makeš
Dominique de Ménil
Aomi Okabe
Alfonso E. Perez Sanchez
André Pieyre de Mandiargues
Maurice Rheims

8

Venice, a city filled with history, with a privileged and unique position, hosts the first retrospective exhibition of Giuseppe Arcimboldo. The event has been made possible by the exceptional participation of important Austrian, Czech and Swedish institutes which generously agreed to lend their masterpieces.

Our thanks go first to Hermann Fillitz, director of the Vienna Kunsthistorisches Museum, and the superintendents of the collections, Elisabeth Scheicher, Manfred Leithe-Jasper and Christian Beaufort-Spontin; to Jiří Kotalík, director of the Prague Národní Galerie, and especially to Eliška Fučíková for her valuable advice; and to Per Bjurström, director of the Nationalmuseum of Stockholm, Ulf G. Johnson, Olle Granath, Arne Lösman and Agneta Lundström. Our gratitude also goes to the directors of the collections of the Musées Nationaux de France, Roseline Bacou, Michel Laclotte, Alain Erlande-Brandenburg, to Bernard Ceysson, director of the Musée National d'Art Moderne of Paris, and to the director of the Bibliothèque Nationale in Paris, André Miquel.

An important contribution of expertise has come from Anna Maria Petrioli Tofani, director of the Gabinetto dei Disegni e delle Stampe degli Uffizi in Florence, Ardea Ebani, director of the Museo Civico Ala Ponzone of Cremona, Gian Albino Ravalli Modoni of the Biblioteca Nazionale Marciana of Venice, and the Superintendent of the Beni Artistici e Storici of Venice and his co-workers.

We are also grateful to Alfonso Perez Sanchez of the Museo del Prado in Madrid, Alessandro Bettagno, of the Fondazione Cini of Venice, William S. Liebermann of the Metropolitan Museum of Art, Richard E. Oldenburg and William S. Rubin of the Museum of Modern Art in New York, Anne d'Harnoncourt of the Philadelphia Museum of Art and Sue Reed of the Boston Museum of Fine Arts.

A great many people have supported us from the beginning with their friendship and advice. We would particularly like to mention Mme Claude Pompidou, Mme Dominique de Menil, Mme Teeny Duchamp, Mme Juliet Man Ray, Mme Elisa Breton and Mrs. Elsa Geiger. And also Johann Marte, Ake Meyerson, Karl Flinker, Leo Castelli, Attilio Codognato, Robert Descharnes and the late Robert Lebel. Finally, we must mention the kindness shown to us by Salvador Dalí and Margaret Barr.

*Pontus Hulten*

*Editorial Director*
Mario Andreose

*Editors*
Simonetta Rasponi
Carla Tanzi

*Iconography*
Ioana Rausch

*Research*
Susan Stivin

*Coordination*
Pierre Astier

*Production Staff*
Silvano Caldara
Augusta Galbiati
Giancarlo Galimberti

Book designed and
produced by Yasha David

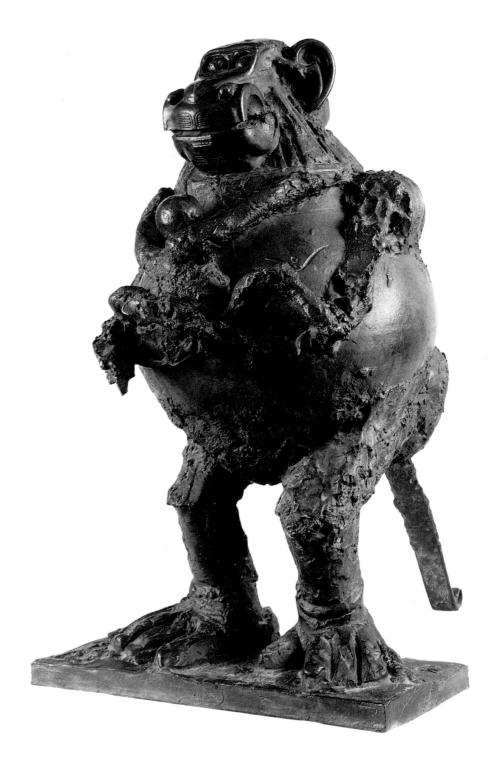

# Foreword

By a historical coincidence the *Effetto Arcimboldo* exhibition has been organized fifty years after the *Fantastic Art, Dada, Surrealism* show put on at the Museum of Modern Art in New York by Alfred H. Barr, Jr., to whom we dedicate the present work. Amongst its other qualities, that exhibition had the merit of presenting Giuseppe Arcimboldo in the context of 20th century art for the first time.

His rare, universally known paintings — never previously brought together —, his bold composite portraits, all have in common a new central device: the representation of man by the original method of putting together a head using natural elements and different objects. This apparently unknown iconographical procedure appears in the middle of the 16th century, a crucial period of radical changes in all spheres.

The comments of his contemporaries on the symbolical meaning of Arcimboldo's work and the repetitive interpretations of today do not address the basic issue of the real significance of his gesture in intervening on the human face to reconstruct it. It is clear that humanity is being put to the question, thereby opening a new aspect in our vision of the multidimensional man. It is a phenomenon that can be observed during the first period of the Modern age, subsequently disappears, during the classical period, for almost two centuries and resurfaces in the "decadent" period.

We have therefore divided the routes through the exhibition and organized the works into two separate and distinct historical parts. Over and above the texts aimed at examining the artist's work and the phenomenon simultaneously through the prism of philosophy, science and art, the iconography has its own independent life. This is the basic scheme that we have worked from. Its essential purpose is to bring out in a contemporary perspective one of the multiple aspects of vision.

*Yasha David*

*An asterisk marks the works displayed in the exhibition*

Pablo Picasso
*Baboon and Youngster,* 1951
Bronze, 53.2×32.2×61 cm
Museum of Modern Art, New York *

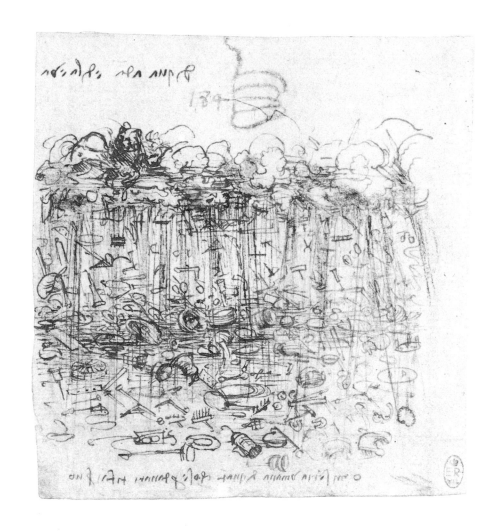

Leonardo da Vinci
*Implements Rained Down on the Earth from the Clouds*, 1498 c.
Inscriptions: top left, di qua adá e di la eva (on this side Adam and on that side Eve)
below, O miseria umana di quante cose per danari ti fai servo
(O human misery, how you make yourselves slaves for money)
Pen and sepia on paper with traces of charcoal, 11.7×11.1 cm
Royal Library, Windsor Castle

# Part one: 1500-1650

## Chronology

1500 Birth of Charles V
1503 Birth of Ferdinand I
1509 Birth of John Calvin
1519 Charles V becomes Emperor of Germany.
Death of Leonardo da Vinci
1521 The Diet of Worms excommunicates Martin Luther
1527 Charles V's imperial army sacks Rome.
Birth of Philip II, son of Charles V
Niccolò Macchiavelli dies.
Birth of Maximilian II, son of Ferdinand I and cousin of Philip II.
Giuseppe Arcimboldo, son of Chiara Parisi and Biagio Arcimboldo, artist-painter is born in Milan
1528 Death of Albrecht Dürer dies; publication of his treatise on human proportions in four books
1529 The Turks outside Vienna
1530 Fracastoro writes a didactic poem called *Syphilis sive de morbo gallico* (Syphilis or the French disease)
1532 The first edition of *Pantagruel* is published in Lyon, anonymously
1534 German translation of the Bible by Martin Luther
1535 Birth of Giamb. Della Porta
1541 Calvin founds the Church of Geneva.
Death of Paracelsus.
Michelangelo finishes the *Last Judgment*
1543 Publication of Copernicus's *De revolutionibus's orbium coelestium* and of Vesalius's *De humani corporis fabrica*
1546 Dearth of Martin Luther
1548 Birth of Giordano Bruno
1549 24 December, the name of Arcimboldo is mentioned for the first time in the *Annali della Fabbrica del Duomo di Milano*
1550 Agricola publishes his *De re metalica* 1556
1552 18 July, Rudolf II, son of Maximilian II and of Maria, sister of Philip II, is born in Vienna
1555 Nostradamus publishes his predictions, *Centuries astrologiques*.
Death of Agricola
1558 On the death of Charles V, Ferdinand I becomes Holy Roman Emperor.
Arcimboldo finishes his work for Milan Cathedral and projects cartoons for a tapestry for Como Cathedral
1560 The works of the Sacro Bosco at Bomarzo, begun by Vicino Orsini, are completed
1561 Birth of Francis Bacon
1562 Outbreak of the wars of religion.
Maximilian becomes King of Bohemia and "King of the Romans".
Arcimboldo sets off for the imperial court in Vienna, where he replaces Seisenegger as portraitist and copyist
1563 Beginning of the Counterreformation in Bavaria
Rudolf II and his brother Ernest are sent to Spain.
Arcimboldo paints the first series of the *Seasons*.
28 April, Imperial Governor Adam Swetkowyz describes in a letter to Ferdinand I the nature and quality of the work of "Maister Josephen".
John Dee, astrologer and alchimist, arrives in Prague.
Thadée Hajek z Hajku publishes his *Astrology of Physiognomy*
1564 25 July, Ferdinand I dies; his son, Maximilian II, becomes Emperor.
Death of Michelangelo in Rome and John Calvin in Geneva.
Birth of Galileo Galilei and William Shakespeare
1565 Arcimboldo is mentioned in the records of the Imperial court as Hof-Conterfetter

# Chronology

1566 Death of Nostradamus
Arcimboldo paints *The Jurist* and begins to work on the series of the *Seasons*. He makes a journey to Italy.
1568 Giovanni Battista Fonteo becomes Arcimboldo's collaborator
1569 Death of Pieter Bruegel the Elder
On the occasion of the New Year celebrations, Maximilian II is presented with the *Seasons* and the *Elements*, accompanied by a poem written by Arcimboldo and Fonteo
1570 For the wedding of Elizabeth, the daughter of Maximilian II, with Charles IX of France, Arcimboldo takes part in the organization of a tournament in Prague
1571 The Turks are defeated at the battle of Lepanto.
Birth of Johann Kepler.
31 May, Rudolf, son of Maximilian II, returns to Vienna
The celebrations in Vienna in honour of the wedding between Archduke Charles of Austria and Maria of Bavaria are directed by Arcimboldo, Jacopo Strada and Fonteo
1572 St. Bartholomew Massacre in Paris during the night from 23rd to 24th August.
Rudolf II is crowned King of Hungary at Bratislava.
Further versions of the *Seasons*
1573 Arcimboldo paints the third and fourth series of the *Seasons*, commissioned by Maximilian II as a gift for the Elector of Saxony.
1575 Rudolf II is crowned King of Bohemia in Prague and, later, King of the Romans in Regensburg.
Arcimboldo takes part in the celebrations.
Birth of Benedetto, illegitimate son of Otilla Stummeri and Arcimboldo.
14 July, Emperor Maximilian II signs

in Prague the act of legitimization
1576 25 June, Death of Maximilian II; 9 November, Rudolf II becomes emperor.
1579 Jacopo Strada leaves Prague 23 May, Rudolf II confirms the nobility of Arcimboldo's family
1582 8 September, Rudolf II writes to Raimund Dorn in Kempden, Bavaria, to introduce Arcimboldo to whom he has entrusted the task of finding and buying antiques
1584 Giordano Bruno writes *De la causa, principio e uno* and *De l'Infinito universo e mondi*.
Publication in Milano of the first text on Arcimboldo in Lomazzo's *Trattato dell'Arte della Pittura*
1585 Arcimboldo offers to Rudolf II a series of 148 drawings of costumes, hair styles, ornamental details, etc.
1586 Giambattista Della Porta publishes his *De humana physiognomia*.
Proposal to Ferdinand Hoffman for a project of frescoes accompanied by 13 pen drawings on Sericulture
1587 Arcimboldo definitively leaves Prague for Milan. As a sign of gratitude he receives from the emperor 1550 guilders
1588 Giordano Bruno passes through Prague
1589 Della Porta's *Magia naturalis* is published in Naples.
Arcimboldo from Milan sends the painting *Flora* to Prague, together with a poem by Gregorio Comanini
1590 Lomazzo publishes his *Idea del Tempio della Pittura*, with the *Madrigale per Ninfa Flora* by Gherardini
1591 Giordano Bruno publishes *De Immense e innumerabilibus*
1591 In Mantua Gregorio Comanini publishes his *Il Figino*.
Arcimboldo sends the portrait of Rudolf II as Vertumnus to Prague, again celebrated by Comanini

Hans Weiditz
*The Fool*, 1530 c.
Woodcut, 28×23 cm
Dr. Günter Böhmer Collection
Munich *

# Chronology

1592   28 March, Jan Amos Komensky, called Comenius, is born in Moravia 1 May.
Arcimboldo is nominated Palatine Count by Rudolf II.
Publication in Bergamo of the *Nuova Scielta di rime* by Gherardo Borgogni and, in Venice, of Paolo Morigia's *Historia dell'Antichità di Milano*
1593   Il July, Arcimboldo dies in Milan. He is buried in S. Pietro della Vigna, a church that no longer exists, with an epitaph by his friend Cesare Besozzi
1595   Paolo Morigia's *Della Nobiltà di Milano* is published in Milan
1596   Johann Kepler writes his *Mysterium cosmographicum* and sends it to both Tycho Brahe and Galileo.
Birth of René Descartes
1597   Rudolf II invites Tycho Brahe to Prague
1598   Death of Philip II, king of Spain. His son Philip III succeeded him
1600   Giordano Bruno is burnt at the stake in Rome.
William Gilbert, an English doctor and physicist, writes his *De magnete*
1601   Tycho Brahe dies in Prague: Johann Kepler is nominated imperial "mathematician"
1609   Rudolf II guarantees religious tolerance to the Bohemian Protestants.
Galileo invents the telescope
1610   Publication of Galileo's *Sidereus Nuncius* and Johann Kepler's *Dissertatio cum Nuncio Sidereo*
1611   Gustav Adolph becomes King of Sweden.
Inventory of the Emperor's treasury drawn up by Fröschl, Imperial "antiquarian"
1612   22 January, death of Rudolf II. His brother Matthias is elected emperor

1615   4 February, Giambattista Della Porta dies in Naples
1616   Death of Shakespeare
1617   Ferdinand II, cousin of Matthias II, becoms King of Bohemia
1618   Revolt in Bohemia.
Defenestration in Prague of Emperor Matthias's two governors.
Beginning of the Thirty Years' War
1619   Palatine Elector Frederick V is elected King of Bohemia by the Czech aristocracy who denies the sovereignty of Ferdinand II.
Ferdinand II becomes emperor after the death of his cousin Matthias.
Kepler's *Harmonices mundi libri V* is published
1620   Francis Bacon's *Novum organum* is published
8 November, the armies of the Catholic Holy Alliance defeat Frederick V's soldiers at the White Mountain, near Prague Elizabeth, the Queen of Bohemia, called the "Winter Queen," leaves Prague and takes with her the 1573 version of the *Seasons*
1627   Kepler's *Tabulae Rudolphinae* is published
1633   Galileo is condemned by the Inquisition
1637   Ferdinand III is elected emperor after the death of Ferdinand II
1646   Publication of Athanasius Kircher's *Ars Magna, Lucia & Umbrae*
1648   Sack of Prague by Swedish soldiers und the command of Marshal Karl-Gustav von Wrangel. The imperial collections are pillaged; some of the works by Arcimboldo are taken to Sweden.
End of the Thirty Years' War; demographic collapse and economic depression throughout Europe

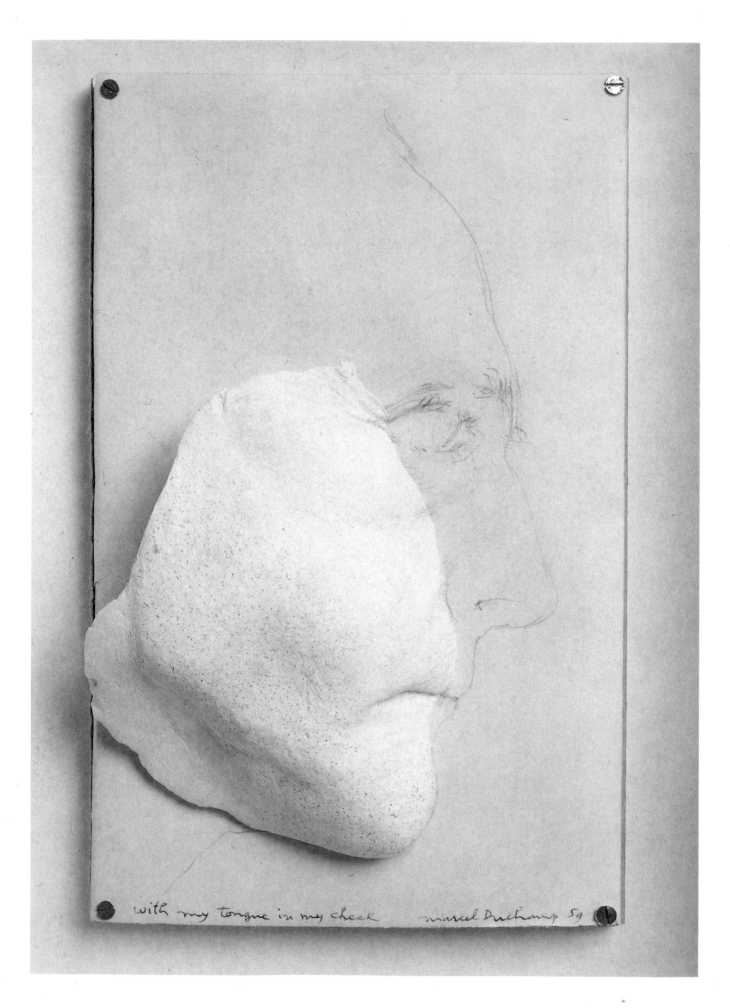

with my tongue in my cheek          marcel Duchamp 59

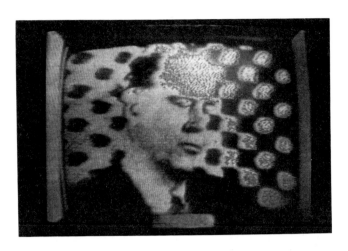

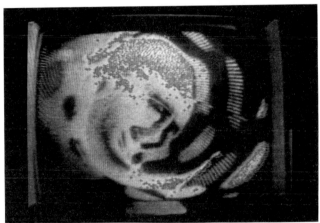

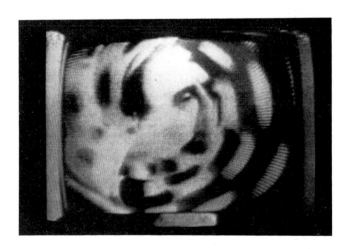

Nam June Paik
*MacLuhan Caged*, 1967
Video *

Marcel Duchamp
*With My Tongue in My Cheek*, 1959
Plaster and pencil on paper mounted on wood, 25×15×5.1 cm
Jean-Jacques Lebel Collection, Paris *

| Characteristic Argument of the Interpretation | Spectator's Reaction | Argument in Favor of Interpretation |
| --- | --- | --- |
| 1. Amusing work of fantasy and invention | Curiosity in front of something curious (leads to the "double image") | First, immediate reaction; popular vision adopted by many |
| 2. Allegory related to the Hapsburg Empire and 16th-century science | Perception of a complicated language of symbols (something to be understood by specialists) | Texts and statements from 16th century; iconographic evidence |
| 3. Metaphysical statement: New vision of man | Fascination; awe; the sense that one is confronted with something profound | Fine quality of the best of the paintings in Vienna; other arguments not sufficient to explain the fascination of these paintings |

# Three Different Kinds of Interpretations

by Pontus Hulten

## 1. The first interpretation: An amusing curiosity

The immediate reaction to a typical Arcimboldo painting by someone without preconceived ideas is fascination and attraction, attraction to something new, unknown, different. This was the reaction of his contemporaries, and the reputation that he acquired during his lifetime was based on his use of fantasy and surprise — his paintings were called "bizarre inventions," *capricci, scherzi, quadri ghiribizzosi,* and *grilli.* Later art historians classified him as a "mannerist," a member of the school of art that succeeded the Italian High Renaissance in Italy, France, Vienna, and Prague. Mannerist paintings are often complicated, both in form and content. They developed the Renaissance interest in classical Greece and Rome in a problematic and superacademic fashion. Mannerist painting aims to intrigue the spectator — to puzzle and to mystify him. Arcimboldo therefore should fit in well with the mannerist group, but we shall see that, in some respects, he may be thought of as an "anti-mannerist."

Arcimboldo's paintings were a great success at the Hapsburg court in Vienna. He apparently had to make several versions of some of his original paintings, probably because other European courts in the Hapsburg universe wanted those works in their collections. The demand seems to have been so great that copies were even made by other hands, and some original conceptions have survived only as replicas or copies. (As no Arcimboldo exhibition has been made before, no comparison of the existing paintings has been possible, and therefore no certain attributions can be made.)

Arcimboldo's themes were continued by some minor painters of the following generations — the "Arcimboldesques" — who both simplified and transformed his ideas. In one line of Arcimboldesque development the desire to astonish dominated, and sitting or lying figures composed of flowers, fruits and other natural objects were integrated into romantic and otherwise normal landscapes. These pictures do not possess great meaning or quality, and are interesting only for their amusing and decorative effects. Another Arcimboldesque line developed the "double image," an image that represents two different things at the same time. For example, Arcimboldo's

painting of *The Vegetable Gardener* appears to portray the head of a man, but, when inverted, the image reads as a bowl of vegetables. This concept seems to have been developed by a family of painters in Switzerland, the Merians. Sometimes quite strange details appear in these Swiss Arcimboldesque paintings — in one of them you see the head of a man with a beard that is at the same time a summer landscape. On the man's cheek stands a little figure aiming his rifle at a target. The target is the man's eye. Is it possible that this original and intriguing idea goes back to an unknown, lost work by Arcimboldo?

It is a work by one of the Swiss Arcimboldesque painters that led to Arcimboldo's reappearance in the art world after an absence of four hundred years (even his name had disappeared).

Little is known about Arcimboldo's personal life except for what can be deduced from reading his sketchy biographies, inspecting his two self-portraits, and looking at his paintings; thus the conceptual origin of his main contribution, the magnificent series of *The Seasons* and *The Elements*, will probably never be fully known. It seems likely that Arcimboldo was familiar with Horace and Vitruvius and other classical writers, and perhaps had read their discussions of such fantastic beings as sphinxes, centaurs, chimerae, griffons, and other *grotesques* and *confuse cose*.

Looking at a photograph of his self-portrait (the original painting is at present impossible to locate), one has no difficulty in imagining him to be a cultivated and well-read man. He looks more like a philosopher than a painter. Or he could be a man of the court of a great prince, which is actually what he was for a large part of his life — it was Arcimboldo's main occupation to organize the festivals of the imperial court. There is a certain melancholy in his self-portraits that corresponds well with the mood that exists in his paintings of *The Elements* and *The Seasons*. The quiet beauty of these panels, a serene musical melancholy, is similar in tone to Vermeer's work, despite the difference between the two painters on many other levels. The other self-portrait, a drawing, also conveys the impression of a rather self-centered man, aristocratic in his attitude, but emotionally complicated — an intellectual with a rich private life.

Although the origin of the idea for the great "composite heads" is likely to remain unknown, it is certain that the heads have not one but several meanings and can be interpreted on several levels of understanding. These multiple meanings reflect the conception of art in Arcimboldo's time. It was common knowledge among artists and their public that pictures should not be taken at face-value, and that their several meanings could be hidden like boxes within boxes.

Any transformation of the human face is bound to contain an aspect of humor, of the ridiculous. In Arcimboldo's heads the transformation projects a good-natured irony, an irony that we especially enjoy because the decomposing of facial features — nose, mouth,

Woodcut (anonymous)
In *Libro di modelli per artisti armeni*
(*Book of Models for Armenian Artists*)
16th century
Biblioteca di San Lazzaro, Venice *

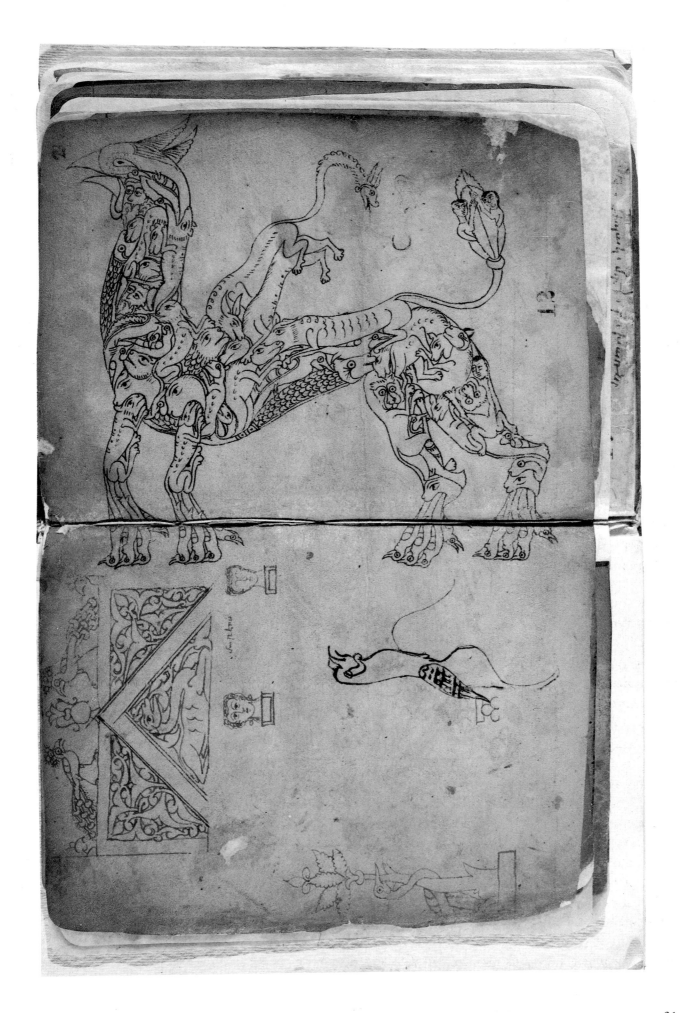

21

and ear — and their restructuring in the form of an impressive head built of natural objects seems to have been done without any effort, like child's play or a happy game. Some of the jokes may have been even funnier for Arcimboldo's contemporaries, while others may be appreciated more in our own time, as ironies revealed by modern knowledge. The mouth of *Water* (was she the empress?) is actually the mouth of a Heterodontid shark, a small but not very dangerous shark that swims along the bottom of the sea, scavenging. The inventiveness with which the heads are composed gives the observer long moments of pleasure looking at the details of construction and the care given to every color and texture. If there was humor in these portraits, it was humor that could please and delight the rulers of the Empire. These jokes were very serious jokes.

The court of Vienna was one of the most curious intellectual milieus of all times. The court of Hapsburg may have been more favorable to the invention and development of the composite head than similar milieus in, for example, Florence or Paris. These paintings possess an emotional intelligence that reveals itself as a kind of concentration on an idea. Such concentration might be more possible in a relatively small and insular court than in a large city.

## 2. The second interpretation: An allegory of Empire and Science

As Thomas DaCosta Kaufmann has pointed out, Arcimboldo's work contains not only fantasy and invention but also complex allegory, allegory based on the Empire he served. Certainly Arcimboldo's heads are closely connected with the intellectual life at the Hapsburg courts, first in Vienna and then in Prague. Arcimboldo served three Hapsburg emperors: Ferdinand I, Maximilian II, and Rudolf II. He was probably closest to Maximilian, and it was to Maximilian that he gave the first version of *The Seasons* and *The Elements* on New Year's Day of 1569. Arcimboldo's inventive paintings must have been the subject of great discussion at the Hapsburg courts, and the content of *The Seasons* and *The Elements* was of the highest importance for the imperial family, the nation, and its role in the world.

An allegorical system works with allusions, hints, and correspondences, and in *The Seasons* and *The Elements* a parallel is created between the bases of the natural universe and the political and spiritual leadership that the Hapsburg Holy Roman Empire was meant to exercise on earth. As the Hapsburgs in fact ruled over a great part of the world and aspired to rule over all of it, they were depicted as omnipotent and ever-present, like the seasons and the elements, the rulers of the microcosm and the macrocosm.

As the seasons and the elements would exist forever, so would the Hapsburgs. In the cycle of the year, *Spring* portrays an adolescent, *Summer* a young man, *Autumn* a mature man with a beard, and

Anonymous
*Das Wiener Musterbuch* (Collection of face types), 15th century
56 drawings on paper, 9.5×9 cm
Sammlung für Plastik- und Kunstgewerbe
Kunsthistorisches Museum, Vienna

Michael Wohlgemut and Wilhelm Pleydenwurf
*Monstrosa Fabulosa* (detail),
In *Welteronuck* by Hartman Schedel, Nuremberg, 1495
Woodcut, 36.2×5.7 cm
Dr. Günter Böhmer Collection Munich *

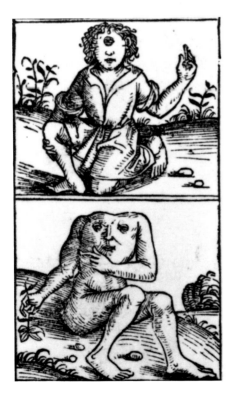

*Winter* an old man whose skin has withered into the bark of an ancient and weatherworn tree. Arcimboldo's friend Fonteo, who wrote a poem to explain the intricate system of correspondences on which the iconography of these paintings depends, indicated that these persons of different ages corresponded to the boys, youths, men, and old men of the House of Hapsburg. However, Arcimboldo's portraits describe more than just the princes of the court. A woman has been included in the panel representing *Water*. She wears a string of pearls around her neck and a pearl dangles from her ear. Red coral suggests that she wears the crown of the imperial family on her head.

It is not easy to think of these heads as portraits, as likenesses of living members of the Hapsburg house; but again, there may be an intricate play of allegory involved and the likenesses may be more metaphorical than physical. The images do not represent people as figures, they are not persons with bodies: they are heads. But these heads are heraldic representations with a high degree of symbolism. Allegorically, the head is the ruler of the body just as princes are rulers of their nations.

As the cloak of *Winter* is emblazoned with a fire-iron, the impresa of the Order of the Golden Fleece (the House Order of the Hapsburgs), and the four strokes of the letter M read as the initial letter of Maximilian, there can be little doubt as to whom the image refers. Fonteo explained that the founders of the Roman Empire thought of winter as the beginning of the year — *caput anni* — and therefore Winter would be the appropriate season to represent Maximilian: as Winter was the head of year, Maximilian was *caput mundi*, the head of the world.

Always set against an abstract, dark background, these heads have something totally natural in their way of existing: there is never anything forced or cramped about them in spite of their very complicated structure. Every element has found its place seemingly without any effort — there is no hesitation, nothing too much, nothing too little, no filling in of a space between two shapes. One need only compare Arcimboldo's work with that of his followers to see how masterly the originals are. In Arcimboldo's paintings the parts that make up the heads — the flowers, fruits, and vegetables, the fishes in the sea and the animals on earth — are all joined in an agreeable, beautiful fashion. If we read this composition allegorically rather than emotionally, the harmonious relationship depicts the beneficent rule of the Hapsburgs.

The inscription found on the back of *Spring* relates the panel to *Air*, and suggests further complexities of allegory and relationship between the panels. Because of the insignias he wears — the ram's head of the golden fleece and the crown of antlers — *Earth*, like *Winter*, represents Maximilian. Could it be that all of the panels are related, that each of the seasons was meant to correspond to each of the elements? Maybe one of the heads in the pair was meant as

23

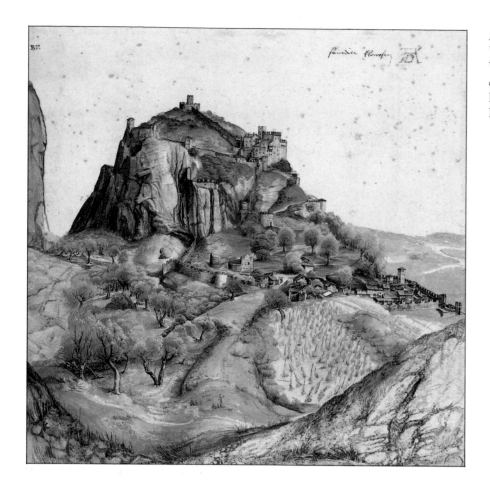

Albrecht Dürer
*View of the Val d'Arco*, 1495 c.
Watercolor and gouache highlights
on paper, 22.3×22.2 cm
Département des Arts Graphiques
Musée du Louvre, Paris

an allegorical statement of power and the other as a symbol representing the prince's personal appearance. In this way, Arcimboldo could more easily include and combine the different levels of meaning that he wanted to present in these series. Fonteo's poems might have been written for the emperor at the presentation of the paintings, as part of an explanation or development of their content.

Just as *The Seasons* and *The Elements* depict personalities at the Hapsburg court, it has been shown that *The Librarian* is a portrait of Wolfgang Lazius, a scholar and antiquarian who was an important member of the nucleus of intellectuals around the emperor. *The Jurist* (or *Calvin* as he has been mistakenly identified) is a portrait of Johann Ulrich Zasius, an administrator in charge of the finances of the imperial house.

There is, however, a substantial difference between the way the heads in the series of *The Seasons* and *The Elements* are composed and the more casual construction of the two courtiers. The severe and ceremonial profiles of the idealized bearers of the imperial power exist on a finer level, both conceptually and technically. One could imagine that the two courtiers were painted as an afterthought — as a joke to be understood and appreciated within the circle of the court. Alfons has pointed out that *The Seasons* and *The Elements* and possibly other of Arcimboldo's paintings might have been part of a general plan for a museum that Maximilian had planned for

24

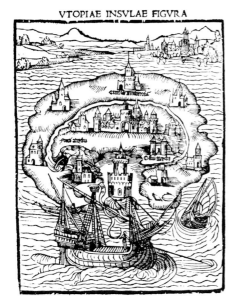

Woodcut (anonymous)
In *The Island of Utopia* by Sir
Thomas More, Louvain 1516

Vienna. The museum would not only house his vast and various collections, but would be a visual condensation of current knowledge about the world and a demonstration of the Hapsburg rule. According to Alfons's theory, the eight paintings would have been placed at the entrance of the museum around a great fountain by Wenzel Jamnitzer. The paintings and the fountain would, each in its own way, express the cosmogonic and political ambitions of the emperor.

The museum was never built. Jamnitzer's silver fountain, when it was finally completed, went to Prague, not to Vienna, and was melted down in 1747. Only the four sculptures that formed the base, another version of the four seasons, remain.

Sven Alfons's argument that the four paintings were destined for a museographical and cosmogonic context seems to be reinforced by a careful analysis of the animals represented in one of the paintings, *Water*. The list of sea animals in this picture contains forty different species — among them mammals, amphibians, reptiles, platyhelminthes, annelids, polychaetes, and mollusks. It is obvious that Arcimboldo prepared the panel with the help of a scientist and that efforts were made to represent the largest possible number of marine animals.

Many mysteries remain concerning Arcimboldo's unique series of heads. For example, why are the mouths of the people portrayed always open? Perhaps answers to some of these questions might be

Detail of Albrecht Dürer's
*View of the Val d'Arco*: a rock in the
shape of a human head in profile

25

found in the descriptions that were arranged and designed by Arcimboldo, but until now investigations have not led very far.

## 3. The third interpretation: A metaphysical transformation

Arcimboldo was essentially a court painter who executed commissions that were intended for specific circumstances, and no doubt all the details of the pictures together build up allegorical structures directly connected to the situation for which they were intended. These explanations and the interpretations add to our understanding of Arcimboldo's pictures, but they are not rich enough, intellectually and emotionally. They do not entirely satisfy a modern spectator; the paintings possess a fascination that seems to come from a more generally available source, one related to the subconscious as well as to the rational. His images have a spiritual tonality that should not be ignored.

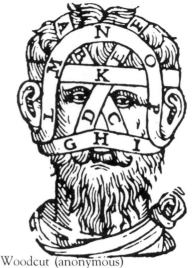

Woodcut (anonymous)
*Head - Alphabet*, 15th century

Furthermore, Arcimboldo was a very good artist, a great painter. Therefore, it seems unlikely that he would have been content to be confined within a merely political or academic range of creation. He was also an exceptional inventor who created a totally new type of imagery, an imagery that, in spite of the fact that only a few of his paintings more or less miraculously survived the following four centuries, represents one of the most extraordinary concepts of man that one can find in art.

Arcimboldo was a most complex man and his time was one of transition. Religious wars, economic chaos, changing social structures, important new inventions and discoveries, dogmatism and reaction — these provided the background for his era. In the complicated world in which he lived no avenues were simple and easy for the mind to walk. In an environment that still included elements of the medieval world, the great values of the Italian Renaissance had started to crumble. Leonardo had died in 1519; Michelangelo in 1564. Titian, living into his late nineties, was to die in 1576. In Italy, the Renaissance had been the time of the exalted ego, the time of princes: princes of states, of cities, of the church, and of art. Arcimboldo lived in a period when the world was struggling to define a new image for itself.

In art the last great fireworks of the Renaissance world had been produced by Benvenuto Cellini, the Florentine sculptor, goldsmith, and writer. He was born in 1500 and died in 1571. His formidable nervousness and egotism made him an extreme exponent of a lifestyle that had developed over a hundred years. In a world full of tension in every sphere — religious, political, social, artistic, and military — Cellini put man, and himself, in the center of the world. He wrote a great book about himself. Cellini is not a very important artist but he is an interesting case in that he represents the end of a line of evolution. His art was characterized by a rather static

Pyrrho Ligorio
*The Ogre*, 1551
Sacro Bosco di Bomarzo

classicism, and the following cultural movement, the baroque, also referred to the classical, but in a more dynamic and independent way. (There seems to have been no way to avoid the ancients.) The next link in the chain was Giovanni da Bologna (1529-1608), whose sculpture turned upward and around itself like a flame around a wick.

Before he moved to Vienna and then to Prague, Arcimboldo had lived in Milan, in the midst of the cultural universe of the Italian Renaissance. Through his grandfather, the Archbishop of Milan, and his father, a painter in the cathedral, he had been connected to the many sides of Milanese life. When he returned to Milan in 1587 after an absence of twenty-six years, he seems to have entered his old milieu without much difficulty, but having been a respected member of the Hapsburg court must have helped. In Milan Arcimboldo continued to paint for the Hapsburg court, and soon after 1590, Rudolf II made Arcimboldo a Count Palatine, an honor rarely given to an artist.

In the relative isolation of the courts of Vienna and Prague, Arcimboldo had developed his mysterious and magnificent art. He had a perspective that was larger than his fellow artists — he saw the Hapsburg courts through the eyes of a man raised in Renaissance Milan; but as a part of the cultural world of Vienna and Prague, he was in the center of another intellectual world, one built and inhabited by such men as Copernicus (1473-1543), Tycho Brahe (1546-1601), and Kepler (1571-1630).

In this environment Arcimboldo created his new image of man, one totally different from that envisioned by his predecessors or his contemporaries. God was the center of the medieval universe, and in the Renaissance, man and his ego were the most important. In a time of transition, of pessimism and melancholy (states of mind that are very much present in his paintings), Arcimboldo declared that man is not separate from nature: he is a part of nature — a part of the elements and of time — and nature is a part of man. Such a metaphysical stand was revolutionary. It is a stand more easily understood in our day than in the second half of the sixteenth century.

The fact that man could solve some of the mysteries of nature and reveal its secrets was precisely what separated him from nature. He could no longer explain himself as a part of world from which his knowledge placed him apart, defining him as an observer. No longer in harmony with the natural universe, man would have to fight in order to re-establish contact, running the risk that his efforts would look like satire.

If one forgets the allegorical significance of the heads (and in view of the loving care he gave to his flowers and fishes it is easy to believe that Arcimboldo did so himself), then one stands in front of a truly mythical creation. Classical Greek myths display similar transformations of being: Daphne becomes a tree to escape Apollo, or Zeus changes into a swan to seduce Leda. The basic poetic obser-

Detail of Michelangelo's *Last Judgement*, 1536-1541
St Bartholomew holding in his left hand the skin of a flayed man whose head is probably a self portrait of Michelangelo
Sistine Chapel, Rome

Woodcut by Nicolas Béatrizet in *Anatomia del corpo humano* by Juan Valverde de Hamusco, Rome Salamanca and Lafréry, 1560
Biblioteca Nazionale Marciana Venice *

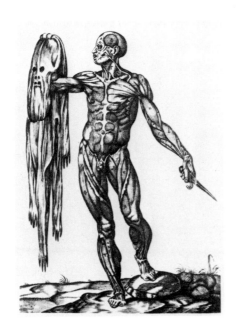

vations in both Arcimboldo's paintings and the Greek myths are each as just, as light, as irrational, and as unforgettable.

This is an entirely different relationship to the classical than that of the mannerist iconography of elongated women and goddesses in the arms of gesticulating bearded men and gods. Arcimboldo's pantheistic concept of the world — in which all beings are treated with equal reverence and attention — is certainly in contradiction to the rather dry, academic, and mechanical presentation of the ancients' universe created by the mannerists. Thus Arcimboldo can be thought of as anti-mannerist.

Arcimboldo reached as deeply as the Greeks into the heart of the idea that they had sensed but had expressed differently, and his works are as valid and as beautiful as theirs. The powerful emotion that carries both is the need to express our wish of belonging to the whole, to nature and to the divine. Arcimboldo's symbolic mythology is universal in the same way that variations of the myths of Spring, Summer, Autumn, and Winter exist in most cultures and religions. It is similar to the fascination with nature that we see at the end of our own century. Our necessary defense of nature will probably create myths depicting the struggle between what is natural and what is man-made but of equal beauty. Or have these myths already been created and it is only that we have not yet recognized them?

Why is it that few of Arcimboldo's contemporaries understood the meaning implicit in his art? His perception of the world was pantheistic, somewhat like Greek or Chinese philosophy, although his way of expressing it was completely new. But no one followed him in his vision — a vision that made man and nature inextricably one — as he indicated by the loving way in which he painted the animals, flowers, fruits, and stones that compose his imperial heads.

Other thinkers and artists have, in different ways, made similar statements. One can mention Magnasco. Or better, Vermeer. Johannes Vermeer in the Netherlands of the seventeenth century painted a world of serene light where every part of a room, every person and every object in it, was painted with the same care, as if all were a part of a divine whole. And Spinoza, Vermeer's friend, englobed everything in the universe in an image of God. The central controlling idea of Spinoza's philosophy was that all things are necessarily determined in Nature, which he conceived to be an absolutely infinite, unified, and uniform order. God was Nature.

Closer in time and space to Arcimboldo was the lyrical philosophical speculation of Giordano Bruno (1548-1600). Bruno, who was burned at the stake for his heretical ideas, was the first to propose a heliocentric universe, which made man a part of the universe, equal to the other parts of that universe.

Somehow Arcimboldo's metaphysics were lost on his fellow artists. He created for himself a niche of great beauty and magic, but a niche that was an isolated refuge.

## 4. The three-in-one conclusion

It is important to realize that these three different kinds of interpretations (and there are probably others that could be advanced) do not exclude each other.

The reaction of amazement and curiosity in front of these intriguing and beautiful paintings is as important as the scholarly study of their delicate and complicated allegorical system of reference and correspondence. Arcimboldo was able to transport the ambiguity inherent in allegory into a new and more important unity by connecting each detail with the overall meaning. With striking shortcuts he managed to combine the multiple into one image, and he did this while guarding the secret qualities that belong to the essence of symbols.

However, today the metaphysical aspect of Arcimboldo's work is the most important. During a time of transition and hesitation, Arcimboldo managed to formulate a statement of his own, different from everything else done during that time, and yet, even today, it remains totally satisfactory, filling some universal need.

Did the philosophy implicit in Arcimboldo's art go too far too quickly, leaving too many of his contemporaries behind? How else can one explain the disappearance of his work for so many years, for neither his concepts nor his compositions entered the mainstream of art. Painting, and art in general, took quite a different road. Mannerism, with its garbled interest in the classic, developed into the baroque, and the baroque and different forms of classicism dominated art for a long time.

The pantheistic worldview expressed in different ways by Arcimboldo and Vermeer in both cases led temporarily to oblivion. Vermeer's name disappeared for two hundred years. Now he is considered one of the greatest masters in the history of art. There is no mention of Arcimboldo from the end of the sixteenth century until the beginning of the twentieth century. Today hardly a week passes without one seeing his inventions used, for one purpose or another.

Woodcut (anonymous) in
*Libro... nel quale si insegna a scriver ogni sorte lettera, antica et moderna*
by Giovanni Battista Palatino
Rome, 1561
Figurative Sonnet
Biblioteca Nazionale Marciana
Venice *

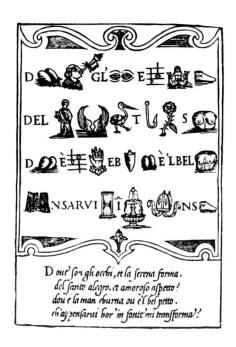

*Comment ilz fignifioient*
*Dieu.*

*Cōmēt ilz fignifioient les dieulx infernaulx*
*quilz appelloient manes.*

Pour fignifier dieu ilz paignoient vng oeil pource que ainfi que loeil veoit & regarde ce qui eft audeuant de luy dieu veoit confidere & congnoit toutes chofes.

Pour fignifier les dieux infernaulx quilz appelloient manes ilz paignoient vng vifaige fans yeulx & audeſſus deulx yeulx pource q̃ par les yeulx ilz fignifioient les dieux cõme dict eſt & par le vifaige fans yeulx ceulx qui font en lieu bas & tenebreux.

*Fin des hieroglyphyques adiouxtez.*

*Convex Mirror*, 16th century
Glass, papier mâché and paper, diam 120 cm
Kunsthistorisches Museum
Sammlungen Schloss Ambras, Innsbruck *

# The Imperial Court in the Time of Arcimboldo

by R.J.W. Evans

When Giuseppe Arcimboldo, previously a little-known designer of windows and frescoes at Milan, traveled across the Alps in 1562 to become portraitist to the court of Vienna, he joined a state that was hardly older than himself and likewise only just beginning to make its name. Created by a dynastic union of the Austrian provinces of Bohemia and Hungary in 1526, just a year before Arcimboldo's birth, the new territory was for decades not regarded as a distinct political unit. Its ruler, Ferdinand I, stood under the shadow of his elder brother, Charles V, and had to struggle not only with power groups inside his very disparate domains, but with external pressure from the Turks, who even besieged Vienna in 1529. When, in 1558, he succeeded Charles as Holy Roman Emperor, it was not yet clear whether that lustrous title, with its ill-defined and fragile authority over the whole of Germany, would bring to the Austrian Hapsburgs anything more than the responsibility and frustration that had led his brother to abdicate. Arcimboldo could still feel himself part of a pioneering exercise in sovereignty.

Yet the shrewd and resolute Ferdinand had gradually been building up his position. As the base for his operations he could use the institutions nurtured and the values propagated by his grandfather, Maximilian I, that model of an ambitious Renaissance prince, in the first years of the century. Imposing controls on unruly elements in his Austrian heartlands, such as the burghers of Vienna, Ferdinand then extended the scope of his administration to Bohemia, where he was able to profit by an abortive revolt in 1546-47 to intimidate the opposition and drive a wedge between the noble and urban estates. In time the Hapsburg rulers of Austria and Bohemia could draw on a body of loyal and efficient servants, men like the President of the Chamber, Ferdinand Hoffman, for whom Arcimboldo later devised his drawings of silk manufacture, one of the characteristic enthusiasms of an enlightened bureaucrat of the day.

During the 1550s Ferdinand created new governing bodies for all his lands, with a wise balance between aristocratic and commoner counsellors and between the conflicting claims of different provinces: a Privy Council to steer the affairs of state, a Financial Chamber (*Hofkammer*) to collect and distribute taxes, a law court for imperial arbitration, a War Council. In Hungary, where Ottoman

forces had progressively occupied over half the country since the Christian calamity on the field of Mohàcs, the War Council had a particular function. Even there Ferdinand fought his way, through bloody exchanges in battle and through the endurance and finesse of his diplomats, to a stalemate.

The most damaging discord of all, however, was found within Christian Europe. Perhaps Arcimboldo actually passed through the city of Trent on that Alpine journey of his in 1562. If so, he would have observed the dignitaries of the Catholic Church gathered for the last session of the great Council, dedicated to the recovery of morals, the renewal of organization, the revival of mission under the direct aegis of a militant papacy. The Council had already codified doctrine and anathematized all Protestant teaching. Yet Lutheran supporters were by now officially recognized in the German Empire and increasingly widespread throughout Austria, Bohemia, and Hungary, while more radical anti-Catholic sentiments gained in popularity.

This placed Ferdinand in a very uneasy situation. A Catholic, his support for reform of the Church was tempered by awareness of the need for concessions. Himself a guarantor of the religious peace negotiated for Germany, he numbered among his advisors leading spokesmen for humanist, conciliar traditions (one of them was Ulrich Zasius, whose diseased face appears to be pilloried in one of Arcimboldo's canvases). Thus while Ferdinand fostered the work of the young Jesuit order in his lands and reconstituted the archbishopric of Prague to minister to the Catholic remnant in Bohemia, he urged Rome to permit communion by the laity and perhaps also clerical marriage, and he avoided provoking Protestant sensibilities.

In the territories of the Spanish Hapsburgs the ruler set himself different priorities. Again at the very time of Arcimboldo's move to Vienna, Charles's son Philip II, who coveted the imperial title for his own branch of the family, was introducing far-reaching change in the religious practice of the Netherlands, together with a concerted assault on any Protestant deviation there. Within a few years the outcome was an armed conflict which by degrees called into question the whole established political order in Europe. Under the central European Hapsburgs things developed otherwise. There the key actor now became Ferdinand's eldest son, Maximilian, elected King of the Romans in the year of Arcimboldo's arrival and automatically succeeding as emperor on the death of his father two years later. Though they were exact contemporaries, Maximilian could hardly have been more remote from Philip, his cousin and brother-in-law (and afterwards son-in-law too!). To Arcimboldo, likewise his exact contemporary, Maximilian proved an enthusiastic patron and friend.

In his youth Maximilian II had been a warrior, and he rose to the occasion again after his accession, taking the field against Suleiman

"If you paint that on a wall in front of which you can move freely, it will strike you as out of proportion because of the great difference between OR and RQ [the intervals]. This stems from the fact the eye is so close to the wall that it appears foreshortened. And if despite that you want to paint it, your perspective must be seen through only one aperture."

From *Trattato della pittura* by *Leonardo da Vinci.*

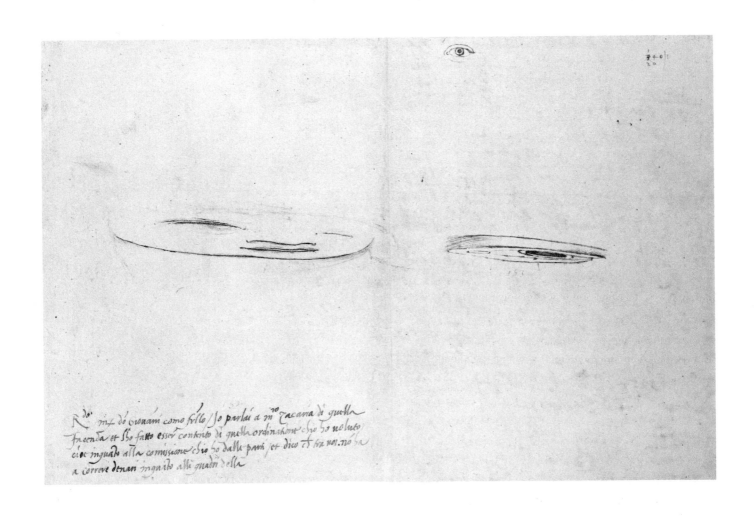

Leonardo da Vinci
*Drawing of an Eye and Anamorphic Head of a Child*, 16th century
Pen and sepia on paper, 26.8×39.7 cm
in *Codice Atlantico*, Fol. 98
Biblioteca Ambrosiana, Milan

the Magnificent on the plains of Hungary in 1566 — an episode reflected in Arcimboldo's personification of *Fire* in that year, with its depiction of cannons and the Hapsburg order of the Golden Fleece around its "subject's" neck. But Suleiman died on the campaign, and so the new emperor had a chance to cultivate the arts of peace on his exposed eastern front, initiating a long truce there that was interrupted only by skirmishes with the principality of Transylvania (a stronghold of Hungarian opposition allied to the Ottomans), and by intrigues directed toward gaining the Polish crown for a Hapsburg candidate and fanning Christian discontent in the Balkans.

Engraving (anonymous) denouncing the sale of papal indulgences as condemned by Martin Luther in 1517

In Germany Maximilian's desire for peace was still more evident. He positively sought a resolution of the most burning issue of the day, mediating between Catholics and Protestants both at the diets of Augsburg (1566) and Speyer (1570) and privately. His response to papal and Spanish overtures was cool at best. His mistrust of the "impertinent bishop of Rome," as he described Pius V to an English diplomat in 1570, knew no bounds; the pontiff for his part believed the emperor capable of a second march on Rome, which might repeat the chastisements in the year of Maximilian's birth. From his Spanish "brother" (as they addressed each other in writing) Maximilian found himself even more alienated. He offered his good offices to heal wounds in the Netherlands (still nominally a part of the *Reich* over which the emperor exercised sovereignty), yet his overtures were rebuffed — by both sides, but especially by Philip. With the execution of Egmont and Hoorn, and the Don Carlos affair in Madrid the situation worsened. Four years later the massacre of Parisian Protestants on St. Bartholomew's day, approved by Spain and Rome, aroused Maximilian's fury.

Far from representing mere political expediency, Maximilian's stance reflected deep personal uncertainty. During the 1550s he toyed with Lutheran ideas himslf, collecting Protestant books and moving among theologians of Protestant inclination, like Kaspar Nidbruck, with whom he discussed church history, Sebastian Pfauser, who became his court chaplain for a time, even Luther's old lieutenant, Philip Melanchthon. Maximilian's relations were appalled, and he was persuaded in the dynastic interest not to forsake the Catholic fold. Probably he had no great desire to do so anyway, since his clear rebuff to the Tridentine mood was matched by distaste for the sectarian squabbles raging inside the Protestant camp. Despite some contact with heterodox intellectuals like Vergerio, Palaeologus, and Basilikos, Maximilian showed no sympathy for immoderate ecclesiastical regimes such as the Calvinist one in the Rhenish Palatinate.

It seems evident that the new emperor genuinely favored a religious middle way, as a means of conciliating divergent interests, even in a spirit of tolerance foreign to most sixteenth-century

leaders. The mouthpiece for the idea was his adviser and friend, Lazarus Schwendi; the fact that Schwendi also functioned as Austrian military commander only lent weight to the appeal. It seemed to have greater prospects of success in Maximilian's home territories than abroad. In the Austrian duchies, for which the emperor was directly responsible (whereas the Tyrol, Styria, and other Alpine provinces came under the administration of his brothers Ferdinand and Charles after 1564), protracted negotiations with the estates brought compromise by 1571. The Protestant majority among the nobility achieved the ruler's personal guarantee for their faith. In Bohemia Maximilian took counsel from loyal but patriotic magnates with whom he had been associated almost since childhood: the Master of the Court, Adam Dietrichstein; the Chancellor, Vratislav Pernstein; the Grand Burgrave, Vilem Rožmberk. With their help his management of local interests, though certainly not without friction, yielded results. In 1575 the Bohemian diet gained verbal confirmation of the rights of both Hussite and Lutheran confessions. Even strife-torn and divided Hungary, where some grumbled at Hapsburg neglect and others at Hapsburg interference, enjoyed reasonable tranquillity.

A mild commitment to the universal Catholic Church suited the international cultural aspirations of Maximilian and his court. Here too was a pioneering exercise, and one in which Arcimboldo could take a direct part. The ambition grew out of two circumstances, one particular and one general. First was the emperor's own character and talents. "All contemporaries agree in extolling the grace and elegance of Maximilian's manners and the fascination of his conversation and deportment. His life and reign exhibit the fairest and most pleasing picture of the qualities of his mind." Perhaps this eulogy by a later English commentator overdoes things: Maximilian could also be excitable and inconstant, and he suffered from chronic ill-health. Yet he was undoubtedly a friendly, witty, and civilized companion, who could converse in several languages and possessed a genuine love of learning. The personal factor accompanied a widespread desire in the later sixteenth century to advertise the cultural pretensions of Renaissance rulers. Precisely, perhaps, because the institutional infrastructure of their state remained primitive and inadequate to the growing tasks of centralized government, monarchs sought to embellish it with the symbolism of sovereignty: humanist rhetoric and historical exemplars, visual apotheosis and dramatic representation. Specific imperial themes were near at hand, easily derived from antiquity and already reactivated by the artistic and literary circles around Maximilian's great-grandfather and namesake in the years just after 1500.

In the first instance such endeavors rested on the home territories of the Austrian Hapsburgs, with which Maximilian II identified himself more closely than had Ferdinand II. He was the first member

of the dynasty, and for a long time the last, to command, in some serious measure, the native languages of his subjects, and he collected around him a historiographer from Hungary, humanists from Silesia and Bohemia, poets and lawyers from the University of Vienna, and so forth. But the imperial court appeared a natural focus for intellectuals from more foreign lands, not just from regions of Germany that were already closely related to it, but especially from the richly endowed Italian cities and the increasingly troubled Low Countries. Some noteworthy Italians settled in Vienna and Prague during the decade before Arcimboldo's arrival, the antiquary Jacopo da Strada and the long-serving architect Ulrich Avostalis de Sala among them. They were joined, and then outnumbered, by a flood of Netherlanders like the celebrated diplomatist Busbecq, the composer and *Kapellmeister* Philippe de Monte (who proved more amenable to imperial invitation than Palestrina), the natural philosophers Dodoens and Clusius, and the bibliophile Blotius. Many others came for shorter periods, the young Justus Lipsius for example; as did visitors from farther afield, such as the rising Anglo-Welsh sage, John Dee, and the brilliant young literary aristocrat, Sir Philip Sidney.

Characteristic of Maximilian's entourage was a broad curiosity, combining the rediscovered learning of classical antiquity with a new concern for observation and comparative analysis. The emperor evinced a particular interest in botany. He loved to frequent the gardens of his residences, beautified with the latest horticultural skills (Busbecq brought tulips, stocks, and lilacs back from Constantinople); and Matthioli, Dodoens, and especially Clasius achieved work of lasting importance in plant identification and classification, which surely underlies the floral portraits by Arcimboldo. Botany shaded, via the technical use of herbs, into medicine, where the imperial court likewise proved a major intellectual center. The cosmopolitan royal physicians: Crato and Camutius, Biesius and Alexandrinus, Hàjek, the Guarinonis, and even the maverick Dr. Carrichter, whom his colleagues accused of killing Ferdinand I with a quack cure, were extensively consulted, read, and admired. Moreover, many of them displayed wider interests, ranging from philology to alchemy.

Thus the doctors participated in various activities of a kind that we should today consider part of natural science. Among these was the purposive exploration of the natural landscape. Clusius and the court mathematician, Paul Fabritius, made some of the first forays into the Austrian Alps; while Lazarus Ercker, superintendent of the royal mines in Bohemia, wrote a pioneering treatise on metallurgy that he dedicated to Maximilian in 1574. All this found reflection in the contemporary passion for collecting, which revolved around the assemblage of natural specimens, the more exotic the better. Maximilian's younger brother Ferdinand led the way as collector,

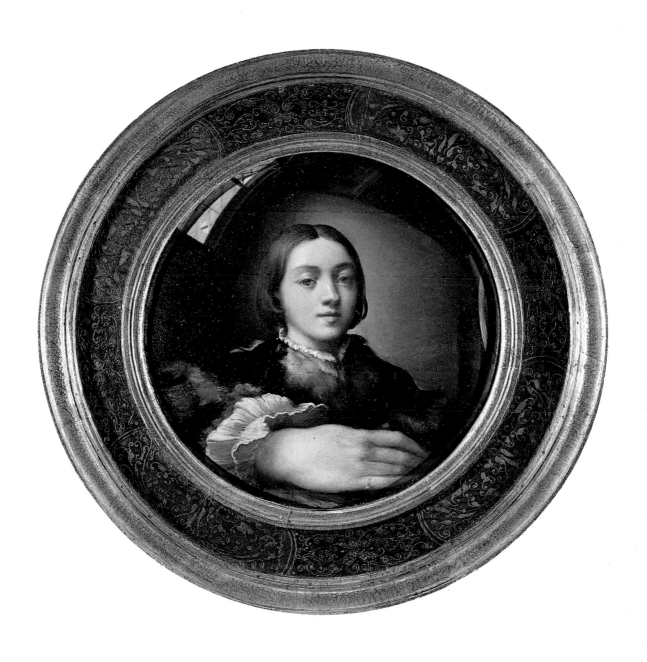

Parmigianino
*Self Portrait in a Convex Mirror*, 1523-24
Oil on convex wooden support, diam. 24.4 cm
Gemäldegalerie, Kunsthistorisches Museum, Vienna

with a fabled cabinet of curiosities (*Kunst-und Wunderkammer*) that he eventually consolidated at his castle of Ambras, near Innsbruck. But the emperor shared the taste for choice natural objects, flora and fauna. Surely we can see, in Arcimboldo's composed menageries, a mirror of Maximilian's zoo on the castle bastion in Vienna?

But *naturalia* did not, of course, exhaust the scope of sixteenth-century collections. Their other purpose was to bring together *artificialia*, the fruits of human creativity and invention. These could be antique, and Strada had the task of acquiring and describing classical statuary, coins, and gems. Modern pieces might be equally valued: although the great drive to acquire Renaissance art was instigated by Maximilian's son Rudolf, the enthusiasm began earlier, and it extended to practical objects like weaponry, armor, and artisans' tools (again Arcimboldo illustrates the point with his *Cook* and *Cellarer*, made up of household equipment and painted for the Elector of Saxony, who owned tens of thousands of such utensils).

Woodcut by Geoffrey Tory
in *Champ Fleury*, Paris, 1529

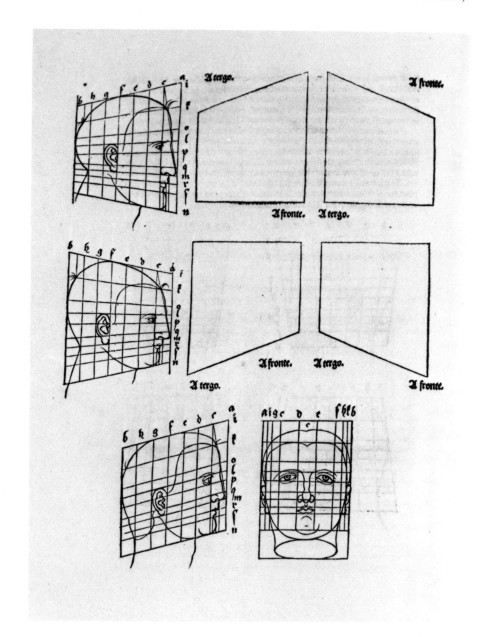

Woodcut by Albrecht Dürer
In *De Symmetria Partium in Rectis Formis Humanorum Corporum*
Nuremberg, 1532-34
Biblioteca Nazionale Marciana
Venice *

Not least among the artefacts came the products of human learning: manuscripts and printed books. Under Maximilian the court library was set on a regular footing, with Wolfgang Lazius and Johannes Sambucus as its custodians, until a young Dutchman, Hugo Blotius, was appointed as the first professional librarian (once again a composed "portrait" by Arcimboldo — probably depicting Lazius — comes to mind). The book collections of Maximilian and his humanists also furnished the wherewithal for new scholarship: for works on Roman antiquities by Lazius and Pighius, on Greek texts by Sambucus and Dudith, two very distinguished and characteristic figures of Maximilian's circle. Sambucus, who possessed one of the largest private libraries of the day, combined medical with literary interests and functioned as court historiographer; Dudith was actually an apostate Catholic bishop who remained in imperial service.

The artistic expression of the age of Maximilian was mannerism, a style intimately linked with the aulic humanism we have just con-

Woodcut by Erhard Schön
In *Unterweissung der Proportion und Stellung der Bosse*
Frankfurt, Christian Egenolff, 1543
Staatsbibliothek, Bamberg *

(following pages)
Woodcut by Erhard Schön
*Anamorphic Portraits of Charles V Ferdinand I, Pope Paul III and Francis I*
1533 c.
Staatliche Museen zu Berlin *

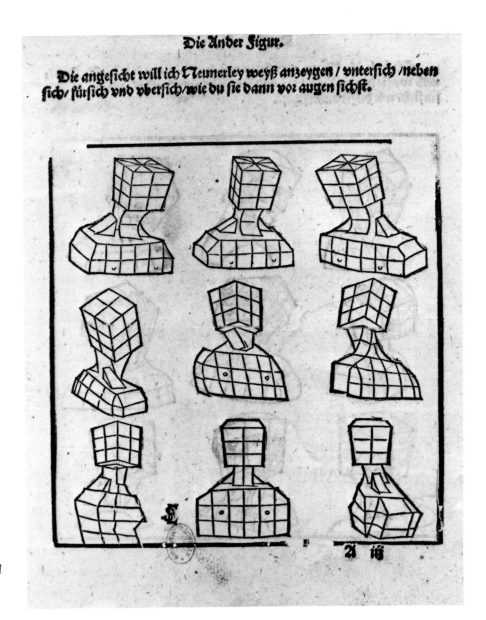

sidered, which traveled into central Europe along the same routes. Like Arcimboldo it crossed the Alps from Italy, beginning in the 1550s with such migrants as Avostalis and the medallist, Antonio Abondio; but more and more of its exponents were Netherlanders, like Bartholomaeus Spranger and Alexander Colin. The features of international mannerism in the later sixteenth century are discussed elsewhere in this volume. For my purpose it suffices to point to the twofold character, indeed the ambivalence, of the style. On one hand mannerists displayed exuberance and urbanity, cultivating elegance and virtuosity. They operated *par excellence* through the royal or princely court, conceived as a manifestation of splendor and power, and they invested their work for it with the polish and *savoir-faire* of Renaissance high society. At the same time, however, there was a darker side, where self-consciousness rather than self-confidence dominated, where Renaissance forms and perspective were not developed but distorted, where the courtly milieu gave scope for elite and esoteric preoccupations, full of secrets, mysteries, and puzzling symbolism.

Both kinds of mannerism are well illustrated in Arcimboldo's work; indeed, their juxtaposition there forms one of the principal problems posed by his art. But under Maximilian II the expansive and assured facets of the style tended to preponderate, as in the suave sinuous compositions of Giovanni da Bologna which the emperor so admired ("Giambologna" — typically a Dutchman settled in Italy — would not come to Vienna himself, but sent his pupils). We encounter this confident courtly *maniera* above all in the ceremonies and festivities for marriages, prominent visitors, and the like, with their triumphal arches, masques, and tournaments designed to exhibit the grandeur of the dynasty. For such occasions Maximilian could use his palaces and parks, especially the "New Work" or Neugebäude, a masterpiece of intricate invention just south of Vienna, surrounded by gardens with waterworks and other contrivances. And he employed Arcimboldo as his master of ceremonies, designer and stage-manager. After all, one clear purpose of Arcimboldo the painter, as early as 1563, was to act as "buffone aristocratico," to startle and delight cultivated *mondains*, to contribute to their highly formalized amusements. Here was a society able to laugh at its own expense, a society in which the scope for agreed solutions, or at least accepted rules of the game, still appeared considerable.

In October 1576, amid tough negotiations with the German estates, and not long after a protracted, troublesome, and fractious, but ultimately productive session of the Bohemian diet, Maximilian II suddenly died. Rudolf II, a capable and intelligent twenty-four-year-old already initiated into the political business of the Austrian Hapsburg lands, continued in his father's footsteps. His training was more obviously Catholic: whereas Maximilian had visited Spain

Woodcut by Erhard Schön
In *Unterweissung der Proportion und Stellung der Bosse*
Frankfurt, Christian Egenolff, 1543
Staatsbibliothek, Bamberg *

Luca Cambiaso
*Fighting Figures*, 16th century
Pen, sepia and watercolor on paper
35×24.5 cm
Gabinetto Disegni e Stampe degli Uffizi, Florence *

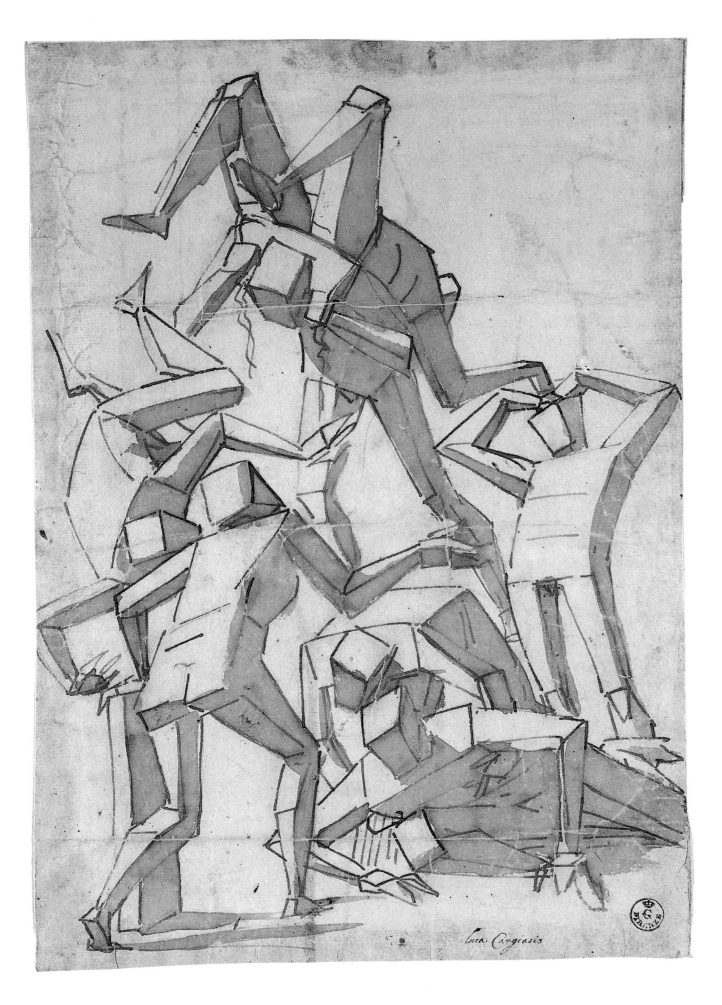

*Luca Cangiasio*

47

principally to celebrate the arranged marriage with his cousin Maria, Rudolf spent eight years of his youth there at the behest of Maria's brother, Philip II. He moved rather more firmly against sectarian disturbance. Yet the accommodating policies and intellectual openness associated with his predecessor were not measurably affected.

Rudolf too sought a pacification of the Netherlands and a negotiated settlement of disputes in Germany, though he enjoyed little success. Neither the Spanish government nor the breakaway Dutch provinces could be brought to acknowledge imperial jurisdiction, and a hotheaded unofficial demarche by Rudolf's maverick younger brother Matthias, who set himself up as putative mediator in Brussels, did nothing to help. In the *Reich* religious tensions assumed more menacing political forms, especially as embodied by rival branches of the house of Wittelsbach: the electors of the Palatinate, who aimed to confirm Calvinist leadership of Protestant Germany by blocking any cooperation between Lutherans and Catholics; and the dukes of Bavaria, who placed themselves in the vanguard of the Counter-Reformation, and scored a notable victory by capturing the archbishopric of Cologne in 1582. Further east Rudolf maintained Hapsburg ambitions in the Slav lands and beyond, attempting to wield influence as far afield as Muscovy and Persia and — in a desultory fashion, at least — to weaken the Ottoman regime from within.

Rudolf held to most of his father's advisors, and continuity of personnel is particularly marked in the cultural field. It included Arcimboldo, of course, who was ennobled in 1580 and created Count Palatine in 1592. Ceremonial events remained important in the life of the court, beginning with the elaborate obsequies for Maximilian. All the imperial symbolism was confirmed, indeed deepened by Rudolf, who displayed a powerful sense of his sovereign calling. Although he removed the center of his operations to Prague by 1583, that did not necessarily signify much: Ferdinand and Maximilian had frequently resided in the Bohemian capital, and there were some good practical reasons for preferring it to Vienna.

Yet gradually a shift in the character and direction of Rudolf's government became apparent. The emperor grew increasingly unpredictable and unorthodox. He hesitated chronically over the logical step of accepting the proffered hand of the Spanish Infanta; at the same time he refused, despite a bout of severe illness, to take other steps toward securing the succession to the imperial crown within his family. His moodiness, detachment, and procrastination, features observed by the perceptive from the start, were more and more evident, yet he refused to delegate any responsibility for decision-making. Rudolf lived an immobile and withdrawn life within the walls of the Hradschin, the fortified palace overlooking Prague, indulging in some of his father's proclivities — and contemporary fashions in general — to extremes. As he did so, that "darker

side" which we have identified in the contemporary mannerist view of the world came to the fore.

One area of Rudolf's obsessive concern was the patronage of artists and scholars. Here he appeared as in some ways the very paragon of a Renaissance monarch, promoting much creative talent (Spranger and Aachen, de Vries and Savery, Hoefnagel and Sadeler, Lehmann and Miseroni, Tycho Brahe and Kepler, Boodt and Burgi, the Stradas) and assembling the greatest collection in Europe of objects beautiful, contrived, and strange. For all the vagaries of taste at the Prague court, not least its indulgence of erotic subjects, the crippling burden upon an already strained treasury, and the very restricted access granted to the imperial treasures, contemporaries and posterity have found in Rudolf as maecenas much to admire. Yet these artistic and scholarly concerns overlapped heavily with another, much more notorius pursuit, for the stress on bizarre, mannered stylistic effects and the liberated intellectual curiosity were associated with an enhanced role for occult forces in human affairs.

Occultism had already played its part in Maximilian's time. The court library collected magical manuscripts, and the emperor accepted the dedication of books on the subject, among them John Dee's arcane *Monas Hieroglyphica*. The prophecies of Nostradamus were translated for the emperor by Michael Eitzinger, on whom Arcimboldo's painting of *Summer* is said to be based and whose *Pentaplus Regnorum Mundi* represents a kind of mystical invocation of Hapsburg power. The alchemist Thurneysser served at Maximilian's court, and members of the entourage, like the poet Corvinus, conducted alchemical experiments. Royal physicians such as Carrichter were heavily influenced by the medical and spiritual ideas of the great Renaissance magus Paracelsus. Many items in the imperial collections possessed their inexplicable, hence seemingly supernatural "virtues," and the cult of emblems, in which Sambucus was prominent, evolved its own secret symbolism.

Moreover, such concerns were not merely an accidental accretion. They proceeded from the distinctive cast of the late Renaissance mind, and were called forth by the inability of rational, critical methods, pioneered by the humanists, to embrace the expanding universe of the sixteenth century, to bridge the gap between traditional assumption and a new reality. Men strove for universal knowledge, revealed and occult, for "pansophy," precisely because their traditional world-view was breaking apart. Arcimboldo's work surely bears interpretation in this sense: his physiognomic constructions seem to rest on a philosophy that draws on the theory of correspondences and the microcosm (is Arcimboldesque man the measure of all created things, or merely a composite of them?), on hidden essences, on a supposed harmony in plurality as sought by the *Wunderkammern*, on the encyclopedic learning of late humanism as mysteriously distilled in the *Monas* of John Dee, whom

Woodcut by François Desprez
In *Songes drôlatiques*
Paris, Richard Breton, 1565
Bibliothèque de l'Arsenal, Paris *

49

Woodcut by Heinrich Vogtherr
In *Livre artificieux et tres proffitable pour pointres...* by Heinrich Vogtherr
Antwerp, Jehan Richard, 1551
Bibliothèque Royale Albert Ier
Brussels

Francesco de Rossi Salviati
*Study of a Helmet*, 1541-43 c.
Pen, sepia, brown pencil, and white highlights on grey-green paper
49.4×37.1 cm
Département des Arts Graphiques
Musée du Louvre, Paris *

Arcimboldo may well have met at the Hapsburg court.

Under Rudolf, then, such preoccupations came to hold cultural sway, and Prague attracted large numbers of seekers after hidden truth, who attached themselves to the imperial court with greater or lesser degrees of official approval. Among them were persons of learning and consequence: after all, the outstanding scientists Tycho and Kepler enjoyed Rudolf's patronage no less as astrologers than as astronomers. Others hovered on the fringes of both intellectual and social respectability. Others again were plain adventurers, like some, though by no means all, of the court alchemists — whose numbers, however embroidered by legend, seem to have been very considerable. By the time of Arcimboldo's departure from Prague in 1587, of his remarkable *chef d'oeuvre* depicting Rudolf as the mysterious Etruscan god Vertumnus, and of the painter's death in 1593, a major transformation in the public face of Hapsburg authority was under way.

The emperor was embattled, psychologically and politically. He progressively lost control of German affairs, last attending the diet in 1594; his revulsion against Spanish intransigence and papal pretensions caused him covertly to abandon serious marriage plans and forsake normal Catholic observance. In the west the kingship of Henry of Navarre betokened the enhanced power of France; in the east Rudolf found himself drawn into renewed war against the Turks that, while it could rally support for a time and arouse visions of heroism and conquest, in fact degenerated into numb and largely unsuccessful campaigns. At home, in Bohemia and Austria, the consensus that had yielded the compromises of the 1560s and 1570s was worn down by religious and social tensions. Peasant disturbance, Counter-Reformation militancy, and an increasingly strident tone of opposition among the Protestant estates took place.

In all this we should see a change, not only in the emperor, albeit his mental instability, private foibles, and inability to espouse a firm line of action certainly grew more marked, but in the climate of the times. The Prague court became a bastion of uncommitted, allusive humanism and of mannerist unease just when other contemporaries began to reject those values and to look for simpler, more direct, more orthodox solutions. The outcome for Rudolf is well known. After 1600 affairs worsened, and by the time of his death in 1612 that *composed* head formed by Arcimboldo in the guise of Vertumnus, god of change, became the *deposed* head of a ruler dispossessed in all his territories by his presumptuous brother Matthias. Only the tarnished imperial crown, without imperial authority, remained to Rudolf.

Arcimboldo's career in Vienna and Prague turned out to coincide with the peak of the cultural attractiveness and cultural radiation of the Austrian Hapsburg court. Later emperors might favor the arts, especially architecture and music, but they never recaptured a role

of full European significance (and when Austrian culture itself later took on such a European significance, that was not thanks to imperial patronage). Meanwhile the age of Rudolf, like the work of Arcimboldo, was condemned to centuries of misunderstanding and ridicule; while the brief florescence under Maximilian, which had preceded it and made it possible, fell largely into oblivion, and has still to find its historian. At least we are today much better placed to appraise this central European background, against which Arcimboldo's art can appear in proper perspective.

Further Readings

The newest study of Ferdinand I is P.S. Fichtner, *Ferdinand I of Austria: The Politics of Dynasticism in the Age of the Reformation* (New York, 1982), helpful mainly on politics. For dealings between Spain and the Austrian Hapsburgs see B. Chudoba, *Spain and the Empire 1519-1643* (Chicago, 1952). On Ferdinand and the Council of Trent see R. Trisco in *Reform and Authority in the Medieval and Reformation Church*, ed. G. Lytle (Washington, D.C., 1981).

Fundamental for Maximilian II is *Die Korrespondenz Maximilians II. I-II: Familienkorrespondenz 1564-7*, ed. V. Bibl (Vienna, 1916-21), though it is not revealing about his private life. The only biography is V. Bibl, *Maximilian II, der rätselhafte Kaiser* (Hellerau bei Dresden, 1929), helpful especially for the religious side. The English historian of Maximilian cited is W. Coxe, *History of the House of Austria*, I-III (4th ed., London, 1864-73), II, 19-62, quoted at page 54. On the cultural life of his court a number of older works retain their value: *Caroli Clusii... Epistolae*, ed. P.F.X. de Ram (Brussels, 1847); J.F.A. Gillet, *Crato von Crafftheim*

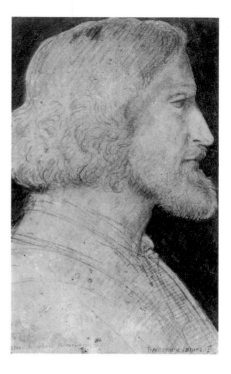

Bernardino Luini
*Portrait of the Painter Biagio Arcimboldo*, undated (signed lower right: Bernardino Louino F. Inscription lower left: Blasii Arcimboldi Pictoris imago)
Charcoal and watercolor on paper
23.6 × 14.7 cm
British Museum, London

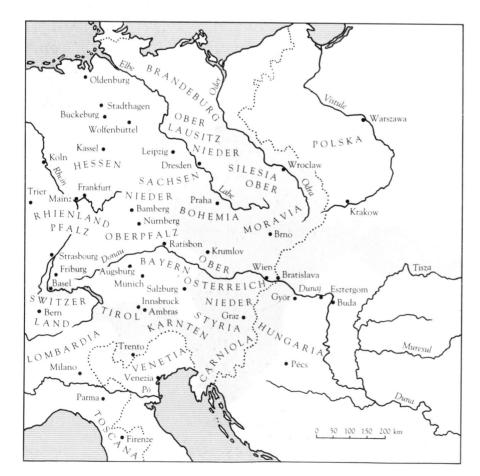

Central Europe in the 16th Century

•••••• Boundaries
of the German Holy Roman Empire

▬▬▬ Territories
of the Austrian Hapsburg

*und seine Freunde*, I-II (Frankfurt a.M., 1860); C.T. Forster and F.H.B. Daniell, *The Life and Letters of Ogier Ghiselin de Busbecq*, I-II (London, 1881); G. Doorslaer, *La Vie et les oeuvres de Philippe de Monte* (Brussels, 1921); F.W.T. Hunger, *Charles de l'Escluse (Carolus Clusius)*, I-II (The Hague, 1927-43); A. Costil, *André Dudith, humaniste hongrois* (Paris, 1935). Schwendi is reappraised by R. Schnur in *Zeitschrift für Historische Forschung* (in press).

For Rudolf II I refer to my own *Rudolf II and his World, A Study in Intellectual History, 1576-1612* (2nd ed., Oxford 1984, with new bibliography). The latest summary is K. Vocelka, *Rudolf II und seine Zeit* (Vienna, 1985).

On Germany and Austria in this period nothing has replaced L. von Ranke, *Zur deutschen Geschichte vom Religionsfrieden bis zum Dreißigjährigen Krieg* (Leipzig, 1869), and especially M. Ritter, *Deutsche Geschichte im Zeitalter der Gegenreformation und des Dreißigjährigen Krieges*, Vol. I: *1555-86* (Stuttgart, 1889), for imperial politics; and T. Fellner and H. Kretschmayr, *Die österreichische Zentralverwaltung*. Part I: *1491-1749*, I-II (Vienna, 1907), for central administrative institutions.

The latest brief synthesis on Bohemia is in *Prehled dejin Ceskoslovenska*, Vol. I-II: *1526-1848*, ed. J. Purs and M. Kropilak (Prague, 1982). The great work by F. Hrejsa, *Ceska Konfesse: jeji vznik, podstata a dejiny* (Prague, 1912), is still fundamental.

For Hungary in this period see the new collaborative history, with rich bibliography: *Magyarorszag törtenete*, Vol. III: *1526-1686*, ed. R.A. Varkonyi I-II (Budapest, 1985).

Anonymous (school of Giovanni
Battista Serabaglio)
*Helmet of Ferdinando II*, 1560 c.
Iron, brass, leather, silk, and cotton
lining, 32×21.5×32.5 cm
Waffensammlung
Kunsthistorisches Museum, Vienna *

53

*Annali della Veneranda Fabbrica del Duomo di Milano*
vol. III, app. IV, reg. 331, 1548-49.
Under the date of December 24 1549
Giuseppe Arcimboldo is named
for the first time beside his father,
Biagio, and other artists.
The entry of a sum of money confirms
that Arcimboldo was active
in the Workshops of Milan Cathedral. *

# The Madrid-Prague Axis

by Alfonso E. Perez Sanchez

So much has been said and written about the court of Vienna and Prague, the exquisitely refined circle of Ferdinand I, Maximilian II, and Rudolf II wherein the bulk of Arcimboldo's opus developed, that it seems necessary to begin with a few considerations about these sovereigns, whose peculiar sensitivity and remarkable education produced the closed world in which the great Milanese painter's startling and enigmatic subtleties unfolded.

When modern eyes contemplate this artist's complicated and ingenious "conceits," it is tempting to see them as a forerunner of certain modern forms, especially those typical of surrealism, in which the subconscious yields up waves of unconnected images that, if considered in psychoanalytic terms, can reveal a profound significance to the conscious reason. Arcimboldo's great popularity, after his "discovery" in this century, is largely due to this intriguing interpretation, which makes him a surrealist *avant la lettre*.

Surprisingly, this singular artist arose out of a deeply Catholic environment, and worked for sovereigns with extremely close ties — both familial and ideological — to the strictest Catholic orthodoxy, including the staunchest of its defenders in the tense and confused Europe of his time: Philip II of Spain.

Arcimboldo was born in Milan in 1527, the year in which Rome was sacked by the troops of Emperor Charles V. It was also a tense moment for the duchy of Milan. Despite ancient bonds of friendship between the Sforza and the emperor, the duke participated in the League of Cognac — or Florentine League — in May of 1526, thus becoming an ally of Francis I and Pope Clement VII against the growing strength of the Hapsburgs. The "Peace of the Ladies" definitively marked the fall of the duchy of Milan under Hapsburg influence, and it eventually became little more than a province of the Spanish crown. Beginning in 1535, Milan was the residence of a Spanish viceroy. Arcimboldo was thus a subject of the Spanish crown.

In 1562, at the age of thirty-five, i.e., when he came fully of age, Arcimboldo was summoned to Vienna by Emperor Ferdinand I. The emperor, who offered him hospitality, protection, and commissions, was the brother of Emperor Charles V and his successor in governing the Empire and the dynastic holdings of the Hapsburgs in Austria. Furthermore, when his wife's brother King Louis II of Hungary died

in the battle at Mohács against the Turks, he became king of Hungary and Bohemia.

The emperor Ferdinand — son of Philip the Fair and Joan of Castile — was born in 1503 in Spain, at Alcalá de Henares, and spent his childhood and early youth in the Iberian peninsula, under the sway of his grandfather, King Ferdinand whose name he bore — and entrusted to a noble Leonese-Castilian family, the Núñez de Guzmán. Many thought that Ferdinand was destined to inherit the crown of his maternal grandparents, while his brother Charles would have only the European states of Burgundy and Austria. Events did not fall out in that way, however, and the Spanish-spirited Ferdinand became emperor of Germany while Charles, with his solid Flemish and German education and influences, wore the Spanish crown, and with it the complex heritage of Burgundy.

Ferdinand maintained close relations with the Spanish world and had Spanish secretaries in his service. It should therefore come as no surprise that, recalling with nostalgia his Spanish boyhood and hoping to maintain those ties, Ferdinand sent his scion Maximilian to Madrid to be raised alongside the son and heir to the emperor Charles V, the young prince Philip, the future Philip II.

The two cousins, therefore, grew up together, under the care of Cardinal Juan Martínez Siliceo, a respected theologian, a professor at Salamanca, and a man of strict Catholic orthodoxy. Maximilian was one year younger than Philip, and they had quite different temperaments and characters. Philip was silent, reserved, perhaps shy; Maximilian was noisy, garrulous, turbulent, and outgoing. Although they studied and played together, there was apparently no true intimacy between them. The separation caused by Maximilian's return to Vienna and Ferdinand's assumption of power during the long absences of the emperor (c. 1543) separated them yet more. Maximilian's sympathy for certain aspects of Protestant thought, at least in terms of a sense of tolerance and comprehension, clashed with Philip's dogmatic strictness and would seem to have led them to a definitive split. But political and family interests — the desire to maintain the unity of the House of Austria and a close relationship between the states of Austria and Spain — led Philip himself to insist that the emperor give his sister Maria to the archduke Maximilian, as indeed he did. Maria was Philip's much beloved older sister, both intelligent and beautiful. The wedding was decided upon in 1547 and Maximilian, who was in Vienna, returned to Spain for the ceremony. It was further decided that, since Philip was to travel with the emperor, who wished to show himself to his subjects in Germany and Flanders, Maximilian would govern Spain during the absence of the emperor and the prince.

Despite their shared education, the close bloodties, the demands of court etiquette and palace ceremonies, it was clear that a certain rift was developing between the two. Maria and Maximilian's wed-

Giuseppe Arcimboldo
*Decapitation of St. Catherine*, undated
Stained-glass window
Milan Cathedral

Milan, 6 November 1564
"Giuseppe Meda, painter, appeared and complained that Bernardino Campi is saying that he was the one chosen to paint the organ shutters; that he, Bernardino, claims to be better than the others, forgetting that having come into competition several times with *Giuseppe Arcimboldi*, the complainant's partner, including for the new gonfalon of St Ambrose, he has always remained inferior; and he (Meda) insisted that the previous order should be put into effect, whereby each of the two painters was to do a shutter as a test, the commission for the whole work then going to the one who proved the more successful."
From the *Annali della Fabbrica del Duomo di Milano*, IV, p. 56.

*In* Selva di notizie autentiche riguardanti la fabbrica della Cattedrale di Como, *811, p. 99, Carlo Francesco Ciceri states that in 1558, Maestro Giuseppe Arnaboldo received 158 lire and 19 soldi from the Fabbriceria del Duomo for preparing the carton.*
*The* Passing of the Virgin *is one of a series of eight tapestries illustrating the Old and New Testaments.*

ding took place in Madrid on 17 September 1548, with great fêtes, tourneys, *corridas,* jousts, and banquets; plays were also performed, including one by Ludovico Ariosto. Philip left for Flanders and Germany, where his father, the emperor, was working on his candidacy to the Empire, preparing for the succession — when the time came — of Ferdinand, who had already been elected king of the Romans, that is, successor to the emperor. Thus Maximilian was second-in-line and could only aspire to the imperial crown if Philip died before him. Maximilian hurried to Augsburg to defend his interests and, having consolidated his position, returned to Spain in order to greet Philip, who returned in 1551. Maximilian supposed that Philip might then be persuaded to give up his own imperial ambitions.

When Ferdinand took the imperial throne in 1556, following the abdication of the emperor Charles, Philip — who was already Philip II of Spain — sent him a congratulatory message. The unity that Charles had dreamed of was already irreparably shattered, but the family relations had to be strictly safeguarded, and the exchange of books, jewels, and artworks continued for a long time in a chilly political climate.

Maximilian succeeded his father Ferdinand I in 1564 and reigned until 1576. Arcimboldo reached Vienna in 1562, and in the two following years (1563-1564) barely managed to complete part of what his lord required. But it was during the reign of Maximilian (1564-1576) and, above all, in the first eleven years of the reign of Rudolf II, that Arcimboldo became irreplaceable, and began

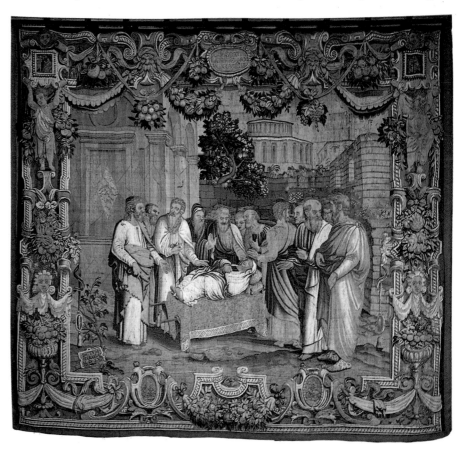

From a cartoon attributed to Giuseppe Arcimboldo
*The Passing of the Virgin*
Tapestry woven in the workshop of Giovanni Karcher in Ferrara in 1561-62
423×470 cm
Como Cathedral *

wielding a decisive influence in the life of the Austrian court.

Rudolf, the eldest of Maximilian's sons, was born in 1552 and he too was educated in Spain. Philip II suspected that educational methods were lax in Vienna and Prague and further feared that — given the precarious health of his son, the unfortunate Don Carlos — the crown of Spain might one day go to the heirs of the Austrian branch of the Hapsburgs. He therefore wished to ensure their orthodoxy with a strict education. He succeeded, through the good offices of the empress, his sister, in having Maximilian send to Madrid, first his two eldest sons, the archdukes Rudolf and Ernest, and later the younger sons, Albert and Wenceslaus. The elder sons remained in Spain for seven years, from 1563 until 1570, and became playmates and classmates of Don Carlos, of the young John of Austria, the natural son of the emperor, who came to the court in 1559 to be educated, of Alessandro Farnese, born in 1545, the son of Ottavio, duke of Parma, as well as of Margaret of Austria, another sister of Philip II.

The years spent at the court of Madrid, and intimate contact with the refined and rigorous Spanish world, whose sovereigns were at the peak of their greatest splendor, amidst a profusion of jewels and trophies from the New World, when ties with Titian were strengthening and the Escorial was becoming a reality — all this must have created a profound impression in the archdukes, and may be the source of Rudolf's obsession with secret beauty and perfection, seen as a haven from the pressure of a hostile and difficult world.

Philip II had a fervent interest in alchemy and astrology, a penchant for the occult sciences and hermeticism, and Juan de Herrera, an avid proponent of magic, played an important role in court life. (In the context of the sixteenth century, magic was not only a diabolical activity, but could also mean a wise use of the secret forces of nature.) The years of Rudolf's stay in Madrid (1563-1570) correspond precisely with the period in which the king became familiar with Herrera. In 1563, he was named adjutant to Juan Bautista de Toledo, the first architect of the Escorial; in 1567 he took over the overall supervision of royal works, especially the Escorial; and as time passed he became extremely close to the king. The archduke could not have been ignorant of that esoteric environment, that familiarity with obscure texts which his royal uncle was accumulating with such care.

When Rudolf gathered in Prague those famous and astonishing collections of which Arcimboldo was to be curator, he was doing little more than imitating with obsessive energy — almost to the point of mania — what Philip had created as a secret haven from his ongoing political battle on all European fronts. The taste for rare, curious, sumptuous products of nature and for the extremely refined fruits of human activity — jewels, weapons, scientific instruments, automata, exotic animals (alive or dissected), sophisticated paintings

Detail of a tapestry from a cartoon attributed to Giuseppe Arcimboldo
*The Baptism of Jesus* (tapestry no. 5), undated
415×720 cm
Museo dell'Opera del Duomo
Monza

Giuseppe Arcimboldo
*Self Portrait*, undated
Oil on canvas
(Dimensions and present location unknown)

that lent themselves to several interpretations — filled both Rudolf's *Wunderkammern* and the halls of the Escorial with "naturalia" or "artificialia." The atmosphere of radical Catholicism that prevailed in Spain could not prevent — at least while the complex monarch reigned — the development of a taste for rarities and enigmas, for all that which required two or three levels of interpretation.

The king of Spain's predilection for Hieronymus Bosch endowed the Museo del Prado with the world's richest collection of works by Bosch. His "diableries," his astonishing imagination, the enigmatic assembly of disparate elements, integrated in absurd and multiple creatures, all certainly harbor a complex allegorical meaning, which must have been far less mysterious to his contemporaries than they are to us. Of course, his language was never open and comprehensible to all, as witness numerous sixteenth-century references to the difficulty of understanding the works of Bosch and their problematic nature, always viewed as "bizarre," although Padre Sigüenza emphasized, "I read more things in this panel [the *Haycart*] at just a glance, than in other books in many days..." Of the *Garden of Delights* he said: "In this painting one sees, as live and clear, many passages of the Scriptures which have to do with man's evil, since many allegories or metaphors exist in the Scriptures to represent it, in the Prophets and in the Psalms, under the appearance of animals that are tame, courageous, fierce, lazy, wise, cruel, carnivorous, suited for labor or bearing loads, for esthetic uses, for play, for ostentation, sought by men and transformed into men by the inclinations and habit, and the way that the two blend, is here depicted with wonderful precision. The same is true of birds and fish and reptiles, because the Holy Scriptures are full of them. Here there is reference as well to that transmigration of souls imagined by Pythagoras, Plato, and other Poets who wrote learned fables about these Metamorphoses and transformations, who desired only to show us the bad customs, uses, or evil thoughts in which the souls of miserable men are clothed, who are lions for pride; tigers for revenge; mules for lust; fish for tyranny; peacocks for vanity; foxes for sagacity and diabolical intrigue; apes and wolves for gluttony; donkeys for insensitivity and malice; sheep for elementary simplicity; for roguery, little goats, and so on in other cases and forms that are based on this human being; and so they become monsters and grotesqueries, and all for an aim that is so lowly and vile such as the desire for revenge, sensuality, a quibble, externality, and reputation, and other things of this sort that almost do not reach the palate or wet the mouth, such as the taste of a strawberry or a strawberry-tree berry, or the aroma of their blooms, so that many are nourished merely by the smell . . .

"I wish that all the world were as full of images as this painting, as it is of truth and originality whence Hieronymus Bosch drew his *bizarrie* because, aside from his great skill, his ability, and the

Adam Swetkowyz letter of recommendation dated 28 April 1563 to Ferdinand I in favor of Arcimboldo
Finanz- und Hofkammerarchiv Vienna *

On 28 April 1563, in a letter to Ferdinand I, the imperial governor Adam Swetkowyz thus described the type and quality of the work done by "Master Giuseppe":
"... His Imperial Majesty commissioned the caricatures from Master *Giuseppe*, His Majesty's painter, who is working with such vigor that he hopes to finish them within eight days..."

Valerio and Vincenzo Zuccherini
*Ferdinand I*, 16th century
Framed mosaic, 25.4×22.2 cm
Kunsthistorisches Museum
Sammlungen Schloss Ambras
Innsbruck *

strangeness and considerations that are in everything (it is wonderful that a single head could have created so many of them), it would be of great help to all to see depicted from real life that which they have within themselves, unless they do not know what they have within them or are so blind that they do not recognize the passions and vices that have made them similar to a beast or many beasts.''

In the court of Philip II, the great Flemish painter represented that taste for the strange, the astonishing, and the monstrous that one encounters in the collections of Rudolf II and in Arcimboldo, and also in Brueghel, who was far more closely linked to a Flemish tradition that derives from Bosch. The analysis of the works in symbolic, allegorical, or moralizing terms explained their monstrosity and brought them into the current of esoteric significance, enlightening the readers who were initiated in the language.

These princes, all of the same blood, linked by several consanguineous marriages, the three emperors whom Arcimboldo served and the Madrid monarch who was fascinated by the Flemish world, may be the living expression of one of the acmes of European mannerism, a sort of secret axis between Madrid and Prague.

The mixture so often noted in mannerism of reality and dream, of religious faith and pre-scientific speculation, of overflowing sensuality and extreme asceticism, is explicit and manifest in any analysis of the personalities of these patron kings.

Alongside the wild imagination that Philip II sought and admired in Bosch, we find an obsession for the rigorous documentation of visible reality that crystallized in the collections of flowers and animals of the Indies, which were described with scientific precision. Likewise, Rudolf not only appreciated the composite fancies of Arcimboldo and the exquisite and artificial mythologies of Spranger — he also gathered naturalists; illustrations that depicted the myriad aspects of nature. The dissemination throughout Europe of the first Flemish still lifes and genre scenes, which Brueghel himself composed at the same time as his fantasy scenes, coincides with the creation of anthropomorphic landscapes and anthropomorphic games.

The exchange of experiences and the spread of the most exquisite products of the spirit within the narrow circle of true ''connoisseurs'' who could follow the tortuous itinerary of ''conceits'' and ''games of wit,'' created a remarkable similarity between the extremes of the Hapsburg axis, despite their different political climates. Spain was the fortress of Catholicism, jealous of its presumed virtues and based on a system of apparent certainties that had to be upheld; Bohemia was half Protestant and half Catholic, with a rich Jewish colony, the cross-roads of a central Europe perpetually gripped by crisis. Both courts isolated themselves, and their sovereigns devoted themselves — Philip II in a limited and measured way, Rudolf II in an impassioned and total fashion — to the desperate search for a magic or symbolic key that could unlock the secrets of the unknown.

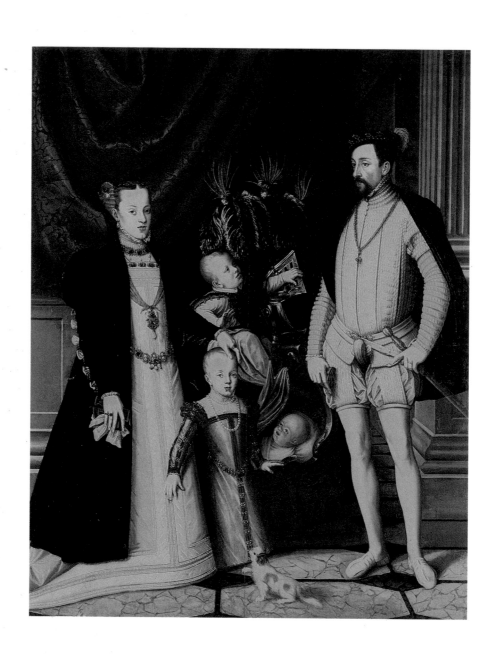

Giuseppe Arcimboldo
*Maximilian II and His Family*, 16th century
Oil on canvas, 240x188 cm
Kunsthistorisches Museum
Sammlungen Schloss Ambras, Innsbruck *

The Spanish artistic presence in Austria and Bohemia was very strong, and is shown chiefly through the portraits of the sovereign and his children that the reigning house was continually sending as family information (periodically updated), and in the portraits of several noble Spanish families that had created lasting ties with far-off Bohemia. A clear demonstration is offered by the series preserved in the castle of Roudnice, which comes from the Pernestejn family, which was linked by successive marriages to the Spanish family of the Manrique de Lara. When, in 1580, the empress Maria, mother of Rudolf and widow of Maximilian, wished to return to Spain — crossing Europe in an eight-month voyage that ended in the Monasterio de las Descalzas of Madrid, founded by her sister Isabela, queen of Portugal — she was accompanied by two daughters of the Pernestejn family. One of them was married at Zaragoza with the duke of Villahermosa, and the other, after becoming a nun, rose to the position of prioress of the Monasterio de las Descalzas.

In Vienna and Prague, the Spanish influence was strong, affecting not only politics, but also social customs, literature, fashion, jewels, and hairstyles. In turn, the arrival in Spain of artworks from the imperial headquarters in Prague or Vienna was also important, and of course included works by Arcimboldo that can still be traced in Spanish collections and inventories, showing that cultivated Spanish circles maintained their taste for magic inventions loaded with symbolic and allegorical messages. It is interesting to observe that several works by Arcimboldo and his circle were included — beginning very early on — in the royal collections of Spain, but also in collections of the nobility, alongside works that speak of a taste

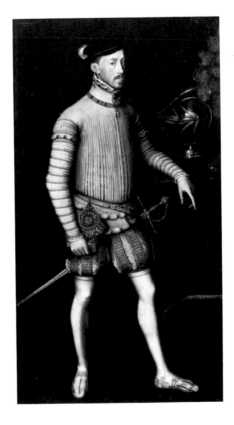 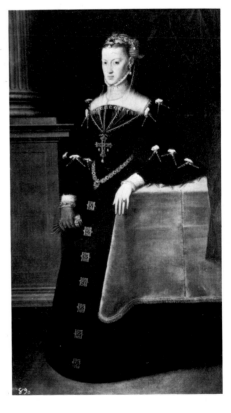

Antonis Moor
*Portrait of Maximilian II, 1550*
Oil on canvas
Museo del Prado, Madrid

Antonis Moor
*Portrait of the Empress Maria, 1550*
Oil on canvas
Museo del Prado, Madrid

similar to that which crystallized at Rudolf's court.

Don Juan Alvaro de Castilla, a Madrid nobleman, possessed in 1580 two "capriccios by Arcimboldo," in a notable collection of works that illustrate our earlier observations: some "small panels of peasants of both sexes," which lead us to think of the world of Brueghel, and of "witches' enchantments" which recall the fantasies of Bosch or of later German artists such as Strigel.

This taste appears in many other Madrid collections of the period but, of course, it can be seen most clearly in the collections of the crown. In the royal inventories, even the later ones of the late eighteenth century, it is possible to gather documentation of the presence of works whose description — now that the name of Arcimboldo, never familiar to Spanish ears, was completely forgotten — dovetails precisely with the specialities of the great artist who was ennobled by Rudolf II, just as Titian had been by Charles V.

So, for instance, in the inventory of the Alcazar of Madrid of 1666, we find in the "Bóvedas de la Priora": "Four heads of various knick-knacks, together worth forty silver ducats." In the inventory of 1686, note is made of paintings in the corridors "de las Bóvedas" at the foot of the stairs of the "Galeria del Zierzo": "Three heads on panels, which represent the seasons and are composed of various fruits and flowers, by an unknown hand"; and in the small hall of the above-mentioned "Bóvedas de la Priora": "A head on panel two thirds of a vara high, made up of various types of fruit and grain, of the school of Hieronymus Bosch." In the same inventory, we find in a hallway of the "Casa del Tesoro": "A half body formed of various kitchen implements on a canvas that is one vara high and three quarters of a vara wide with a black frame." As a curiosity, it is worth mentioning that the head composed of fruit and grain (certainly an allegory of Summer) was still in the workshop of the painters of the chamber when Luca Giordano received the keys in 1694. The stupendous *Spring* of the Real Academia de Bellas Artes of San Fernando is certainly one of these works, and was once in the royal collections of Spain.

The strangest thing about these inventories is the attribution to Bosch, or to his school, of works that were certainly by Arcimboldo. This attribution underlines — by revealing intuitively the hidden link between the mentality of the two masters — that in Spain the name of the great Flemish painter summed up the strange allegorical and moral mentality that is present in the Milanese painter.

The powerful tie that linked the two Hapsburg courts along the axis that we have pointed out, sank its roots deep into the tradition of the late Middle Ages when, just as in the unsettled and desolate world of mannerist Europe, the most obsessive analysis of reality existed alongside the most complete abandonment in fantastic creation — the only way to depict, in metaphoric terms, all the contradictions of that very reality.

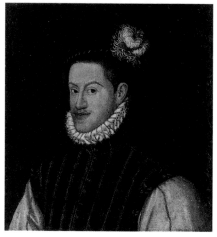

Sanchez Coello
*Philip II*
Oil on canvas
Museo del Prado, Madrid

Sanchez Coello
*Archduke Rudolf*, 1570 c.
Oil on canvas, 43×39 cm
Středočeská Galerie, Prague

Giuseppe Arcimboldo
*Peasant Woman Going to the Market*, 1563
(signed lower left:
Giuseppe Arcimboldo Mediolanensis F.)
Pen, sepia and blue-grey watercolor on paper
25.5×18.1 cm
Biblioteca Nacional, Madrid *

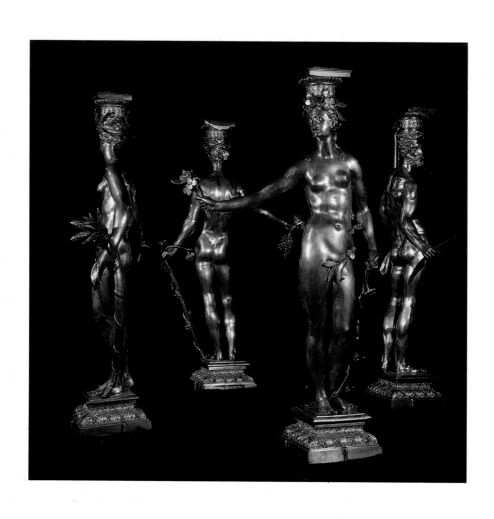

Wenzel Jamnitzer and Johann Gregor van der Schardt
*Allegories of the Seasons*, 1580
Cast in gilded copper, h. 70 cm circa
Sammlung für Plastik- und Kunstgewerbe
Kunsthistorisches Museum, Vienna *

# The museum as image of the world

by Sven Alfons

As late as the mid-sixteenth century, the Hapsburg collections were still clearly the product of a medieval conception of the treasury[1] — objects were appreciated chiefly for their material value and were therefore stored in well-guarded places. We can gather an idea of the old Hapsburg treasury from the carvings on the monumental wooden doors of Maximilian I. This may not be an entirely realistic interior view, but it is without a doubt true to the basic concept. We see the vaulted room of a castle, dimly lit by a narrow slit window covered by a grate. The collection is partially arranged on tables and partly in strongboxes. The underlying principle is chiefly that of storage, and there is none of that systematic approach that is inherent in the display of a collection.

Though Maximilian I was certainly motivated by genuine interest in history and antiquities, he essentially intended to use those objects to illustrate the history of the Holy Roman Empire and of his own dynasty. This overriding concern limited the scope of the collecting activity of the Hapsburgs. The emperor also possessed curious or odd objects, scientific exhibits, and exotica of all sorts. Certainly these collections were not all stored in the same place. We can exclude this possibility for two reasons: there existed no permanent residence, and the emperor was the product of a very specific cultural formation. The inventories drawn up after Maximilian's death, as well as other sources, indicate that the objects were scattered throughout numerous residences, chiefly at Schazruhen and Gewelb.

Charles V made no changes in this arrangement of things, nor do we have any indications — with reference to the first half of the sixteenth century — that objects normally stored in strongboxes or storerooms were put on display. It is not until the last years of the reign of Ferdinand I that this occurs, under the impulse of a new age.

The first prerequisite for an installation of the sort required was satisfied in 1530 when Ferdinand I selected Vienna as his permanent residence and as the center of government. It also appears that a decade later he started to take a personal interest in collecting; as usual, he veered toward material connected with the Holy Roman Emperor and his family. His aim was to complete the existing collections, and he chiefly collected coins and other antiquities that could

serve as documentation. Even at this early point, Ferdinand was planning to assemble a systematic coin collection. An inventory dated 27 December 1547 lists the coins in no particular order. There is a notation, however, to the effect that the coins should later be stored in their own strongbox. This was in fact done. The court official Leopold Heyperger, guardian of the collections, compiled a large systematic catalogue between 8 April 1555 and 3 August 1556. We may presume that Heyperger turned to the court historian Wolfgang Lazius for numismatic and antiquarian expertise, and indeed, Lazius claimed to have reordered the collections. It was during this first, partial reordering that the *Schatzkammer* — the storeroom of the medieval treasure — was reorganized according to the objects' historical characteristics, with a view to illustrating the family history. Ferdinand I disliked the idea of dispersing his coin collection, and he willed it (25 February 1554), in its uncatalogued state, to his eldest son Maximilian.

Antonio Abondio
*Profile of Maximilian II*, 1567
Silver medallion, diam 5.3 cm
Münzkabinett
Kunsthistorisches Museum, Vienna *

Ferdinand's collections, however, contained many antiquities in addition to coins. Archeological finds and other objects were kept for considerations other than that of material worth. Those that were valued for cultural reasons (oddities of every sort, paintings, scientific exhibits) were assembled in a *Schatzkammer* of art objects. We cannot be sure whether more imposing ancient monuments were also present. Interest in these objects was limited to their inscriptions, and at the time of Ferdinand I ancient sculpture was not yet collected for its esthetic value. In all probability, the library was considered to be the place for antiquities, but the library had not yet been installed in appropriate rooms.

In 1554 we find the first indications of an imperial *Schatzkammer* for works of art. The citation appears in Heyperger's inventory of antiques stored in the castle of Graz. For certain curious objects there is a recurrent notation, "hat Heyperger in der Kunst-Camer," i.e., (placed by) Heyperger in the artistic treasury. Heyperger does not give us the year in which this *Kunstkammer* was established, but it was probably not created much earlier. In 1563, the emperor appointed Adam Swetkowycz to find "in our *Schatzkammer* in Vienna" a portrait of Ferdinand himself to have it copied by Arcimboldo.

Maximilian was greatly interested in science; his zoological gardens, in the castle of Ebersdorf and later in Neugebäude, seem to be linked to the *Kunstkammer*. He certainly added much scientific material, and his patronage of such great botanists as Mattioli and Charles de l'Ecluse must have left its mark on the collection. His keen interest in problems of physics, hydrostatics, and mechanics probably led him to expand the artistic and scientific collections with every variety of equipment, as was the current use.

Maximilian also acquired great quantities of ancient objects, and now for their esthetic value. His great love for parks allowed him to grasp easily the decorative value of statuary, and he learned much

from Italy. He also attempted to purchase some Italian paintings: certain letters dated 1568 and 1571 concern the purchase of works by Titian and Paolo Veronese. As Lomazzo wrote in his *Idea del tempio*, Maximilian also summoned to his court the Italian artist Giuseppe Arcimboldo, to confer greater glory to the museum of his Caesarian Majesty. The curator of the collection, Heyperger, had died in 1560, and no replacement had yet been named. Probably, given his expertise, Wolfgang Lazius took care of the collection. It is not unlikely that the court painter Arcimboldo was called in on more than one occasion, as later occurred under Rudolf II.

The establishment of the Hapsburg collections in Vienna in a display of art and science or *theatrum scientiae*, coincides with similar initiatives (or perhaps inspired them) in other princely courts north of the Alps.

Once art collections began to be put into order, the problem of their internal organization inevitably arose. The planners of the new *Kunstkammer* were no longer satisfied with gathering together wholesale rarities with which to satisfy the idle curiosity of visitors, nor was it enough to strike the visitor into dumbfounded amazement. They attempted to establish a unity based on a dominant criterion; they tried to fashion a frame within which to arrange the individual phenomena. With respect to the collections, they tended to present this frame through images or writing. One may safely presume that the Viennese curators meant to express a fundamental concept, appropriate to a museum: the structure of the material world and its interconnections. The only available model was the so-called scholastic encyclopedia, which originated under the Romans. This work developed its allegorical and didactic form during late antiquity, and was given its final order during the High Mid-

Severin Brachmann
*Emperor Maximilian II
and Empress Maria*, 1560
Limestone relief, 23×31 cm
Sammlung für Plastik- und
Kunstgewerbe
Kunsthistorisches Museum, Vienna *

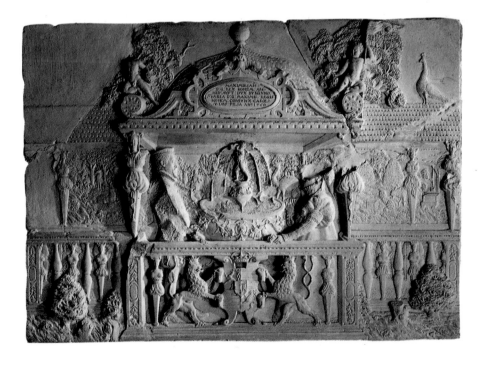

dle Ages.[2] The system found its clearest exposition during the thirteenth century in the *Speculum Maius* by Vincent de Beauvais. The *Speculum doctrinale* discusses theoretical knowledge (which included the seven liberal arts, metaphysics, physics, and theology), ethics (that of the individual and that of society, as well as jurisprudence), and mechanical knowledge (the seven mechanical arts). These systems were also fundamental for sacred and profane painting, and imparted a specific iconographic order to the didactic decoration of rooms devoted to study, especially of libraries. This encyclopedic system also supplied an ideological foundation to the artists of the Hapsburg court, as one sees in the *Weisskunig* and in the *Theuerdank* of Maximilian I. Hans Burgkmaier executed a woodcut according to concepts developed by Konrad Celtes, the *Aquila divus imperialis*, in which the two-headed eagle contains the structure of the educational system. The two heads are flanked by the captions *Sacrum* and *Imperio*, and symbolize the Holy Roman Empire with its ecclesiastical and political power. Upon the eagle's neck is depicted the *tri pos*: the emperor alongside a representation of political power and another of ecclesiastical power. Beneath the emperor's feet gushes forth the *Fons Musarum* which fills a large fountain, whence the water pours into the basin of the *Novem Musae*. Beneath this come the seven liberal arts, then the three Fates, and lastly the *Judicium Paradis*, flanked by Mercury and Discord. The eagle's right wing bears a depiction of the Creation; the days of the Creation, the *sex opera dierum*, are depicted in six medallions. His left wing bears a corresponding number of medallions that illustrate the creations of man: the seven mechanical arts (*septem mechanicae*). The central images, the spring and the fountain, determine the architectural arrangement of the whole, while symbolizing the interior flow and cohesion of the depiction. Similar examples can be found in the fountains of medieval cities, such as in the *Fontana Maggiore* of the Pisano, in Piazza del Duomo in Perugia, which dates back to approximately 1270. Other examples can be found in more recent periods, such as in Maximilian's orders for the construction of an encyclopedic fountain.

Wenzel Jamnitzer entered the service of the archduke Ferdinand in the mid-sixteenth century. For the archduke he constructed or designed (among other things) various fountains, one of which — according to certain letters — had a "formidable jet of water; it is used in a hall." After Maximilian II's succession to the throne in 1564, Jamnitzer had intermittent commissions from this emperor as well. The most important among these was a fountain made of silver and other metals, which was completed in 1586 (after Maximilian's death) and delivered to Rudolf II. In 1747, the fountain was melted down, save for four figures; we do have a description of the fountain written by a student of Altdorf, who saw it around 1640.[3] It too was designed to be installed indoors. It was shaped like the imperial crown, was five feet wide and ten feet tall (approximately 1.5×3

Giuseppe Arcimboldo
*Self Portrait*, 1575 c. (signed top left in sepia:
Joseffi Arcimboldi imago)
Pen and blue pencil on paper
23×15.7 cm
Národní Galerie, Prague *

clock with the seven planets." It was given by Maximilian to Duke Augustus with the evident intention of inculcating in the recipient ducal virtues and loyalty toward the emperor. Furthermore, in 1574, by imperial order, Arcimboldo executed "several paintings and works" for the same duke, a probable reference to the paintings that Philipp Heinhofer saw in 1629 in the fourth hall of the *Kunstkammer* of Dresden. He described them as "strange talking heads of the cook or waiter, with their various appurtenances; (I also saw) four other talking heads, or faces, of the four seasons." The testimony of Lomazzo could confirm the hypothesis that Arcimboldo's paintings are rather closely tied to the *Museum of his Caesarian Majesty Maximilian II, Emperor*.[4] "In order to expand (this museum) and give it greater luster," the emperor summoned the great painter Giuseppe Arcimboldo who "there painted the figures of the four elements . . . Furthermore he depicted the four seasons . . ." These are fairly vague phrases, but that does not exclude the interpretation according to which the creation of "symbolic signals" for the *Kunstkammer* had been planned when Arcimboldo was summoned. Nor should we rule out the possibility that the singular paintings were not part of the *Kunstkammer* as objects on display, and that they served strictly as ornaments in the halls of the museum. It is interesting to note that Lomazzo, the first time he mentioned these depictions of the seasons and elements in his *Trattato*, had already perceived clearly the special "signal" quality of Arcimboldo's paintings. He included Arcimboldo in the chapter entitled *Il genere di pittura adatta a Scuole e Licei, nonché quella adatta a Locande e luoghi sifatti* and here he summed up the principles that govern symbolic ornamentation of places of study with encyclopedic images. Unfortunately, he did not specify the locations appropriate to paintings like those done by Arcimboldo.

One cannot see in Maximilian a patron who promoted free and independent artistic creation, and it is especially difficult to suppose that a court painter should to such a degree indulge in caprices and entirely personal artistic creations. Almost all of Arcimboldo's creations, for that matter, formed part of large series of images: the stained glass windows for the Duomo of Milan, the Como tapestries, the processions. Arcimboldo himself, in his letter to Ferdinand Hoffman, observed that the paintings of the ancients were not the products of happenstance, but had a precise aim; hence modern ornamentation too should have a cohesive internal significance. The symbolic series by Arcimboldo must be the result of a commission based on a specific idea of their use. In effect, their placement in the imperial *Kunstkammer* implies a specific destination. In this case, to whom should we attribute the inner meaning of Arcimboldo's ornamentation of the *Kunstkammer*? We have already met Wolfgang Lazius in connection with the *Kunstkammer*. It was he who gave a scientific organization to the numismatic collections. Lazius was an ardent collector and scholar, and around 1560 he was closely tied to

Woodcut by
Hans Sebald Lautensack
*Portrait of Wolfgang Lazius*, 1554

the court as an historian. In ideological terms, he certainly would have been the best candidate for the task of planning the collections.

The system that Arcimboldo illustrated was chiefly a system of natural philosophy, which would seem to fit in badly with the ideological baggage of Lazius, biographer and antiquary. In reality, however, he was a student of the sciences and had long practiced as a physician. At the beginning of the sixteenth century, the theory of the elements was still fundamental to scholastic medicine and in *Li capricci medicinali* (c. 1560), it could still be the basis of a physician's excogitations.

Lazius had a still closer tie to the theory of the elements, however. During his travels in search of ancient texts, he uncovered a manuscript that he then published in Vienna, believing it to be hitherto unpublished, just a few years previous (1549) to the design of the *Kunstkammer*. The manuscript was entitled *De Imagine Mundi Libri Quinque, Hautore Honorio Gotho quodam, in quibus quatuor elementa ita discutiuntur, ut cosmographiae ex his rudimenta simul astrorumque scientiae haurias*. Lazius was mistaken in believing this to be an original discovery — the first edition bears no place and date of printing, but was probably published in Nuremberg in 1472. There was a reprinting in Nuremberg in 1491 and other editions in Basel in 1497 and 1544. Doubts exist as to the identity of its author. The work has been attributed at various times to Anselm of Canterbury (1033-1109), Honoré d'Autun (active around 1120), and lastly to the English Benedictine monk Honorius Inclusus (active around 1090). For many reasons, the latter attribution seems to be the most likely.[5] *De Imagine Mundi* was certainly read widely during the Middle Ages, and is an important link in the chain of the transmission of traditional cosmogony. The author opens his description of the world with a painstaking repetition of the theory of the elements.[6] In the third chapter of the first book, he establishes that all of creation is made up of four elements: "These transmutate, fire into air, air into water, water into earth, whence earth becomes water again, water becomes air, and air fire. The elements have a reciprocal cohesiveness due to special characteristics, as if they were endowed with arms, and conjoin their essences — hostile one to another — in a harmonious union. Dry and cold earth merges with cold water, the cold and humid water is attracted by humid air, the humid and hot air is united to the hot fire, and the hot and dry fire is conjoined with the dry ground." And so we know that Lazius had ready access to a clear exposition of the theory of the elements, the rough outline of a cosmogony that could serve as the basis for the didactic ornamentation of the *Kunstkammer*. What was the ideological system that Arcimboldo transformed into images? The author of *De Imagine Mundi* helps us to see a plastic form in his work, in which the elements are linked together as if they were endowed with arms (*quasi quibusdam brachiis se invicem tenent*). Comanini seems to be

Giuseppe Arcimboldo
*Spring*, 1563 (signed lower right: Giuseppe Arcimboldo F.)
Oil on panel, 66.7 × 50.4 cm
Real Academia de Bellas Artes de San Fernando, Madrid *

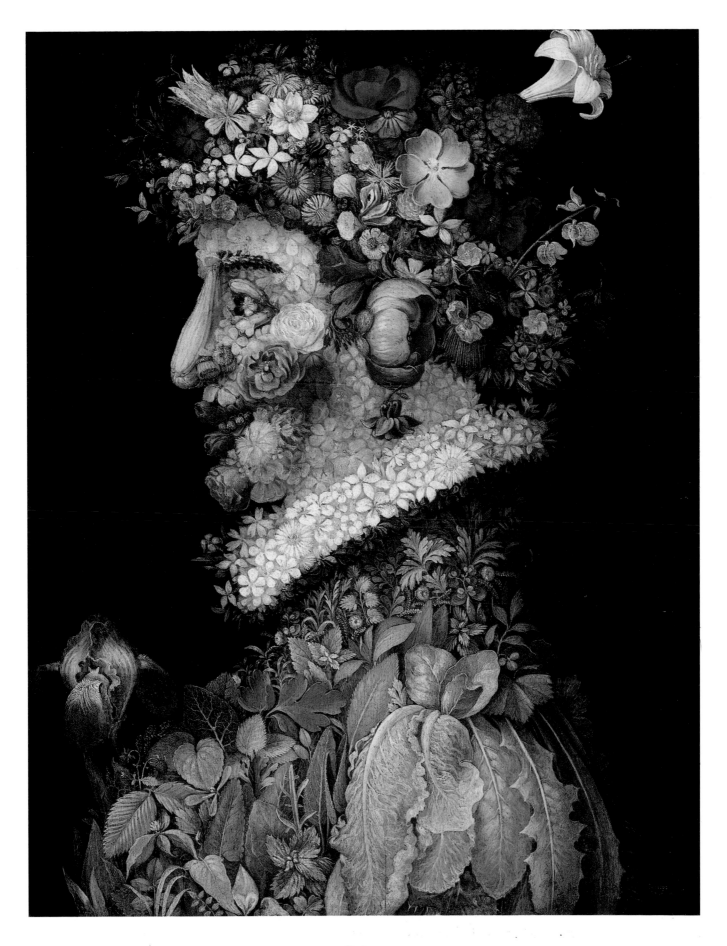

*Spring*

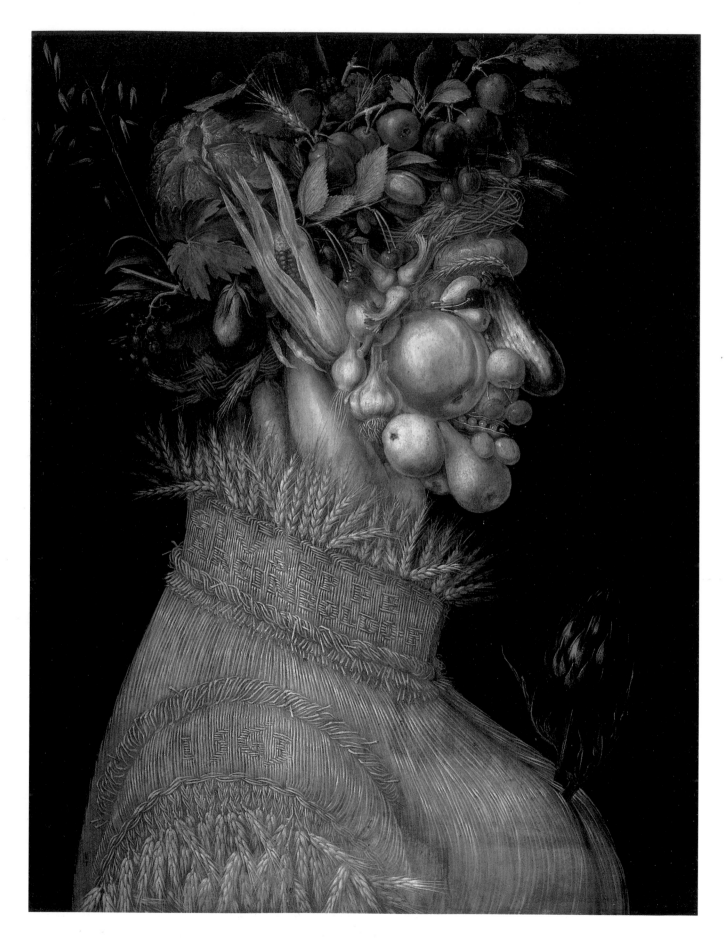

*Summer*

alluding to an analogous figure in the cosmological system contained in the introduction to his poem *Vertumnus*, and we should not rule out the possibility of a link to the conversations that he must have had with Arcimboldo. The latter may have illustrated something of the sort in Vienna. Comanini says the following about the elements: they bond one to another, "they mix and separate, humid and dry, hot and cold, like four links in the chain that turns gems into a necklace." This figure — the elements that form a necklace of wisdom by means of links — can be found in one of the most important sources of *De Imagine Mundi*.

Isidorus Hispalienses, bishop of Seville, at the beginning of the seventh century, did more than anyone else in the High Middle Ages to save the ancient knowledge that was beginning to disappear. He synthesized and transmitted it, though in a watered-down, lexicographic manner, in his great work *Etymologiae*. This work was said to contain the plan of the entire medieval university system.[7] Even during the Renaissance there was great interest in the work of Isidorus: the *Etymologiae*, printed for the first time in Augsburg in 1472, had at least ten editions during the sixteenth century. In one of his lesser works, *De Natura rerum*, Isidorus summed up all that was known in that period of the natural sciences, which is to say, the sketchy cosmogony of antiquity based on the theory of the elements. The *De Natura rerum* was fundamental to medieval cosmogonies, and Honorius in *De Imagine Mundi* cites his predecessor here and there. In Isidorus, who in turn cited Saint Ambrose, we find the recurrent image of the elements binding through their principal characteristics, "as it were, by arms" (*quasi quibusdam duobus brachiis*).[8] Isidorus also frequently illustrated his rough attempts at natural philosophy with diagrams that showed the linking of the elements. At the same time as the first printed edition of the *Etymologiae*, the *De Natura rerum* was published under the title *De responsione mundi et de astrorum ordinatione* (Augsburg 1472), with the diagrams of Isidorus reproduced in woodcuts.[9] These depict the elements as four interlinked circles: *Ignis* is a bonfire; *Aqua* is a river; *Aer* is a group of personified winds, among clouds; *Terra* is represented by a landscape. Perhaps this is the very first inspiration for Arcimboldo's symbol of the earth — buildings on a rise set in the center of the painting, and a river that runs under a bridge in the foreground. Above all, in *De responsione mundi* we find a diagram that represents the elements, the various seasons, and the "humors," linked by means of the arms or by their qualities. The decorative depiction of the diagram recalls the necklace to which Comanini refers. Does it not also recall the anthropomorphic concepts of Arcimboldo? The central circle closes the three complex parallel units: *Mundus, Annus, Homo*. At the top is the world, the macrocosm; at the bottom is man, the microcosm. The four-part division of these three units takes place through a series of concen-

Giuseppe Arcimboldo
*Summer*, 1563 (signed on collar:
GIVSEPPE ARCIMBOLDO F. and dated
on shoulder: 1563)
Oil on panel, 67×50.8 cm
Gemäldegalerie
Kunsthistorisches Museum, Vienna *

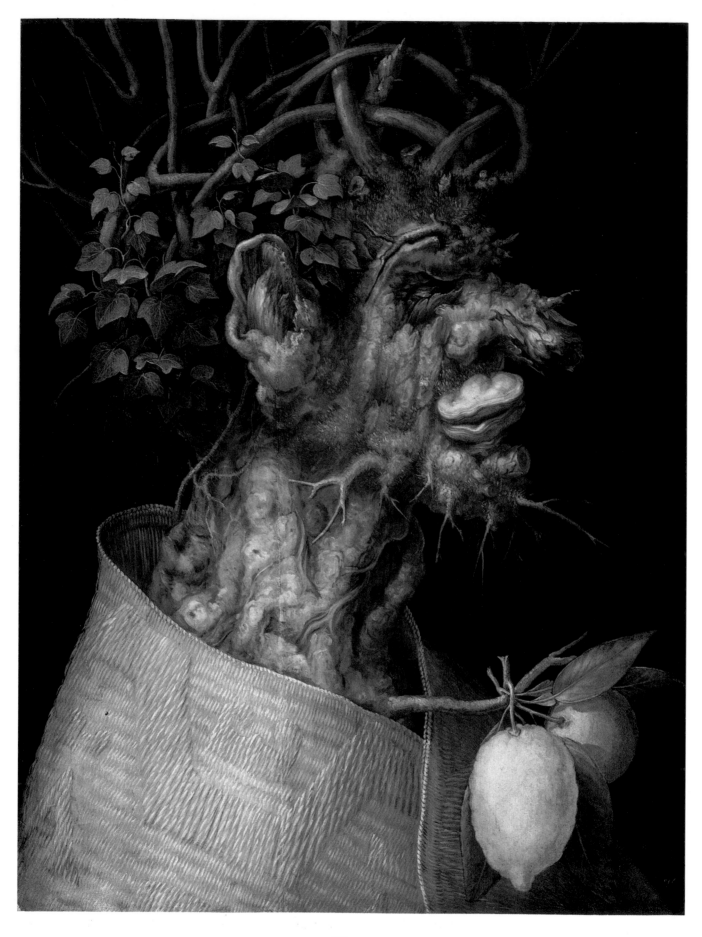

*Winter*

tric circles around the central circle, and is articulated in the following fashion: the world is divided into its elements, the year into seasons, man into his humors. The four qualities — *siccus, calidus, humida, frigida* — unite these divisions into a solid structure. Arcimboldo depicted the elements and the seasons, and I would tend to see the humors as well in the latter. We have no documentation concerning a possible depiction of *Mundus*. From Lomazzo, we know that Arcimboldo executed an *Annus*, "a Janus with a serpent biting its tail around his neck represents the year." Lastly, I believe that one can detect *Homo* in the figure composed of quadrupeds. This interpretation gains credibility if we compare it with the diagram of Isidorus. The figure thus fits into a particularly significant context. By the same token, the depiction of the year emerges from aimless chance and takes on a fundamental significance.

Thanks to systems such as that of Isidorus, a considerable percentage of the known works by Arcimboldo begin to take on an ideological cohesiveness that unquestionably corresponds to a practical function. As far as we can tell, Arcimboldo's opus was executed upon commission for the imperial collections, where it appeared in its entirety. We may therefore safely suppose that its practical function was directly linked to those collections, and hence that Arcimboldo's work was an encyclopedic introduction to the museum.

Isidorus's diagram, however, does not explain many other paintings by Arcimboldo, and especially those executed by the artist during the last years of his life, in Milan, long after Maximilian was succeeded by Rudolf II. The latter had already transported the collections from Vienna to Prague. The paintings of the last period, especially *Flora* and *Vertumnus*, are orientated toward a different ideology. The diagram of Isidorus also fails to explain the portrait of Zasius, clearly a jesting piece of perfidy destined for the court. It also excludes the *Man-Book, Agriculture, Kitchen,* and *Cellar.* This does not mean, of course, that these paintings cannot have a functional significance with respect to encyclopedic systems and the *Kunstkammer,* in a broadening of the program suggested by the diagram of Isidorus. As late as 1566, Arcimboldo was still at work on a series of depictions of the elements. If it was Lazius who suggested the idea of the symbols for the museum, he was not to see the realization of his idea; he died in 1565. A possible amplification would have taken place only after the previous series had been exhausted, and in that case through the good offices of a mind other than that of Lazius. Such an amplification was necessary. The symbols that had been completed did no more than trace a system of natural philosophy and describe the structure of the physical world. An important part, however, of the imperial collections, the part concerning history, is excluded from this system. The most significant collections were of antiquities, especially coins and plaques. This part too required a symbolic image, the *Man-Book,* or *Anti-*

Giuseppe Arcimboldo
*Winter*, 1563 (Signed lower right: GIVSEPPE ARCIMBOLDO F. and dated on back: 1563)
Oil on panel, 66.6×50.5 cm
Gemäldegalerie
Kunsthistorisches Museum, Vienna *

*quitas*. I have suggested elsewhere that it was Johannes Sambuccus, the successor to Lazius, who conceived of this broadening of the series of images thus far executed. He was Lazius' peer not only in terms of culture, but also in terms of his position at court. His activity as an emblemist must have made him that much more competent than Lazius at understanding the works of Arcimboldo. For the painter, it was certainly natural to take Lazius as a model for the *Antiquitas*. It was a jesting sign of homage to the man who — more than any other — had worked to conserve antiquities, and — more than any other — had worked to organize the *Kunstkammer*. Lazius, moreover, was enough of a bibliophile — perhaps in a slightly ridiculous manner — to be easily depicted as a book. While the book, in this case, stood for something quite ancient, the symbolic contamination of painting by books and antiquities was not merely an emblematic operation; it corresponded to a sort of display approach, that to a certain degree has always been present in the National Library of Vienna. In effect, the vestibule and stairway of the library are decorated with an important collection of plaques from late antiquity. Antiquities were considered more appropriate to the library than to the *Kunstkammer*. This appears even more clearly in Munich, where in 1563-1567 a special building was erected for the *Kunstkammer*. A few years later, Wilhelm Eckl and Jacopo da Strada began the construction of a magnificent building planned as a library on the ground floor and museum of antiquities on the upper floors.[10] Maximilian II could not afford a similar level of magnificence in Vienna. In 1575, when Hugo Blotius was appointed the first official librarian in Vienna, the Hapsburg library was quite neglected and was housed in unsatisfactory rooms in the convent of the Grey Friars, near the fortress where it had been ever since the time of Ferdinand I, according to a moderately reliable report by Blotius. There it remained until 1623.[11]

There is no evidence that the antiquities, entirely or in part, were also in that convent. The link between library and collection of antiquities that we find in Munich did not exist in Vienna. Probably this can be explained by such difficulties as war and economic problems and — not to be overlooked — the frail health of the emperor.

When Maximilian was young, he had enthusiastically promoted the idea of creating a library at the same time as the *Kunstkammer*, and on 11 January 1558 he wrote to Johann Ulrich Zasius, who had not yet entered the service of the court of Vienna: "We graciously refrain from concealing that we are currently involved in the preparation of a library and that, through our councillor Dr. Caspar von Nydbrugg, we have already started work and have assembled a goodly supply of books."[12] The latter went on to commission Zasius to purchase the collection of volumes owned by Johann Albrecht Widmanstetter. On this occasion, Zasius did not comply with Maximilian's request. The letter of reply expressed quite skeptical views

Woodcut (anonymous)
In *Emblemata, et aliquot nummi antiqui operis* by Johannes Sambucus
Antwerp, ex Officina Christophori Plantini, 1566
Bibliothèque Royal Albert Ier
Brussels

which indicate a certain animosity that probably stayed with him even after the emperor reluctantly appointed him vice-chancellor. The same animosity can be detected in Arcimboldo's pungent satire. Widmanstetter's collection of books was, instead, taken to Munich where it served as the foundation for the rapidly expanding library. Maximilian's disappointment and the death of Caspar von Nydbrugg the previous year were perhaps factors that slowed the progress of the library. The combination of library and museum of antiquities already existed elsewhere, and probably something of the sort was being planned in Vienna, though never completed. Hence the two-fold meaning — symbolic and real — of the composition by Arcimboldo, which found only partial correspondence in the collection.

The fountain by Wentzel Jamnitzer, supported by the elements and the seasons, was in the shape of an imperial crown, and on its four arches were depictions that symbolized earthly realms and cities. At the peak of the arches was Jupiter, "thanks to whom all realms are assigned and organized," alongside a great eagle "that symbolized the great earthly chief, that is, His Imperial Majesty." Below the eagle stood the representatives of the four monarchies, "Ninus of the Assyrians, Cyrus of the Persians, Alexander the Great of the Greeks, and Maximilian II who represented the Roman realm." The first three held lowered spears to indicate that their reigns were over; Maximilian instead held royal insignia because "he still guides the government firmly." The arches bore a series of "dignitaries of the realm." First came the seven elector princes, represented by their coats-of-arms. Then came the entire hierarchy of the Empire, with the four dukes in the first row, followed by the four margraves, then the four burgraves, the four landgraves, four counts, four knights, four cities, four villages, and lastly at the bottom of the hierarchy, four peasants, lowly manual laborers of the great state bureaucracy, at the service of the seasons and the elements. The natural order here found a cohesive superstructure in the depiction of the social order. Did the series of paintings by Arcimboldo in the *Kunstkammer* have a similar superstructure in the views of the world, the year, and man? A superstructure of social symbols that coordinated the ingenious ordering of nature with the great agrarian bureaucracy? Probably the three paintings, *Agriculture*, *Kitchen*, and *Cellar* find their correct placement in this context.

The medieval encyclopedia is not directly illustrated in the series of symbols created by Arcimboldo. Scholastic thought could not fit entirely into this context, as its minute division of concepts would have required an enormous number of images. The scholastic differentiation of concepts, however, can also help us in interpreting the symbolic structure in the *Kunstkammer* of Vienna. The scholastic system, despite its minute specifications, was not entirely closed and inflexible. The figures of Arcimboldo also illustrate a circumscribed ideological structure, a system with very real links to the

Titian
*Portrait of Jacopo Strada*, 1567-68
Oil on canvas, 125×95 cm
Kunsthistorisches Museum, Vienna

reality that produced it. *Homo*, a central figure of the system that we have just discussed, illustrates human passions and suggests ways to ennoble the viler instincts by means of *virtus*. Here there is a didactic intent, a cryptic treatise on the individual. In Vincent de Beauvais' encyclopedic system, the ethics of the individual was a subset of *Virtus*, which was split into *virtus monastica* (ethics of the individual), *virtus oeconomica* (ethics of the family and ethics of its economic operation), and *virtus civilis* (ethics of the state). Considering the emphasis the Hapsburgs placed on their family and dynasty, and the deep roots they had in the culture of nobility, it might have seemed natural to depict, through appropriate symbols in their family collections, the concept of the State as a bureaucratic administration similar to the family. This also seemed to be justified by the fact that the old economic order still applied in full among the highest strata of the court. With intelligent economic management, it was possible to draw the greatest amount of profit from the products of nature and the season. Through good husbanding, it was possible to create within the dynasty a model society, a microcosmos corresponding to the cosmos. This management of one's own household was in the final analysis merely the government of oneself; this was the ethical nucleus of the realm, even within the broader context of the State.

Three forces helped to elevate man above the ignorance of his instincts and his weakness, generated by original sin: *sapientia* (intellectual knowledge), *virtus* (ethical strength), and *necessitas* (an impelling need). *Necessitas*, in turn, contained within it the seven mechanical arts which, in more ancient depictions, were *lanificium, armatura, navigatio, agricultura, venatio, medicina, theatrica*. By medicine, strictly practical medicine was intended. At the beginning of the sixteenth century, this was limited almost exclusively to prescriptions to regulate the equilibrium of the bodily humors through the diet, and it was quite close to the culinary arts. We can see that in the symbolic woodcut of the *Aquila divus imperialis* commissioned by Maximilian, medicine has been replaced by *coquinaria*. In this woodcut, the seven mechanical arts serve as counterparts to the six days of the Creation, and the terrestrial corresponds to the divine. Hence we see that *agricultura* and *coquinaria* have risen to new dignity in the symbolic representation of the Holy Roman Empire — agriculture and the culinary arts are important members of the body politic. They possess this high state as well in the series of symbolic images in the *Kunstkammer*. Through the unification of certain concepts, belonging to the broader complexes of *virtus* and *necessitas*, it was possible to illustrate the formula of state. The prince immediately appeared as the *paterfamilias*, and therefore as the lord of natural order, as he is shown in the theory of the elements. In 1571, at the wedding of the archduke Karl, Arcimboldo, at the wish of Maximilian II, emancipated the elements and

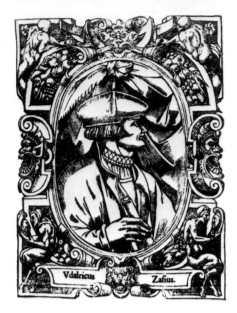

Woodcut (anonymous)
*Ex libris Ulrich Zasius*

Giuseppe Arcimboldo
*The Jurist*, 1566
(signed and dated on back:
Giu. Arcimboldo 1566)
Oil on canvas, 64×51 cm
Statens Konstsamlingar
Gripsholm Slott, Sweden *

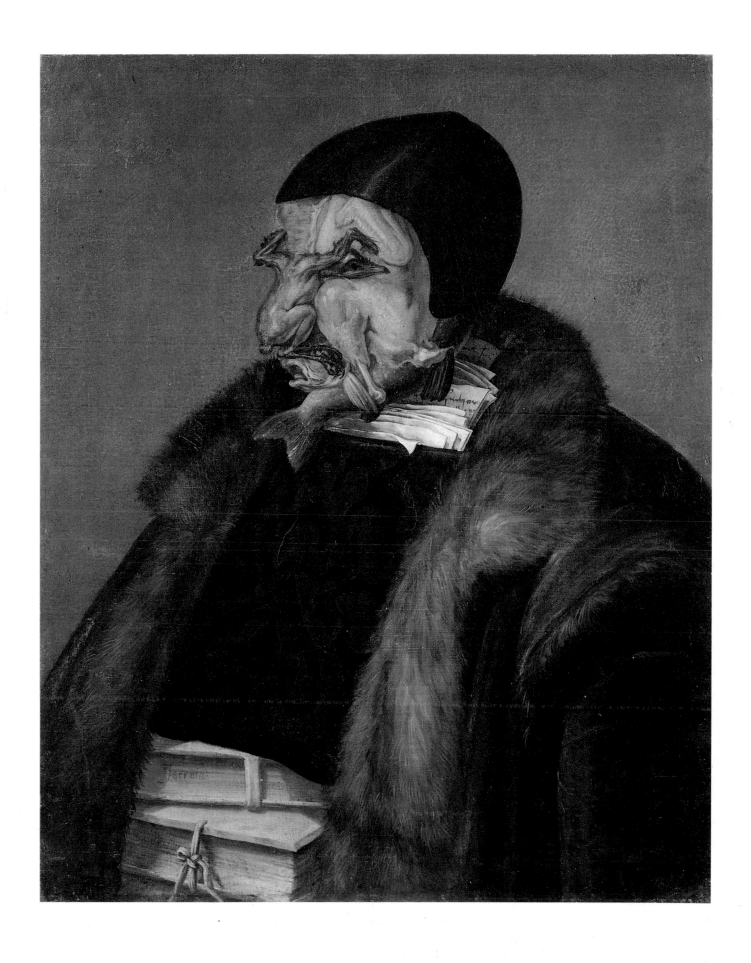

*The Jurist*

seasons from their narrow chambers, in a confined setting such as the *Kunstkammer*, and presented them as living figures on a broader stage. The painter organized on that occasion a festive performance based on the encyclopedic system. The four elements and the four seasons, that is, the series of symbolic images that had already been created, were elaborated with other correspondences; the four ages of man were shown, the four metals were assembled, and, to illustrate the current situation in Europe, the four European nations were added, followed by their greatest rivers. The winds also presented their respects to the archduke, according to the classical formula of the "rose" of winds. Even in this nuptial celebration, however, the antiquated cosmogony had a superstructure marked by knightly ideology. This part of the procession is less clear to us in the confused account that Wirrich gives of it, but we can at any rate make out the principal features. *Virtus* and *sapientia*, truly aristocratic qualities, struggled against greed and ignorance. *Sapientia* was represented by the seven liberal arts, *virtus* was represented by the four cardinal virtues, which in the *victori* celebrated their triumph over the four sins. *Sapientia* and *virtus* made it possible to manipulate one's own destiny, represented by the three Fates, as in Burgkmaier's woodcut *Aquila divus imperialis*. It is possible that another detail of the procession has a connection here — the base of the fountain depicts the Judgment of Paris, just under the Fates. Paris, an ignorant sleeping pagan, is awakened by Discord and called to express a judgment that will inevitably cause a bloody war. The war will be broken only by the intervention of the Holy Roman Empire, thanks to the virtue and knowledge that flourish under its protection and to the constant completion of divine creation by terrestrial necessity. In Burgkmaier's woodcut the entire structure rests on the discord between goddesses, the same motive with which the procession of 1571 began.

Woodcut by Heinrich Wirrich
In *Contrafactur der Europe*, 1571

Woodcut by Wenzel Jamnitzer
In *Perspectiva Corporum Regularium*
Nuremberg, 1568
Biblioteca Nazionale Marciana
Venice *

Wirrich's woodcuts give us only a partial idea of the performance organized by Arcimboldo and of the preparation of the figures, but the program of the procession indicates the concept intended in most of the production of this artist of the court of Vienna. He was certainly not a court buffoon. In the heart of the Empire he supplied a need for symbols and essential allegories; he fulfilled an incessant requirement to frame "terrestrial government" in a cosmological framework, transforming philosophical systems into spectacles. Arcimboldo, *homo facetus*, knew how to make the most of jests and bizarre effects to provoke laughter and, in fact, the emperor laughed at his jokes and jests. This does not mean that Arcimboldo, with his clever and appropriate form, did not create a perfect symbol based on canons set by previous artists.[13] He transformed ambiguity into a new and superior unity by means of an unusually complete identification of the concept with its extension. He succeeded in condensing the manifold into a single character, without giving up the arcane and cryptic essence of the symbol.

Woodcut by Lorenz Stoër
in *Geometria et Perspectiva*
Augsburg, 1567
23.6×18 cm
Germanisches Nationalmuseum
Nuremberg *

1. For a historical summary of the Hapsburg collections under Maximilian I, Ferdinand I, and Maximilian II, I made use of the appropriate chapter in Lhotsky.
2. Julius von Schlosser, "Giusto's Fresken in Padua und die Vorläufer der Stanza della Segnatura, II. Die encyklopädische Bilderkreis und die Vorläufer von Raffaels Stanza della Segnatura," in *Jahrbuch* 17, pp. 31-100. Compare Paul Weber, *Beiträge zu Durers Weltanschauung* (Studien zu Deutscher Kunstgeschichte, 23), p. 45 ff.
3. *Jahrbuch* 7 reg. 4732. - Thieme-Becker, 18 (1925), art. Jamnitzer. Julius von Schlosser, *Werke der Kleinplastik in der Skulpturen-sammlung des a.h. Kaiserhauses*, Vol. 1, pl. 16. Ernst Kris, "Der Stil 'Rustique'," *Jahrbuch*, N.F. 1 (1926), p. 151 ff.
4. Lomazzo, *L'Idea*, p. 153 ff.
5. M. Denis, *Wiens Buchdruckergeschichte*, 2, pp. 440-42. Pierre Duhem, *Le système du mond*, Vol. 3, pp. 24-34. George Sarton, *Introduction to the History of Science*, Vol. 1, p. 749.
6. I was unable to consult Lazius' edition; the text varies from one edition to another. Here I quote from the text contained in Migne, *Patrologiae latinae*, 172, column 115 ff.
7. E. Brehaut, *An Encyclopedist of the Dark Ages, Isidore of Seville*, p. 88.
8. Migne, *Patrologiae latinae*, 83, column 963 ff.
9. Albert Schramm, *Der Bilderschmuck der Frühdrucke*, Vol. 2, pl. 34.
10. Hartig, "Die Gründung der Münchener Hofbibliothek durch Albrecht V und Johann Jacob Fugger," in *Abhandlungen der Königlich Bayerischen Akademie der Wissenschaft* 28:3, p. 93, n. 5.
11. Ottokar Smital, "Miszellen zur Geschichte der Wiener Palatina. II. Die Kaiserliche Bibliothek bei den Minoriteten," in *Festschriften der Nationalbibliothek in Wien*, p. 780. *Die Österreichische Nationalbibliothek. Geschichte, Bestände, Aufgaben* (Biblos-Schriften, 6), p. 6 ff.
12. Hartig, "Die Grundung der Münchener Hofbibliothek," p. 281.
13. Karl Erik Steneberg, *Kristimatidens måleri*, p. 76.

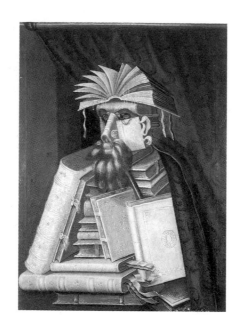

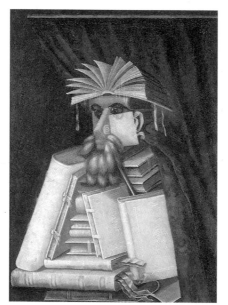

(opposite page)
Giuseppe Arcimboldo
*The Librarian*, 1566 c.
Oil on canvas, 97×71 cm
Skoklosters Slott, Sweden *

(Top to bottom, three versions of
uncertain attribution)
Oil on canvas, 100.2×72 cm
Eva Hökerberg Collection
Stockholm *

Oil on canvas, 100×70 cm
Stifts och Landsbiblioteket
Linköping, Sweden *

Oil on canvas, 99×71 cm
Jack Levinowitz Collection
Stockholm *

*Note in the third version
the two bookmarks that form
the lower part of the left cheek,
linking it to the original painting
preserved at Skoklosters Slott*

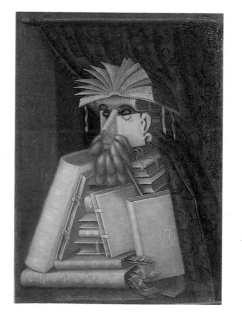

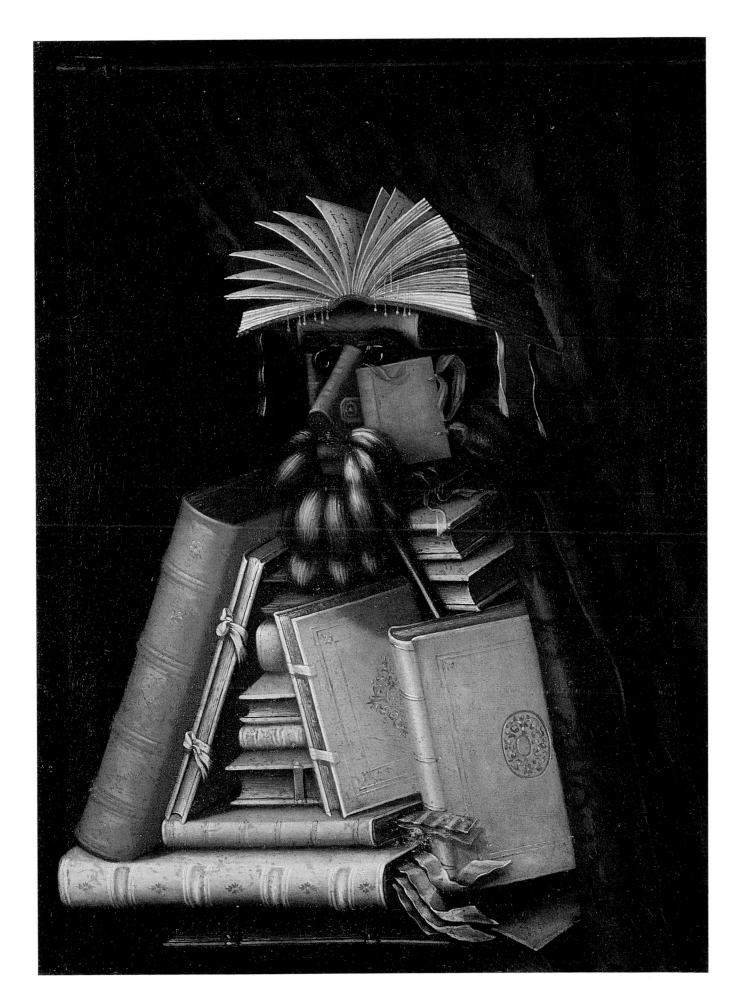

# BAP·FONTEII
# PRIMIONIS
# EVROPALIA
## HOC EST

Species dignitas, significatae solennis eius Pompae, quam Maximilianus II. imperator inuictissimus, cum illustri Europae ostentatione ijs produxit ludis, quos egit summo incredibiliq splendore, atq apparatu, dum Sereniss. Archiducis Caroli fratris nuptialem celebritatem ornandam amplificandamq suscepit, diuinoq simul praesagio foederata aduersus Barbaros militia fortunatos q euentos expetens, et Triumphum portendisse uisus est, aie ipse quadragesimo ante magnam uictoriam naualem.

## MEMORIAE

## ANTIQVITATI MAGNIFICENTIÆ
## CLEMENTIÆ, FELICITATI
## ABSPVRGIÆ AVSTRIÆ DOMVS
## SACRA DICATAQ.

Frontispiece of *Europalia* by Giovanni Battista Fonteo, 1568 c.
Handschrift- und Inkunabelsammlung
Österreichische Nationalbibliothek, Vienna *

# The Allegories and Their Meaning

by Thomas DaCosta Kaufmann

"Ingegnosissimo pittor fantastico": so did the Lateran canon Gregorio Comanini describe his friend Giuseppe Arcimboldo, and so has the notion of *fantasia* been associated with Arcimboldo's art since his own time. Other contemporary writers, including Arcimboldo himself and his collaborator Giovanni Battista Fonteo (Fontana), also laid emphasis on the role of imagination, *fantasia*, in his creation of new inventions. Using terms somewhat differently, eighteenth-century critics also employed similar language to refer to Arcimboldo's work. In the twentieth century it was under the impact of fantastic art and surrealism that an interest in Arcimboldo was first revived. Thus an interpretation of Arcimboldo needs to deal with the meaning of the fantastic in his art. But an historical approach, which seeks for an understanding of what Arcimboldo's art could have meant in his own time and which finds clues in contemporary texts on, and by, the artist, indicates that the imaginative also has a serious import in his work, and that the fantastic coincides with the allegorical.[1]

Arcimboldo's most notable *invenzioni e capricci*, as both Comanini and the Lombard painter and theorist Giovanni Paolo Lomazzo called them, are of course his paintings of composite heads.[2] The features of such heads are composed out of the elements pertaining to the subject represented, *Flora* out of flowers, for example. Although Arcimboldo's early activity in Lombardy is now becoming better known, and he was also renowned in his time as a portraitist, designer of tournaments and other court festivals, and inventor of ciphers and waterworks, as well as of a color system for musical notation, of all his works these paintings have attracted the most attention, both in sixteenth-century literature and more recently. Arcimboldo's composite heads, which were painted beginning in 1563 for the imperial court in Vienna and Prague, chiefly for Maximilian II and Rudolf II, relate a serious message in seemingly fanciful form.

Moreover, while Arcimboldo's paintings were called *capricci, bizzarrie, scherzi, quadri ghiribizzosi*, and *grilli*, these words do not in fact mean that his works are to be regarded as merely fanciful, in the present-day sense, nor as simply humorous.[3] The most extensive discussion of Arcimboldo as a "fantastic" artist, namely that found in Comanini's *Il Figino* of 1591, occurs in a more general theoretical

dialogue on artistic invention and imitation. This discourse sheds a different light on notions such as *fantasia, bizzarria, capriccio,* and even *scherzo*.

In Comanini's treatise Arcimboldo's pictures are mentioned in the course of a discussion of the status of painting as a form of artistic imitation. Comanini's dialogue raises an issue that was first adumbrated by Plato, whether painting can be considered a form of artistic imitation, which Comanini defines as a representation of things that are or can be, or rather a form of fantastic imitation, which he says represents something "di capriccio, & d'invention sua, & che non habbia l'essere fuori del proprio intelletto" ("from one's fancy, and one's own invention, and which does not exist outside of one's own intellect").

The interlocutors in the dialogue consider the role of *fantasia*, meaning the power of the imagination, in the creation of works of art. Arcimboldo's composites are evoked because while the individual elements in them are said to have been imitated all directly from flowers, fruits, and animals found in nature, they can nevertheless be regarded as examples of fantastic imitation. In them natural elements have been combined to create something that cannot be found in nature itself, such as a woman made up of flowers. Since Comanini applies *capriccio* and *bizzarria* to painting elsewhere in conjunction with fantastic imitation, discussed in the same sense, it seems that in his work these notions have a comparable meaning.[4]

Furthermore, whereas Comanini's treatise may take a Neo-Platonic turn, characteristic of much sixteenth-century art theory, his description of Arcimboldo's paintings as products of fantasy, and his comparison of Arcimboldo's transformations of the human face to the products of dreams, have a broader resonance: they recall traditional commonplaces in the discussion of imaginary images. Comanini's text (p. 28) mentions sphinxes and centaurs, mythical beings formed out of the parts of various creatures, as examples of such images. These creatures exemplify the sort of being that had traditionally been deemed the product of fantasy. Horace had called paintings of creatures such as those formed out of a human head attached to the neck of a horse ridiculous, and compared them to the dreams of a sick man. But though Horace and Vitruvius (*De Architectura* VII. 5. 3-5) had condemned this kind of image, their texts were used in a different manner when, with the rediscovery and revival of grotesque ornament, composite images became a topic for discussion in the sixteenth century. Grotesques were also compared to chimerae, and said to resemble dreams, in that they were constituted from *confuse cose*. In this regard they were also called *fantasie*, in that grotesques imaginatively recombined elements that were not to be found in nature, but only in the intellect.[5]

Arcimboldo most likely knew Horace's text, because it was cited by Fonteo during a time when he was working closely with the

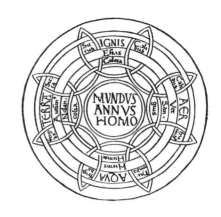

Woodcut by Isidorus Hispalienses
*The Four Elements*
in *De Reponsione Mundi*
Augsburg, 1472

Giuseppe Arcimboldo
*Fire*, 1566 (signed lower right:
Josephus Arcimboldus M+nensis. F)
Oil on panel, 66.5×51 cm
Gemäldegalerie
Kunsthistorisches Museum, Vienna *

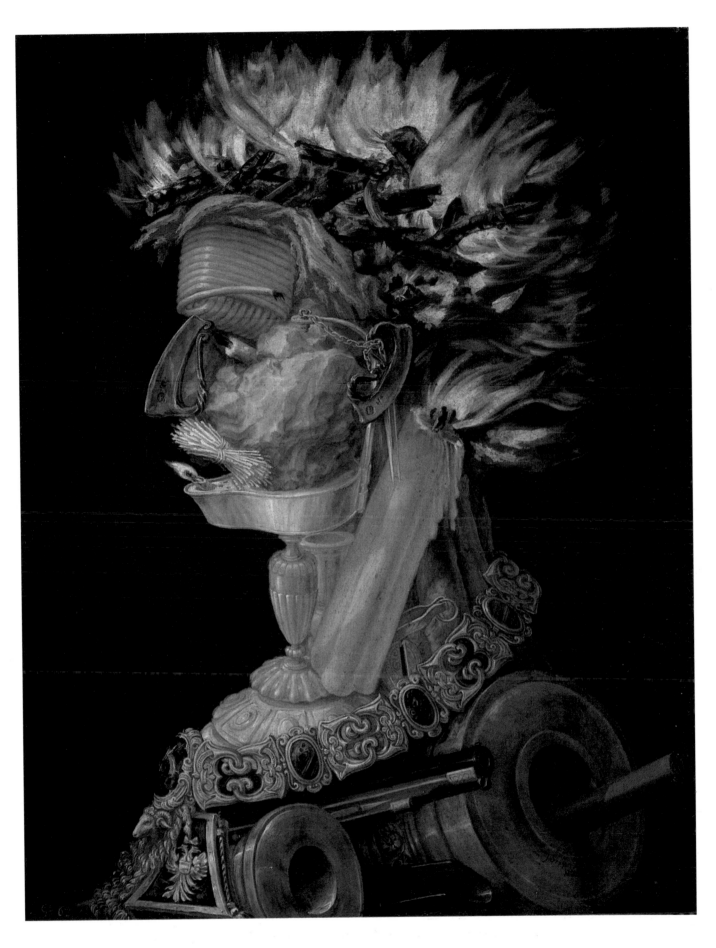

*Fire*

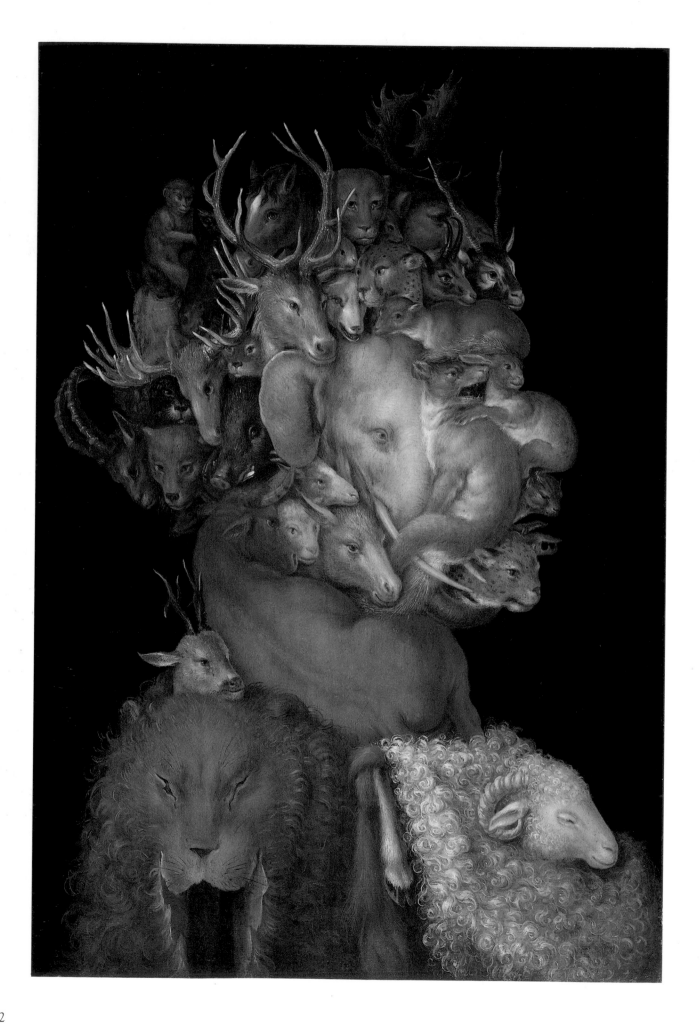

Woodcut (anonymous)
*The Golden Fleece*
in *Devises Héroiques* by
Claude Paradin, Antwerp, 1567

Giuseppe Arcimboldo
*Earth*, 1570 c.
Oil on panel, 70.2×48.7 cm
Private collection *

painter, and a letter written by Arcimboldo himself to accompany some drawings he did to illustrate the process of silk manufacture demonstrates that he was familiar with the terms of the debate over imaginative imagery that had centered on grotesques.[6] Arcimboldo's letter, which was probably written shortly before he returned to Milan in 1587, in fact proposes a grotesque decoration for the Prague residence of the Imperial Hofkammer president Baron Ferdinand Hoffmann von Grünpichl und Strechau. In it Arcimboldo's choice of language and topics may be associated with Renaissance discussions of the power of the imagination, *fantasia*. In particular, Arcimboldo describes his sketches as *macchie* (*maggia, maggie*), a term that echoes a frequent Renaissance discussion of the power of the imagination to create forms, as was said, out of *confuse cose*. Among other writers Leonardo da Vinci had referred to the spot, *macchia*, as something to be used to stimulate the *ingegno*, or wit. Whatever the possible impact of Leonardo on Arcimboldo and the invention of composite heads may have been, and it is intriguing to speculate on this issue,[7] Arcimboldo's description of his sketches as *macchie* supports other internal evidence that allows a reading of his text as an argument for the possibility to create new inventions — he uses the word *invenzione* — and not merely to imitate existing models.

Arcimboldo's letter can be read as a contribution to the perennial debate of the ancients versus the moderns, in which the chief issue was the role of free invention versus imitation in art. In dispute was the possibility to create something that was unknown to an ancient canon or model that was otherwise espoused. In his letter on grotesques Arcimboldo can be seen to have assumed a modern position, since he specifically proposes representing "modern" subject matter in an ancient form. Arcimboldo discusses the origins and reasons for the term "grotesques," but suggests using them in a way the ancients had not: to depict a new manufacturing subject, which moreover was a process he thought had remained unknown in Central Europe. Arcimboldo's specific choice of silk manufacture is further significant because silk-making was a subject evoked in the ancient-modern debate as one of the *nova reperta*, or modern discoveries that the ancients had not known. This discussion also seems pertinent to Arcimboldo's paintings, because his pictures were also described in ways that contrasted them with ancient works. Comanini contrasted his painting of Vertumnus with those of ancient artists, and Fonteo claimed that the pictures of the seasons and elements were inventions unknown to antiquity.[8]

Arcimboldo's discussion of grotesques can moreover be linked with the description of his paintings as *grilli*, as Fonteo also suggests when he compares Arcimboldo's invention of *grilli* with the accomplishments of ancient painters. Lomazzo had also used *grillo* to apply to inventions, and linked *grilli* with grotesques. The word *grilli* is to be understood in a similar manner as it is employed by Fonteo,

who equates *grilli* with chimerae, a word also applied to grotesques, and says that he means thereby that Arcimboldo's pictures are composed out of the instruments or objects pertaining to the thing depicted, such as a cook made out of kitchen utensils. Arcimboldo's composite heads considered as *grilli* can also be compared to grotesques in that they are free, capricious inventions.[9]

Whether as grotesques or as *grilli*, Arcimboldo's paintings would have been considered to be products of wit, *ingegno*. It is of course for his wit, *ingegno*, that Comanini, Lomazzo, and Paolo Morigia, the author of a history of Milan, all praised the artist. Wit, innate talent, was in general linked with *arte*, skill, in the creation of works of art. And in the sixteenth century wit is to be conceived as the faculty that seeks out and realizes the hidden resemblances between things. In Emanuel Tesauro's later discussion of witty expression, of *acutezza* (and Lomazzo also describes Arcimboldo's *ingegno* as *acutissimo*), *grilli*, grotesques, and *capricci* are all linked together.[10]

Some other surviving contemporary literature on Arcimboldo's art, namely the poems on his paintings of Flora written by Comanini, Giovanni Filippo Gherardini, and Gherardo Borgogni, and Comanini's poem on his picture of Vertumnus, may accordingly be regarded as fitting responses to his work.[11] All are witty compositions, in the sense mentioned above: in one instance they play off the *concetto* of Arcimboldo's *Flora*, a personification of the goddess of flowers composed out of flowers, in the other off *Vertumnus*, which is made up of fruits and vegetables. Poetic conceits, they respond to what has aptly been called the visual conceit involved in his paintings, which may further be related to poems in that they had themselves employed a variety of what may be considered poetic devices. Most obviously the pictures employ metaphor, by which a fire iron can become an ear.[12] The poem on the *Vertumnus* may even directly take up the challenge of Arcimboldo's picture, which can now be shown to have been based on an ancient poem. Arcimboldo established in it a contrast, a *paragone* of the sort beloved during the Renaissance, which the poets answer.[13]

Thus Arcimboldo's inventions should be considered to display their wit as new demonstrations of brilliant artifice. Humor, if present, is only to be regarded as one espression of wit. While Lomazzo relegated his pictures of the seasons to bar rooms, inns, *hosterie*, it can now be demonstrated that they expressed a political allegory; a related image, representing the four seasons in one, which Comanini called a joke (*scherzo*), may have had a similar import.[14] In any event, in Arcimboldo's era the idea was also current that a joke might have a further, more serious import; Comanini may expound a similar conception when he discusses the symbolic significance of games. For Comanini artistic imitation is also a game, perhaps to be understood as such in that art involves a play of imagination.[15] Hence while Comanini recognized that a viewer might approach

Woodcut (anonymous)
Detail of a sea elephant
in: *Historia* by Olaüs Magnus
Rome, 1555;
*Icones* by Conradus Gesner
Tiguri, 1560;
*Des monstres et prodiges* by Ambroise
Paré, 1573
(see no. 37 in the diagram, p. 97)

Giuseppe Arcimboldo
*Water*, 1566
Oil on panel, 66.5×50.5 cm
Gemäldegalerie
Kunsthistorisches Museum, Vienna *

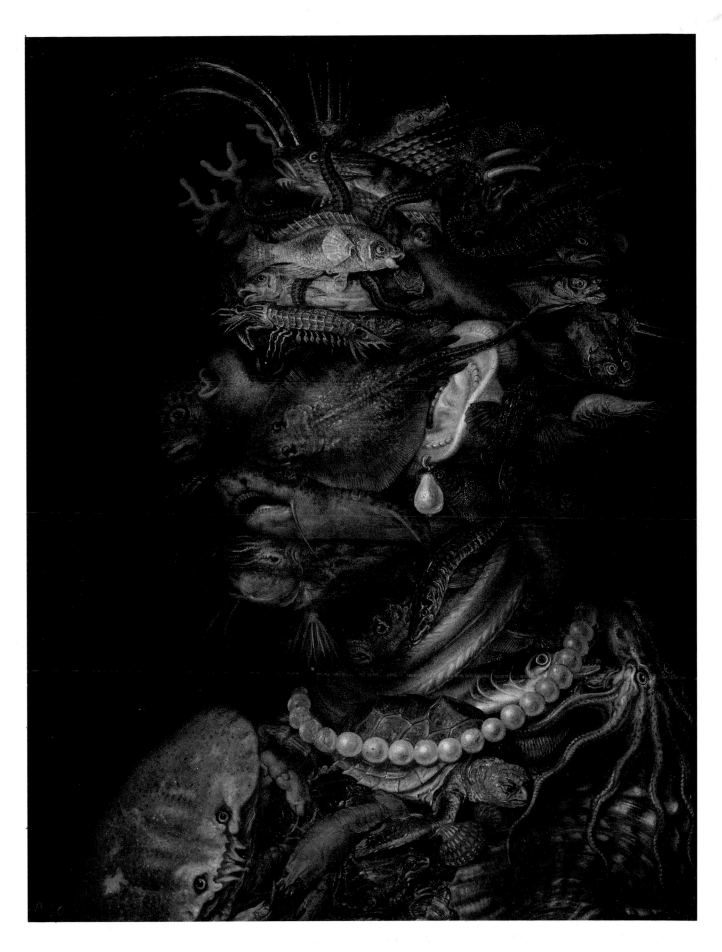

*Water*

Arcimboldo's *Vertumnus* with a smile on his lips, he quickly dispelled this expectation and exposed the work's symbolism. If Arcimboldo's fantastic paintings are to be called jokes, they are properly so only in a specific Renaissance sense: they are serious jokes.

A reading attentive to certain aspects of Renaissance discussions of the fantastic and the grotesque indeed suggests that there was also an approach to such considerations in which even this view of Arcimboldo's caprice could itself be seen to have a serious side. When Comanini describes the combinatory images of Arcimboldo's fantastic invention as a kind of dream picture, and compares him with the makers of dreams, this again does not imply that his paintings were necessarily to be understood as free flights of fancy. Dream pictures were often regarded as a kind of picture writing. In sixteenth- and seventeenth-century interpretations of dreams there was often an equation between dream images and hieroglyphs, conceived as symbolic pictures.[16] Similarly grotesques, as discussed by Lomazzo and the humanist artist Pyrrho Ligorio, were a kind of hieroglyph, symbolic images used to veil the truth from the masses. Lomazzo spoke of grotesques as "fatte non altrimente che enimmi o cifere o figure egittie, dimandate ieroglifici, per significare alcun concetto o pensiero sotto altre figure, come noi usiamo negli emblemi & nelle imprese" ("not otherwise made than enigmas or ciphers or Egyptian pictures, called hieroglyphs, to signify some concept or thought under other forms, as we use in emblems or heraldic devices"). In this manner grotesques too could be understood as symbolic images, much in the way that the Renaissance saw such sorts of pictures as developing from a tradition stemming from ancient Egypt.[17]

While Arcimboldo's own brief discussion of grotesques does not itself directly propose such a symbolic interpretation, he too concentrates on the information grotesques can convey, and emphasizes the didactic depictions that would have been placed within more playful surroundings. More tellingly, in his poem on the *Vertumnus* painting Comanini referred to Arcimboldo as "qual dotto Egittio" who "sotto 'l velo di si bei frutti" depicted Rudolf II.[18]

This description of the veiled image of the learned Egyptian Arcimboldo should therefore already have made it manifest that his painting of Rudolf II in the guise of Vertumnus was not meant to make the emperor laugh at himself, but rather belonged to a type of image whose seeming incongruity is resolved in a deeper truth. In this his painting also resembled other forms of symbolic imagery, such as emblems or *imprese*, with which Lomazzo indeed also compares grotesques. Emblems and *imprese* were cultivated at the imperial court where Arcimboldo worked. In addition to formal comparisons, there may even be some further connections between Arcimboldo's work and that of the emblematists, in that Arcimboldo's collaborator Fonteo was an avowed admirer of the famed emblematist and humanist Andrea Alciati.[19]

Species in Arcimboldo's *Water*

VERTEBRATES

I FISH

1. *Murena murena*, Moray eel *
2. *Mola mola*, Ocean sunfish *
3. *Hippocampus hippocampus*, Seahorse *
4. *Salmo trutta*, Adriatic trout *
5. *Belone belone*, Gar-fish *
6. *Sciaena umbra*, Black umbra *
7. *Esox lucius*, Pike *
8. *Lota elongata*, Blue ling *
9. *Cyclopterus sp.*, Lumpfish *
10. *Cyclopterus sp.*, Lumpfish *
11. Bothoid *
12. Labroid (*Labrus turdus*), Green wrasse *
13. Triglid, Gurnard *
14. Triglid, Gurnard *
15. *Agonus sp.*, Thwaite shad *
16. *Pegasus sp.* *
17. *Raja sp.* (*Raja clavata?*), Ray (Thornback ray?) *
18. Head of a Teleostean
19. Head of a Teleostean (Catfish?)
20. Head of a Teleostean
21. Head of a Teleostean after desiccation
22. Head of a Teleostean
23. Head of a Teleostean
24. Head of a Teleostean.
25. Dorsal fin of *Callionymus sp.* Dragonet
26. Tail fin of a Teleostean
27. Tail fin of a Teleostean
28. Gills of a Teleostean
29. Skin of *Scyliorhynus caniculus*, Small spotted dogfish, Selachians
30. Shark with barbels (Heterodontide?)
31. Pike (?) with supernumerary gills

\* Sub-class of Teleosteans

II AMPHIBIANS

32. *Rana temporaria*, European frog, Anurans

III REPTILES

33. *Caretta caretta*, Loggerhead turtle, Chelonians

IV MAMMALS

34. *Pelagius monachus*, Monk seal, Pinnipeds
35. Seal's head, Pinnipeds
36. Seal's head, Pinnipeds

37. Sketch of a pinniped similar to an amphibian

## INVERTEBRATES

### I PHYLUM OF CNIDARIANS

38. *Corallium rubrum*, Red coral, Hexacorals
39. Profile of a sea pen, Pennatularians

### II PHYLUM OF PLATYHELMINTHES

40. *Planaria*, Turbellarians

### III PHYLUM OF ANNELIDS

#### Class of POLYCHAETES

41. Annelid of the *Phyllodocidae* family
42. Unidentifiable Annelid

#### Class of CLITELLATES

43. Hirudinean (sea leech)

### IV PHYLUM OF MOLLUSCS

#### Class of GASTEROPODS

44. *Tritonium nodiferum*, Newt, Prosobranchs
45. *Buccinum sp.*, Whelk, Prosobranchs
46. *Buccinum sp.*, Whelk, Prosobranchs
47. Unidentifiable
48. Slug, Pulmonates

#### Class of LAMELLIBRANCHS

49. *Arca sp.*, Blood clam, Filibranchs
50. *Cardium sp.*, Eulamellibranchs
51. *Cardium sp.*, Eulamellibranchs
52. Oyster pearl
53. Oyster pearls

#### Class of CEPHALOPODS

54. *Sepia officinalis*, Cuttlefish, Decapods
55. *Octopus sp.*, Octopus, Octopods

#### Class of CRUSTACEANS

56. *Squilla mantis*, Mantis prawn, Hoplocarids
57. *Astacus fluvialis*, Freshwater crayfish, Decapod Peracarids
58. *Palaemon sp.* (cooked), Prawn, Decapod Peracarids
59. *Cancer pagurus*, Hermit crab, Decapod Peracarids
60. *Astacus astacus* (cooked), Freshwater crayfish, Decapod Peracarids

### PHYLUM OF ECHINODERMS

#### Class of STARFISH

61. Starfish

#### Class of SEA URCHINS

62. Crown made of rays that look like the aculei of a Cidaroid.

Remarks

a) The number of species depicted is slightly higher than the number of species identified; some animals are represented in too summary a way for exact identification.

b) The precision of the representation generally allows identification at the species level. In a few cases this cannot be exactly determined (it may depend on the nature of the taxonomic characteristics that must be taken into consideration, not on the accuracy of the drawing of the exterior morphology). The different animals are not depicted on the same scale.

c) Some of the animals represented do not correspond to known forms (cf. nos. 30, 31, and 37).

d) Certain anatomical features appear to have been deliberately modified, particularly the eyes, which are given a humanoid character both by the change in their shape and exaggeration of their dimensions (cf. the crab in 59) and as a result of being shifted to the frontal plane. The intensity of the resulting "look" gives a dramatic cast to the picture as a whole.

e) The marine species are the most numerous. The vast majority of them are native to the Mediterranean. Some of them have become rare. One species, the *Pegasus* (16), is native to the Pacific and Indian oceans.

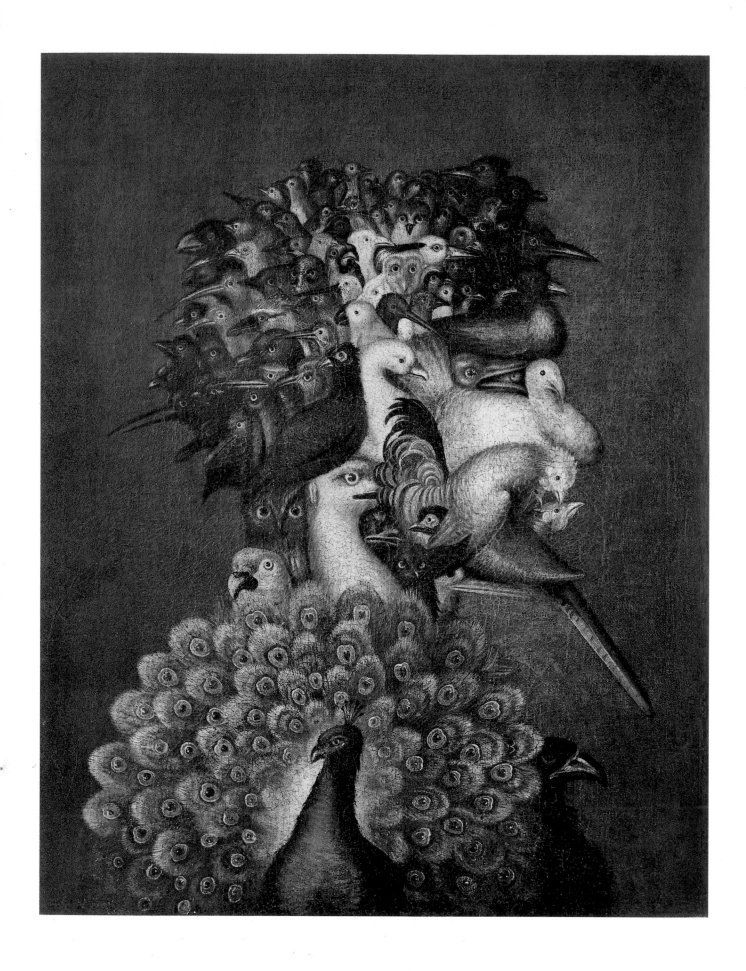

*Air*

| ARCA RERVM FOSSI-lium Ioan.Kentmani. | | |
|---|---|---|
| 1 TERRAE | * | 2 SVCCI NATIVI. |
| 3 EFFLORE-SCENTES | * | 4 PINGVES |
| 5 LAPIDES | * | 6 LAPID. IN A-NIMALIBVS |
| 7 FLVORES | * | 8 SILICES |
| 9 GEMMAE | * | 10 MARMORA |
| 11 SAXA | * | 12 LIGNA IN Saxa corporata. |
| 13 ARENAE | * | 14 AVRVM |
| 15 ARGENTVM | * | 16 ARGENTVM VIVVM |
| 17 AES SEV CVPRVM | * | 18 CALMIA MET. PLVMBAGO |
| 19 PYRITES | * | 20 PLVMBVM NIGRVM |
| 21 CINEREVM | * | 22 CANDIDVM |
| 23 STIBI | * | 24 FERRVM |
| 25 STOMOMA | * | 26 MARINA VARIA |

*Quicquid terra sinu, venisq, recondidit imis,*
*Thesauros orbis hæc breuis arcq tegit.*
*Laus magna est tacitas naturæ inquirere vires,*
*Maior in hoc ipsum munere nosse Deum.*
*Georg.Fabricius.C.*

Woodcut by Johannes Kentman
in *Arca Rerum Fossilium*, 1565

Inscription on verso
of *Spring*, 1563:
LA PRIMAVERA va accompagnata
con l'aria ch'una testa di uccelli
(Spring is accompanied by Air, a
head of birds)

Anonymous (after
Giuseppe Arcimboldo)
*Air*, undated
Oil on canvas, 74.4×56 cm
Private collection, Basel *

Comanini not only identifies the subject of the painting of Vertumnus, but also reveals that there are carefully conceived principles at work in the composition of another painting by Arcimboldo. He discourses at length on a picture that can now be identified as a version of Arcimboldo's *Earth*, suggesting that the elements of the face are composed according to the principles of physiognomic theory. Hence, Comanini says Arcimboldo makes not only a "gratiosa inventione," but also "dotte allegorie," such as he had never seen.[20]

The rediscovery of several texts by Fonteo that were directly connected with some of Arcimboldo's best known paintings reinforces this reading of Comanini and clearly indicates that there was also an important allegorical aspect to Arcimboldo's major cycles of composite heads.[21] Fonteo collaborated with Arcimboldo at the imperial court at least during the period 1568-1571. He wrote the cartels, or program, for an imperial festival in 1571 which Arcimboldo designed and which he co-ordinated, made a drawing (now West Berlin, Kunstbibliothek) for an as yet undetermined festival, and wrote programs on approval for Arcimboldo's designs for festivals in 1570 and 1571. Most directly pertinent to Arcimboldo's paintings are poems on his *Seasons* and *Elements*, as well as another poem with information on them. Although it is likely that Fonteo's poems, the first version of which dates to 1568, were written after Arcimboldo had painted his earliest versions of the *Seasons* and *Elements*, which are dated respectively 1563 and 1566, it is nevertheless most probable that they were written with the artist's knowledge and approval. Indeed, at least one version of the poems accompanied the paintings when they were given to Maximilian II on New Year's Day 1569; other notes by Fonteo were intended to eliminate other misunderstandings that the emperor may have had of the pictures. The poems thus give the most immediate clues to the identification and interpretation of the painting. They allow for a reconstruction of the series as they had been assembled.

They establish a correct interpretation of Arcimboldo's images as imperial allegories.

To understand how both Fonteo's poems and indeed Arcimboldo's plays of wit operated, it is necessary to review the system of thinking on which they are based. This was the so-called system of correspondences, common throughout the Renaissance. Parallels

were found between the parts of the universe, as for example between the greater world or macrocosm, the lesser world or microcosm of man, and the body politic. Fonteo suggests that the message of Arcimboldo's metamorphoses is one of homage to the new Roman — Holy Roman — emperor. As the emperor rules over the body politic, hence the world of the microcosm or man, he may be seen to rule over the greater world of seasons and elements.

There are several other aspects to the parallels found in the paintings. One suggests a message of harmony. Much as the fruits, vegetables, animals, and other items are harmoniously conjoined in each head, so too do the elements and seasons co-exist harmoniously to constitute each series. This harmonious relationship expresses the harmonious rule of the Hapsburgs. It is manifested in the poems by the dialogues between the various seasons and elements, and visually by the way each image answers the other. *Summer* and *Winter* face right, while *Spring* and *Autumn* face to the left; *Air* and *Earth* face right, *Water* and *Fire* left. Similarly each season is matched with its appropriate element: *Spring* with *Air*, and so on. These relationships suggest that the clement, harmonious rule of the Hapsburgs will exist throughout time, Fonteo says.[22]

According to Fonteo the harmonious conjunction of the seasons and elements has a prophetic significance. The seasons return in a perpetual cycle; nature exists forever in the combination of the traditional four elements. Hence the Hapsburgs, who are seen to dominate the seasons and elements, will have eternal rule.

This message is also expressed in the ages given to the seasons and elements, which Fonteo says correspond to the boys, youths, men, and old men of the House of Hapsburg. Visually this order is manifested by the appearance of the four seasons and elements in Arcimboldo's cycles according to the traditional four ages of man. *Spring* for instance is shown in early youth, with a face full of fresh flowers, *Summer* as an adolescent, with ripening fruits, *Autumn* as a mature man with a beard, and *Winter* as an old man with scraggled beard and withered bark-skin.

Fonteo also explains that the choice of heads to provide the form for the personifications has another prophetic significance. It was told that the ancient Romans who first fortified the Capitoline Hill had discovered there a head (*caput*), which not only gave its name to the hill, but portended that Rome would be seat of an empire, (*caput mundi*). So too do the heads of the elements and seasons offered to Maximilian II foretell that the world will be ruled throughout eternity by the House of Austria.

Although some of Fonteo's explications were probably invented *ex post facto*, for example his references to Maximilian II's politics of marriage, details in the paintings themselves confirm his interpretation in general. An inscription on the back of the original version of *Spring* (Madrid, Real Academia de Bellas Artes de San Fernando),

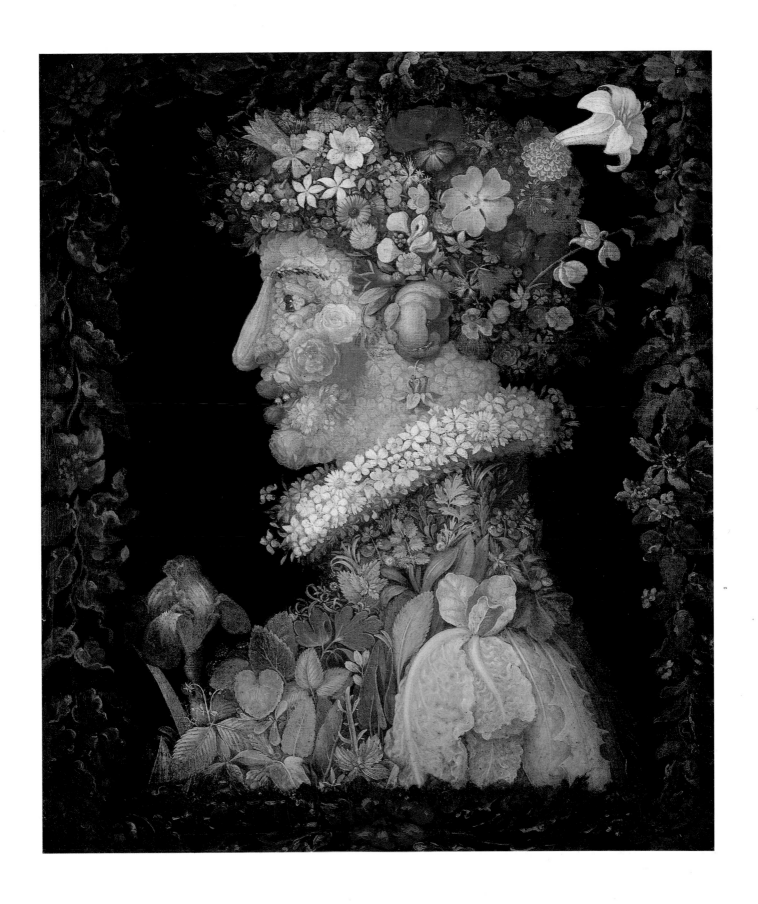

Giuseppe Arcimboldo
*Spring*, 1573
(garlands added at a later period)
Oil on canvas, 76×63.5 cm
Musée du Louvre, Paris *

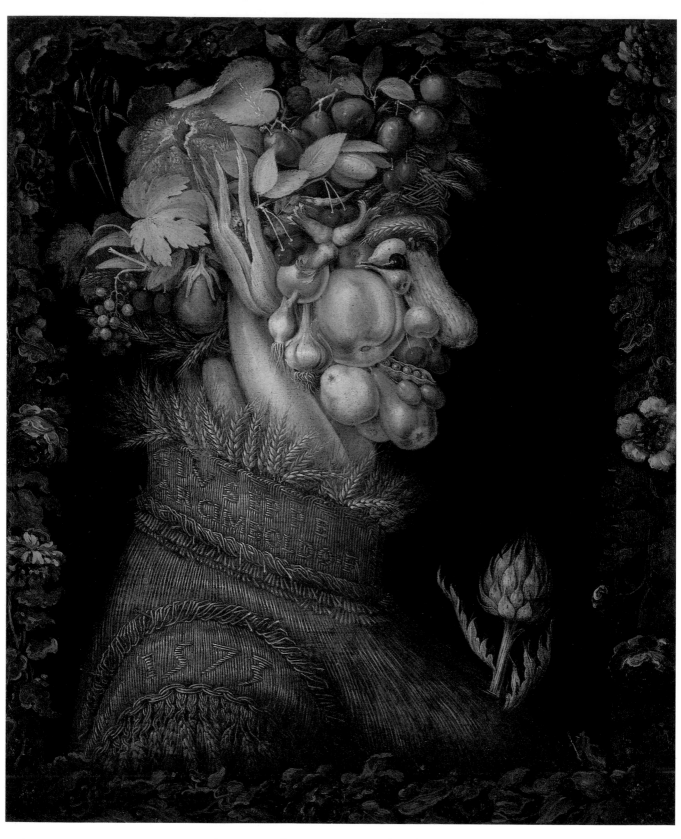

Giuseppe Arcimboldo
*Summer*, 1573
Signed on collar: GIVSEPPE ARCIMBOLDO·F.
and dated on shoulder: 1573
(garlands added at a later period)
Oil on canvas, 76×64 cm
Musée du Louvre, Paris *

Frontispiece of *Carmen Clementia*
by Giovanni Battista Fonteo
Vienna, 1568
Handschrift- und Inkunabelsammlung
Österreichische Nationalbibliothek
Vienna *

for instance, indicates that this work did accompany a painting of *Air*. The conjunction of forms in the appearance of a wreath or crown in all the paintings does seem to mark them as royal or imperial images: Comanini had noticed that the horns of the animals in a version of *Earth* formed a royal crown. Fonteo had suggested that the lion, found in the same painting, was a symbol of the Kingdom of Bohemia, a Hapsburg dominion, and, as Comanini indicates, this detail can also be read as the lion skin of Hercules, just as he associates the sheep skin with the Order of the Golden Fleece. Both Herculean and Golden Fleece symbolism can be associated with the Hapsburgs, as the Hapsburgs regarded themselves as descendants of Hercules, and promoted the Order of the Golden Fleece as their house order: indeed imperial portraits often contain both elements. Similarly, as Fonteo also suggests, the eagle and peacock found prominently in *Air* are emblematic supporters in Hapsburg heraldry. *Fire* wears the chain of the Order of the Golden Fleece as well as a medallion with the arms of House of Austria, and, as remarked, for an ear has a fire iron, which is another Hapsburg device (*impresa*). *Winter* bears another such device: its cloak is emblazoned with a fire iron. Furthermore, four strokes of the letter M for Maximilian can also be discerned in its cloak. They mark the image out as the emperor's own. As Fonteo explains, the Romans, authors of the empire, made winter the beginning of the year, *caput anni*; hence Maximilian II's own head is winter.

The creation of subsequent series of seasons and of elements for other rulers also underlines their political symbolism. Versions of the *Seasons* and *Elements* were probably sent to Spain.[23] Maximilian II commissioned a series of the *Seasons* for Elector August of Saxony (now Paris, Louvre). In these paintings the crossed swords of Meissen, for Saxony, replace the crowned M and fire iron in the cloak of *Winter*. The message of eternal rule is thereby transferred to Saxony. The gift of these images was probably part of an initiative of Maximilian II to gain support for his political position in the Empire.[24]

The culmination of the imagery of the *Seasons* and *Elements* is found in the painting of Rudolf II in the guise of Vertumnus. Comanini's poem on this picture suggests that the apotheosis of the emperor as god of the seasons also implies that he is god of the elements. And whether or not Comanini actually wrote his poem for Arcimboldo, Renaissance mythography, which syncretized Vertumnus with Janus as a god of the parts of nature, supports his reading.[25] This painting thus compresses the allegory of Arcimboldo's earlier metamorphoses into a single image, in which not only the fruits and flowers of all seasons, but, as Comanini indicates, those born under all the signs of the zodiac, and found in all parts of Europe, can be seen. But since all these flowers and fruits are shown flourishing at the same time, Rudolf's image betokens one

everlasting undifferentiated season. This is the season of eternal spring, the era of the Golden Age. The return of the Golden Age, a dream of imperial and royal propaganda, is thus suggested to have occurred under Rudolf's beneficent rule.

Other *capricci* and *invenzioni* mentioned by Lomazzo and Morigia further unfold the symbolism of these paintings. These were his inventions for entertainments, such as tournaments, which Arcimboldo arranged for the imperial court, most likely from the 1560s, and to which a bundle of drawings given to Rudolf II in 1585 (Florence, Uffizi), but connected with a variety of events, is related. We are however best informed about his designs for festivals in 1570 and 1571, for which Fonteo, among others, has left an account, and for which a few drawings are attributable with certainty. Copies of Fonteo's poems are to be found in a collection of festival descriptions and documents, which reveal the imagery of festival and paintings to be similar. For instance, in the 1571 festival held in Vienna on the occasion of the betrothal of Archduke Charles to Maria of Bavaria, the seasons, elements, and parts of Europe all appeared. The elements even wore costumes whose description suggests that they resembled Arcimboldo's paintings. The festivals, and particularly that of 1571, expressed the power of the Hapsburgs and the harmony of the world under their reign, in which Europe was united. Finally, as Arcimboldo's *Vertumnus*, the Hapsburgs, members of their court, and guests, appeared in varied guises, Maximilian II as his personal season *Winter*, for example.[26]

Arcimboldo's designs for court entertainments may also be regarded as having presented on a large scale a similar combination of fantasy and allegory to that which is to be found in his paintings. On the one hand tournaments, and other such pastimes, would have engaged and amused the court, at the same time as they impressed spectators with an abundance of inventions. On the other hand, the apparent play of these inventions also symbolized the power of the Hapsburgs. And a similar combination is to be found in many other works created at the imperial court.[27]

It has been said with some reference to Arcimboldo that the "play of fantasy is never without significance," and that "allegory provided justification for the activity of fantasy as the servant of higher truth."[28] While Arcimboldo's art bears out these points to some extent, it would be mistaken to separate these elements in his work. Fantasy and allegory are inextricably connected in his art. Both are grounded in a view of the world that allows wit to make its associations, and allegory to operate on the assumption that there is an underlying order to be found, in which the emperor surmounts an earthly hierarchy. It is therefore not only the absence of key texts for some of Arcimboldo's paintings, and the ignorance until recently of clues such as Fonteo's poems and Arcimboldo's letter, which relate to other paintings, that has long obscured the historical interpreta-

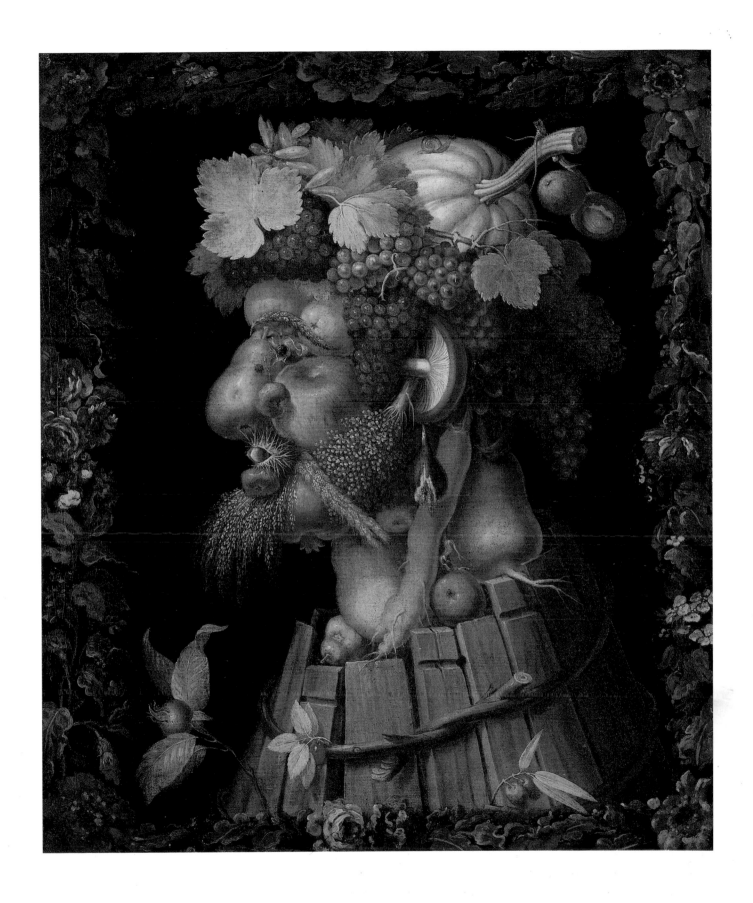

Giuseppe Arcimboldo
*Autumn*, 1573
(garlands added at a later period)
Oil on canvas, 76×64 cm
Musée du Louvre, Paris *

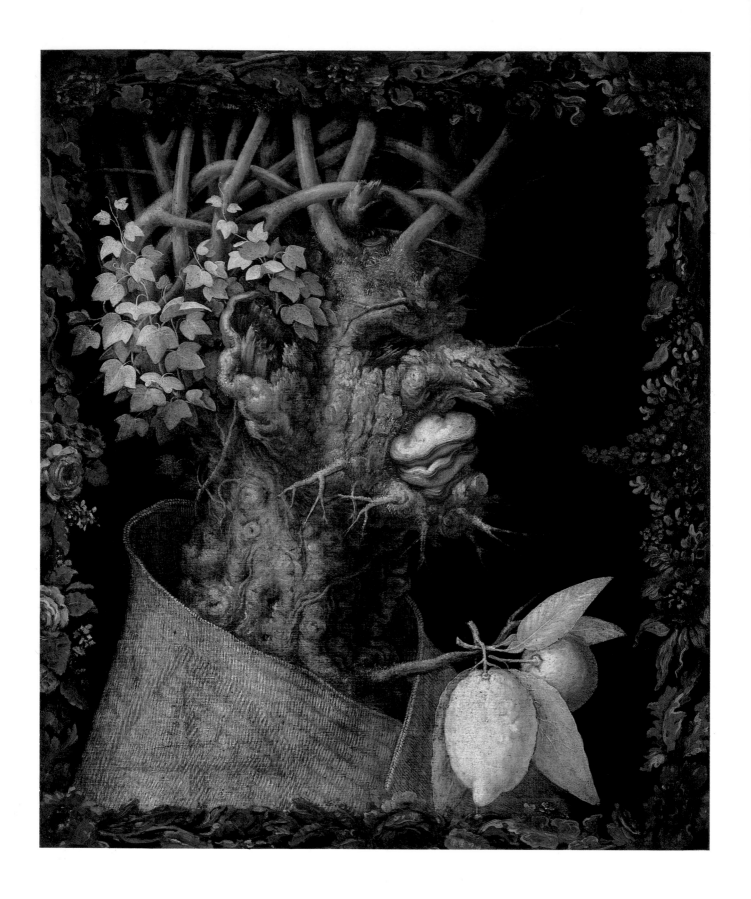

Giuseppe Arcimboldo
*Winter*, 1573
(garlands added at a later period)
Oil on canvas, 76×64 cm
Musée du Louvre, Paris *

"All that which is to be found inside can be known thanks to the outside.

God did not wish it, that everything he gave to man for his own and for his profit should remain hidden... And if he has concealed certain things, he has given each one a mark visible from outside by means of particular signs — like a man who has buried some treasure and, in order to find it again, marks the spot.

We men discover all that a mountain hides thanks to exterior signs and through correspondences; and in the same way we find out all the properties
of plants and what there is inside stones. There is nothing in the depths of the sea, nothing in the heights of the firmament, that man is not capable of discovering. No mountain is so vast as to conceal what it encloses from the eyes of man. Everything is revealed by signs... In the same way, all that a man encloses can be seen from the outside, and thus, by observing the exterior, we can get to know the inside..."

Paracelsus

tion of his art. The world view of Arcimboldo's time has disappeared, as has its conception of art. Another notion of art as an expression of poetic imagination, hence another meaning of fantasy, have developed since the eighteenth century. It is therefore not for what it may have meant for his own sixteenth-century audience, but for much different reasons that Arcimboldo's richly witty, symbolic transformations of the human head may fascinate a late twentieth-century public.

1. Comanini, *Il Figino*, p. 30. For the critical fortunes of Arcimboldo in this regard, see Kaufmann, "Arcimboldo's Imperial Allegories," *Zeitschrift für Kunstgeschichte*, 39, p. 275; and also Porzio, *L'Universo illusorio di Arcimboldi*, p. 5.
2. Comanini, *Il Figino*, p. 30; Lomazzo, *L'Idea del Tempio della Pittura*, p. 154.
3. For the use of these terms see Comanini, *Il Figino*, pp. 30, 49, 50; Morigi, *Historia dell'antichità di Milano*, p. 562; Morigi, *La nobiltà di Milano*, p. 461; and Kaufmann, "Arcimboldo's Imperial Allegories," pp. 281-282.
4. See Comanini, *Il Figino*, pp. 30-53, 82. This issue is also discussed by Panofsky, *Idea, A Concept in Art Theory*, pp. 212-215; the commentary by Barocchi to her edition of Comanini, *Trattati d'arte del Cinquecento*, vol. III, pp. 516-599, is also helpful. For an introduction to the question of *fantasia*, see Bundy, *The Theory of Imagination in Classical and Medieval Thought*, and Kemp, "From Mimesis to Fantasia: The Quattrocento Vocabulary of Creation, Inspiration and Genius in the Visual Arts," *Viator* 8 pp. 347-398.
5. See especially Dacos, *La Découverte de la Domus Aurea et la Formation des Grotesques à la Renaissance*, pp. 121 ff.; also Kayser, *The Grotesque in Art and Literature*, pp. 19-28.
6. This and the following paragraphs summarize Kaufmann, "Ancients and Moderns in Prague: Arcimboldo's Drawings for Silk Manufacture," *Leids Kunsthistorisch Jaarboek*[2] pp. 179-207.
7. Giovanni Francesco Melzi preserved much of Leonardo's manuscript material in Lombardy; Lomazzo owned drawings, manuscripts, and other works by Leonardo, some of which he sold to the imperial court; Carlo Urbino, a native of Crema active c. 1553-1585, also worked in Milan and composed the Leonardesque treatise "Codex Huygens." It is likely that Carlo Urbino is identical with "Carlo da Crema," who Lomazzo (*Trattato dell'arte della pittura, scoltura ed architettura*, p. 350) says made paintings like Arcimboldo's. See Rosci, "Leonardo 'filosofo' — Lomazzo e Borghini 1584: due linee di tradizione dei pensieri e precetti di Leonardo sull'arte," in *Fra Rinascimento, manierismo e realtà — Scritti di Storia dell'arte in memoria di Anna Maria Brizio*, pp. 53-77; Pedretti, *Studi Vinciani*, pp. 62-76; Marinelli, "The Author of the Codex Huygens," *Journal of the Warburg and Courtauld Institutes* 44, pp. 214-220; and Kaufmann, "The Perspective of Shadows: The History of the Theory of Shadow Projection," *Journal of the Warburg and Courtauld Institutes* 38, pp. 275-276.
8. The point can be extended to Arcimboldo's use of a poem by the Roman poet Propertius as a source for his painting of Vertumnus: see Kaufmann, "Arcimboldo and Propertius — A Classical Source for Rudolf II as Vertumnus," *Zeitschrift für Kunstgeschichte* 48, pp. 117-123.
9. For full references see Kaufmann, "Ancients and Moderns," pp. 191-193.
10. Kaufmann; for the definition of wit used here, see Mazzeo, "Metaphysical Poetry and the Poetic of Correspondence," *Journal of the History of Ideas* 14, p. 223; for *ars* and *ingenium* see the discussion in Baxandall, *Giotto and the Orators*, pp. 15-17.
11. Versions of Comanini's and Gherardini's poems are found in Comanini, *Il Figino*, pp. 32-43, and in Lomazzo, *L'Idea*, pp. 156-157; Borgogni's is in Borgogni, *Nuova scielta di Rime*, p. 140.
12. The description of Arcimboldo's paintings as conceits was first suggested by

Bousquet, *Mannerism*, p. 231; Barthes, *Arcimboldo*, pp. 36-50, expands on the rhetorical devices found in Arcimboldo's painting.

13. Kaufmann, "Arcimboldo and Propertius," pp. 122-123.

14. Comanini, *Il Figino*, p. 49; for this thesis about "serious jokes," and its relation to art at the court of Rudolf II, see Kaufmann's "Arcimboldo's Imperial Allegories," and also his "*Eros* et *poesia*: la peinture à la cour de Rodolphe II," *Revue de l'art* 18, pp. 29-46. These issues are also discussed in Kaufmann's *The School of Prague*.

15. *Painting at the Court of Rudolf II*. Comanini, *Il Figino*, p. 80.

16. See Browne, "Dreams and Picture-Writing: Some Examples of this Comparison from the Sixteenth to the Eighteenth Century," *Journal of the Warburg and Courtauld Institutes* 44, pp. 90-100.

17. Lomazzo, *Trattato*, p. 423. Dacos, *Domus Aurea*, pp. 129 ff., discusses this aspect of grotesques. See also Gombrich, "*Icones Symbolicae*: Philosophies of Symbolism and Their Bearing on Art," in *Symbolic Images*, pp. 123-195.

18. Comanini, *Il Figino*, p. 42. It is interesting to note that Pellegrino Antonio Orlandi uses similar language in connection with Arcimboldo when he mentions his "quattro Stagioni, ogn'una dipinta con i suoi geroglifici" in *L'Abecedario Pittorico*, p. 196.

19. For this type of imagery see Gombrich, "*Icones Symbolicae*"; for Fonteo and Alciati, see Savio, "Giovanni Battista Fontana o Fonteio", *Archivio Storico Lombardo* Serie 4, 3, pp. 356 ff.

20. Comanini, *Il Figino*, p. 48.

21. This and the following paragraphs summarize Kaufmann, "Arcimboldo's Imperial Allegories."

22. It is also possible that the paintings are matched by gender; the theme of marriage is in any event stressed by Fonteo — see Kaufmann, "Arcimboldo's Imperial Allegories," pp. 288-289, 292.

23. The evidence for a series of works probably executed by Arcimboldo in Spain is now to be found in Orso, *Philip IV and the decoration of the Alcázai of Madrid*, pp. 162-163, 203.

24. See Kaufmann, "Arcimboldo au Louvre," *Revue du Louvre et des Musées de France* 27, pp. 337-342.

25. See Kaufmann, "Arcimboldo and Propertius." Arcimboldo is also reported by Lomazzo, *L'Idea*, p. 156, to have painted a *Janus*: could this also have been an imperial image?

26. For Arcimboldo's role in these festivals see Kaufmann, *Variations on the Imperial Theme in the Age of Maximilian II and Rudolf II*, on which Beyer, *Giuseppe Arcimboldo Figurinnen*, relies heavily; also see Vocelka, *Habsburgische Hochzeiten 1550-1600*.

27. See Kaufmann, *Variations*, and Kaufmann, "The *Kunstkammer* as a Form of Representation: Remarks on the Collections of Rudolf II," *Art Journal* 38, pp. 22-28.

28. Summers, *Michelangelo and the Language of Art*, pp. 456, 584, n. 14. I do not, however, agree entirely with Summers' distinctions of types of fantasy in reference to Arcimboldo.

*This set is the last version of the Seasons. The cape of* Winter *shows the insignia of the Elector of Saxony.*

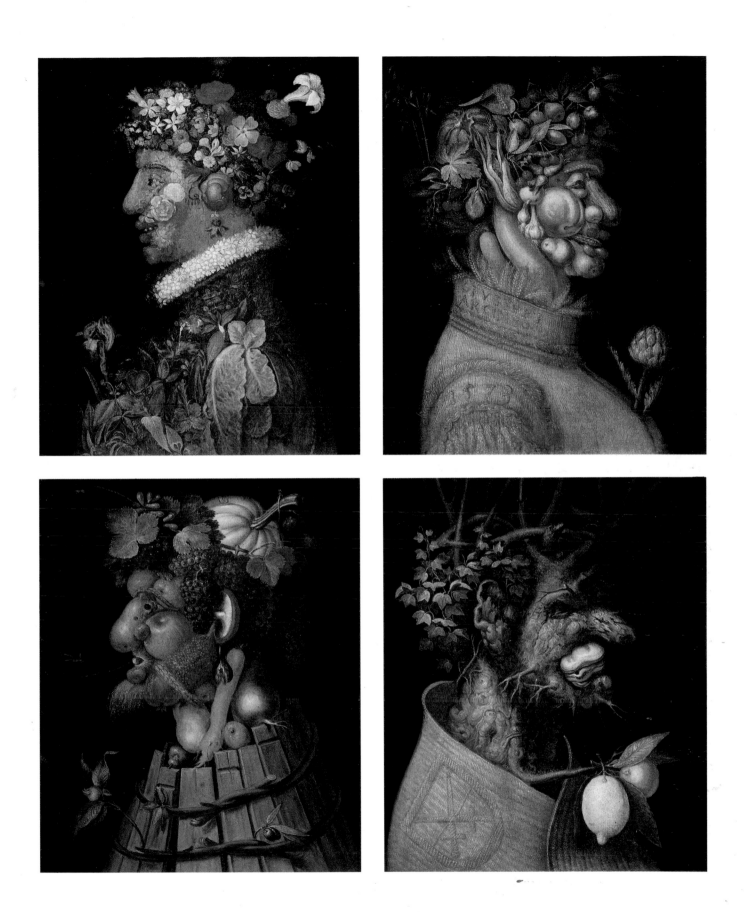

Giuseppe Arcimboldo
*The Four Seasons*, 1573
Oil on canvas, 72.5×59 cm
Former Cornelia Collection

Tobias Stimmer
*Gorgoneum Caput*, 1577
Woodcut, 41×27.3 cm
Zentralbibliothek, Zurich *

# The Prince of Pictorial Whims

by Maurice Rheims

On the gangway of the Ship of Fools, the captain and the gathered crew are worried, the psychiatrist in his hangman's gear has ordered the anchor to be cast. The horde tumbles out onto the docks and overruns the city, claiming for the unemployed, the right to strike, for recruits, breast-feeding, and for washerwomen the right to slap their sides instead of wet clothes. From now on legal texts are to be printed on larks' wings. Annoyed by the idea that all bespeaks of untroubled waters, that Salon painters shall triumph, they stamp their feet at the thought of being robbed of cage and chains. At nightfall, to move the vessel out of port, they blow, as Hieronymus Bosch teaches, up the anus of the elect, into the cavity of the sail spun by the ship's spider. Hail the Ship of Fools. If it didn't exist, we would have all died of boredom long ago.

"Look here, preambler, just who do you think you are? Are you perhaps unaware that to speak of Arcimboldo nowadays you have to be the guardian of the new order, gloomy and psychiatrist, as they say today?"

"But I'm a little of all that and what's more I'm looking for lost models, the ones that haunt the panels of the emblematists, and I must hurry, for those hysterics and convulsionaries, those madmen and melancholiacs, or lypemaniacs as they were known in the days of Vesalius, are on the point of extinction: healed, in other words dead. With them, our good kings, their patrons, have died out. Ah, the good old days."

What a good laugh King Henry must have had at the sight of the beheading of his lawful wives when he was about to do the same to this good Thomas (More), with the excuse that he failed to turn royal horse dung into gold marks.

From Giotto to Filippino Lippi, from Rembrandt to Ensor, from Magritte to Bacon, we have felt no weariness in sketching you — and it's not all that easy — passing without respite from the atrocious to the ridiculous. To portray you the way you looked, simpering and convulsive, deformed, ferocious or slobbering, but with this reserve of humor, otherwise who would have commissioned the compositions? Seeing you exactly as you are is bad for the market.

"So tell me, painter, do you know that these people you take as models are among my subjects?"

"But I know you, bearded one: your black doublet, your gold braid, your feverish face, your faded jaundice-colored ruff, I painted them, half-length, full-length, you're Charles V. You paid most handsomely, I could have gone on brushing your visage; unfortunately, with age, it no longer falls into place and besides, Illustrious Emperor, turning communion wine into your daily fare makes you even more lantern-jawed and they'll soon be able to make a new balcony for the Escorial out of your chin. Go join the tomb of your mother, Juana la Loca, otherwise you'll transmit your sickly mien to your heirs. Ah, how I pity my comrades, the Velasquezs, the Goyas, saddled with disposing on canvas the gloomy emperorship of your descendants."

So it is that confronted by the simpering faces of Anna, of Elizabeth, of Maximilian, Henry, and Rudolf, at the sight of those lineaments marked by the vast melancholy of the courts, one understands better what Arcimboldo the Milanese had in mind: supplant such uncomely effigies with the leavings of the fruit and vegetable market, handling them like the Creator once handled skin and bones.

The witchcraft painted by Arcimboldo was to make a flashy display, seeing that by fathoming his art, nurturing that fondness for the morbid and the eccentric so present in the spirit of the contemporaries of Dürer and Leonardo, the Milanese found the way to add charm and whimsical humor to human features, which was not always the case with the works of the Dutch, the crazier ones, any more than with those of the Rhineland Germans.

Astonishing, even in that period, was the ambiguous attitude of the Church and the princes with regard to censorship. While they slaughtered Savonarola for crying out against the establishment, and sentenced writers and philosophers to the worst punishments, pictorial works seem to have escaped all threats. No one dreamed of sending a painter, an engraver, a sculptor to the stake. All told, for certain people, often the best, living in 1500 must have had its charms, maybe because the minds of rulers spun like tops, most of them eccentrics of the first water, not dolts like the Messieurs Jourdain of Molièrian memory, or the oil tycoons of today.

The ruling society of the time was fancied as thinking of nothing but the spirit and all its forms, anxious to mix everything together, the real and the unreal, so that many a time one gets the impression that this ancient world consisted of nothing but artists and frauds. Actually, there were no more then than there are today, except that in the twilight of the Middle Ages, credulity could take childish turns, perfectly consistent with a constant search for the absolute. In analyzing our times in the year 2000, reading our Lacans, our Foucaults, our Verdigliones, seeing the mobiles of Calder, the graffiti of Dubuffet, the four o'clocks of Niki de Saint-Phalle, people will deem us just as extravagant, just as indefinable as the vassals of Julius

Back of *The Female Cook*
(see opposite page)

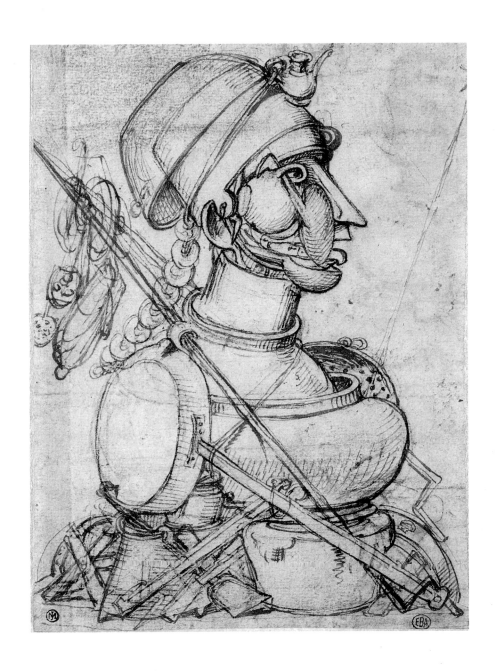

Anonymous
*The Female Cook*, undated
Black stone, pen and sepia on paper, 20×14.7 cm
Bibliothèque de l'École Nationale des Beaux-Arts, Paris *

II are for us. Except that in 1987 we have lost the amazing innocence that prevailed at the Windsor courts in London and at the Hradshin in Prague. In those days, people knew how to burst not only with laughter but from having drunk too much, the bladder of the table companion could break wind under the prince's nose, as happened with Tycho Brahe. In Prague, it was forbidden to leave the table as long as His Highness was enjoying himself.

Lacking precision gauges like ours, the illuminati of the Renaissance, in turn, had at their command means of exchange as easy to master as modern computers. Latin, Greek, Hebrew were living languages; in 1550 when John Dee landed in Paris he needed no translators, for learning seeped through like spring water. Dee, Queen Elizabeth's wizard, enjoyed a widespread reputation at the

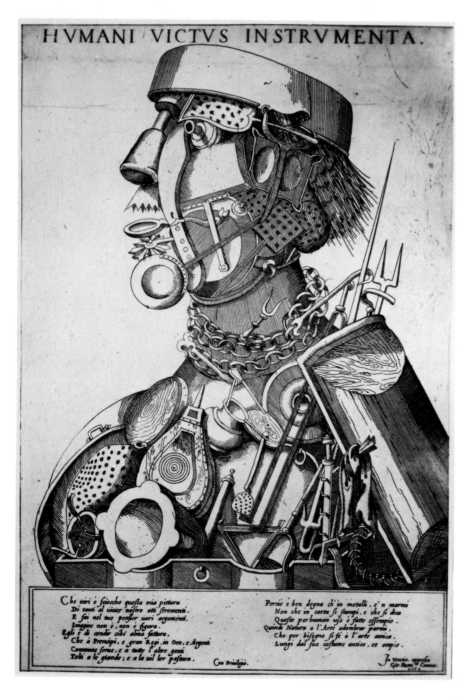

Anonymous
*Humani Victus Instrumenta: Ars Coquinaria* (*Instruments of Human Sustenance: Cooking*), 1569
Etching, 37.9×27.7 cm
Kunstindustrimuseum, Copenhagen *

Martin Wörler
*Allegory of Agriculture*, 1600 c.
Woodcut, 35.5×24.2 cm
Dr. Günter Böhmer Collection
Munich *

time. In his study, often visited by the queen and the court, he would display the most beautiful precious stones, each one, according to him, containing powers that affected the very essence of life and the spirit. Elizabeth received guests in her astronomical chamber, its walls completely inlaid with sheets of crystal. Passionately fond of gems, she was, like many of her contemporaries, convinced of their endless power. And every day her attendants had to read selections to her by the great revealers, where it was noted that rubies suited sensual and haughty brunettes, that for pallid blondes nothing was better than aquamarines.

When Arcimboldo reached Prague in 1562, the West was swarming with these raving madmen, each claiming to be the chief source of phantasmagorias and diabolism. The great were surrounded by the most wondrous objects: fossilized reptiles, gallows ropes, sundials designed by the German Reinemann, boxes for holding the lover's pierced heart, bezoars, magic mirrors — all were illustrations of the feverish designs of astronomers, geographers, zoologists, doctors,

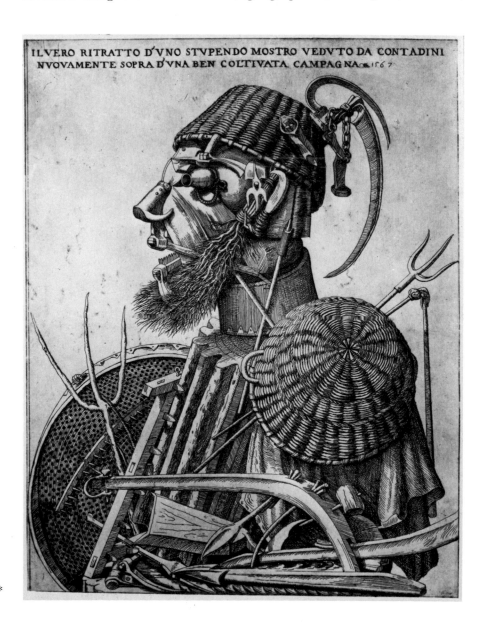

Anonymous
*Humani Victus Instrumenta: Agricultura* (Instruments of Human Sustenance: Agriculture), 1567
Etching, 37.3×25 cm
Kunstindustrimuseum, Copenhagen *

115

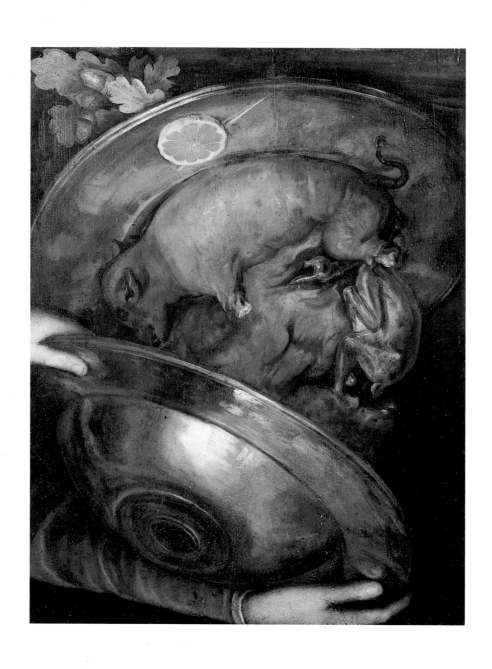

Giuseppe Arcimboldo
*The Cook* (reversible), 1570 c.
Oil on panel, 52.5×41 cm
Private collection, Stockholm *

miracle-workers, and astrologers. But towering over them all was the most inventive and the most original mind, Tycho Brahe — phoenix of astronomy, as he was called, messenger of the stars — who would link his name to the study of sunspots. At the age of eighteen, he had already designed a gigantic solar mirror capable of contributing to the formation of multifaceted alloys of precious stones, and at the age when our children are learning the rules of three of kind, he, his eye glued to the telescope, asserted that a star situated a little northwest of Cassiopeia was about to shine brighter than Venus. A few days later, to the amazement of star-gazers, the heavenly body appeared at the said hour. Not the least impressed was the prince; what he expected rather was that Tycho Brahe discover at last the secret of transmutating metals. Create gold!

All these people lived off princes in palaces of depraved constructions; driven from one court they would run to some other more

Giuseppe Arcimboldo (?)
*The Cook*, 1574 c.
Oil on canvas, 90×69 cm
Former Dr. M. Müller Collection
Prague

generous abode, crazier, however, than the one they had left behind.

Emperor Rudolf, who offered bed, board, and protection to all passing freaks, kept a lion chained in his antechamber, and threatened to sit the beast on the coattails of the majordomo if the service was poor. Consumed by alarms of all kinds, his head stuffed with the forecasts of an astrologer who assured him of an even more dramatic death than that of his cousin Henry III, who was stabbed by a monk, Rudolf buried himself in the furthermost recesses of his granite halls, sleeping in a different bed every night. When a rodent troubled his sleep, he would shake an enormous bell cast out of *electrum magicum* which was such, as Paracelsus said, "that its every ring, unique in the world, had the power of summoning up a spirit." The strange thing is that while ranting and raving, these princes, anxious for their souls, insisted upon having defenders of the faith, just as they kept by their side, as if to exorcize their priestly powers, magicians, miracle-workers, and apostles of satanism, and, refined to excess, expected their artists to contrive for them the most sublime stage settings, nothing being too beautiful for their eyes to fall upon.

Arcimboldo the Milanese would seduce the archduke to such an extent that in 1592, the archduke made him his cousin, the least of honors for the man whose droll genius well deserved the title of Prince of all pictorial whims. At that time, some morose spirits saw the devil's hand in them, saying that this painter — as was later to be said about Picasso — undid what the Creator had done. But how could charges be brought against the man who could fling in the face of his detractors a passage from the *Summa Theologica* in which St. Thomas Aquinas writes, in the middle of the thirteenth century, that Christ is to be found whole in all or any part of nature, and in the bread both when the host is whole and when it is crumbled. Does the art of Arcimboldo spring from magic, from symbolism, or is it quite simply the expression of a playful and elegant mind? Perhaps at that time, some people could have been amused by it, like our grandparents at the sight of those funny nineteenth-century plates with mountains painted around the edge where the figures of the queen of Cyprus and her retinue could be seen. What can be said about him? Nothing but what he set down on his canvases, if not that he was a brilliant inventor, along the lines of a Leonardo, intrigued by what faces concealed in those times when the plague ran wild, wiping out whole populations, when the average age barely exceeded thirty. The painter, after his fashion, succeeded in removing a little of the anxiety that must have seized so many of his contemporaries; that is why it was considered expedient at the time for this buffoon of painting to receive the honors and glory reserved to the masters of his day. Prince of pranks and take-ins, that is my view. In him I'll accept the contradiction, and as long as there is stew for him to warm over, he will supplant my odd-looking face with his cabbage leaves, his turnips and carrots.

Giuseppe Arcimboldo (?)
*The Cellarer*, 1574 c.
Oil on canvas, 90×69 cm
Former Dr. M. Müller Collection
Prague

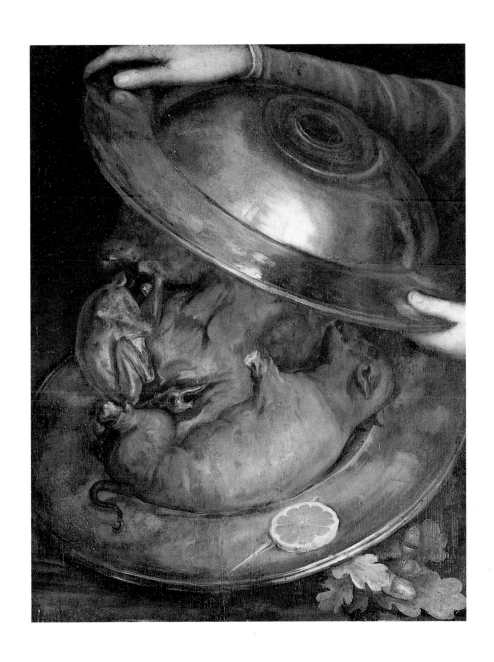

Giuseppe Arcimboldo
*The Cook* (reversible), 1570 c.
Oil on panel, 52.5×41 cm
Private collection, Stockholm *

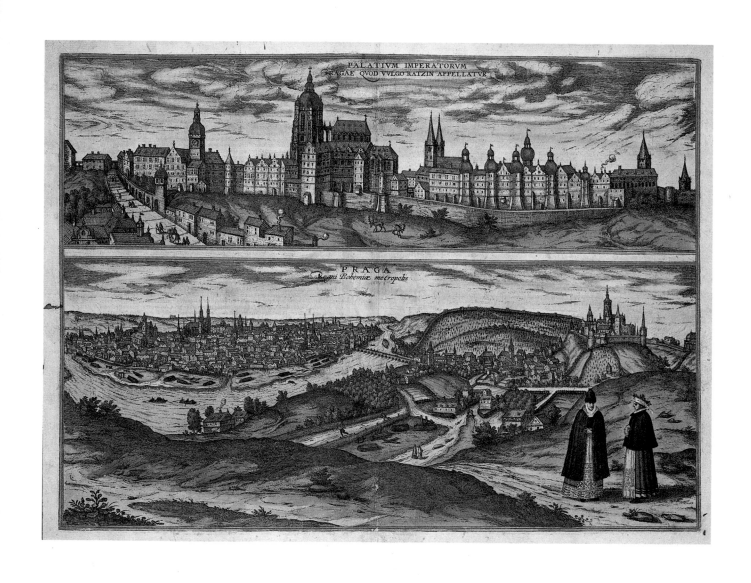

Joris Hoefnagel
*View of Prague*, 1590 c.
Watercolored engraving
Státní Ustřední Archiv, Prague

# The "Divertissements" of Prague

by Eliška Fučíková

Woodcut by Conradus Gesner
*The Prismatic Rocks of Stolp
in Bohemia*, 1565

Arcimboldo was appointed official portraitist to the emperor, and fulfilled all his duties with great diligence including, the less attractive ones which involved copying ancient Hapsburg portraits. Despite this, he still had time for work of a completely different nature. He applied his own infinite inventiveness to projects for imperial processions, tournaments, and theatrical representations. His desire to contribute to the discovery of nature's secrets found expression in his depiction of the relationships between the microcosm-Man and the macrocosm-Nature, using the philosophical principles that were expounded by scholars of the imperial court and by Maximilian II himself. He based his composition of the allegorical heads of the *Seasons* and of the *Elements* on the analogies between the human body and the "great world," using anything and everything to express symbolically his own understanding of reality. Arcimboldo later abandoned the conventions of official portraiture and depicted his subjects in accordance with the same principles used in the *Elements* and the *Seasons*. Success was not long in coming, nor was appreciation, as we learn from Lomazzo: "He (Arcimboldo) therefore gained much favour with the emperor, who trusted his judgment in everything, adapting his own taste to his and holding him dear. Because this man was truly unique in his inventions."[1]

Arcimboldo's fantastic and allegorical paintings and scenes must undoubtedly have pleased the young Rudolf II, who took part in some of these court festivities. It is therefore understandable that, when he succeeded to the throne on the death of his father in 1576, he kept the painter on in his own service. This in itself was not exceptional, for all of Maximilian's artists continued to work at his successor's court, although not all of them did so with the same intensity as before. Arcimboldo's star in Prague shone as brightly as in Maximilian's day; it seems, however, that its light derived not so much from the famous composite heads as from the other activities to which he now gave his attention.

We know very little about the painter's activity at the imperial court during the reign of Rudolf II. Most of the extant paintings date from the period prior to Rudolf's succession to the throne (1576), whereas those actually commissioned by him were painted after Arcimboldo had left the court and was living in Milan. Did he paint

during the years 1576 to 1587? The two portraits of Rudolf II wearing the Czech and imperial crown and a mantle bearing the coats of arms of the Seven Electors would indicate that Arcimboldo was still working as court portraitist at the time of Rudolf's succession, for the works cited probably served as models for official portraits of the emperor on coins and medals.[2] In the early years of Rudolf's reign Arcimboldo still planned various court events. Furthermore, Arcimboldo desired to constantly invent something new and to ensure for himself an honorable place among famous painters by creating totally original images.

It is possibile that the reversible paintings — those still-life pieces that, when turned by one hundred and eighty degrees, transform themselves into human heads — date from his stay at Rudolf's court. These paintings did not strike the observer with their depth of content, but instead demonstrate the painter's incredible mastery and inventiveness in the composition of forms, whereby two totally different images could be depicted simultaneously.[3]

However, it is probable that Arcimboldo did not spend much time experimenting with this type of painting. He believed that painting should explore a much greater variety of subjects than had hitherto been dealt with. The urge to study different working and technical processes led Arcimboldo to the idea of producing a cycle of paintings whose content certainly had precedents,[4] but which were to have their place in a specific symbolic or allegorical context. Arcimboldo suggested to the financial counsellor and President of the Imperial Treasury Ferdinand Hoffman von Grünpichl und Strechau that he decorate the rooms of his palace with scenes depicting manufacturing processes, which were to be composed of silk, wool, linen, and canvas. As far as we know, Hoffman was not the owner of a textile works and therefore had no reason to show his guests such products in order to augment his own wealth. On the other hand, Arcimboldo himself explains in a letter what it was that had led him to choose his subject. Arcimboldo considered those themes equal to the obligatory mythological or religious ones and he hoped that Hoffman would respond favorably to his proposals for an interior decoration of such a completely untraditional nature. Arcimboldo's reliance on Hoffman was undoubtedly correct, even if the project never actually came to fruition.

Baron Hoffman was one of the extraordinary personalities of his day and was, in many aspects, not unlike the emperor whom he served so faithfully. His vast collection of books, most of which is still preserved today, testifies to the incredible breadth of his interests. The library was probably supplemented by a large art collection about which, however, we have little concrete information.[5] The engraving of 1607 by the imperial court engraver Egidius Sadeler, dedicated to Hoffman, would seem to refer to this *Kunst-Kabinett*.[6]

*Translation of the autograph dedications by Arcimboldo on the drawings on the opposite page:*
"The crown with which Rudolf was crowned King of Rome on the Ist of November 1575 in Ratisbon. The crown came from Aachen and was made for Charlemagne, and it was so wide that it projected two finger-widths on either side, all of gold and of this shape.
I, Giuseppe Arcimboldo, was present."
"The crown with which Rudolf was crowned King of Bohemia, finished as can be seen in this drawing, 1575, St Mary's Day in September.
I, Giuseppe Arcimboldo, was present."

Giuseppe Arcimboldo
*Profile of Rudolf II, Roman Emperor*, 1575
Pen and black ink on paper
16.5×16.5 cm
*Profile of Rudolf II, King of Bohemia*, 1575
Pen and black ink on paper
15.5×15.5 cm
Národní Muzeum, Prague *

The contents of Hoffman's library suggest that he was interested in practically everything: religious tracts, mathematics, geography, emblematic literature, natural sciences, *belles lettres*, works by ancient classical authors, treatises on civil and military architecture, and so forth. The list is seemingly endless. This library, therefore, gives some idea of the type of research and investigation going on at the time. The collections served as illustrations *in natura*, offering useful material for further studies, as they did at Rudolf II's residence in Prague, where Hoffman in his turn found inspiration.[7]

Arcimboldo's project for Hoffman's house was part of the endeavor at that time to discover the secrets of nature and of the relationship between microcosm and macrocosm, and to reveal the miracles of creation and of the creative process.[8] In separate drawings the painter depicted the complex process of silk manufacture, from the cocoon stage to the dyeing of the thread, a process in which Nature and Man interacted in harmonious symbiosis. It seems that this new subject was much more stimulating than the usual depiction of religious scenes. Hoffman doubtless saw it this way, but Arcimboldo ignored traditional painting in order to study the mysteries of the cosmos.

We should add another note about Arcimboldo's stay at the court of Rudolf II. On 8 September 1582 Rudolf wrote to Raimond Dorn, citizen of Kempten, saying that he had received the list of his collection of "antiquitaten und kunststuck" from his own counsellor Alexander von Pappenheim. Given his interest Rudolf proposed sending "unsern hofconterfeter Josephen Arcimboldo... und ime bevolhen dieselben zu sehen und dasjehnig, so er für uns zu sein vermainet, uns zuezubringen."[9]

The origins of Rudolf's collection are not sufficiently documented. We know neither when, nor how he began. What is certain, however, is that his first purchases were from Spain, where Hans Khevenhuller was his ambassador at the court of Philip II, and from Italy, where he initially used local "art agents" such as his close friend Jakob König.

Rudolf's interest in Dürer's work later led him to concentrate his attention on the Germanic countries.[10] We do not know in what measure he relied on his court artists to seek out and purchase works of art (a common practice at the imperial court from the 1590s onwards). We know that Giulio Licinio was in Venice in 1579 and 1580, but no explanation of the motives for these visits exists. Therefore, Rudolf's letter regarding Arcimboldo is probably one of the first to document with certainty the court painter's activity as advisor and purchaser for the imperial collections. The question now is to discover whether this particular mission given to Arcimboldo by Rudolf was a unique case. I shall now try to explain why I think it was not.

Thanks to his friendly relationship with Arcimboldo, Maximilian

Giuseppe Arcimboldo
*The Processing of Sericulture*, 1586
Series of 13 drawings (following pages) and an autograph letter (above, see translation p. 129)
Pen, blue ink and watercolor on paper, 30×20 cm
The Museum of Fine Arts, Boston *

Questo p° capitulo dimostra la semenza del bigatto
la uerso la p^a uera quando il tempo e caldo le
femine pigliano il seme et lo mettano nel seno e con
quel calore la si comenza a mouere tenendola a
lochi piu caldi e temperati che a lochi fredi il
seme e di questa grossezza o e quando quel bigat
to uermino e nato et che per far la galla e di
questa grossezza et faciono
la galla e di tal grossezza

come qui                    si uede

125

qui si coglie la foglia del moro biancho per pa...
detti bigatti

qui si monda detta foglia del moro leuendo
li castoni et il frutto po azerbo po maturo

Come il bigatto uien grosso le femine lo u...
separandolo in piu tauole danaole magior...
per passerlo

Dapoi che detto bigatto e fatto alla grossezza che
da essere le femine uano imboscando co ra...
de Genestra saluatica ed bigatto ua per le ra...
facendo la gala

6

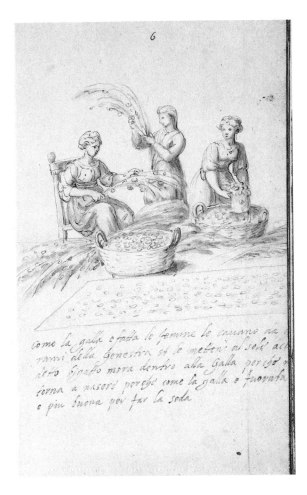

come la galla e fatta le femine le cauano via
rami della Genestra et le metton al sole al
detto S gatto mora dentro alla Galla per cio no
torna a naser perche come la galla e fuorata
e piu buona per far la seda

7

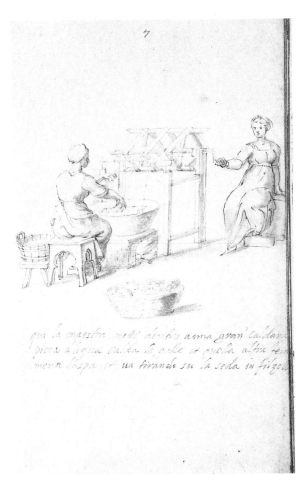

qui la maestra mete dentro a una gran caldan
piena d'Acqua calda le galle et quela a fu tem
mena laspa et va tirando su la seda in filzol

8

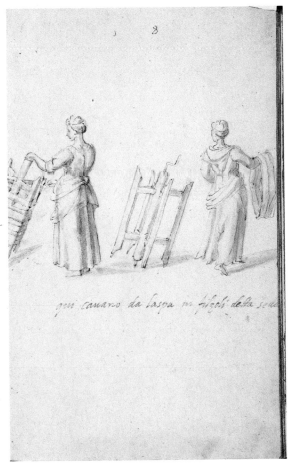

qui cauano da laspa in filzoli della seda

9

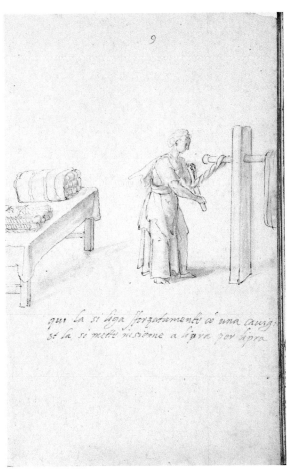

qui la si liga sforzatamenti a una cauig
et la si mette in sscione a lipra per lipra

10

qui la se incassa hover se in balla doue
la si manda per tutte le Prouintie

11

Dapoi cauata da le balle le femine la tirano a
fizoli sopra le canne

12

sto e un molino doue un homo sta nel mezzo ch
cilita ua incirculo et fa andar in circulo tutte
elle aspe et quelle canne e nel tirare sum la
da la ua duplicando et stergiendo

13

qui la si tenge de tutte quelli c
ege si uole

"To His Most Illustrious Lordship
Baron Lord Ferdinand Hoffman,
President of the Chamber of His
Imperial Majesty
Knowing what pleasure painting
gives to all nobles and how Your
Most Illustrious Lordship delights in
it and truly it is worthy of all great
Princes; and knowing that Your
Lordship is about to have some
rooms repainted, it seemed to me
proper to communicate some ideas
drawn up in great haste, for I did
not have the time to carry out with
diligence the sketches needed for the
occasion, since I am at present
engaged in work for His Holy
Imperial Majesty my Lord.
I shall say how ancients were the
first inventors of grotesques, but they
were not called grotesques by them;
they were given this name by the
moderns because in Rome every day
they discover more buildings buried
underground in the grottoes and
they find painted on the ceilings the
said inventions; and since the
painters did these drawings in the
grottoes they have called them
grotesques; it is clear that it is not
by chance that the ancients placed
no figures and no animals in said
grotesques, but there was an
intention; from this I have thought
that the moderns in the same way
will be able to place illustrations of
textiles in the spaces; just as the
ancients put sacrificial altars, animals
or other things, so one will place
some manufacturing processes; in the
present sketches I illustrate the
production of silk, which I have
dealt with first since it is unknown
in Germany; in another room we
could illustrate the manufacture of
wool and in another still the
production of canvas, I mean the
origins of linen, how it is first
gathered and then gradually how
canvas is made."
Your Most Illustrious Lordship's
Most Devout Servant
                  Giuseppe Arcimboldo

II adapted his own taste to that of the painter. This meant that Ar- cimboldo participated, directly or indirectly, both in the intellectual life of the court and in the creation of Maximilian's collections, and not only by contributing his own paintings. The emperor had his own administrator for the collections, Jacopo Strada, but Strada was strongly oriented towards "antiques" — that is, antiquity, history, numismatics, linguistics, and so on.[11] The emperor, however, was exceptionally interested in the natural sciences; he had several ex- cellent botanists and physicians at his court. Arcimboldo had in- direct but profound contact with this world. His paintings derived from the same philosophical thought and reproduced in pictorial form the same conception of the world as that held by court scholars.

Arcimboldo was thus able to convince Maximilian II that not on- ly were classical ideals of beauty and culture worthy of attention, but that one's everyday surroundings were also interesting; it is only necessary to know how to look at them and to understand the sign language with which things communicate with us. Maximilian II's projects at Fasangarten and Neugebäude — stables, gardens, ponds, enclosures for animals — were clearly not only designed for court entertainments.[12] Their purpose was perhaps the same as that at Rudolf's court in Prague: to unite in a small space all that Nature has created and to complete it harmoniously with human in- telligence, so that a kind of model of the world is created with which one can study its laws and reveal its mysteries.[13]

Arcimboldo painted very little at Rudolf's court, but instead dedi- cated himself to his own research and investigation. This research into the mysteries of the world was from a philosophical rather than a political standpoint. This conception had been formulated fully by Francis Bacon in 1594; its origins date back to the first half of the sixteenth century and are linked to the great development of the natural sciences and the beginnings of pansophism, which reached its peak in the early decades of the seventeenth century.[14]

Natural science collections in the second half of the sixteenth century were by no means an exception. At the royal court they followed very much the same lines that Jacopo Strada was trying to impose on the Hapsburg collections: ancient and contemporary art predominated, as well as genealogy, history, and aesthetics. Did Jacopo Strada suddenly quit his post as Keeper of Antiquities because he disagreed with the new ideas on collecting, or was it rather his jealousy of the person whose word counted for more with the emperor? These considerations are purely hypothetical; it is unlikely that convincing proof will ever be found to support them.

The ideas formulated by Arcimboldo in the *Elements* and the *Seasons* during the 1560s were still flourishing at the beginning of the seventeenth century. In 1609 the emperor's Court Physician — and, it should be added, one of the founders of modern phar-

macology — published the *Basilica Chymica*. In the final part, "Tractatus de signaturis internis rerum seu de vera et viva anatomia majoris et minoris mundi," he wrote that a language of signs which Man may understand is proper to Nature itself and that "magia" is that type of investigation into Nature that makes this knowledge possible. "Cognitionem autem virtutis Arcanae dat magia quae in lumine naturae doctrix est, et totius philosophiae naturalis perfectissima et consummata scientia... In homine enim ipso minore mundo non est membrum, quod non respondeat alcui Elemento, alicui Planetae, alicui Intelligentiae et alicui Mensurae ac numerationi in Archetypo... Omens herbae, flores, arbores, aliaque e terra provenientia sunt libri et signa magica ab immensa Dei misericordia communicata."[15]

This desire to discover and master the mysterious signs of Nature continued for decades after Arcimboldo had painted his pictures. Croll, who dedicated himself so intensely to these studies, obtained rare materials from Rudolf II's imperial collection precisely because their function did not consist in remaining untouchable objects in a gallery of curiosities, but were meant to be used in the pursuit of knowledge.[16]

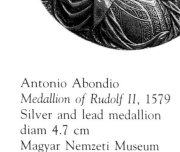

Antonio Abondio
*Medallion of Rudolf II*, 1579
Silver and lead medallion
diam 4.7 cm
Magyar Nemzeti Museum
Budapest *

1. Lomazzo, *Scritti sulle arti.* Vol. I, p. 362.
2. National Museum, Prague, inventory number 40155. Familien-Besitz, S. Reproduced in Heinrich Geissler, *Zeichnung in Deutschland, Deutsche Zeichner 1540-1640.* Stuttgart 1979. Vol. I, p. 53.
3. These pictures seem to me to have been drawn more freely and more pictorially than the early works of Arcimboldo in the 1560. Furthermore, they presuppose other pictorial experiments — the anamorphic paintings — which have not been preserved but are listed in the 1621 inventory of the imperial collections.
4. For example Cavalori's *The Wool-Working Process* in the Studiolo of Francesco I de' Medici in the Palazzo Vecchio, Florence.
5. The catalogue of the Hoffman library as well the greater part of its contents passed into the hands of the Dietrichstein family and is now kept in the University Library in Brno. V. Dokoupil, *Il manoscritto conteso della biblioteca Dietrichstein.* The *Kunst-Kabinett* was common in the families of high ranking court officials, even in those such as Trautson or Rumf who had no particular interest in art or science. A reference to their collections can be found in the diary of the French ambassador's secretary at the court of Rudolf II, F. Bergeron.
6. Egidius Sadeler, *The Four Seasons,* engraving.
7. See E. Fučíková, "Die Kunstkammer und Galerie Kaiser Rudolfs II als eine Studiensammlung," in *XXV. Internationaler Kongress für Kunstgeschichte, Vienna 4.10.1983, 4, Zugang zum Kunstwerk: Schatzkammer, Salon, Ausstellung, Museum.* Vienna 1986, pp. 53-55.
8. See Erich Trunz, "Pansophie und Manierismus in Kreise Kaiser Rudolfs II," in *Die österreichische Literatur. Ihr Profil von den Anfangen im Mittelalter bis ins 18. Jahrhundert. (1650-1750).* Graz 1986, pp. 865-986.
9. *Jahrbuch der Kunsthistorischen Sammlungen des Allerhöchsten Kaiserhauses,* V, 1884, II. Teil, Reg. 4565.
10. See E. Fučíková, "Umění a umělci na dvoře Rudolfa II: vztahy K Itálii," in *Umění 34* (Art and artists at the court of Rudolf II: links with Italy, in *Arts 34*) 1986, pp. 119-127.
11. Renate von Busch has studied the antiquarian activities of Jacopo Strada. *Studien zu Deutschen Antikensammlungen des 16. Jahrhunderts.* Diss. Tübingen 1973,

Giovanni and Cosimo Castrucci
*View of Prague*, 1600 c.
Mosaic of semi-precious stones
18.5×34 cm
Uměckoprůmyslové Muzeum
Prague *

pp. 193-219. Also Dirk Jakob Jansen, "Jacopo Strada (1515-1588): Antiquario della Sacra Cesarea Maestà," in *Leids kunsthistorisch jaarboek.* 1982, pp. 57-69.

12. Hilda Lietzmann is preparing a detailed study on this construction. A brief description of the literature on the subject can be found in an article by H. Lietzmann, "Das Neugebäude zu Wien," in *XXV Internationaler Kongresses für Kunstgeschichte, 5: Europa und die Kunst des Islam, 15. bis 18. Jahrhundert*, notes 7, 3. Vienna 1985, pp. 91-96.

13. For literature on the subject see *Trattati d'arte del cinquecento fra manierismo e controriforma*, ed. Paola Barocchi. Bari 1962, p. 260.

14. Francis Bacon, *Gesta Grayorum*, 1594. E. Trunz (see note 8) has written a great deal on the subject of pansophism at the court of Rudolf II.

15. The *Tractatus* has its own pagination. The passages cited here are from pages 1 and 32.

16. Croll himself writes of this in the introduction to the *Tractatus.*

131

Anonymous
*Dodecahedron*, 1570 c.
Wood, iron and watercolor on paper
diam 39 cm
Kunsthistorisches Museum
Sammlungen Schloss Ambras, Innsbruck *

Giovanni Andrea
*Lyre*, 1511
Wood, 80.5×27.5×4.5 cm
Sammlung alter Musikinstrumente
Kunsthistorisches Museum, Vienna

# The Treasure and Art Chamber of Prague[1]

N. 1. In a cupboard, in the upper section:

1. The upper part of a female figure in flesh-colored plaster, on a flesh-colored and red support.
   In a painted cupboard, in the lower section:
2. Several boxes of various kinds of painted Indian quills and other uninteresting things.

N. 2. A cupboard with three sections:

In the upper section:

3. Beautifully manufactured Indian cups and various pieces of pottery, in all thirty pieces.

In the second section:

4. Chest containing various types of Turkish napkins.
5. Two water-flasks with silver studs Indian
6. Another 9 flasks Indian
7. And further, 4 drums Indian
8. And also a round chest with a few jugs in *terra sigillata*.
9. Five Indian writing sets, one of which in mother-of-pearl.
10. And also a box with a chess set and ivory painted red.
11. Five Indian drinking implements.
12. Seven Indian purses and two hold-alls.
13. One round brass cup with Indian inscription.
14. Three other uninteresting Indian objects.

In the third section:

15. Eighteen large and small earthenware ancient Egyptian shards.
16. One cauldron with two brass lids and an Indian bell with whistles.

N. 3 In the cupboard marked N. 3 there are three sections:

In the upper one there are:

17. 28 Indian utensils in straw and painted wood, all equipped with smaller pieces of the same kind.

In the second (middle) section:

18. A chest and two other Indian pieces in painted metal, containing many small Indian objects in straw and wood as well as a small jug.
19. And also 22 pieces of Indian pottery of various kinds, some of which empty and some filled with tiny items.

In the third section:

20. An Indian organ and several Indian seeds, and together with these several uninteresting objects.

[...]

C. On the lower shelf:

899. * First of all half a cake, as though eaten by a catfish, by Arsimboldo. (Orig.)

900. * Venus with a Satyr, by an unknown master.

901. * The Four Seasons (twice) with the faces composed of a variety of birds, flowers and fruit, by Arsimboldo. (Orig.)

[...]

F. On the shelf:

1038. Venus and Dadanus, by Flores. (Orig.)
       *Cod. 8196 states*: Venus and Adonis.
1039. A Large Globe, by Blomart. (Orig.)
1040. Conversion of St. Paul, by Flores. (Orig.)
1041. A Poor Household, by Francken. (Orig.)
1042. Fish Market, by Campo Cremonio. (Orig.)
1043. Diana under the golden rainfall, after Correggio, copied by Hans von Aachen.
1044. Fruit Market, by Campo Cremonio. (Orig.)
1045. Saint Cecilia, by David Teniers. (Orig.)
1046. Adonis Killed by the Boar, by Tintoretto. (Orig.)
1047. Venus Plays with Pallas with Youthful Thoughtlessness, by Octavio Venus. (Orig.)
1048. Roadside Robbery, by Franck.
1049. Abraham Receives the Blessing of God the Father, a good copy after Bassano.
1050. Last Judgment, by Flores. (Orig.)
1051. Syrinx and Pan, by Giulio Romano, a good piece. (Orig.)
1052. Hercules caught in the Spires of Hydra, by Spranger. (Orig.)
1053. Fame, by Spranger. (Orig.)
1054. Venus and Adonis, by Titian. (Orig.)
1055. Venus and Cupid before Jupiter, by Spranger. (Orig.)
1056. Shipwreck, by Grimmet. (Orig.)

Caspar Lehmann
*Rudolf II*, undated
Engraved glass
Kunsthistorisches Museum, Vienna

Joris Hoefnagel
*Allegory on the Transience of Life*
(Diptych), 1591
Watercolor on parchment, 12.3×18
and 12.3×18 cm
Musée des Beaux-Arts, Lille

Letter of Rudolf II to Raimund Dorn
Haus-, Hof- und Staatsarchiv
Vienna *

*On September 8 1582 Rudolf II wrote
to Raimund Dorn, a citizen of Kempten
in Bavaria, a letter of presentation for
Arcimboldo, commissioned to find and
buy antiquities and rare animals for the
imperial collections:*
"Having learned from an inventory
sent by you to Alexander zu
Bappenheim, our marshal of the realm,
that you have antiquities and works
of art and intend to sell them to
a worthy person, and since we would
wish to see some and, against payment,
enter into possession of them,
we have sent to you our court
caricaturist Giuseppe Arcimboldo,
charged to look at these
works and bring us those he thinks
suitable. We pray you to convey the
above antiquities here by the
shortest route, or have them
conveyed by someone on your
behalf. We not only wish to
conclude the purchase together with
the payment of the expenses,
but also graciously reward
your kindness in another way.
Augsburg, 8 September 1582."

1057. Mary and Joseph, by Rottenhamer. (Orig.)
1058. Judgment of Paris, by Heller. (Orig.)
1059. Mathematics, by Gundelach. (Orig.)
1060. The Blinding of a Soldier, by Francken the Younger.
1061. A Lute, by Arcimboldo.
1062. Head composed of vegetables, by Arsimboldo. (Orig.)
1063. Small Landscape, by Königssloe. (Orig.)
1064. Sacrifice of Noah, by Francken the Younger.
1065. Mediocre portrait of a lady.
1066. Large nude with wild boar, by Tintoretto. (Orig.)
1067. Aeneas Carries his Father Anchises to Safety, away from the Fire, by
      Federico Baroccio, remarkable piece. (Orig.)
1068. Two Indian animals.

[...]

G. Below:

1069. Portrait of a Lady, by Leonardo da Vinci. (Orig.)
1070. Midas and Vice. (Copy)
1071. Hunter with his dog and a large boar's head, by Sauerj. (Orig.)
1072. Sea Fish and Snails, by Schneider. (Orig.)
1073. Bad Landscape.
1074. Fire near the Seaside, watercolor.
1075. Bust of a Lady, by Gundelach. (Orig.)
1076. Night Scene with Fire, by Agidio Mustert. (Orig.)
1077. Foreshortened head.
1078. Landscape with Spa, by Sauerj.
1079. Another landscape by Grimmer the Elder. (Orig.)
1080. Face made up of turnips, by Arsimboldo. (Orig.)
1081. Andromeda and Perseus, by Corln Murs. (Orig.)
1082. Orpheus with the Wild Beasts in a Landscape, by Sauerj. (Orig.)
1083. Face made up of various roast meats, by Arsimboldo. (Orig.)
1084. Painting of a small animal without frame.
1085. Face made up of various birds, by Arsimboldo. (Orig.)
1086. A White Crow, by Sauerj. (Orig.)
1087. Face made up of various fruits, by Arsimboldo. (Orig.)
1088. Landscape, by Falckenburg the Younger. (Orig.)
1089. Four people laughing, by Günter.
1090. Fire, by Ägidio Mustert. (Orig.)
1091. Ancient circular landscape with Daniel and Baal, by Bohl.

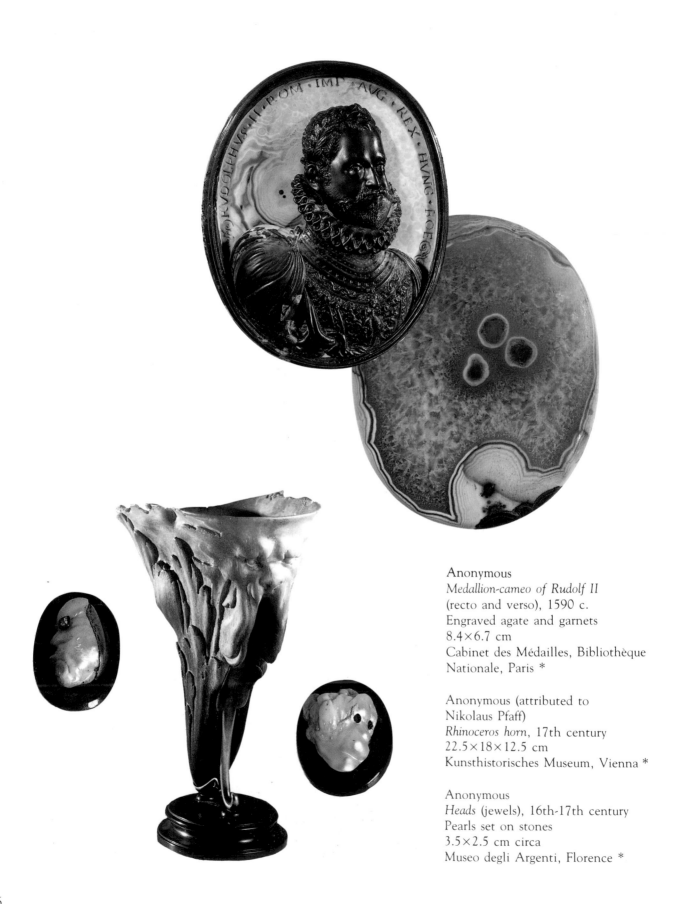

Anonymous
*Medallion-cameo of Rudolf II*
(recto and verso), 1590 c.
Engraved agate and garnets
8.4×6.7 cm
Cabinet des Médailles, Bibliothèque
Nationale, Paris *

Anonymous (attributed to
Nikolaus Pfaff)
*Rhinoceros horn*, 17th century
22.5×18×12.5 cm
Kunsthistorisches Museum, Vienna *

Anonymous
*Heads* (jewels), 16th-17th century
Pearls set on stones
3.5×2.5 cm circa
Museo degli Argenti, Florence *

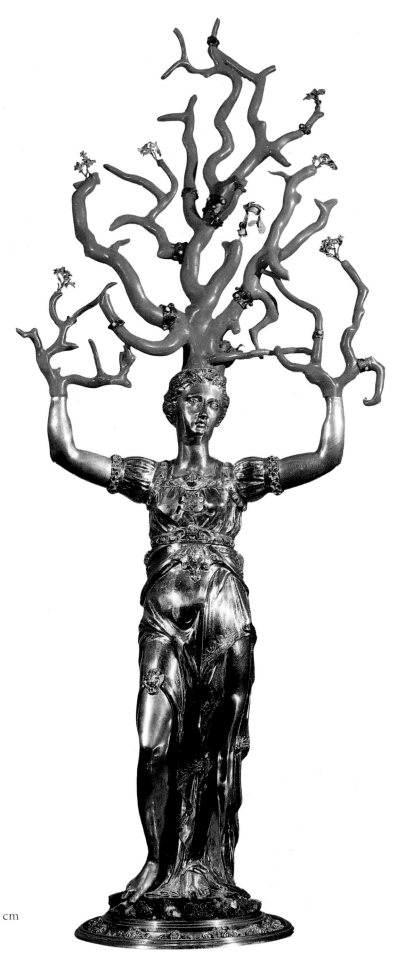

Wenzel Jamnitzer
*Daphne*, 1550 c.
Gilded silver, coral and
semi-precious stones, h. 67.5 cm
Musée de la Renaissance
Château d'Ecouen *

1092. A temple seen in perspective at night, by Mustert. (Orig.)
1093. St. Christopher walking on the water, by Hieronymus Bosch. (Orig.)
1094. Small landscape. (Copy)
1095. The Flood, by Peter von der Bürckt. (Orig.)
1096. Peasants beating the soldiers, by Pieter Brueghel the Younger. (Orig.)
1097. Daedalus and the Eagle, by Hanns von Achaen. (Orig.)
1098. Perspective with masked celebration, a mediocre work.
1099. Fire, by Mostert.
1100. Landscape, by Civetta. (Orig.)
1101. Peasants' Dance, by Brueghel the Younger. (Orig.)
1102. Lot and his Two Daughters, by Hieronymus Bosch.
1103. Love intrigue with a fool, by Jeremia Günter.
1104. Head of Bacchus, by an unknown artist.
1105. Landscape with Roman building, by Carl Verhafft.
1106. Landscape with Jacob and Esau, by Falkenburg the Younger. (Orig.)
1107. Dutch Banquet, mediocre work.
1108. Mary and Elizabeth, copy after Günter.
1109. Perspective with a ballgame, by Ulrich Regern. (Orig.)
1110. The Temptation of St. Antony, by Hieronymus Bosch. (Orig.)
1111. Face made up of various birds, by Arsimboldo. (Orig.)
1112. The Salon in Prague, by Egidio Sattlern. (Orig.)
1113. Pluto and Proserpine on a wagon, by Franckh. (Orig.)
1114. Venus and Cupid, by Anthonios Moor. (Orig.)

[...]

On the stairs, beyond the gallery:

1183. Flora in the Garden, by Franzen de Mor. (Orig.)
1184. Large Boar, by Severi. (Orig.)
1185. Lucretia Romana.
1186. A map.

The following paintings are in the Spanish room:

J. Above:

1187. Love Intrigue, by Günther. (Orig.)
1188. Painting of three goddesses, by Johann Baldruck.
1189. Ixion, after Titian. (Copy)
1190. Market, by Ambrosio Francken. (Orig.)

Erasmus Habermel
*Armillary Sphere*, 1600 c.
Gilded engraved brass, h. 40 cm
Uměleckoprůmyslové Muzeum
Prague *

Joris Hoefnagel
*Sea Fish*, undated
Pen, watercolor and gouache on
parchment, 14.3×19.3 cm
Národní Galerie, Prague *

138

Joris Hoefnagel
*Seashells and Crustaceans,* undated
Pen, watercolor and gouache on
parchment, 14.3×19.4 cm
Národní Galerie, Prague *

Anonymous
*Little Statue,* 16th century
Assemblage of shells on wood and
papier mâché, h. 53 cm
Museo degli argenti, Florence

1191. Sisiphus in Hell, after Titian. (Copy)
1192. Venus cutting her nails, by Joseph Arpinas. (Orig.)
1193. Mercury and two female figures, by Paolo Veronese. (Orig.)
1194. Leda and the Swan. (Copy)
1195. Contemplation, by Marco de Baccher.
1196. A bath with Calisto, by Luca de Genua.
1197. Virtue struggling against Vice, by Bacchar.
1198. Pan and Venus, after Giulio Romano.
1199. The Tower of Babel, by Jost Mumpern. (Orig.)
1200. Three Goddesses, by Spranger. (Orig.)
1201. Venus and Adonis, by Paolo Veronese. (Orig.)
1202. Hercules and Deianira with her two dogs, by Spranger. (Orig.)
1203. Banquet with the Centaurs seizing Deianira, by Bassano the Younger. (Orig.)
1204. A Banquet, by Bassano the Younger. (Orig.)
1205. Decapitation of Medusa, Pallas and Pegasus, by Spranger. (Orig.)
1206. Venus on a shell in the sea. (Copy)
1207. Nature enveloped in the clouds, and below the fertile earth, a very beautiful painting by Tintoretto. (Orig.)
1208. Andromeda and Perseus, by Spranger. (Orig.)
1209. Europa on the Bull, by Spranger. (Orig.)
1210. Pan and Venus. (Copy)
1211. Venus and Adonis. (Copy)
1212. Virtue and Fortitude, by Paolo Veronese. (Orig.)
1213. Vision of Tantalus with two female nudes, by Tintoretto. (Orig.)
1214. Neptune and Senis, by Spranger. (Orig.)
1215. Judith and Holophernes, by Dyonysio Calavant.
1216. How Vice converts to Virtue, by Paolo Veronese. (Orig.)
1217. Ixion trying to pick the apples, after Titian. (Copy)
1218. Tantalus on his wheel, after Titian. (Copy)
1219. St. Sebastian, by Anthonis Moor.
1220. Portrait made up of books, by Arsimboldo. (Orig.)
[...]

On the ground:

1236. Pantaloon with a lute.
1237. Lucretia.
1238. Susanna and the two elders, by Martin de Voss. (Orig.)
1239. An adulteress is forgiven by Christ, by Perin del Vaga. (Orig.)

1240. Magician's trick, after Hieronymus Bosch. (Copy)
1241. Banquet in a garden, a mediocre work.
1242. Women looking in the mirror, by Hans von Aachen. (Orig.)
1243. Landscape, by Tobias Ferhafft. (Orig.)
1244. Last Judgment, by Marten Hemskirchen. (Orig.)
1245. Portrait made up of birds, by Arsimboldo. (Orig.)
1246. A Globe, by Spranger.
1247. Weeping Bride, by Günter.
1248. Landscape with Saint Jerome, by Civetta. (Orig.)
1249. A Madonna seen in perspective.
1250. Love Intrigue, by George Penzeln. (Orig.)
1251. Female nude bathing, by Rulandt de Voss. (Orig.)
1252. Portrait of a Spanish queen, by Hans Holbein. (Orig.)
1253. Last Judgment.
1254. Woman lying on her bed, by Wilhelm de Voss. (Orig.)
1255. Landscape with Saint Jerome, by Civetta. (Orig.)
1256. The Queen of Sheba leads King Solomon to idolatry, by Hisabel Peom. (Orig.)
1257. Female nudes bathing, by Egidio Congiet. (Orig.)
1258. Landscape with four blind men leading each other, by Hans von Mecheln. (Orig.)
1259. The Rape of Helen. (Copy)

1. Inventory of all the objects found after the victory in his Majesty's Treasury and Art Gallery in Prague and inventoried by order of His Majesty and His Lordship the Prince of Lichtenstein on 6 December 1621
(Giuseppe Arcimboldo's works are marked by an asterics)

Anonymous
*Mandragore*, 16th century
Wood, h. 54 cm
Kunsthistorisches Museum
Sammlungen Schloss Ambras
Innsbruck *

Anonymous
*Composite profile of Pietro Bacci known as L'Aretino*, 16th century
Bronze medallion, diam 4.68 cm
Civici Musei d'arte e storia
Brescia *

Anonymous (after a drawing by Mantegna)
*Console*, 16th century
Wood, 64×41×57 cm
Galerie Charles Ratton et Guy Ladrière, Paris *

Joris Hoefnagel
*Horoscope of Rudolf II*, undated
Watercolor on paper
Österreichische Nationalbibliothek, Vienna

Anonymous
*Fool's Head Cup*, 16th century
Coconut with gilt, engraved silver
surround, 12.7×10.8 cm
Historisches Museum, Basel *

Giuseppe Arcimboldo
*Project for a Costume: The Cook*
Pen, blue ink and watercolor on paper, 30.5×20 cm
Gabinetto Disegni e Stampe degli Uffizi, Florence *

# Anthology of Sixteenth-Century Texts

edited by Piero Falchetta

*Dedication [1585] by Giuseppe Arcimboldo to Rudolf II on the frontispiece of a collection of 148 drawings preserved in the Gabinetto dei Disegni e delle Stampe degli Uffizi in Florence:*
"Invictissimo romanorum imperatori semper augusto Rodolpho II domino clementissimo / Josephus Arcimboldus Mediolanensis has pro hastiludiis multas varias ornamentorum inventiones manu propria delineatas dicavit / Anno DNI M DXXXV"

"Lewd world, ungrateful world, world hostile to God, blind, mad world, hideous world, pestiferous, pernicious and detestable customs of the world. 'Nolite,' says the Apostle, 'conformari huic saeculo': therefore keep far from you those pagan customs, those dissolute diversions of peoples who have neither knowledge of God nor hope of a life other than the present one. Let the memories and vestiges left by the pagans be altogether cancelled (...) And you, open your eyes, O Milan . . ."[1] These words, which come from the *Memorial* written to the Milanese by Carlo Borromeo in 1579, give a clear picture of the atmosphere that Arcimboldo must have found in his native city when he returned in 1587, after an absence of twenty-six years spent beyond the Alps, at the imperial courts of Vienna and Prague. And while, during the times of the plague and in those immediately following, the impassioned cardinal inveighed against the exclusion of the divine from the lives of men, and pointed an accusing finger at the "past memories of the games, spectacles, masquerades, and uglinesses of the carnival"[2] that had covered over and cancelled the memory of divine beneficences, Arcimboldo was at the Hapsburg court painting the allegorical cycle of the *Seasons* and of the *Elements*, with a view to representing not only the dominion of the emperor Maximilian over the peoples and the nations, but also his lordship over the time of humanity and the things of nature.

And of that Milan which had been one of the cities most fervently and intellectually active, most open to the new ideas and most attentive to what artists and writers were putting forward during that extraordinary period of Italian history called the Renaissance; of that same city, in 1584, Borromeo wrote: "Among others who come to this huge city are many of those who live beyond the Alps, and who have abandoned the true faith (this I know from personal experience), and they see our people given over to lasciviousness with more intemperance than if they were without baptism and still immolating themselves to the gods of the gentiles (and indeed are not the insane festivals of the bacchanalia something like an idol?)."[3] And this was while Arcimboldo, beyond the Alps, was visiting magicians, astrologers, natural philosophers, and hunters after marvels and freakishnesses, and moreover — with the assistance of a canon of the Church, Fonteo, also a Milanese — setting up one of the most

splendid and extravagant festivities of which we have any record, and in which all those "vestiges left by the pagans" lived once more to lend light and magnificence to the emperor's worldly revels.

In spite of the fact that the wind of reform raised by Borromeo blew with such vehemence, the city managed to keep faith in many respects with its civil and intellectual life, with that spirit of tolerance that had always distinguished it, and in spite of all the anathemas hurled against worldly corruption and fidelity to classical ideals, Arcimboldo on his return was still able to find many among his fellow citizens who admired him and applauded his talent. It is surely a thing of no small importance that two authors, among those who in such a cultural climate bore witness to the art of this famous painter, were in fact churchmen. This is an indubitable sign that intellectual resistance to the rigors with which, toward the decline of the century, the new age was ushered in, was not something confined to callous pleasure-seekers and atheists.

Once he had settled definitively in Milan, Arcimboldo painted two more portraits of "composite heads" for Rudolf II of Austria: *Vertumnus* (which depicts the transfigured image of the emperor himself) and *Flora*. Both these works were sent off to Vienna, but while they were being painted a number of artists, writers, and other interested people in Milan had a chance to appreciate how learned and skilful was the hand of this painter, their fellow townsman. And in all probability these two works were the only ones of Arcimboldo's "heads" known in Italy during his lifetime. This is interesting if considered in relation to the accounts of him that have come down to us from Morigi, Lomazzo, and Comanini.

When he returned to his native land, the creator of the *Seasons* and the *Elements* could not expect to be preceded by a great reputation, for he had always lived beyond the Alps, and for twenty-six years served, as it were, always the same master, who was the only one to commission his work. It is true that he was coming back to a city where he could rediscover deep roots of his own, both from a biographical point of view (his family had produced three archbishops of Milan) and from an artistic one (we need only mention his work on the windows of the Duomo, done in his youth along with his father, Biagio); and it is equally true that the title of Count Palatine bestowed on him by the emperor must have contributed not a little to confirming his merit among his fellow-citizens. However, it is certain that his painting could not have left its mark on the artistic and cultural life of Milan, and this was the sole recognition that was lacking to crown his last days, which he wished to live out in the place where he was born. Now, as we read the accounts of Morigi, Lomazzo, and Comanini, we seem able to discern, over and above their sincere admiration for the truly astonishing work of this artist, his need to publicize himself, to make himself known in order to be recognized, to insert himself *ex novo* into the

Giuseppe Arcimboldo
*Project for a Costume: The Sea Dragon*
Pen, blue ink and watercolor on paper, 29×19 cm
Gabinetto Disegni e Stampe degli Uffizi, Florence *

144

fabric of social and cultural relationships in his city, and in some way to become its jewel, its rediscovered treasure, its prodigal son — but from the commanding position of undisputed authority. It does not in fact seem purely coincidental that he chose to entrust his biographical and artistic confidences, the memories of a lifetime spent in a foreign country, and the catalogue of his best paintings, to the works (which were published in those last years of his life) of three authors who differed very greatly from one another: a scholar of modest stature, Morigi, who was however also a scrupulous chronicler of the municipal life of Milan; a painter, Lomazzo, who later became one of the leading contemporary theorists of the art of painting; and a man of bizarre and many-sided talent, Comanini, a poet of elegance and an original and incisive thinker. As we read the passages in their works that refer to Arcimboldo, it does not seem improbable that Arcimboldo, with their more or less explicit consent, planned the promotion of his own artistic image, as we would say today, in that place that was indeed his homeland, but where almost no one yet knew about him.

On the one hand the fact that certain biographical details are very similar in the writings of the three authors mentioned, and on the other the absence of *other* information concerning his life and activities, support the hypothesis that Arcimboldo was his own interpreter not only in pictures, but also by means of a kind of skeletal verbal self-portrait, in which he put only what might serve his purpose in reconstructing — but *sub condicione* — the outline of his own image for the benefit of the Milanese, who had by the very nature of things forgotten him. We are in fact struck by the scarcity of information about him, his life, and his painting; and if on the one hand we can admit that nearly all his pictures were destined for a

Giuseppe Arcimboldo
*Project for a Costume: Cerberus*
Pen, blue ink and watercolor on paper, 19×23 cm
Gabinetto Disegni e Stampe degli Uffizi, Florence *

146

court and were therefore excluded to some extent from enjoying a wider fame, it is hard to believe that a man and an artist of such value left such scanty traces of himself (as Geiger's careful research in the archives tells us[4]) both in the imperial environment of Vienna and, later on, in his own city. In other words, we know almost nothing about him except the little that he himself divulged through the writings of those three admirers.

We have to bear this in mind in reading the short anthology reproduced below, because what seems to be speaking in it is not just the encomiastic labors of Morigi, or Lomazzo's conceptual system, or the cordial conversationalists of the *Figino*, but rather the more imperious but wary voice of the painter himself, of a man who had spent whole years planning and realizing grandiose festive celebrations, of a personage who, in his shrewd-disenchantment, knew very well the value and the merits of that wholly human,

secular, and "political" world that he transfigured in such a peerless manner.

Giovanni Battista Fonteo (1546 c. - 1580 c.)

Even though in the early years of this century the name Fonteo (derived in turn from the Latin name of Fonteius) had already been attributed to its rightful owner, that is to say the Milanese scholar and historian Giovanni Battista Fontana,[5] it was only very recently that a number of papers of this Fonteo were discovered in the National Library in Vienna. From these it was possible to deduce that he must have spent some time in Vienna and there, on several occasions, collaborated with Arcimboldo.[6] We know very little about Fonteo's stay at the imperial court; however, it is probable that it took place between the years 1568 and 1571, and that during that time his duties must have been those of a "cultural adviser" (as we would say nowadays), and one who could boast of being a direct descendant of Primo de' Conti, one of the greatest scholars of the city of Milan. Those few years in Vienna were certainly packed with various activities in which Fonteo was able to give proof of his ability as a

Giovanni Battista Fonteo (?)
*Project for an Allegorical Parade*
(detail), undated
Pen, sepia and watercolor
on a roll of paper, 27.9×266.7 cm
Kunstbibliothek, Berlin *

(following pages)
Giuseppe Arcimboldo
*Eight Projects for Costumes of Allegorical Characters*
Pen, blue ink and watercolor on paper, 30×20 cm circa
Gabinetto Disegni e Stampe degli Uffizi, Florence *

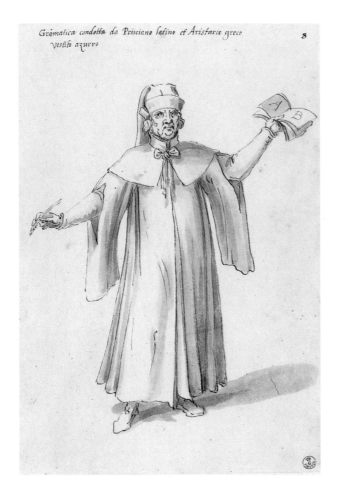

Grámatica condotta da Prisciano latino et Aristarce greco
Vestit azurro

8

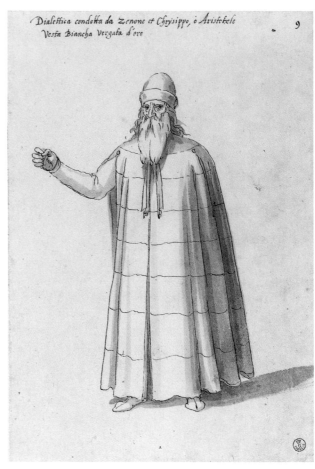

Dialettica condotta da Zenone et Chrysippo, ò Aristotele
Vesta Biancha vergata d'oro

9

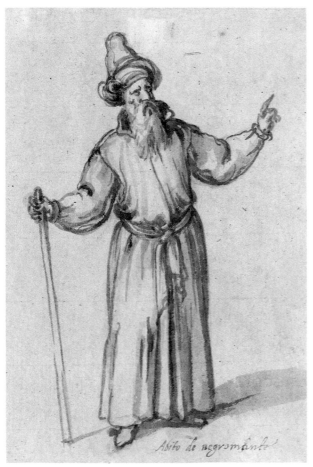

Abito de negromante

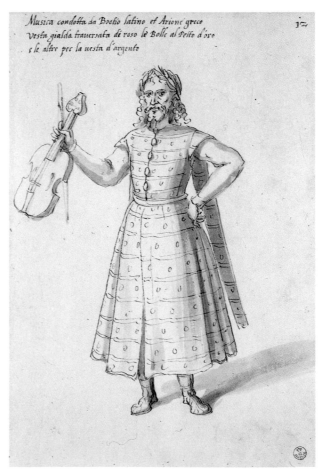

Musica condotta da Boetio latino et Arione greco
Vesta gialda trauersata di roso le Bolle al Petto d'oro
e le altre per la uesta d'argento

10

Rhetorica condotta da Cicerone Romano et Demostene Ateniese
Vesta rosa

10

Aritmetica condotta da Pitagora italiano et Euclide Greco
Vesta verde

11

Geometria condotta da Archimede Siciliano et Archita calabrese
Vesta morella

13

Astrologia condotta da Ptolomeo Alesandrino e da Iulio Hygino Romano
Vesta biancha le fasse rose cõ le stelle d'oro

14

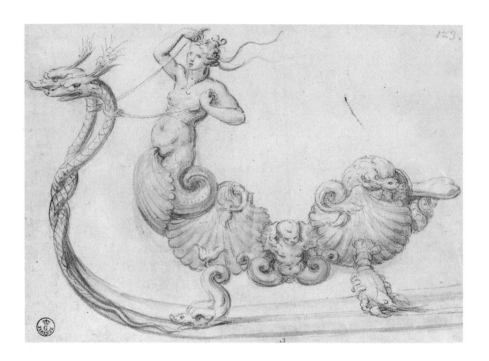

writer, of the breadth of his culture and the range of his interests, as well as of the versatility that enabled him on the one hand to devote himself to the planning of the great allegorical procession with which the court celebrated the wedding of Archduke Charles of Styria and Princess Maria of Bavaria, and on the other to compose a highly scholarly philosophico-moral treatise such as his *De risu, sive quod risus sit virtus, dialogus* (Vienna, Österreichische Nationalbibliothek, cod. 10466). On his return to Italy he established himself in Rome, in the household of the Cesi family, a member of which, Federico, shortly thereafter founded the Accademia dei Lincei; Fonteo became the historian of the Accademia with his work *De Prisca Caesiorum Gente* (Bologna 1582). It was in Milan, on the other hand, that he wrote at Borromeo's request a history of the archbishops of that city, a work, however, which was never completed (Milan, Biblioteca Ambrosiana, MS. V 35, sup.), and a biography of *Suor Paola Antonia De Negri milanese* (Rome, 1576). He died at only thirty-three years of age, while engaging, along with Sigonia, on wide-ranging research into archival material on the Kingdom of Italy.

Having completed his cycle comprising the four portraits of the *Seasons* and the four others of the *Elements* in the years 1563-1566, Arcimboldo presented these works to the emperor Maximilian on New Year's Day 1569. In this case, however, it was not the customary homage that a court painter paid to his lord and protector. This offering was more than a simple artistic tribute in which the sovereign could find an echo of his own magnificence transfigured by the artistic talents of a bizarre and original painter: no, this was very different.

Those eight paintings bore witness to a long study that aimed, in the loftiest, most solemn, and at the same time most minute and

Giuseppe Arcimboldo
*Sledge with Mermaid*
Pen, blue ink and watercolor on paper, 19×23 cm
Gabinetto Disegni e Stampe degli Uffizi, Florence *

Giuseppe Arcimboldo
*Women's Hair Style*
Pen, blue ink and watercolor on paper, 26×18.9 cm
Gabinetto Disegni e Stampe degli Uffizi, Florence *

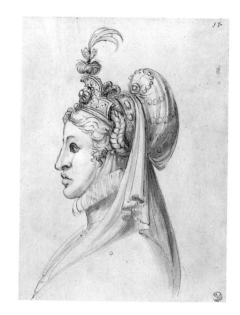

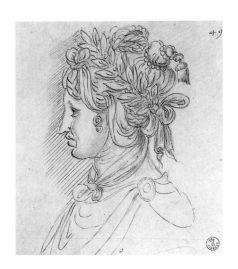

Giuseppe Arcimboldo
*Women's Hair Style*
Pen, blue ink and watercolor on
paper, 15×13.5 cm
Gabinetto Disegni e Stampe degli
Uffizi, Florence *

Giuseppe Arcimboldo
*Sledge with Peacock*
Pen, blue ink and watercolor on
paper, 15.7×18.7 cm
Gabinetto Disegni e Stampe degli
Uffizi, Florence *

(following pages)
Giuseppe Arcimboldo
*Eight Projects for Costumes of
Allegorical Characters*
Pen, blue ink and watercolor on
paper, 30×20 cm circa
Gabinetto Disegni e Stampe degli
Uffizi, Florence *

detailed form, to celebrate the pomp, the splendor, the power, the past history, and the radiant destiny of the House of Hapsburg and its present lord, Maximilian II. The web of cultural and historical motifs that characterize the cycle was, however, so dense and packed with allusions, quotations, and more or less explicit references to names, symbols, facts, and persons in some way connected with the imperial house, that Arcimboldo must have thought it wise to have an accurate explanation (which was at the same time a celebration) of the contents of his work.

Fonteo's *Carmen*[7] set out to render explicit and clearly visible the dense allegorical fabric of Arcimboldo's pictures. But he did not confine himself simply to this, for he gave fresh impetus to the game of allusions and quotations; he made Arcimboldo's web of allegory and the reciprocal cross-references of symbologies denser still, using an artificial, obscure, hyper-literary style full of conceits, intended in all probability to be an embellished poetic equivalent of Arcimboldo's cycle of paintings. The resulting poem, 310 lines in length, is hard going for the reader, evasive and mystifying, elegant in workmanship to the point of intellectual snobbery, and thorny (rather than dense) with contrived references to classical culture (especially to Ovid's *Metamorphoses*).

For us, however, it is a document highly important to the understanding of the cultural and political circumstances that gave birth to Arcimboldo's cycle, above all since Kaufmann, with enormous patience and critical acumen, has succeeded in penetrating that out-and-out labyrinth which is Fonteo's *Divinatio*. Reference to the work of this scholar is compulsory for any attempt to interpret the poem that is not based on guesswork, and for the deciphering

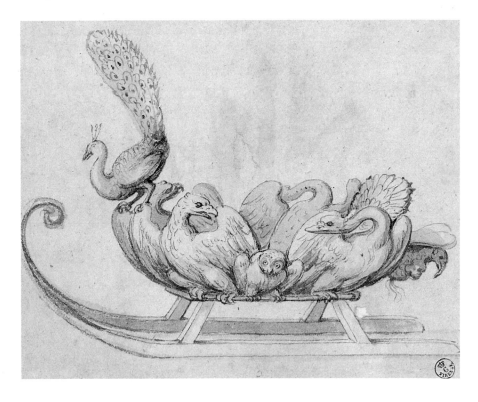

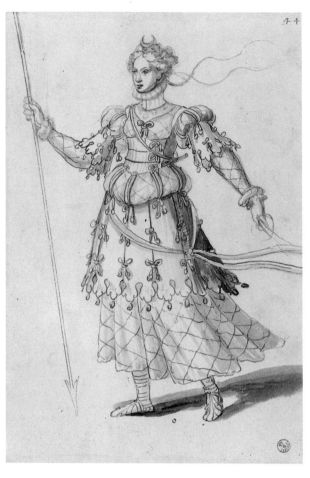

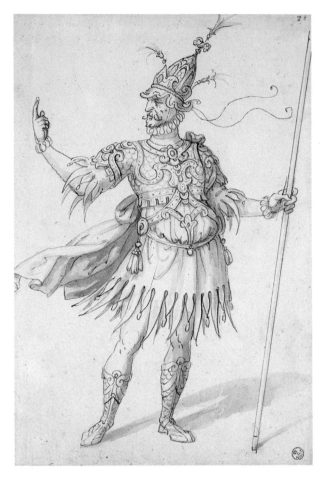

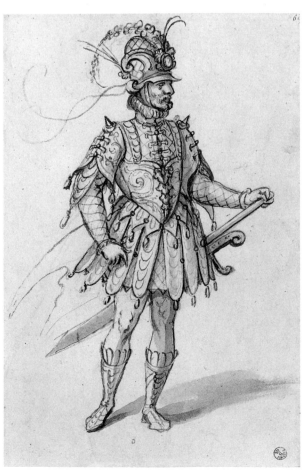

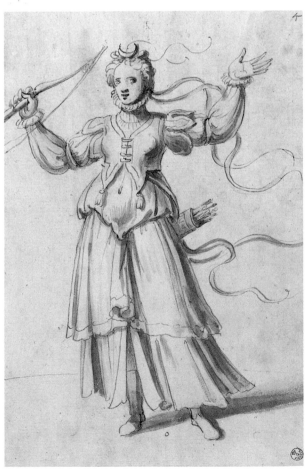

152

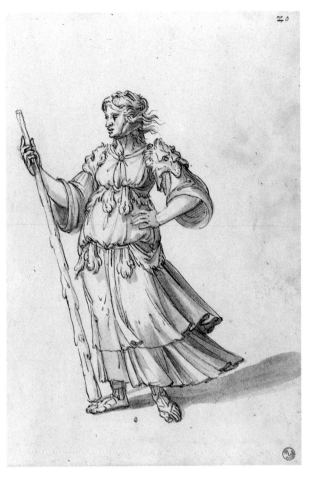

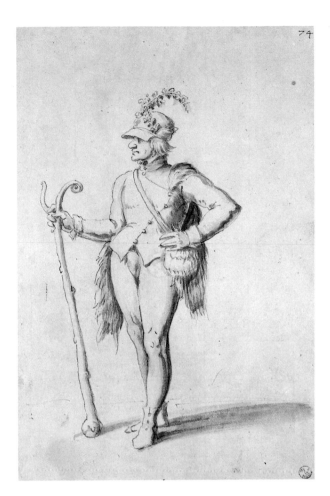

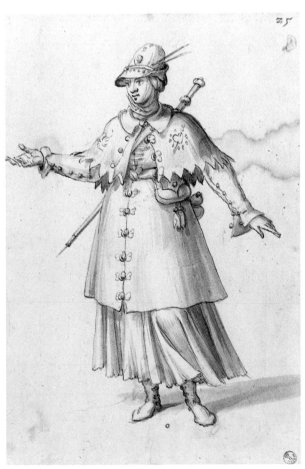

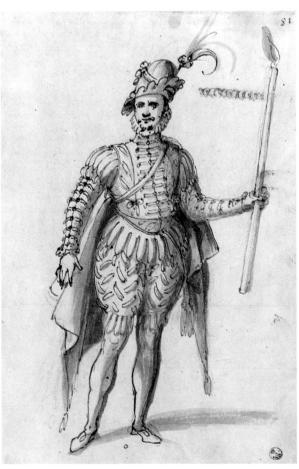

of the closely woven dialogue between those lines and the canvases of the *Seasons* and the *Elements*.[8] The passage below, although translated, will we hope be enough to give some notion of Fonteo's qualities as a writer.

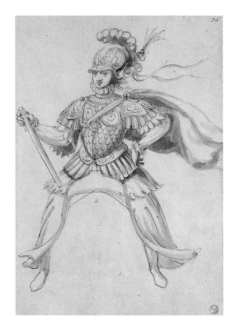

"To His August Majesty
the Invincible and Clement Holy Roman Emperor
Maximilian the Second"

Battista Fonteo Primio

For the painting
of the Four Seasons and the Four Elements
composed according to the human figure
by Giuseppe Arcimboldo imperial painter
and dedicated to the Emperor in person

a poem containing couplets and prophesy
entitled Clemency

Vienna, Austria, December 30th 1568[9]

Poem to His Sacred Imperial Majesty
on the Four Seasons and the Four Elements
depicted in conformity with the appearance of man

O excellent one, saviour on whom rests the world!
Beneath your yoke bow down events and seasons,
Blessèd do we see the city that is subject
To your dominion; we see that men are blessèd.
Before the great Majesty my foresight trembles
Or instinctive awe forbids it the final steps.
But I desist not: since the monarch is generous
I cannot go to him with empty hands;
I therefore bring these greetings
Desirous of giving a voice to the royal pictures,
And in the hope that the work will be more welcome.

Giuseppe Arcimboldo
*Project for a Costume: The Knight*
Pen, blue ink and watercolor on
paper, 30.5×20.7 cm
Gabinetto Disegni e Stampe degli
Uffizi, Florence *

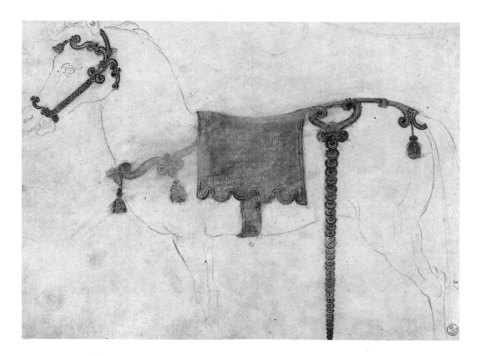

Giuseppe Arcimboldo
*Horse Trappings*
Pen, blue ink and watercolor on
paper, 32×23.5 cm
Gabinetto Disegni e Stampe degli
Uffizi, Florence *

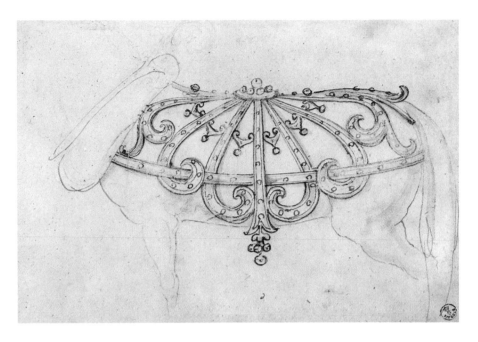

I have enticed the Muses to the well-knit cycle
That they might lend kind favor to the gifts submitted.
Indeed, however we marvel that Jove transformed,
Into various guises, himself, the gods and men
— To quench the ardors of his fervent spirit
And to avoid the shame of adultery —
We marvel now no less at the Elements
    Composed, merciful Caesar, in your honor —
That stand side by side with every Season:
And we will admire their human forms
Made so that they may venerate the benevolent
Graces of the demigods of Austria.
And this not only because you rule the world,
But that of this world you also rule the Elements.
And whether the world prospers in peace or there are
Conflicts in it, you may judge, O Caesar,
From the admirable art of your Giuseppe.
And this he has done not so much so that Bacchus
Should be composed of the things proper to peasants,
Or the cook, in the same way, of his utensils,
But so that with greater wisdom we may consider
If the man is in harmony with these Elements:
And to that man he will soon present these Elements;
And since he was depicted concealed behind them,
So there behind them must we seek for him.

                    [*Carmen*: 1 recto - 2 verso]

As we see, following the dedication to Maximilian and the compliments paid to him, Fonteo connects Arcimboldo's paintings — and with them, his own poem — to one of the great masterpieces of classical literature, Ovid's *Metamorphoses*. This connection is certainly a bold one, but it functions well for the purposes of exalting the figure of the emperor: as Jove, who is lord of the gods and of human time, the Hapsburg sovereign also rules not only over cities and men, but over the four seasons — which is to say, time — and the four elements — air, water, fire, and earth — that compose the

Giuseppe Arcimboldo
*Horse Trappings*
Pen, blue ink and watercolor on
paper, 32x23.5 cm
Gabinetto Disegni e Stampe degli
Uffizi, Florence *

155

cosmos. For each season, we then learn, there is a corresponding element, according to the system of correspondences between macrocosm and microcosm that Neo-Platonic philosophy had taken over from the Greek. The eight portraits in fact form four pairs, which appear in this order: air-spring, fire-summer, earth-autumn, water-winter.

Of special interest are the lines in which Fonteo explains that Arcimboldo's portraits are not to be understood as a simple application of a mechanical and purely factual principle, according to which Bacchus has to be composed of the peasant's tools and the cook of pots and pans: no, what we have is not a mere catalogue, nor is it intended to be simply a classification — even if it is executed with great stylishness and mastery of the techniques of composition. The eight pictures are in reality eight portraits of the same person, the emperor Maximilian, inasmuch as he, ruling over time and things, is able to recognize himself in each of the seasons and elements, since these seasons and elements are themselves natural attributes of his regal power. Take heed, Fonteo therefore warns us, for in those pictures we must first and foremost look for a man; behind those bizarre features there is a person. Thus, presenting (in the manuscript of *Europalia*[10]) the program of the wedding festivities for Charles of Styria and Maria of Bavaria — a program that was conceived by Arcimboldo in collaboration with Fonteo, and therefore repeated many of the allegorical motifs already used in the *Seasons* and the *Elements* — the Milanese scholar sums up the principal meanings of the poem he had composed three years earlier for the cycle of pictures by his fellow-townsman: ". . . in the first place I in-

Giuseppe Arcimboldo
*Sledge*
Pen, blue ink and watercolor on paper, 19×23 cm
Gabinetto Disegni e Stampe degli Uffizi, Florence *

Giuseppe Arcimboldo
*Ornamental Flower*
Pen, blue ink and watercolor on paper
Gabinetto Disegni e Stampe degli Uffizi, Florence *

Giuseppe Arcimboldo
*Crest*
Pen, blue ink and watercolor on
paper, 17×16.5 cm
Gabinetto Disegni e Stampe degli
Uffizi, Florence *

terpret the reasons why the Elements and the Seasons have a human
face, and I say that the cause is the clemency of the emperor Max-
imilian and of the whole illustrious house of Austria. Then I inter-
pret the omens announced by the human faces of the Elements and
the Seasons, and I tell how the human head found by the builders
of the Capitoline[11] predicted domination of the world: the earth —
which is indeed composed of the Elements — was destined to be
governed with great humanity by the house of Austria throughout
the whole course of the years to come — which are indeed made up
of the four Seasons. And just as the Elements and the Seasons are
in accord, and at the basis of human life, so in the same way,
unanimously and concordantly, the nations will accept the rule of
the Austrian line. Then I list the sayings of various philosophers and
the customs and opinions of various peoples. Lastly I enumerate the
resemblances and affinities on account of which Air goes with
Spring, Fire with Summer, Earth with Autumn, and Water with
Winter, in such a manner that they enter the procession two by
two.'' [E2: 8 recto and verso]

The pairing of *Seasons* and *Elements* is also expressed in Fonteo's
poem in a dialogue in which each season and each element speaks
of its own natural attributes and the ways in which these refer to the
figure of the emperor:

Winter to Water:
Tell me, Water, if the body shows a man in me or me in a man
And if thus the divine semblance is sufficiently honored.

Water resolves Winter's uncertainty:
Tell me, do I conceal fish or am I concealed by fish? Both:
Here we display the honors of Austria, there the gifts of nature.

Giuseppe Arcimboldo
*Caparison*
Pen, blue ink and watercolor on
paper, 18.3×23.5 cm
Gabinetto Disegni e Stampe degli
Uffizi, Florence *

157

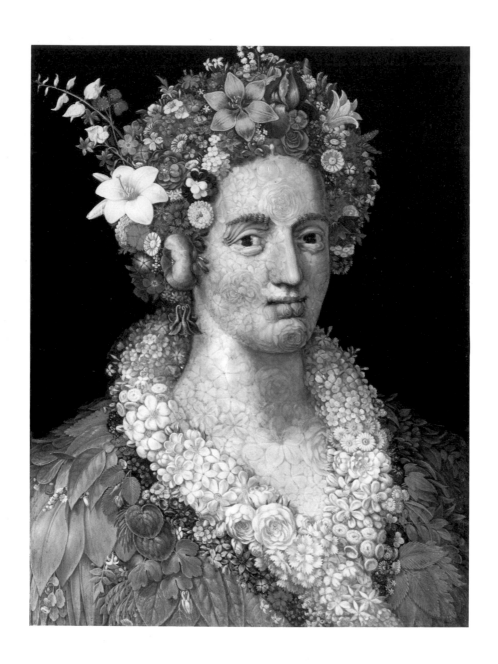

Giuseppe Arcimboldo
*Flora*, 1589 c.
Later inscription top right: LA FLORA DELL'ARCIMBOLDO
Oil on panel, 81.3×61 cm
Private collection

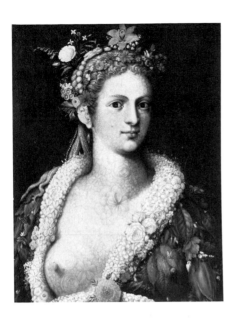

Anonymous
*Portrait of a Woman*, 1595 c.
Oil on panel, 74.3×57.8 cm
Private collection

Spring to Air:
Tell why with good omens, O Air, you show our lord
Birds and colors that grow among verdure and flowers.

Air, in itself, against Spring:
Say if he does not know, whom likewise I illumine with light and colors,
With dews I revive the plants and with air I sustain the birds.

Summer to Fire:
With what pride you flare up, O Fire, fearing for the borders of our Caesar.
Thus am I: naked at first, now dressed in my fruits.

Fire replies to Summer:
As that with which I am lit and burn endures longer than I do,
so the house of our lord will always resist for the love of Austria.

Thus Autumn to Earth:
It is by the will of Caesar that I have the form of man, because fruits are for man:
Say, Earth, why are you composed of so many animals?

Thus Earth to Autumn:
By the will of Caesar I cover the remains in death,
I render the footstep safe on the road and protect the little ones in my bosom.
[*Carmen*: 3 recto and verso]

On the occasion of the nuptial festivities of 1571 the paintings of the *Seasons* and the *Elements* were represented to the court as part of the great allegorical procession that took place in the imperial palace in Vienna. There is, however, on the last page of the manuscript of *Europalia*, a short composition by Fonteo accompanied by an explanatory note. In the latter he speaks of another portrait, a painting that would have been a still better illustration of the contents of the imperial allegory. That painting was, however, not ready in time for the ceremony, and the lines were written so that, in the absence of the finished work, at least the intentions of the emperor's favorite painter could be made manifest. We are unable to say which painting was meant, as there are too few elements for us to identify it by. Fonteo tells us that it was a female figure portrayed according to the technique of the "composite heads," and in a marginal note he thus explains the reasons why the picture was not delivered: "The painter wished to represent the figure, as is his wont, by means of a whimsical fancy,[12] and that is, composing it of the things which are proper to it. But as he was prevented by many impediments from which he was unable to free himself, and being still without any assistance, as if in supplication he presents His Majesty with this brief text, in which mention is made of all the things that will be in the picture and that, well-ordered and arranged, will make it appear as the image of a woman. He presents her therefore as if she were his daughter speaking and praying for help for her father, and he wishes to exhibit her so that all may see and honor the imperial portraits, that is, in such a way that in her are arranged all the instruments of which she is made and

that may be called her parts and her limbs." [*Europalia*: 163 verso]
A timely note, this, in view of the customary obscurity of Fonteo's verse:

O you who govern in splendor over men,
If you have esteem for wondrous art
And do not consider that a spirit divine

Can be content with painting void of meaning,
You will not be offended by these freakish members,
O clement stock, or of resting your strict gaze
On all the other things surrounding them.
Those members that, when they are joined together,
Transform this image into a human figure,
I wished to bring with me, so that from now on
With the Muses' favor we might venerate
The face of Caesar in the well-knit portrait:
But this I cannot do.

Therefore, O Caesar, urge it
That your Appeal to my father may be propitious,
And he will be even more intent than I am

That the human figure should transpire from this
(Just as a pregnant woman tries
To imagine from the shape of her own belly
The features of the child she bears within her),
And he will not dedicate it to his master
Until it is very beautiful and perfect.
Ah, how far all one's forces are insufficient
To such an undertaking! Therefore I beg you,
O Caesar, not to find the waiting wearisome.
Second my father's efforts and lend him aid
So that all these things may be accomplished,
And you in this way aggrandize your dominion
Over the earth, your government of the world.

[*Europalia*: 163 verso]

Among those who took part in the nuptial festivities on 26 August 1571, clad in the costumes conceived by Arcimboldo, were numerous members of the imperial family, nobles, dignitaries, and diplomats from all over Europe, including the emperor Maximilian himself, his daughters, his sons Ernest and Rudolf (the future emperor), Archduke Matthias of Austria, Johan Constantin duke of Austria, Don Francisco Mendoza, the archdukes Ferdinand and Charles, and many others. Each one had a particular role in the allegorical parade, and these roles were based on the themes present in the picture cycle of the *Seasons* and the *Elements*, which they enlarged upon and elaborated. Since in the portraits of the *Seasons*, Winter — on the basis of the classical mythology to which Fonteo was referring — symbolized lordship over time, in the wedding pageant, in which the seasons were also represented, this role was naturally reserved for the emperor: ". . . and this [knight] was the most invincible Emperor Maximilian the Second of ever august

Joris Hoefnagel
*View of Prague*
In *Libro di esempi di scrittura* by Georg Bocskcay
late 16th century
Watercolored drawing
Kunsthistorisches Museum, Vienna

Giuseppe Arcimboldo
*Flora*, 1591 c.
Oil on panel, 72.8×56.3 cm
Private collection, Paris *

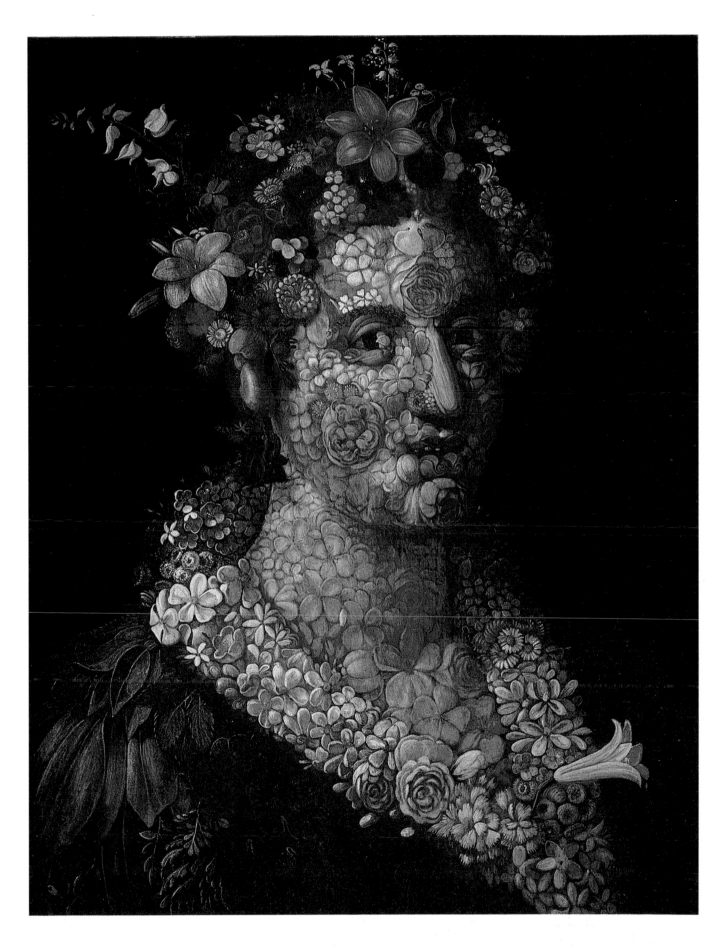

*Flora .*

Austria, presenting himself with grave and venerable semblance and full of Majesty, as Winter the fourth part of the year, and symbolic also of the fourth age of man. Winter was dressed in dove-grey brocade raised and double-raised in silver and lined with snow-white ermine. The undershirt and hose were of silver silk, the trimming of the cloak was of gold braid, ornaments of oak leaves like pure gold, buttons and fastenings of oak leaves and acorns of most fine and noble workmanship. His hat was of silver silk, the crown of it with dry oak branches rising and joined together in such a way that it resembled the imperial diadem. He wore a mask with a pointed beard. He was riding a magnificent chestnut horse, with a saddle of white velvet and silver embroideries, excellent in proportions and ornaments, so that he surpassed the other seasons in appearance, though they by nature make a more beautiful and gladsome display . . .''
[*Europalia*: 153 recto and verso]

Fonteo's descriptions enable us to enter into the atmosphere of that extraordinary celebration; but we are not simply concerned with the luxuriousness, the dazzling splendor of the costumes, the decorations, and the machinery that was put to work. The festive, play-acting aspect of that day should rather be viewed in the context of a far more subtle and sophisticated game, the aim of which was to involve the entire court in the inventions of Arcimboldo and Fonteo so that the various princes, archdukes, and dignitaries could see and recognize — externalized and combined together in the great nuptial pomp — the signs or (better) the deciphered codes of that great cultural hustle and bustle that was, in effect, themselves, the flower of the nobility of Europe, to be promoted by means of the protection and aid bestowed on artists, writers, and philosophers. Thus the allegories and symbols contained in the paintings of Arcimboldo — which Fonteo's lines were meant to illustrate in such a way as to shed light on the elaborate ideological structure that supported them — found their natural continuation in the costumes, the characters, and the scenic situations designed for the wedding feast. In this way, through the intense dialogue between the paintings, the learned poems of Fonteo, the awareness of their own social and political role, and the culture pertaining to them by elective right, the nobles taking part in that festive gathering could recognize each other, thanks to the refined and exclusive signs which that painter and that writer — both of them natives of far-off Milan — had invented for the occasion. Even the representations of evil and of the vices thus became a refined game of allusions continually unravelling itself from the pictures to the poems, from the poems to the scenes, from the scenes to the characters, then to return by an analogous route to the pictures of Arcimboldo: "At the exact opposite to prudence is placed *stoliditas* . . . which is to say folly, there being no sort of men in whom prudence is lacking more than in fools, who number among them morons, madmen, halfwits, and changelings.

Hans van Aachen
*Portrait of Rudolf II*
Oil on canvas, 68×48 cm
Kunsthistorisches Museum, Vienna

Extract from the document appointing Giuseppe Arcimboldo Palatine Count, 1 May 1592
Österreichisches Staatsarchiv Allgemeines Verwaltungsarchiv Vienna *

"...Considering with benevolence the rich and elegant gifts of your talent, and your faithful service over many years during which, by your paintings and many other things not so far considered by us, you earned our good will and even now continue to be honored, we presently wish to demonstrate to you 'our benevolence...
You, the above-named Giuseppe Arcimboldo, we make, create and elect Count of the Holy Lateran Palace, Imperial Hall and Consistory, and graciously we confer on you the title of Palatine Count, and inscribe, add and aggregate you to the rank and consortium of the other Palatine Counts..."

So that to represent the actions of this folly, on the pedestal beneath it is painted an ostrich hiding its head in some shrubbery. For they say that this animal is so foolish that if it hides its head it thinks that its whole body is hidden; which happens also with fools, who when they have made some slight beginning on something persuade themselves that they have completely finished it; and as in this picture we do not see the head of the ostrich, so in the works of fools we see neither wit nor reason; and as the ostrich is sometimes called a bird and sometimes a land-animal, in the same way folly, depending on whether it be greater or lesser, causes fools sometimes to be called madmen, sometimes ignorant and inexperienced... The exact opposite of justice is injury, because as justice duly renders to each his own, so injury unjustifiably takes it away from whoever it can... So that to represent it there is painted on the pedestal below it an eel, which is half out of the water, along with some flies encircling it, and the reason for this is that the Egyptians expressed injury by means of the eel, because this animal does not like to stay with the other fishes, but prefers the company of grass-snakes. So we can say of people who do injury that they consort with wicked men, and do not content themselves with remaining in their own state, but flee the company of their own to seek novelty and occasions to do harm. One can also say that as the eel is slippery and cannot easily be held in the hand, so the unjust and unrestrained do not wish to remain obedient to the law, and indeed they are given to corrupting the judges and breaking their promises, injuring whom they please. The flies are added around the head to signify that unjust and unrestrained men do not wish to be paid any respect at all, but totally lose their sense of shame, because the ancients used the fly to represent insolence... To demonstrate ineptitude, on the side of the pedestal beneath it is painted a camel, which for the ancients represented laziness, and a hare, which denotes fear, this animal being extremely timorous just as the camel is extremely lazy... As the contrary of temperance, which principally consists in moderating the gluttonous appetites of the mind, is placed gluttony, itself represented in the painting by a fish, the fish being by nature gluttonous. . .''
[*Europalia*: 130 verso - 132 verso]

From allegory to allegory, from marvel to marvel, from hyperbole to hyperbole, the splendor of that day is such that neither the idealized homage of the kings of Asia, America, and Africa — who in one of the most gaudy and elaborate scenes arrive to revere Europe — nor the very confines of the terrestial globe are sufficient to celebrate it. Fonteo then thought of calling to witness such magnificence the stars of the firmament, which are invoked to "move from their lofty seat" and descend into the throne-room, which was unroofed for the occasion: "On the evening of the wedding of His Most Serene Highness the Archduke Charles, the chief

163

princes who were there appeared in a masquerade dressed as stars, the roof of the throne-room having been opened up, and singing these verses in Latin, like court musicians:

Nymphs, Mothers, Damsels, O you of human estate whom the
Gods already made into stars, as they will these

O why delay from moving your feet from your lofty dwellings
to festive dances for the Heroine here below?

Leave the chamber of the skies, O Erigone[13] daughter of
Icarius, you who among the celestial women are the Virgin in the Scales

Plough and Polar Bear, you mark the host of Callisto[14], with
Cassiope[15] daughter of Cepheus and Andromeda wife of
Perseus[16]

And you, daughter of Minos, the crown of Ariadne,[17] and you,
Maia[18] first of the Pleiades, mother to the herald of the Gods

Come, Electra mother of Dardanus,[19] second of the Pleiades,
and come Taÿgete daughter of Atlas[20]

And all shining, in a joyous dance of love, mingle among the
people to do them worthy honor.

And when this song was finished, from one side of the hall descended a bridge covered with satin, at the beginning of which, as in a sacrarium covered with gold brocade, the stars were arranged two by two, and torch in hand came into the midst of the dance, and, one of them having bowed to Her Serene Highness the Bride, they all began to dance to beautiful music." [Europalia: 161-162 verso]

## Paolo Morigi or Morigia (1525-1604)

The nobility of the house of the Arcimboldi, and the glories of the family that had given so much to the city of Milan, figure very prominently in the works of Paolo Morigi, or Morigia, also a Milanese, and an associate member of the "Ordine dei Gesuati" as well as a scrupulous commentator on the history of this Order and on that of the municipality. He was not, however, very well known as an intellectual figure, and works such as Il Paradiso dei Giesuati (Venice 1582) or Istorie de' personaggi illustri per santità di vita et per nobiltà di sangue che furono Giesuati (Bergamo 1599) did not make much of a mark at the time, although in some cases they later became useful because of the abundant information they contained on the lives of the Milanese nobility at that time. The prevailing note in his books is in fact encomiastic, even in cases such as the Historia dell'antichità di Milano[21] and La nobiltà di Milano.[22] The result was that, since he was principally concerned with hymning the praises of those

Giuseppe Arcimboldo
Vertumnus - Rudolf II, 1590 c.
Oil on panel, 70.5×57.5 cm
Skoklosters Slott, Sweden *

164

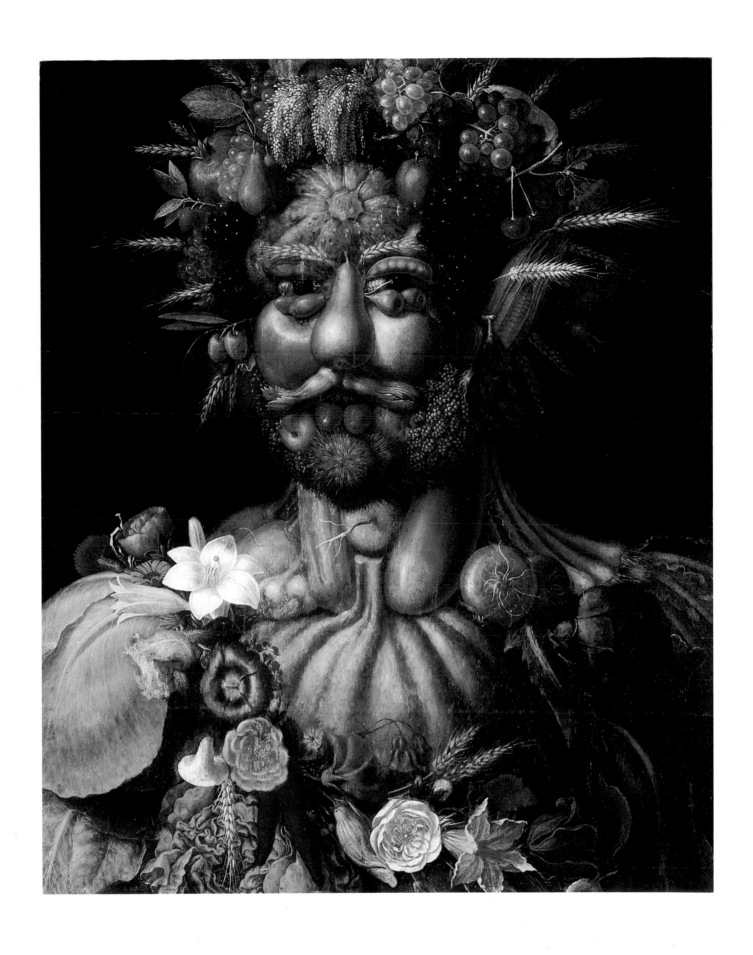

*Vertumnus - Rudolf II*

celebrated families, he accepted as authoritative sources such things as legendary tales, doubtful mythologies, improbable genealogies of antiquity, and remote work-of-mouth testimony that was not always impartial.

The reader may be thus surprised to learn from the good Morigi that the roots of the house of the Arcimboldi lie as deep as the pre-Carolingian era, but this is not altogether the fault of this Milanese "religious," for he did nothing but record what he himself had learnt from Giuseppe, the painter, when he went to interview him. By the time Arcimboldo returned to Milan from Prague, he was already famous, laden with honors and fame, and the possessor of patents of nobility signed by the hand of the emperor Rudolf II. It is not difficult to understand how the recent nobility of the Arcimboldi could shine even more brightly if it were seconded by the echo of a more ancient patent, whose glamorous authority enhanced the splendor of the present, showing the glittering auguries that illuminated the life of the noble house from the start. And, without seeming to do so, Morigi deftly justifies himself by writing: "All that I have so far written about the house of the Arcimboldi, I have had from Signor Giuseppe Arcimboldi, a man of faith and integrity of life, who has served two emperors in Germany, as will be said; and he himself copied this Genealogy and origin of the Arcimboldi from an old Book in parchment written in the German language, which was read to him by the Physician to the emperor Maximilian . . ."[23]

It is useless to hunt for those parchments, and far better to listen to the story — which like all true stories is not in fact true — of Saitfrid, the founder of a line that succeeded, as not many have, in generating adjectives of common use from its own surname. This Saitfrid was "a German gentleman who lived near the banks of the river called Albis[24] which flows into the German sea on the other side of Saxony; and he was the lord of certain lands among which was a Wood of vast extent, which was his special hobby, and with every diligence he tended it and made it good for pasture, so that the animals could live there more comfortably. Then, at a certain time, this same Saitfrid would invite a number of knights from the neighborhood to hunt there, to give them pleasure. This gentleman was of such goodness, and of such a praiseworthy mode of life, that he was loved by all both rich and poor. He feared God and was extremely devoted to the glorious Virgin Mary, so that on her feast days he fasted greatly, and celebrated her festivals with such joy and devotion that it is firmly believed that this is the reason why God and the glorious Virgin caused him to prosper, as was seen, not only in his fortune but in the copious number of his sons, of which he had sixteen. Now, it happened that one day this Saitfrid arranged a boar hunt, to which he invited his usual friends, and when he said farewell to them, and each of them went to his own

Woodcut (anonymous)
in *De Humana Phisiognomia*
Libri IV, by Giambattista della Porta
Naples, 1586
Biblioteca Nazionale Marciana
Venice *

166

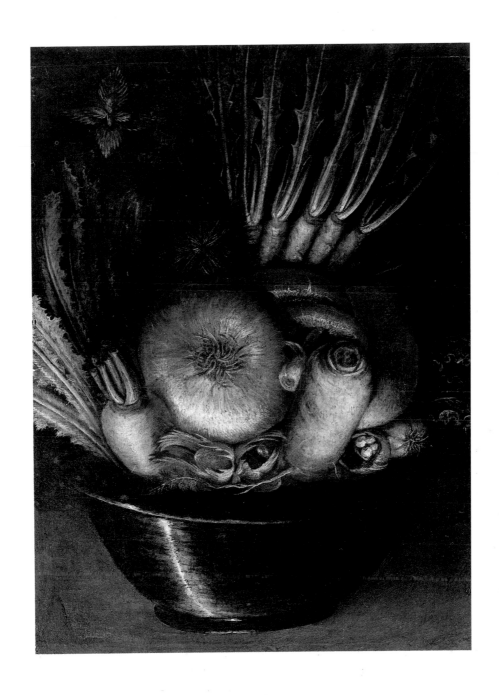

Giuseppe Arcimboldo
*The Vegetable Gardener* (reversible), 1590 c.
Oil on panel, 35×24 cm
Museo Civico Ala Ponzone, Cremona *

home, Saitfrid remained for a while in the aforementioned wood; and being weary from hunting, he lay down to rest on a pleasant hill, having first tied his horse to a tree by the reins. While he was asleep a most beautiful woman appeared to him in a vision, and with a hammer she smote a stone, and, awakened by the noise, Saitfrid saw that his horse was pawing the ground with his hoof. At which, worn out by hunting and weighed down by sleep, he slept once more; and the very same vision came to him, without any other fantasy at all; and the third time he saw the same. When he woke up he thought to himself that this might mean something of some moment, and when he got to where his horse was he saw something shining in the likeness of metal, and for this reason Saitfrid began to think that this vision had happened by the will of God. . . . Saitfrid then left the wood and went home, with the intention of returning with tools suitable for digging out that material to see what it was; as he then did, and having made the experiment he found that this was a silver mine, which was so abundant that it made him rich in a very short space of time. . . . From this mine was derived the surname of Arcimboldi,[25] since Arci in the German tongue (as they say themselves) in our language signifies the material found together with silver, and Boldo in that language means Wood in ours, as if we Italians were to say Mine in the Wood, and the Germans always say it like this (Arcimboldo) in the ancient manner, and they have always preserved this surname, and in those parts beyond the river Albis, as we said above, there is a place which even today is called Arcimboldo."[26]

From this moment on the advance of the family was uninterrupted, proceeding rapidly toward ever greater honor and glory; but, curiously enough, although Morigi tries to bear witness to the ancient and practically genetic inclination of the family toward the liberal arts, its honors and glories in fact arose from very different activities, that is to say, war and still more war, and with its passion for jousts, tournaments, and the flash of steel corrupted the mild intentions of old Saitfrid. The latter, in fact, thanks to the well-being procured for him by his sudden wealth, took it into his head to send Federico, his second son, to Italy, "so that there he might devote himself to the study of letters; but he, being more attracted to arms, left off his studies."[27]

This passion for arms became evident again when Federico, on the death of his father, returned to his native land, only to come back to Italy with his brothers Ierico and Maurizio, "with the thought that they might attend more to letters than he had done,"[28] but after some time devoted to reading Maurizio and Ierico also "left off their studies and attended to the handling of weapons and horses, to jousts, and lancing and other feats and sports."[29]

Once they had started on the great game of war, the three Arcimboldo brothers did not want to stop. On the contrary, when they

Frontispiece of *La Nobiltà di Milano* by Paolo Morigia, Milano, 1595 Biblioteca Nazionale Marciana Venice *

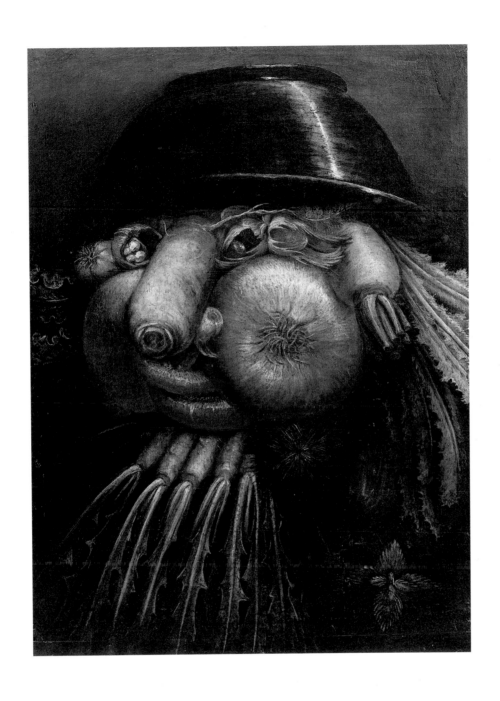

Giuseppe Arcimboldo
*The Vegetable Gardener* (reversible), 1590 c.
Oil on panel. 35×24 cm
Museo Civico Ala Ponzone, Cremona

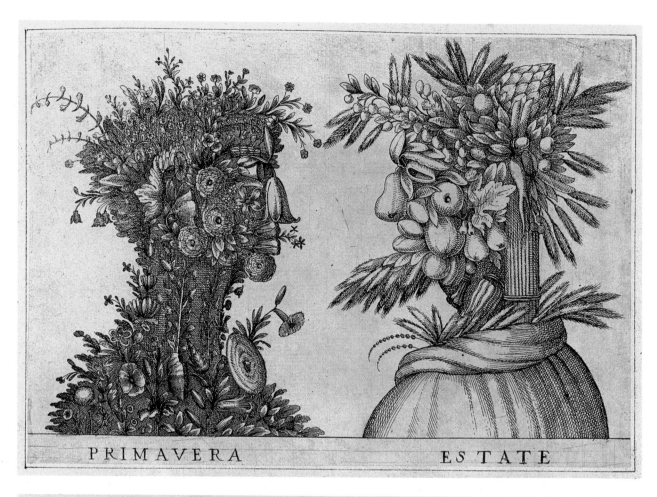

PRIMAVERA                    ESTATE

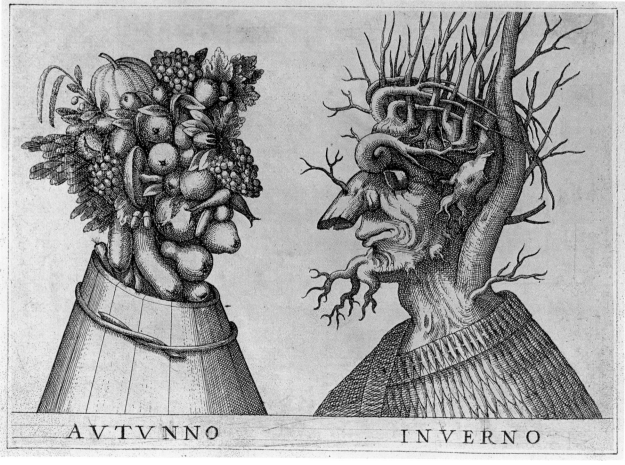

AVTVNNO                    INVERNO

Anonymous
*Spring and Summer*, undated
16.3×23.1 cm
*Autumn and Winter*, undated
17.3×23.5 cm
Etching
Nationalmuseum, Stockholm *

learnt that Charlemagne was about to make war against the Bohemians they decided to equip themselves with horses, new weapons, shield-bearers, and servants, and to join his army. And such was the valor and courage which they showed during the campaign that as a reward the emperor "gave them a red sash with three stars on it: the three stars represented the three brothers, the red sash signified the earth which they had reddened with the blood of the enemy, for they had been like glittering stars in that bloody battle... They put that red sash or bar with the three stars on it obliquely on a shield of shining gold, and always from then on the house of Arcimboldi has borne as its coat of arms[30] the red sash or bar with the three shining stars that represent the three brothers, as we have said, on a yellow background, and the Arcimboldi of Germany, and those of France, like those of Milan and Parma, all have this same coat of arms."[31]

At the end of the war, having obtained their prestigious coat of arms, the three brothers split up. Ierico stayed in Germany in the service of Charlemagne, Federico went to France, where in due time he became "lord of Bourbon," and Maurizio returned to Italy. It is therefore from him, according to Morigi, that the Italian branch of the family is descended; but at this point Morigi loses the threads that he has been following on the basis of the evidence of Giuseppe and of works by such authors as Bernardino Corio, Franceso Filelfo, Giovanni Garimberti, and others, so he is forced to take a bold leap ahead in time, which takes him to the threshold of the fifteenth century, where we find "Giovanni the First," who was "a Gentleman of Parma and a Doctor of law, and Feudal Lord in Parma, and flourished around the year 1400 after the Virgin gave birth"; and after him came Nicolò, "a famous Doctor" who was very "honored, esteemed, and employed" by "Filippo Maria Visconte, third duke of Milan."[32]

With these, therefore, we enter the sphere of history proper, and we are able to follow their doings with the help of a great number of reliable documents (as the biographers of Arcimboldo have done) because the family produced three archbishops of the city of Milan, jurists of resounding fame, and artists such as Biagio, father of our Giuseppe. It is to him that Morigi finally devotes a brief but precise biography: "Having so far said quite enough about the house of Arcimboldi, now I cannot and do not wish to leave off without saying something about another Arcimboldi, by the name of Giuseppe, worthy of being praised for his virtues. He is a painter of rare talent, and in many other arts both studious and excellent; and having given proof of himself both in painting and in many curious inventions, gaining great fame not only at home but also abroad, in such a manner that the cry his fame even reached Germany, and the imperial court, and came to the ears of Maximilian of Austria, who was elected King of the Romans and later succeeded his father as emperor, so that he very insistently requested Arcimboldi to enter

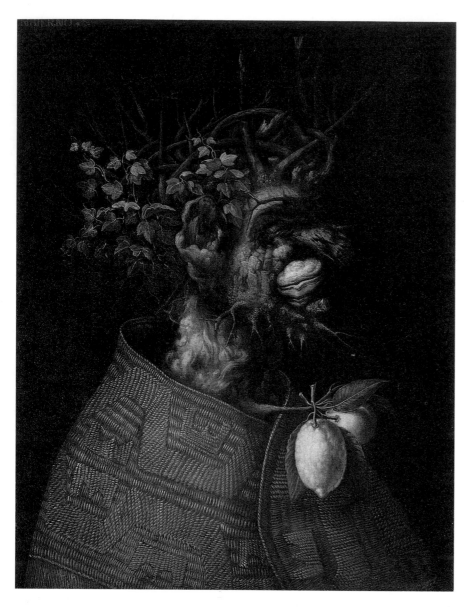

his service. After many entreaties Giuseppe agreed to serve Maximilian, and in the year 1562 he left Milan and went to the Emperor's court, where he was much favored and pampered by Maximilian, and welcomed with great humanity and an honorable stipend into his service, and with many signs of the affection he bore him. Our Arcimboldi was therefore at the imperial court to the great satisfaction not only of Maximilian but of the court as a whole, and not only for his painting but also just as much for his many inventions, such as tournaments, jousts, games, devices for weddings and coronations, and especially when Charles, Archduke of Austria, took a wife. On those occasions this noble spirit found a great number of various, ingenious, beautiful, and rare inventions, filling all the great princes who were present with great wonderment, and his lord Maximilian with great contentment. I shall not omit to say that, when Maximilian succeeded to his father's Empire, Arcimboldi was never prevented from going to the Emperor at any time he pleased, as one of the chief favourites of the Emperor, and in a

Giuseppe Arcimboldo (?)
*Winter*, 1572 c.
Oil on canvas, 92.7×71.7 cm
Dominique de Menil Collection
Houston *

172

Giuseppe Arcimboldo (?)
*Winter*, 1572 c.
Oil on canvas, 76.8×56.7 cm
Private collection *

word the whole house of Austria treated him as a familiar, and loved him for his virtues and nobility of conduct. On the death of Maximilian, his son Rudolf succeeded to the Empire, and Arcimboldi was no less loved and favored by him than he had been by his father. So, this noble and virtuous Giuseppe, having served these two great princes, and the whole house of Austria, for twenty-six years, and having for two whole years pleaded with the Emperor to give him leave to return home to enjoy his old age, at last with difficulty he obtained this grace, he being so valued by his master Caesar that very unwillingly did he deprive himself of his presence. Arcimboldi therefore returned home in the year 1588, and though he settled in Milan, nonetheless he continued in the imperial service in all those things (apart from painting) which in Milan his Catholic majesty is pleased and satisfied to perform. I need not say that Arcimboldi obtained from the Emperor an annual pension in recognition of his welcome and faithful service. Furthermore, as the Emperor wished

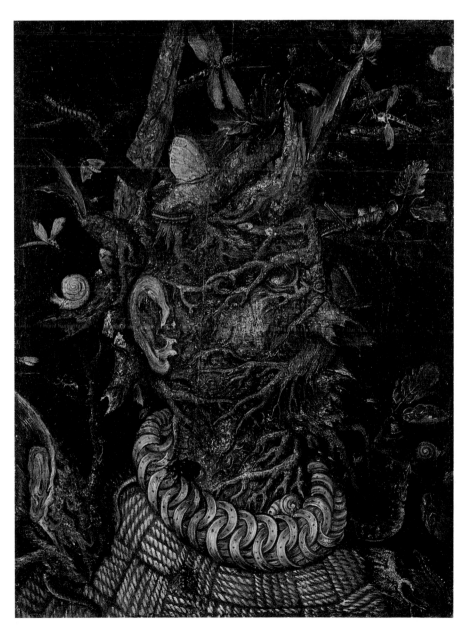

Anonymous
*Winter*, 16th century
Oil on panel, 43.2×31.7 cm
Private collection, Basel *

to show his favour to our Giuseppe, he bestowed on him many privileges, among which, knowing that the house of the Arcimboldi is very noble and ancient in Germany, he therefore as a confirmation and aggrandizement of that nobility, added to the normal arms of the family a crest consisting of a sallet in the Burgundian style open in front, surmounted by a great Royal crown, above which appear the neck and head of a great Eagle with open beak and a red tongue, it too bearing a golden crown; from the sides spring two great branches of coral, while down the sides of the above-mentioned sallet there fall springs of red and gold foliage, adorned with stars on either side, which bestow great beauty and ornament on the whole coat of arms and fill the eye of the beholder with pleasure. I need not say that the Emperor Rudolph did not bestow this privilege on the whole house of Arcimboldi, but only on Giuseppe and his descendants; and this privilege was conceded in the year 1580. It has to be added that this Arcimboldi, as well as being excellent in painting, is also the inventor of many strange and

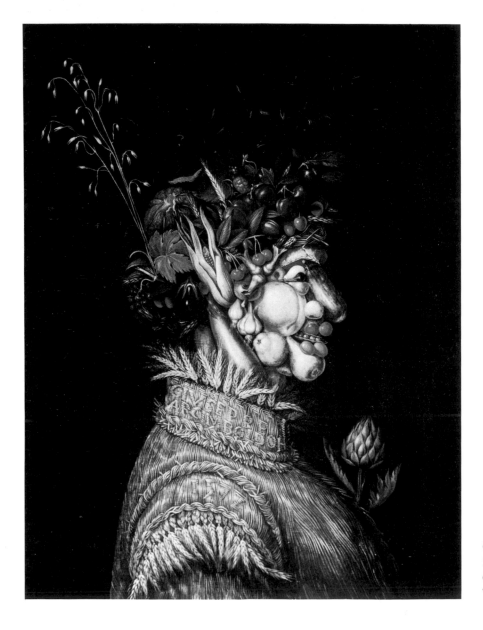

Giuseppe Arcimboldo (?)
*Summer*, 1572 c.
Oil on canvas, 92.2×71 cm
The Denver Art Museum, Colorado

174

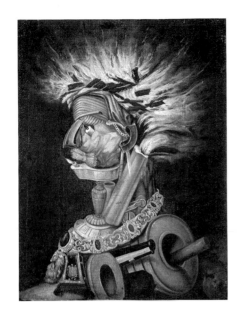

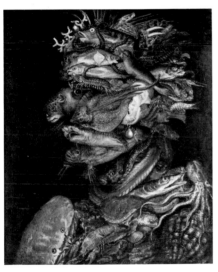

Giuseppe Arcimboldo (?)
*Fire*, 1572 c.
Oil on canvas, 75×66 cm
Private collection, Basel *

Giuseppe Arcimboldo (?)
*Water*, undated
Oil on canvas, 63×53 cm
Musées Royaux des Beaux-Arts de
Belgique, Brussels *

ingenious things, for he will make a portrait that is true to life, but made entirely out of books, others out of birds, others again out of flowers, which is an astonishing and wonderful thing to see, and all those drawings of these inventions and curiosities, which we see printed by copper plates, are all inventions of our Milanese. . . ."[33]

## Giampaolo Lomazzo (1538-1600)

An outstanding artistic and intellectual personality, Giampaolo Lomazzo began studying painting under the guidance of his uncle, Gaudenzio Ferrari, and then went to Rome, with the intention of perfecting his technique, in the company of Giambattista della Cerva. On his return to Milan he painted canvases and frescoes for Santa Maria della Pace, Santa Maria della Passione, Sant'Agostino, San Maurizio, San Marco, San Barnaba, and other Milanese churches, but at the age of thirty-three he was struck down by a disease that caused him to lose his sight. All the passion and art that he had lavished on his paintings he then transferred to writing, producing two works, *Il Trattato de l'arte de la pittura*[34] and *L'Idea del Tempio della Pittura*.[35] In spite of the fact that they have been subjected to various interpretations, these remain an essential point of reference for the understanding of sixteenth-century thought concerning the figurative arts. Thus, if Schlosser considered the *Trattato* as the Bible of mannerism, Longhi, in an equally benevolent judgment, defined Lomazzo as "a kind of friendly sorcerer, mad about metaphysics and aesthetic astrology."[36] But whatever the judgment expressed about him and his work, we cannot deny the importance of the *Trattato* as an original and deliberate attempt to equip thought about art with a "system," or an interpretative methodology that considered the world of pictorial expression throughout its whole range of problems, that contemplated its various aspects on a unified level, and that in short admitted — and this is the most original thing of all — that the "idea" behind the subjective "manner" was a positive quality.

The *Trattato* and the *Idea* are closely connected works, for the simple reason that the second, under the title of *Libro della discrezione*, was to have served as the introductory part of the *Trattato*. This book, which did not enjoy great success among Lomazzo's contemporaries, set out to examine painting according to the seven "kinds" of which it is composed; that is to say "proportion (proportions of the human body and of architectonic orders), movement (passion and inspiration), color, light, perspective, composition (that is, the exemplification, with reference to the works of various artists, of the rules expounded in the preceding parts), and form (this last part is a sort of short treatise on iconography)." In the *Idea*, according to a conceptual pattern based on hermetical writings such as *Picatrix* or *De occulta philosophia* — which had so much importance and in-

fluence on philosophic, literary, and artistic thought during the six-
teenth century — or else on the works of the Renaissance Neo-
Platonists, painting is presented as an ideal temple, constructed as
a circular building supported by seven columns on which rests a
dome with seven segments. In seven different parts of this temple
Lomazzo places the seven kinds of painting, under the sign of seven
"governors."[37]

While stressing the scant success of Lomazzo's works during his
lifetime, and the lively interest that they aroused in the next few
centuries, Klein points out that this could hardly have been other-
wise, since the *Trattato* and the *Idea* are neither historical, critical,
nor technical works; but he adds: "It is in the history of ideas about
art that this book (*Idea*) counts . . . for the precision with which it
raises, formulates, and sometimes solves the basic problems of a
crucial and transitional age."[38]

Lomazzo had a high opinion of Arcimboldo's painting, and indeed
in chapter 50 of the *Trattato* ("Composizione di ritrarre dal
naturale") he describes him as an excellent portrait painter,
something for which he has been sternly reproved by Longhi, who
wrote that the works of Lomazzo "well reflect the environment of
late mannerism in Lombardy, with its dose of fifteenth-century ar-
chaism mixed in with Leonardesque and classical intellectualisms,
plus the most curious forms of symbolism, and even with idolatry for
the extreme technical caprices of an Arcimboldi."[39] But the fact
remains that his works comprise one of the most complete and well
reasoned sixteenth-century attempts at approaching thought con-
cerning art according to an intellectual scheme that is organic and
even, *ante litteram*, "scientific."

Although Arcimboldo's name does not appear among these of the
artists related to the seven "governors" of the Temple, we can
nonetheless establish which of the "kinds" his painting belonged to,
because in the *Trattato* Lomazzo has already described it (on account
of astrological affinities) as ideal for adorning the walls of "Mercurial
places," such as "Schools and Grammar Schools . . . hostelries and
similar places."[40] We should not be surprised that Lomazzo lumps
together schools and hostelries, because in this classification his
thought is ruled by the laws of the *harmonia mundi*, of the Neo-
Platonist utopia of perfect correspondence between the things of the
world on the basis of astral influences. If one starts from a knowledge
of those influences, and therefore from the true and innermost
nature that governs the cosmos in all its manifestations, it becomes
natural to lump together schools and hostelries: both are "Mer-
curial" places because, on the one hand, the influence of this planet
is particularly strong in the field of the liberal arts (and therefore of
study), while on the other the roguish vivacity and din of the
hostelry correspond perfectly well to the prerogatives of Mercury,
who stole Hera's cows and Apollo's sheep — without taking account

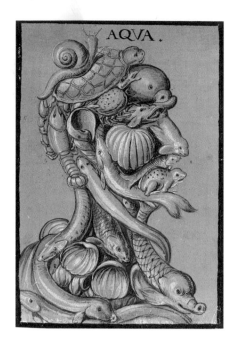

Anonymous (Heinrich Göding?)
*Aqua* (*Water*), 1600 c.
Black and white gouache on green-
colored paper, 24.1×16.3 cm
Graphische Sammlung
Germanisches Nationalmuseum
Nuremberg *

Anonymous (Heinrich Göding?)
*Terra* (*Earth*), 1600 c.
Sepia and white gouache on brown-
colored paper, 24.3×17 cm
Graphische Sammlung
Germanisches Nationalmuseum
Nuremberg *

# TERRA.

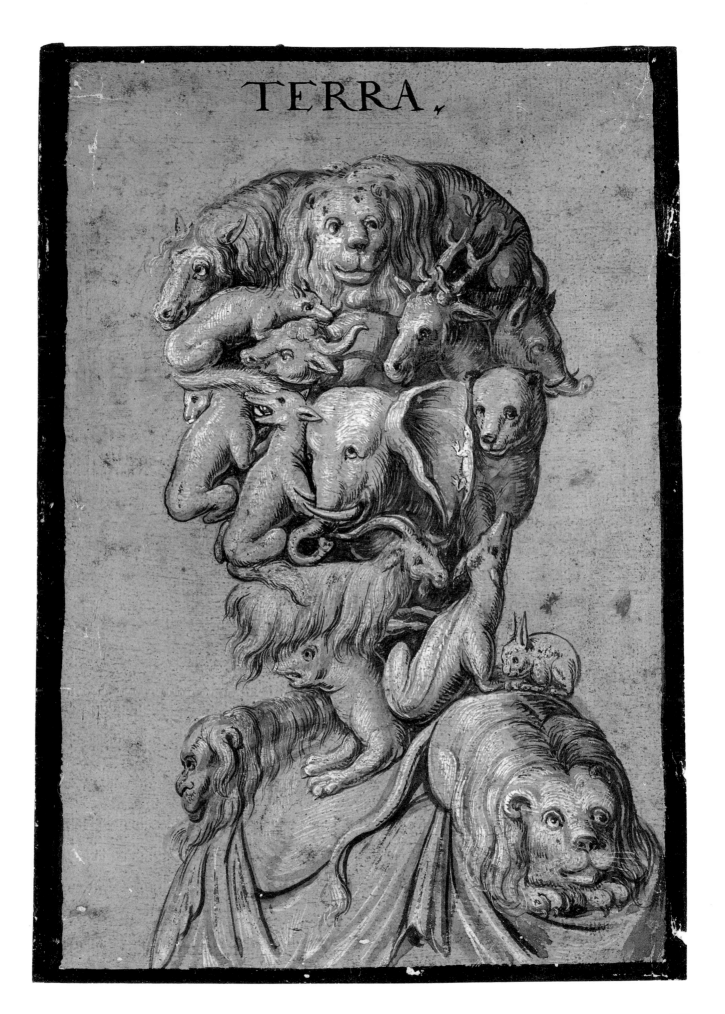

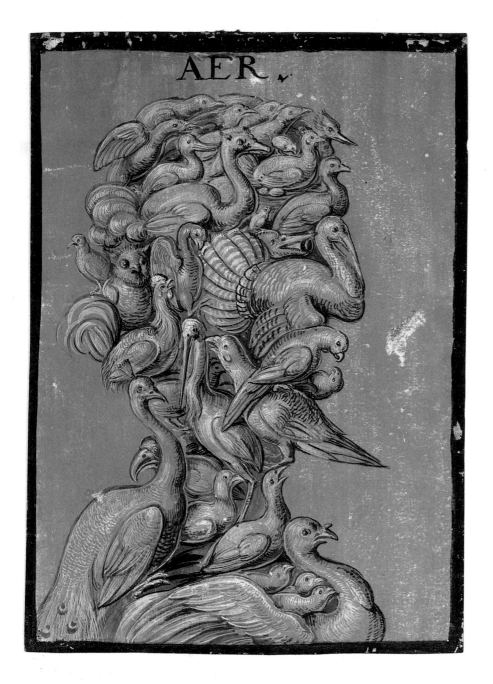

of the proverbial liveliness of mercury as a metal, which we even call quicksilver. Lomazzo in fact writes:

"In inns and hostelries, where they think of nothing but eating, drinking, bargaining, and gambling, one finds (like certain Germans and Flemings when they are together) drunken pimps who are the managers of strumpets, and card-games, thefts, follies, clowning, and pranks, very likely with a debauched outcome; just as in similar places it is the custom to describe the arms and the achievements of Princes with great abuse, as if they were the very banners of revelry and the ensigns of drunkenness. And since there are still mercurial places, all the intervals may be filled with the things that belong to him, though adapting oneself to the nature of the work one is to express in painting, as in representing the form of figures by members that are not their own, as long as they are the same in

Anonymous (Heinrich Göding?)
*Aer (Air)*, 1600 c.
Black and white gouache on blue-colored paper, 24×16.9 cm
Graphische Sammlung
Germanisches Nationalmuseum
Nuremberg*

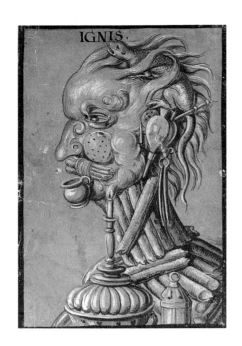

Anonymous (Heinrich Göding?)
*Ignis* (*Fire*), 1600 c.
Black and white gouache on red-
colored paper, 24×16.6 cm
Graphische Sammlung
Germanisches Nationalmuseum
Nuremberg *

proportion; as would be the case with the four elements entirely composed of natural figures with members drawn from each of the elements, like those which Giuseppe Arcimboldi painted for the Emperor Maximilian, in which he composed the figure of fire out of lights, the glare of torches, candlesticks, and other things having to do with fire; that of air out of the birds that fly in the air, so perfectly that the parts all seem in accordance with the air; that of water out of all the fishes and shells of the sea, and so well composed that it truly appears that water has been rendered as a figure; while the fourth element, that of earth, is all stony crags, caverns, tree-trunks, and the animals that walk the earth. After these he painted Agriculture, fashioning all the parts out of the implements of that art."[41]

The four elements painted by Arcimboldo for Maximilian therefore represent, in Lomazzo's opinion, the kind of paintings closest to the "mercurial" spirit, in that their chief quality, that of being illusionistic, corresponds to the ever-changing vivacity that is proper to Mercury. In fact, in the Temple, Mercury is dependent on the "governor" Mantegna and the "genus" of perspective; and to link the painting of Arcimboldo to that of Mantegna, as Lomazzo does, seems perfectly natural, if we think for example of the illusionistic experiment in the oculus of the vault in the Camera degli Sposi in the Ducal Palace in Mantua. Proceeding in the same way, next to the planet Mercury and the metal of the same name, Lomazzo places the snake (since the way it changes its skin is a symbol of continual transformation), Archimedes or Alhazen (because their science of optics leads directly to perspective), the poetry of Sannazzaro (because in Mantegna there is the same "discerning prudence of Sannazzaro"), and Asclepiades (because his art places "figures according to the way we see them").

"Di Messer Biagio un suo diletto figlio / detto Giuseppe dipinse in ponente / gl'elementi, in figure con consiglio" ("A beloved son of Messer Biagio, called Giuseppe, in lands to the west painted the elements, in well-considered figures").[42] This quick glance at the painting of Arcimboldo found in Lomazzo's *Rime* is greatly expanded in the *Idea*, published three years later. The consideration and esteem in which the Milanese writer held his fellow-citizen emerge clearly from his own words:

"... most outstanding and worthy of perpetual memory is the Museum of His Majesty the Emperor Maximilian II. To enlarge and enhance it he summoned the great painter Giuseppe Arcimboldi, who gave evidence of his genius in many paintings by means of his perspective, drawing, and relief, and above all of his inventions and grotesques, in which he is unique in all the world. For there he painted the forms of the four elements... Apart from that he there portrayed the four seasons in the form of human figures made of the things belonging to each season, as for example the Spring made of

flowers, the Summer of ears of corn and vegetables, the Autumn of fruits, and the Winter in the form of a tree. All these are painted in the same number of pictures, with inestimable care and study. He also painted a Janus representing the year itself, doing it in profile in the likeness of Summer, with a head behind which signifies winter, and at the neck a snake with its head in its mouth to mean that it is the year... In addition he there made a picture of the kitchen in the form of a woman with all her implements and equipment, and of the cellar-master in the form of the full figure of a man, composed of all the utensils of the wine-cellar. This last is prized most of all by the Emperor, together with the lifelike portrait of his Vice-Chancellor Cesareo which, seen from some way off by His Majesty and others was held to be the most faithful portrait possible, and looked at from close up was discovered to be entirely composed of animals: the nose was a bird, the chin a trout, and all the other parts were other animals, and so excellently performed that to tell tha truth it is a wonder to behold, just as wonderful indeed are all the other pictures wrought by him with supreme artifice. And so he came into such favor with the Emperor that the latter submitted to his judgment concerning all inventions, adjusting himself to his taste, and lavishing delights upon him. For this man was really outstanding when it come to inventions and devices, and especially at masquerades, so that at the wedding celebrations of His Serene Highness the Archduke Charles, brother to Maximilian, he had the task of contriving all the festivities; and at the first tournament, in which the Emperor himself took part, he had the rare and beautiful notion of bringing on three Kings, who represented three parts of

Anonymous
*Grotesque Face Composed of Birds*
Etching, 25.2×30 cm
Royal Library, Windsor Castle

180

Giovanni Paolo Lomazzo
*Self Portrait as the Abbot of the
Accademia della Valle di Blenio*,
1568 c.
Oil on canvas
Pinacoteca di Brera, Milan

*Rime al Signor Gioseppe Arcimboldo*
in *Nuova Scielta di Rime*
by Gherardo Borgogni
Bergamo, 1592
Biblioteca Nazionale Marciana
Venice *

the world, Asia, Africa, and America, to honor the Princes of the House of Austria; and these were for Asia the Archduke Charles (the bridegroom), for Africa the Archduke Ferdinand, and for America the Archduke's Grand Master of the Horse... And all these were inventions and caprices of this rare painter, to the extent that a certain Fonteo, introduced by Arcimboldo and given the job of making the play-bills, did not hesitate in one of his compositions to make himself out to be the inventor of them... Nor was this great man little dear to Maximilian's successor, the Emperor Rudolph the Second, and he was employed by him in many things. But when he grew old he asked him leave to return home to Milan, and it was with difficulty that he obtained it, promising however that he would continue to invent a few caprices in his service..."[43]

The passage goes on to speak of two other paintings by Arcimboldo, *Flora* and *Vertumnus*; but as these were dealt with at far greater length by Comanini in his *Figino* (1591), we will leave it to him to give a fuller treatment of the subject.

## Gherardo Borgogni (1526-1608)

A restless spirit and a tireless traveler, Borgogni, though his gifts as a poet were not exceptional, acquired a certain reputation in Milan with his verses, and he could be said to have lived off them, since he curried favor with powerful people by putting their virtues and their greatness into rhyme. In the same way he found success in the literary circles of the city, and (under the name of Errante) was a member of the Accademia degli Inquieti. He was a friend of both Figino and Morigi, and to the latter he dedicated some lines on the publication of the *Historia dell'antichità di Milano*: "Living, breathing lines, which will give life / Thanks to you, Paolo, to many lovely works / Which, as the years and stars wheel round, will make / The glory of others more than infinite . . ." He was also a publisher, and it was perhaps as such that he reaped the most worthy fruits of his career in literature. The painting of *Flora*, which Arcimboldo executed in 1589, two years after his return to Milan, became extremely famous when Lomazzo and Comanini — who had had a chance to see it — described it in their works. Purely encomiastic, on the other hand, is this short piece by Borgogni, but it bears witness that the fame of Arcimboldo's caprices was spreading in the city. Here is the text in question, which is certainly not remarkable for any great poetic qualities: "To signor Gioseppe Arcimboldo, concerning the Painting of Flora, by him dedicated to His Majesty Rudolf, Holy Roman Emperor.

> Quite vanished from among us
> Was lovely, graceful FLORA
> Who enamours even the errant zephyr.
> But you, Painter, with your

Breathing, life-giving colors
Wrought into lovely and sweet-scented flowers
(As if by the aid of Heaven)
Have brought her back to life,
Therefore she turns her eyes,
It seems, towards her Lover, and then sighs."[44]

## Gregorio Comanini (1550-c.1608)

The Lateran canon Gregorio Comanini was a man of broad and profound, but also lively and out-of-the-way culture. A poet and writer of treatises, he was born in Mantua and was in frequent contact with the lords of that city, the Gonzaga family. In their honor he wrote and published a *Trionfo del Mincio* (1581), a short epic celebrating the marriage of a Gonzaga to the princess of Parma and Piacenza, and the *Orazione in morte di Guglielmo*, an elegy for the duke of Mantova (1587). His poetic style seems to be modelled on that of Marino, and his lines are imbued with the symbolic game of description typical of that author, especially the *Canzoniere spirituale, morale e d'onore* (1609). He also wrote a treatise entitled *De gli affetti della mistica teologica tratti dalla Cantica* (1590) and an *Orazione a Papa Gregorio XIV* on the occasion of his accession to the papacy. But the work that has undoubtedly contributed to keep the name of Comanini alive in later centuries is *Il Figino*,[45] one of the most interesting treatises of the sixteenth century as regards the debate about mannerist painting.

Toward the end of the century, in a Milan lashed by the intense and passionate reforming zeal of San Carlo Borromeo, three men still capable of tolerance get together to discuss art, or — to be more precise — poetry and painting. They are: Guazzo, a poet of radiant ideals, a secular humanist, and by temperament not only sensitive but realistic and down to earth; then there is Don Ascanio Martinengo, a priest who in all he says tries to temper what reason counsels him — to seek calm, moderation, a sense of proportion — with the religious and ethical imperatives imposed on him by the great wave of the Counter-Reformation; and finally Figino, who rummages in the baggage of his own experience as a painter, and contrives a happy medium between the two and their respective arguments, some possible meeting ground for the three of them, who are there contending together with a courtesy and frankness that outside that coterie are already things of the past.

That the end of art in general and of painting in particular must be delight is the thesis maintained by Guazzo, and this is naturally opposed by Martinengo, who affirms that the painter should aim not to delight but to instruct. Figino, for his part, shifts the terms of the dispute from this over-radical opposition, and falls back on categories drawn from Plato's *Sophist*, dividing artistic expression into two qualities, or rather, two basic "virtues," the "realistic" and

Marcus Gheeraerts
*Allegory of Iconoclasts*
first half of
the 17th century
Etching, 20×15 cm
British Museum, London

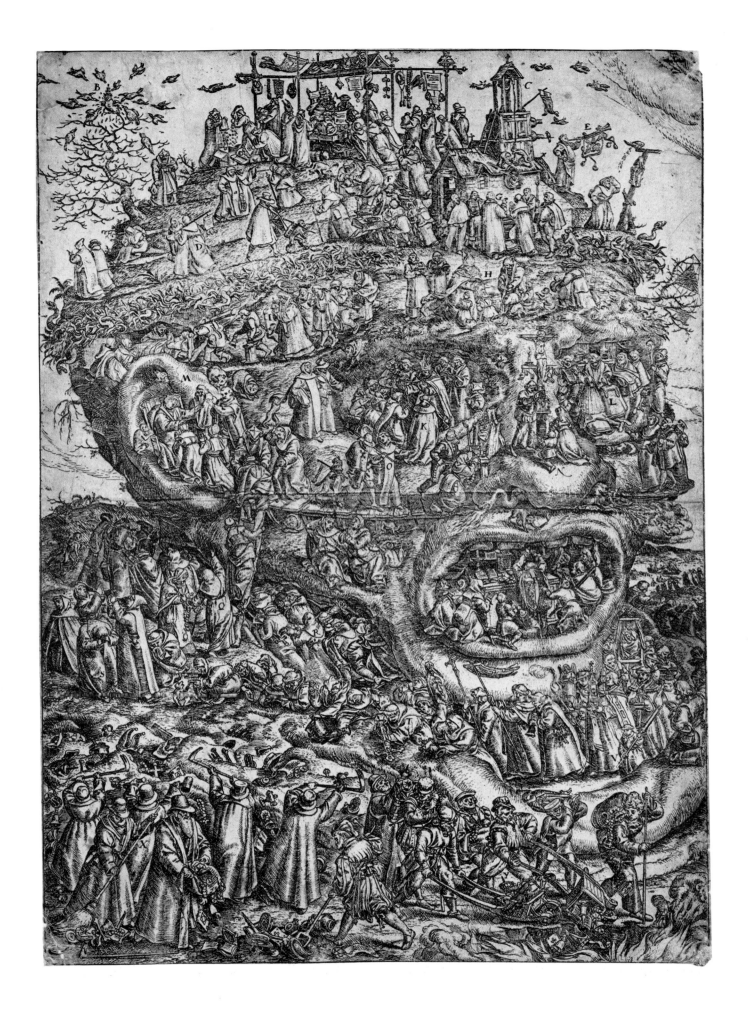

the "fantastic." And as he is speaking as an artist of his time, who therefore looks on freedom and independence of expression above all as conditions necessary for creation, his notion of the *optimum* will therefore be that of the "fantastic," all the more so if this is expressed by having recourse to the "marvellous" — that is, to the ideal conditions of maximum freedom. On the basis of such premises they are virtually obliged to reflect on the work of the painter who more than any other had made the "marvellous" a constant and essential point of reference — their celebrated fellow-citizen Giuseppe Arcimboldo.

Let us therefore follow the amiable discourse of the three gentlemanly contenders:

FIGINO:   Be pleased to listen to me, O Guazzo, and see if I deceive myself. You say that a painter is making a fantastic imitation when he paints things that are caprices and of his own invention, and that have no existence outside his own mind. Is that not so?

GUAZZO:   Exactly so, as you have repeated it.

FIGINO:   Now hear me. Signor Giuseppe Arcimboldo, a gentleman of our city and Painter to His Majesty the Emperor, has formed a Flora and a Vertumnus in such a way that all the parts of the first are flowers, and all the parts of the second are fruits. Do we wish to say that in these two works he was the artificer of fantastic imitation?

GUAZZO:   Why not? Indeed, a most ingenious fantastic painter, and most highly to be praised. For if the fables concerning both Flora and Vertumnus were supplied him from outside, and by poets who have imitated them in verse,[46] and by other painters who have painted them, nevertheless it was his own caprice and invention to make a woman all of flowers and a man all of fruits: a thing that never had being in any other mind. But tell me, where does he dwell?

FIGINO:   Here in Milan, and these works themselves were painted here.

GUAZZO:   You have kindled in my heart the greatest desire in the world to go and look at both of them.

FIGINO:   The Flora you cannot see, because he has already sent it to the Emperor, for whom it was made; but as for the Vertumnus I am sure that he would not refuse you access to see it in his chambers. Comanino is a close friend of his, and often spends many hours in his company and that of Signor Gio. Filippo Gherardini,[47] for these last two share lodgings together. You could choose him to conduct you, and as a mediator in the acquisition of the friendship of such virtuous gentlemen, as they both are. But if in the meanwhile you would like a foretaste of these two pictures, reach out a hand and pick up those sheets you see folded there on the table. There you will read a madrigal composed by Comanino on the subject of the Flora and another new kind of poem by the same hand, in which

Frontispiece of
*Il Figino, overo del fine della pittura*
by Gregorio Comanini, Mantua, 1591
Biblioteca Nazionale Marciana
Venice *

184

Heinrich Ulrich
*Der Naseweise (Mr. Know-it-all)*
1600 c.
Copper engraving, 19.8×14.9 cm
Dr. Günter Böhmer Collection
Munich *

he pretends that Vertumnus, by describing the painting of himself, discovers the art of this worthy painter and brings to light a number of very important secrets.

GUAZZO: You well know that I would like to read both compositions.

MARTINENGO: Read on, Guazzo, for this reading will give you pleasure and the refreshment to continue with greater verve in the discourse you have begun.

GUAZZO: That is how it will be, for certain.

> Am I Flora, or am I flowers?
> If flowers, how then do I come to have
> Flora's smile on my lips? If I am Flora
> How comes it Flora is flowers and only flowers?
> Ah, I am not flowers, I am not Flora.
> Or rather, both Flora and flowers.
> A thousand flowers, on Flora only,
> So that the flowers make Flora, Flora the flowers.
> Do you know how? The cunning painter changed
> The flowers into Flora, Flora to flowers.[48]

MARTINENGO: This madrigal truly imitates the painting of Arcimboldo.

FIGINO: Turn the page over, and you will find the poem about Vertumnus.

GUAZZO: Here we are then.

> Whoever you are, beholding
> My strange, misshapen image,
> And on your lips a smile
> That sparkles in your eyes
> And quickens your whole visage
> With some new-born delight
> At seeing this novel monster
> Who, in their songs, the ancient
> Learnèd sons of Apollo[49]
> Were used to call Vertumnus;
> If you do not admire
> The hideousness that makes me
> Beautiful, then you know not
> By how far hideousness
> Surpasses every beauty.
> I am various from myself
> Yet, various, I am single
> Though made of many things.
> With my various appearance
> I portray many a likeness.
> Compose your grows severely now,
> Withdraw into your mind,
> Listen with close attention,
> So that I may entrust you with
> A secret of new art.
> Once upon a time the world
> Was all in itself confused,
> Because the skies with fire,
>
> And fire and skies with the air
> Were mingled, and the waters
> With the air and with the earth,
> With fire and with the skies:
> Deprived of order, all
> Was without shape, and ugly.
> But the right hand of Jove
> Then balanced the earth upon
> The waters, stretched the air
> Above the waves and the earth
> And, above the air, the fire,
> Each hanging from another,
> Made firm and kept in place
> By moisture and by dryness,
> By the heat and by the cold,
> In the way in which four links
> Are set with many a gem
> To form a single necklace.
> Of the elements, the skies
> Were assigned the noblest place,
> Spreading above the others
> And gathering all things to her.
> Thus, like an animal,
> Lively, proud, and perfect,
> Out of that vast, confused
> Rising and falling mass,
> As from a gravid womb
> That in itself is fertile,

185

Beauteous, emerged the World;
Of which the many-eyed face
Is star-studded Olympus,
The breast is the air, the belly
The earth, and the abysses
The feet; the spirit that warms
And animates this great body
And makes it pulse, is fire;
Its mantle is of fruits and grasses
Good also for other uses.

Now, what do you imagine that
The ingenious Arcimboldo,
Portraying me thus, performed
With his paintbrush which surpasses
Even the brush of Zeuxis[50]
Or of him who played the trick
Of the fine, painted veil
In the contest for high honors?
He was the bold, the skilful
Rival of mighty Jove,
For, choosing from the meadows
A thousand fruits and flowers
(Where Nature had already
Supplied a delightful medley),
He wove a lovely garland
And fashioned them into members.

Behold what binds my temples
And colors and adorns me:
As many sharp ears of grain
As dusty June matures
And turns to gold, and hardens,
Which then the harvester
In his left fist grasps tight
And offers to the crescent steel
Of the blade that severs them.

So many falling tips of gold
Millet, welcome in winter
To the shepherd in the mountains,
So that his wife, his children
With this sweet, wholesome food
Are nourished around the fire
In their humble cabin.

The juicy, pendulous grapes
That, with the wandering brush
Of his warm rays, the sun
Paints yellow or vermilion,
And then the month of Bacchus[51]
Culls from the elm-tree's arms.
See how this involucre
With which my brow is laden,
Lofty, rotund, and swollen,
Makes me resemble Thrace,[52]
Which a long sash engirdles
And in a thousand spirals
Twines round the head, emitting
Scorn and wrath from the eyes.

Look here at the summer melon
Which, when the Celestial Dog
Barks, and the fiery Lion[53]

From the heights of heaven makes
His hot roars heard on earth,
Whether in palace or cavern
Or beside a spring or a river:
It refreshes the parched mouths
Of mighty nobles, humble
Peasants, of wandering Nymphs
And warriors languishing.

Look at him, how wrinkled,
How roughened in its rutty
Bark, he makes my brow,
In which respect I seem like
Some ploughman in the mountains
Who — north toward the Pole —
Lives on Bohemian soil
Among stones, ice, and forests,
Hunched up, freakish in body
And with a darkened visage.

Notice the peach and the apple,
Both round and flushed and vivid,
And each one forms a cheek;
At the same time consider
These eyes: one is a cherry,
The other a crimson mulberry.

If my face is not the living
Image of Narcissus,
You will not deny I might be
— Robust and blithe — a brother
To him whose eyes and features
Radiate forth the virtues
And vigor of the vintage;
And who with a happy band
Of his beloved companions
Drinks, when they feast together,
Until he has drained the cup.

See the two hazel nuts
With their verdant involucres
On the one side of the lip
And on the other, falling
In a pair of twisted locks
To join the pointed beard;
To these, a fit companion
Is a spiky chestnut husk
Engrafted on the chin
And completing to perfection
This manly ornament.

Egad, what handsome Spaniard
In such fine trim as this
Keeps the fleece of his face,
Though (narrow, long, and pointed)
With his fingertips he often
Flatters, gathers, and curls it
Up toward his eyebrows?
Show me the one who dares
Compare his beard with mine,
Which is so strange and novel.

Look then upon this fig
Which, ripened full to bursting,
Is hanging from my ear,

Ottavio Miseroni
*Rudolf II*, 1590 c.
Tin-plated chalcedony, gold mount
Kunsthistorisches Museum, Vienna

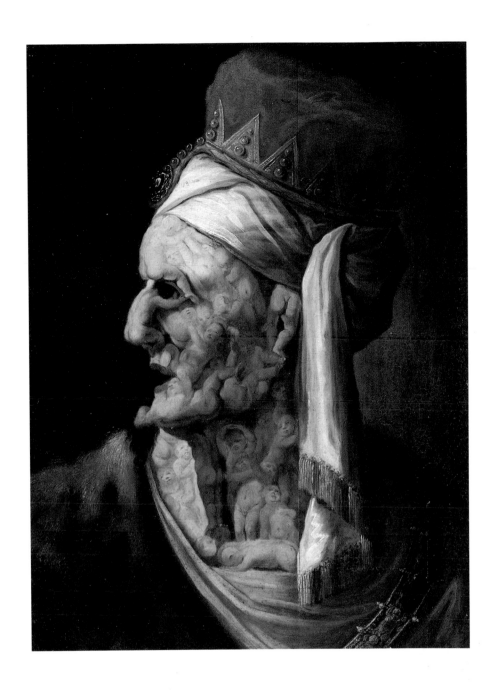

Anonymous
*Herod*, 17th century
Oil on panel, 45.6×34 cm
Tiroler Landesmuseum Ferdinandeum
Innsbruck *

And you will swear that I
Must be some highborn
                    Frenchman/
Who, there beside the Seine,
Charges the tip of one ear
With a resplendent pearl,
And, lovely as a flower,
Radiates grace and love.
Look, lastly, on this baldric
(For of the other fair
Strong members I say nothing)
Fashioned of various flowers
As woven with fine gold,
Which from the right shoulder
Falls aslant the breast:
For then you will esteem me
A proud, high-spirited

Brother-in-arms of Mars,
Who, glad of his bold example,
Carries the selfsame ensign as
The Captain's flourished colors.
But what above all else
I blazon and delight in,
Rising in pride toward heaven,
Is that almost a Silenus
Am I to the Greek youth
So dear to good old men,
So prized by the great Plato,
For without I seem a monster,
But noble looks conceal
Within, and a regal image.
Now tell me if it pleases you
To view what I keep hidden,
For now I remove the veil.

187

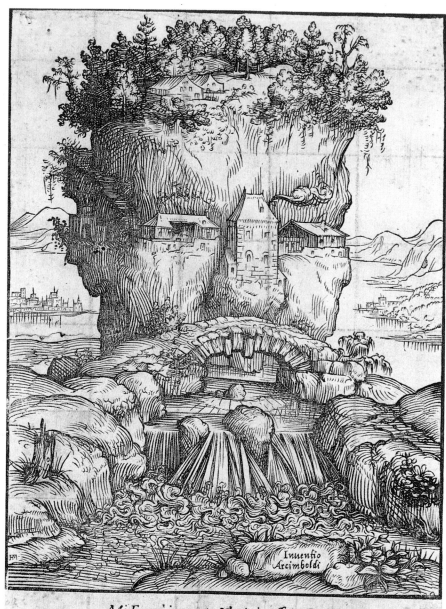

Hans Meyer
*Mi formò in monte e mi ritrasse in carte / natura a caso l'Arcimboldo ad arte*
*(Me into mountain didst form and onto paper didst impart / Nature by accident Arcimboldo by art)*
early 17th century
Inscription lower right: Inventio Arcimboldi
Woodcut, 25×17.3 cm
The Ashmolean Museum of Art and Archaeology, Oxford *

Holy, unvanquished, happy, supreme, august
And pious Rudolf, honor of Austria, glory
Of warlike Germay, to whom the world
Bows in devotion, in whose breast reside
So many virtues, exiled once from the earth,
Worthy of the golden mantle which you bear
And of the throne from which you rule so grandly:
You I resemble, figure forth, record,
I, who of fruits that are produced and painted
By the still-youthful year — which grows thereafter,
Keeps them in ripeness, and in tired old age
When whitened by the snows, and languishing,
It dies to father fruits for another year —
Gather in all their forms to a single store:
Just so, as in your bosom you possessed
As much as man can have of what is lofty
Whether at the time of tender games, or else
At the age of spark and ardour; as a gentle infant
Or as a bold young man; then, having reached
The years in which the mind is most prolific
In valour and in wisdom, you discover
A wealth of glorious and fervent spirits,
So that beneath your yellow locks you nourish
The deepest thoughts, the most sublime and wise,
For in you there is nothing that is lacking
To a hero's ornaments or strength of arms.
Worthy, O worthy are you, who are honored
In the way of silence rather than in words:
For, gazing on sacred things, that man is safest
Who, when he speaks about them, babbles least.
So, like a learned Egyptian,[54] Arcimboldo,
Best and most faithful servant to devote
Heart and hand to your diadem, has veiled
Your divine countenance with beauteous fruits.

Do not disdain that little things should mantle
Your infinite virtues in a modest space,
For even God, when it was his desire
To bring the world to birth, was pleased that things
Of the minutest size should demonstrate
His great, astonishing power so much more clearly
To man, than what is lofty and immense.
Now leave me, O beholder,
For in a few verses I have told you
Both what I am, and how much I hint at;
Leave me, and in departing,
If in your breast you bear
A noble soul and singular, then praise
The Painter, and to great Rudolf bend the knee.

MARTINENGO: Wondrous beauty combined to a great deal of artifice enables me to visualize Arcimboldo's painting by means of this poem of Comanino's. And if it is delightful to hear it recited just once in this manner, what must it be to peruse it?

FIGINO: Bear in mind that there is no fruit or flower that is not taken from life, and imitated with the greatest possible degree of diligence. But the application of such fruits to the parts of the body

is so ingenious that wonder is forced to turn to downright astonish-
ment. And, if you were to see it, what would you say of that head
made of many animals' heads, and each one different, which he
painted in Germany and which was sent by the Emperor some years
back to His Catholic Majesty of Spain?[55] The brow contains all
these animals: an Indian gazelle, a doe, a leopard, a dog, a buck, a
stag, and the great beast.[56] The ibex, an animal found in the
mountains of the Tyrol, is placed at the nape of the neck, together
with the rhinoceros, the mule, the monkey, the bear, and the wild
boar. Above the brow are the camel, the lion, and the horse. And
it is lovely the way that horned animals surround the brow with
their weapons as if to form a royal crown, which is a very pretty in-
vention and a fine ornament for the head. The part behind the
cheek (for the head is seen in profile) is made by the elephant, whose
ear serves in right proportion to the rest of the head. A donkey
beneath the elephant forms the jaw. For the front part of the cheek
we have a wolf, which has its mouth open to catch a mouse, and
the open mouth forms the eye and the mouse the light of the eye;
the tail and thigh of the mouse form the beginnings of the beard,
or rather the moustache on the upper lip. On the brow, beneath the
animals mentioned above, is the fox, which curls its tail around to
form an eyebrow. On the shoulders of the wolf sits a hare, which
forms the nose, while the head of a cat makes the upper lip. A tiger
held beneath the neck by the trunk of the elephant takes the place
of the chin, while the trunk is curled round to form the lower lip.
In the opening of the mouth we discern a lizard. A couchant ox
forms the whole round of the throat, while a roedeer helps to finish
it. Then two animal skins fall onto the breast, one of a lion and the
other of a ram,[57] and here the work ends.

"Well, gentlemen, what do you say? Do you think that we find
mastery in this picture, as well as beauty? Let us take it for granted
that there is no head that is not taken from life, since the Emperor
gave him the opportunity for this by arranging for him to see live
specimens of the above-mentioned animals. But consider also the ar-
tifice of man, and be astonished at it: to represent the brow of man,
with which sometimes if he is happy he feigns grief, and if he hates
he often makes a show of love, the painter has chosen the fox, a very
cunning animal, and placed it in the midst of the other animals. To
make the cheek, which is the seat of shame, he selected the
elephant, of which Pliny writes in the eighth book of his natural
history that its shame is extraordinary, for when it is defeated it
shuns the voice of its conqueror, nor does it ever couple with a
female in public, but only in places where it is not seen by others.
Of the wolf we read that a few hairs in its tail contain a love-potion,
and that among wolves there are also those that are called lynxes,
and have exceedingly sharp eyes. Therefore he used a wolf for the
eye, which has the power to poison hearts with love and is the in-

Josse de Momper
*Anthropomorphic Landscape*
early 17th century
Oil on canvas, 52.5×39.6 cm
Private collection *

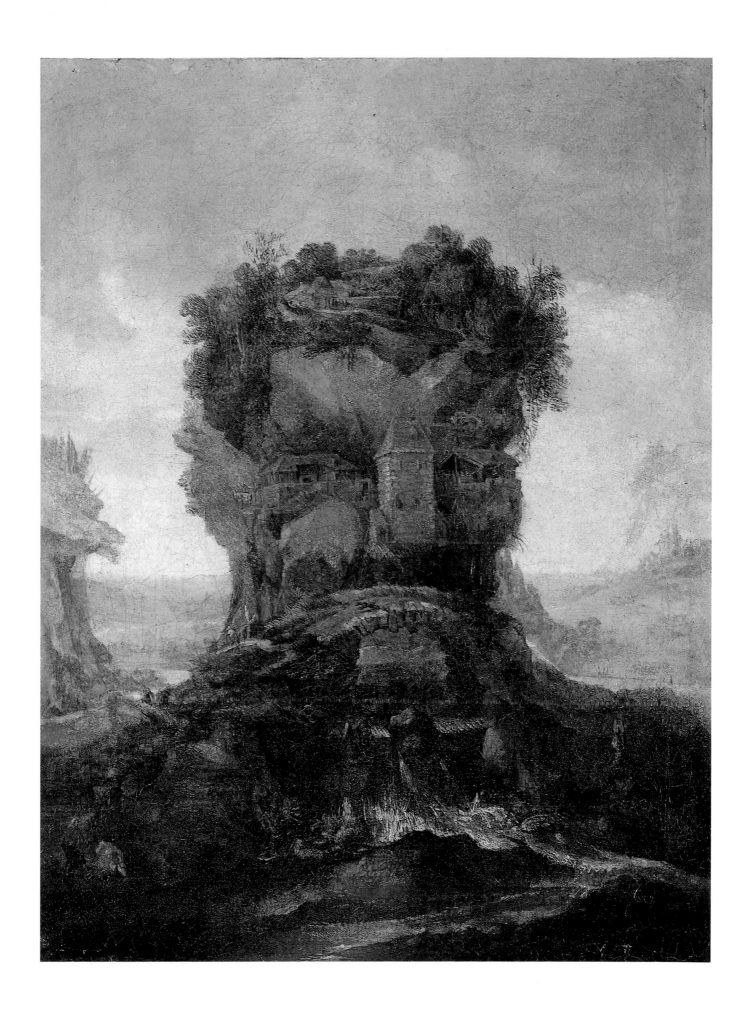

strument of vision. Pliny tells us that Theophrastus wrote that on an island in the Aegean the mice even gnawed through iron, and therefore the Painter used it for the light of the eye, which gnaws at and tames the toughest minds with the passion of love. To represent the nose he selected the hare, not because it has a better sense of smell than other animals, but because, it being imprudent to the extent of not being able to defend itself except by flight, he elected in this way to reveal to us a secret of philosophy; that is, that men with an unusually keen sense of smell are as imprudent as those whose temperaments are unsuited to prudence. I need not tell you why he used the cat to indicate the mouth, since the voracity of this animal shows it clearly enough. But of the ox, which composes the throat, I would like to recount a little moral which is worth the telling, and is nobly hinted at by the worthy painter. Of all animals the ox is (at least among the Garamantians[58]) the only one to walk backward as it browses, as Pliny writes in the eighth book of his

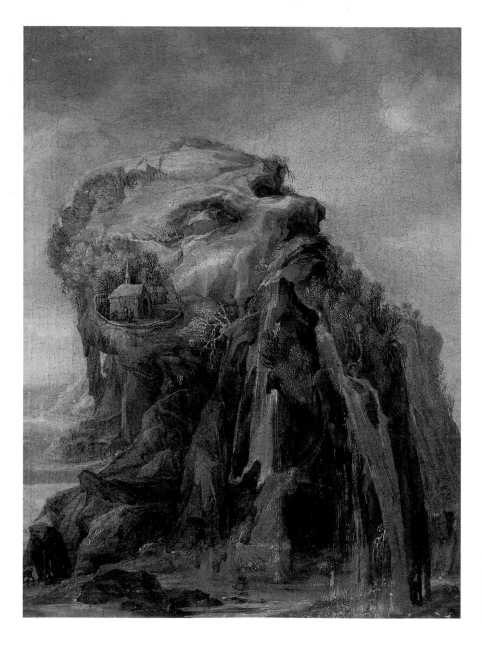

Josse de Momper
*Anthropomorphic Landscape*
early 17th century
Oil on canvas, 52.5×39.6 cm
Private collection *

192

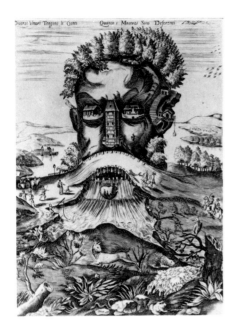

Anonymous
*Diversi umori tengono le genti*
*Quanto i mostazzi sono deferenti*
Etching, 25.5×18.5 cm
Royal Library, Windsor Castle

history. Therefore this ox used by Arcimboldo to represent the throat means that whoever eats or drinks to excess does not live as a man, and does not proceed toward virtue, but walks backward, turning his back on his goal and resembling the brute beasts. And then, the Herculean lion's skin and that of the Order of the Golden Fleece, which compose the breast, show that it is by means of hardihood and trials that one acquires honor and glory..."[59]

Following the long descriptions of the paintings of Vertumnus and of the Earth, and the explanation of the meanings hidden in Arcimboldo's intricate allegories, the three speakers, in agreement at last, pause to admire his great ability to express "intangible things with tangible images." As a further proof of these Figino describes to his companions the portrait of the Year:[60]

"FIGINO: Ask Comanino to show you the joke which the same painter made with regard to the four seasons of the year, and you will see a really lovely picture. A tree-trunk full of knots serves to make the body and the head, in which certain concavities serve for the mouth and the eyes, a big protruding knot for the nose, a number of moss-covered, twisted twigs for the beard, and some boughs on the brow for the horns. This trunk stripped of its own leaves and fruits represents the winter, which produces nothing but enjoys the produce of the other seasons. A number of little flowers on his breast and on one shoulder signify the spring, as a number of bunches of ears of grain attached to certain branches, a cloak woven out of straw to cover the shoulders, two cherries hanging from a knot representing the ear, and two plums at the back of the head signify the summer, while two bunches of grapes (one red and one white) hanging from a branch and a number of apples half hidden among branches green with ivy on the top of the head are representative of autumn. One of the branches of the head he has stripped in the middle, but only a little, and the turned-down scraps of bark fall like a moustache, while on the exposed part of the branch is written *Arcimboldus P...*"[61] Then follows a witty description of the portrait of the Jurist, which for a long time was thought to be a portrait of Calvin:

"FIGINO: Laughable to the highest degree was the portrait he painted, at the command of the Emperor Maximilian, of a certain Doctor (of Law), whose entire face had been ravaged by syphilis, leaving only a few hairs on his chin. It is all composed of various roasted animals and fishes, and he caught the likeness so well that anyone who just glanced at it recognized the true features of the good Jurist. Of the pleasure this gave their Majesties and the laughter it occasioned at the Imperial Court I need not speak. You can imagine it for yourselves..."[62]

Near the end of the chapter of the *Figino* devoted to Arcimboldo, Comanini explains why the art of this Milanese painter may be considered a meeting-point for and a synthesis of the tendencies toward

realism and fantasy, the "objective" vision of the world and the "subjective" of the individual artist. And it is extremely interesting to observe how, in the words of Guazzo, Arcimboldo is placed in relation to the matter of dreams; that is, to the aspect of his painting that has caused a revival of his reputation in our own century, in virtue of a number of respects in which he anticipated the surrealist "poetics" that are said to animate his paintings:

GUAZZO: The poets write that the ministers of Sleep are three: Morpheus, who transforms himself into the likenesses of all men, and imitates their habits, their voices, their ways of walking, their clothes, and the words commonly used by each of them, but represents nothing other than men; Phobetor, who changes into beasts, birds, or serpents, but never into men, or into inanimate things; and Phantasos, who represents inanimate things to men, and changes himself into earth, stone, water, wood, and other similar forms. If these were not fables I would say that all three of these ministers of Sleep are familiars of Arcimboldo, since he knows how to make the transformation that they make. Indeed, he makes use of more things than they do, transforming animals, birds, snakes, knotty wood, flowers, fruits, fish, grass, leaves, ears of corn and straws and grapes into men and the garments of men, into women and the ornaments of women.

"MARTINENGO: Let us therefore tell the truth and own up to the fact that the virtue of fantasy, the task of which is to receive the forms brought to the common sense by the exterior senses, to retain them and to combine them together, is extremely powerful in Arcimboldo; for he puts together the images of tangible things seen by him, forms them into strange caprices and idols no longer invented by strength of imagination; what seems impossible to put together he assembles with great dexterity, making out of it whatever he pleases . . ."[63]

1. Borromeo, "Memoriale al suo diletto popolo," in Taviani, *La fascinazione del teatro*, pp. 24-31.

2. Ibid., pp. 24-31.

3. Borromeo, "Omelia per il battesimo," in Taviani, *La fascinazione del teatro*, p. 36.

4. Geiger, *I dipinti ghiribizzosi di Giuseppe Arcimboldo*.

5. Savio, "Giovanni Battista Fontana," pp. 343-375.

6. Studies of Fonteo's Viennese manuscripts are the work of Kaufmann, "Arcimboldo's Imperial Allegories," pp. 275-296, and "Arcimboldo au Louvre," pp. 337-342. The suggestion that the Fonteo who was in Vienna and collaborated with Arcimboldo is to be identified with the Fontana spoken of by De Savio is due to Porzio, *L'Universo illusorio di Arcimboldi*.

7. Giovanni Battista Fonteo, *Baptistae Fonteij Primionis... Carmen cum Distichis et Divinatio, cui titulus Clementia est*. Vienna, Österreichische Nationalbibliothek, cod. 10152.

8. See Kaufmann's essay included in the present catalogue.

9. Not 29 December, as Kaufmann writes in "Arcimboldo's Imperial Allegories," p. 278.

Jacques de Gheyn II
*Rocks overrun by plants forming grotesque heads*, early 17th century
Pen and sepia on paper
26.6×17.5 cm
Custodia Foundation
Institut Néerlandais, Paris *

10. Giovanni Battista Fonteo, *Bap. Fonteii Primionis Europalia*. Vienna, Österreichische Nationalbibliothek, cod. 10206.

11. The temple of Jove stood on the Capitoline Hill in Rome, from which auguries were observed.

12. The original has *grilli* (lit. "crickets," fig. "caprices"). Pliny used the term *Grylli* to denote certain caricature-portraits (*Naturalis historia*, 35, 114).

13. Erigone, daughter of Icarius, hanged herself from grief when she learned of her father's death. To reward her for this noble gesture the gods placed her in the heavens as the constellation of the Virgin.

14. Callisto, daughter of King Lycaon, was loved by Jove. Juno, out of jealousy, changed her into a bear, which Jove then made into the constellation of the Great Bear.

15. Cassiope, wife of Cepheus, became the constellation of Cassiopeia.

16. Andromeda, daughter of Cephus and Cassiope, was exposed on a rock at the mercy of a sea-monster, but was saved by Perseus, who later married her.

17. The crown of Ariadne, daughter of Minos, was made into a constellation.

18. Maia, mother of Mercury, was placed in the heavens among the Pleiades.

19. Electra also is one of the Pleiades.

20. Taÿgete, daughter of Atlas, was placed among the Pleiades.

21. Paolo Morigi, *Historia dell'antichità di Milano, divisa in quattro libri, del R.P.F. Paolo Morigia Milanese....* In Venetia: appresso i Guerra, 1592.

22. Paolo Morigi, *La Nobiltà di Milano... Divisa in sei libri... Del R.P.F. Paolo Morigia Milanese, de' Giesuati di San Girolamo.* Milan: Stampe del quon[dam] Pacifico Pontio, 1595.

23. Morigi, *Historia dell'antichità di Milano*, p. 556.

24. The river Elbe.

25. Although contested by Geiger (*I dipinti ghiribizzosi di G.A.*, pp. 15-16) the derivation of the name Arcimboldo given by Morigi is, at least from the linguistic point of view, correct. He in fact writes "arci" as the Italian form of the German "Erz," a word that apart from the current meaning of "metal," was formerly used also to mean "mine"; while "boldo" — which according to Geiger is derived from the Frankish "baut," becoming "baldo" (fearless) — might well be an Italianized form of the German "Wald," meaning a wood. As a partial and indirect confirmation of the version recorded by Morigi, we might mention that the name Erzgebirge (in Italian *Monti Metalliferi*: metal-bearing mountains) is still used for a range of mountains near the Elbe and separating Saxony from Bohemia (or Germany from Czechoslovakia).

26. Morigi, *Historia dell'antichità di Milano*, pp. 553-554.

27. Ibid., p. 554.

28. Ibid., p. 554.

29. Ibid., p. 555.

30. Reitstap's great heraldic catalogue in fact refers to the bearings of the Arcimboldi of Milan as gold with a dark red band and three silver stars. See Reitstap, *Armorial Général*, vol. I, p. 61.

31. Morigi, *Historia dell'antichità di Milano*, p. 556.

32. Ibid., pp. 558-559.

33. Ibid., pp. 566-567.

34. *Il Trattato de l'arte de la pittura di Gio. Paolo Lomazzo Milanese pittore. Diviso in sette libri.* Milan: Appresso Gottardo Pontio, 1584.

35. *L'Idea del Tempio della Pittura di Gio. Paolo Lomazzo pittore.* Milan: Paolo Gottardo Pontio, 1590.

36. Longhi, "Quesiti caravaggeschi," p. 314.

37. For the diagram of the "Temple," see Klein, *La forma e l'intellegibile*, pp. 190-191.

38. Ibid., p. 179.

39. Longhi, "Quesiti caravaggeschi."

40. Lomazzo, *Trattato*, p. 348.

41. Ibid., pp. 349-350.

42. Giampaolo Lomazzo, *Rime di Gio. Paolo Lomazzi milanese pittore divise in sette*

Anonymous
*Psyche* (shooting target), 1654
Oil on panel, diam 99 cm
Slovácké Muzeum, Uhérské Hradiště *

Giovanni Battista Bracelli
*Street,* in *Bizzarrie,* Florence, 1624
Etching, 8.5×11 cm
Bibliothèque Nationale, Paris *

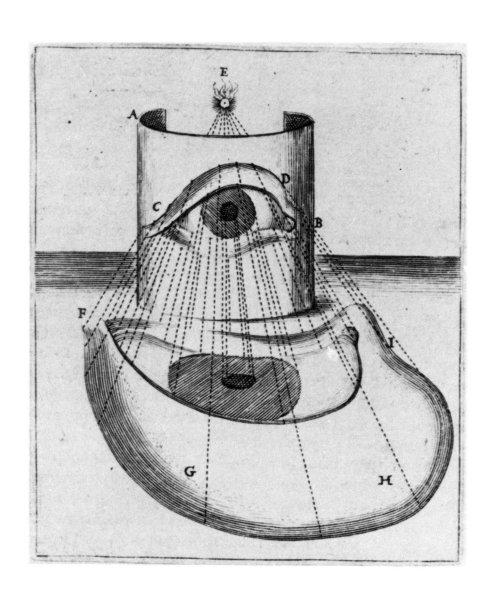

Woodcut by Mario Bettini
*The Eye of Cardinal Colonna*
Anamorphosis for cylindrical mirror
in *Apiarium*, Bologna, 1642
Biblioteca Nazionale Marciana, Venice *

Jacques Callot
*The Vigilant Eye*
in *Lux Claustri*, Paris, 1628
Etching
Cabinet des Estampes
Bibliothèque Nationale, Paris *

Joseph Sacco
*Young Woman's Eye*, 1844
Tempera on stiff paper in its original frame
12.1×8.9×2 cm
The Menil Foundation, Houston *

# Part two: 1800-1987

Chronology

1800 Alessandro Volta invents the pile
1807 Hegel publishes *The Phenomenology of Mind*
1808 In *A New System of Chemical Philosophy*, John Dalton presents the "atomic theory"
1810 Francisco Goya begins his series of etchings on *Los Desastres de la guerra*
1814 Ampère's studies on atoms and molecules
1819 Pompeo Litta mentions Arcimboldo's family in *Milano nobilissima*.
Fresnel proposes the wave theory of light
1823 Nicéphore Niepce discovers the principle of photography
1824 Beethoven writes the Ninth Symphony
1848 Popular uprisings in most European countries
1857 Baudelaire publishes the first edition of *Les fleurs du mal*
1863 Manet paints *Le déjeuner sur l'herbe*
1864 Rodin sculpts *The Man with the Broken Nose*
1865 Gregor Mendel publishes the results of his research on genetic laws in *Experiments in Plant-Hybridization*
1867 Marx publishes the first book of *Das Kapital*.
*Inventory of the Treasures of Prague, December 6th 1621* published with notes by Bela Dudik in *Mitteilungen der K. K. Central Commission*
1868 Lautréamont publishes the first of his *Chants de Maldoror*
1869 Mendeleev publishes his *Periodic System of Elements*, classified according to atomic weight
1871 March 28, the Commune of Paris
1873 World economic crisis

1881 Birth of Pablo Picasso
1883 Nietzsche publishes *Thus Spake Zarathustra*
1884 Paul von Nipkov discovers the principle of television
1885 Carlo Casati publishes an article on *Arcimboldo, pittore milanese* in "Archivio Storico Lombardo"
1886 Olof Granberg publishes the *Catalogue raisonné of paintings in Swedish private collections*
1887 Marcel Duchamp is born
1888 Nietzsche publishes *Ecce Homo*
1895 Röntgen discovers X-Rays. On December 28, in Paris, the Lumière brothers organize the first public cinema performance
1896 H. Becquerel discovers the radioactive properties of uranium
1898 Pierre and Marie Curie discover polonium and radium
1902 Olof Granberg publishes *Kaisar Rudolf II's Kunstkammare och dess svenska oeden*
1905 Einstein publishes papers on the quantum theory, the special theory of relativity and the theory of Brownian motion in the "Annales de physique" in Berne
1908 Julius von Schlosser publishes *Collections of Art Treasures and Marvels of the Late Renaissance*. Arcimboldo is mentioned in Thieme and Becker's *Allgemeines Lexikon der Bildenden Künstler*
1910 Freud publishes *A Childhood Memory of Leonardo da Vinci*
1911 Olof Granberg publishes the *General Inventory of Art Treasures in Sweden*.
Rutherford proposes the theory of a nuclear structure of the atom
1912 Wegener publishes *The Formation of Continents and Oceans*. Duchamp goes to Prague.
First performance

# Chronology

of *Pierrot Lunaire* by Schönberg
1913 Nils Bohr publishes *Theory of Spectra and Atomic Constitution*.
Husserl publishes his
*Introduction to Pure Phenomenology*.
First edition of *Alcools* by
Guillaume Apollinaire
1914 June 28, the assassination at Sarajevo sparks off World War I
1916 Kafka's *Metamorphosis* is published by Kurt Wolff in Leipzig
1917 October Revolution in Russia
1918 The Great War ends with the signature of an armistice by the provisional German government.
The Czech Republic is proclaimed in Prague.
Carl Jung, Richard Hülsenbeck and Raoul Haussman
publish the first Dada review,
*Die Freie Strasse*, in Berlin.
Apollinaire dies in Paris
1919 Signature of the Treaty of Warsaw.
The map of Europe is radically changed: the German, Russian and Austro-Hungarian empires
disappear and numerous small states are created; this is the start
of a serious economic
crisis in Europe.
Rutherford makes his first experiments in bombarding atoms and theorizes
the existence of the neutron
1922 James Joyce publishes *Ulysses* in Paris
1924 Lenin dies.
Hitler writes *Mein Kampf*.
Breton publishes
the *Manifesto of Surrealism*
1925 "First Surrealist Exhibition" in Paris.
Eisenstein directs the film
*Battleship Potëmkin*
1929 Collapse of the New York Stock Exchange and start of the

world economic crisis.
First article by Giorgio Nicodemi on Arcimboldo in "Problemi dell'arte attuale"
1932 J. Chadwick discovers neutrons
1933 Hitler takes over the government; Germany leaves the League of Nations
1934 Fermi experiments the first nuclear fission of uranium.
Irène and Frédéric Joliot-Curie discover artificial radioactivity.
Adolfo Venturi's *Storia dell'arte italiana* includes the first encyclopedia entry on Arcimboldo
1936 Outbreak of the Spanish Civil War.
Alfred Barr Jr. organizes the exhibition "Fantastic Art, Dada, Surrealism"
at the Museum of Modern Art
in New York.
Exhibition of surrealist objects at the Charles Ratton Gallery in Paris
1937 Picasso paints *Guernica*
1939 German troops invade Poland; outbreak of World War II
1941 Vannevar Bush invents the first electronic computer
1944 Allied landing in Normandy
1945 Yalta Conference.
Germany surrenders.
The first atomic bombs are dropped on Hiroshima and Nagasaki
1947 Breton considers including Arcimboldo in the "International Surrealist Exhibition" at the Maeght Gallery in Paris
1948 Political crisis in Prague; Czechoslovakia becomes a People's Republic
1950 Outbreak of war in Korea
1951 The review "Médicine de France" publishes an article
by J. Baltrušaitis, *Têtes composées*
1952 The European Centre for

Collage by Max Ernst for the cover
of Paul Eluard's
*Répétitions*
Paris, Au Sans Pareil, 1922

Nuclear Research is started; the
first thermonuclear bomb is tested.
The *Vegetable Gardener* is shown at
the exhibition on "Still Life" at the
Orangerie in Paris.
1953   The Brussels review
"Les Beaux-Arts" publishes
a series of articles on Arcimboldo
by F. Sluys
1954   The first monography on
Arcimboldo is published
by Benno Geiger in Florence.
For the inaugural exhibition
at the Furstenberg Gallery in Paris,
Simone Collinet shows
the Neger Collection *Four Seasons*
1955   Teilhard de Chardin publishes
*Le Phénomène humain.*
In Brussels, F. C. Legrand and F.
Sluys publish
*Arcimboldo and the Arcimboldesques.*
*Earth,* one of the paintings of the
*Elements* series,
leaves the Joanneum in Graz
for a private collection.
1956   Tumults in Poland; Hungarian
uprising; Suez crisis
1957   The first Sputnik is launched
into space.
In Sweden, "Symbolister" no. 2 is
entirely dedicated
to an important article
by Sven Alfons on Arcimboldo.
Pavel Preiss points out the existence
of two drawings by Arcimboldo in
the Prague National Museum.
Breton publishes *L'art magique*
1961   The Berlin Wall is built
1964   The Louvre purchases the
Neger Collection *Seasons.*
In the royal collections of the
Academia de Bellas Artes
de San Fernando in Madrid
A.E. Perez Sanchez discovers
the painting of *Spring,* from the first
*Seasons* series, 1562
1966   Cultural Revolution in China.

Breton dies in Paris
1967   Pavel Preiss publishes a book
on Giuseppe Arcimboldo in Prague.
Exhibition in Stockholm on the
"Collections of Queen Cristina"
1968   Marcel Duchamp dies in Paris
1973   Picasso dies
1976   Thomas da Costa Kaufmann
publishes his thesis,
*Arcimboldo's Imperial Allegories,*
in "Zeitschrift für Kunstgeschichte"
1977   A. Pieyre de Mandiargues
publishes *Arcimboldo le Merveilleux*
1978   Article by R. Barthes in F.
M. Ricci's *Arcimboldo.*
Exhibition "Mannerist Art, Forms
and Symbols 1520-1620" at Rennes
1979   F. Porzio publishes *L'universo
illusorio di Arcimboldi.*
Arcimboldo is represented in the
exhibition "Still Life in Europe"
in Münster
1981   For the exhibition
"The Baroque in Bohemia,"
the *Seasons* are moved
from the Louvre to the Grand Palais
1983   A. Beyer publishes the corpus
of Arcimboldo's costume designs in
*Giuseppe Arcimboldo: Figurinen
Kostüme and Entwürfe für Höfische
Feste*
1985   Thomas da Costa Kaufmann
publishes *L'école de Prague* in Paris
1986   The Nobel Prise for physics is
awarded to Ernste Ruska, Gerd
Binning and Heinrich Rohrer for the
invention of a "tunnel effect"
microscope, milestone in the field of
direct osservation of the atom
1987   Robert S. Miller attributed
the fresco of the tree in Monza
Cathedral to Giuseppe Arcimboldo.
Fourth centenary of Arcimboldo's
return from Prague to Milan.
At Palazzo Grassi, Venice, first
retrospective exhibition
of Giuseppe Arcimboldo's work.

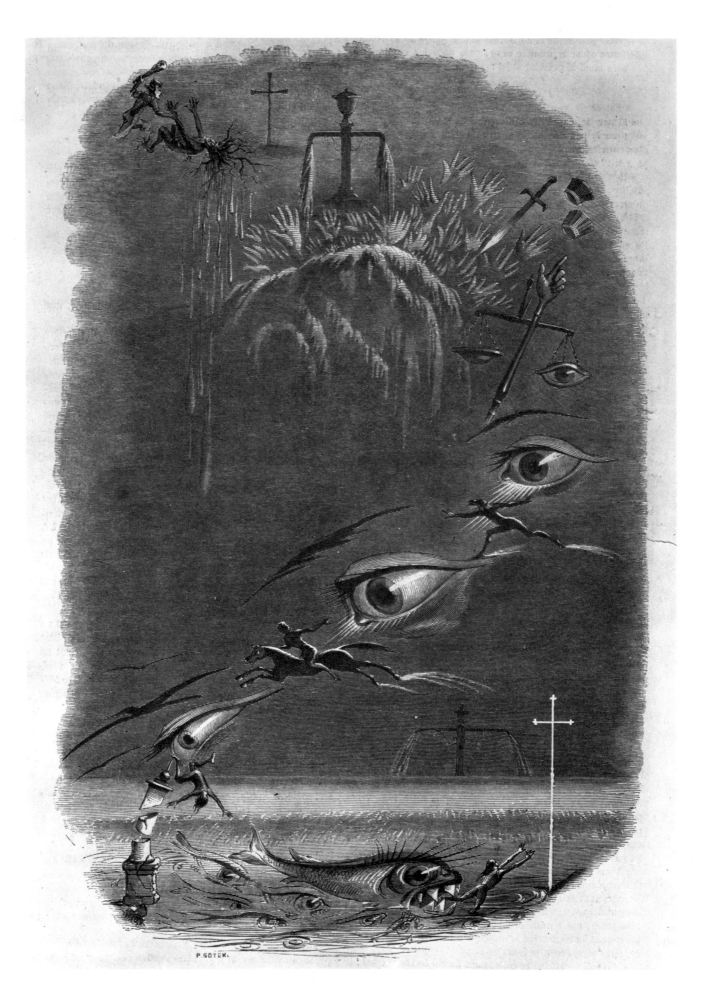

P. GOYER.

# Anthology of Twentieth-Century Texts

edited by Piero Falchetta

We can look at Arcimboldo's paintings in many ways: first of all, of course, as an aesthetic product, very skillfully handled, which can enchant the eye with its brillant execution and original design. The canvases can also be seen as resulting from a highly ambitious cultural project which had its ideal and geographical center at the Hapsburg court in Vienna, and of which they are a significant and major expression. Or we can see in them the scholarly and elegant application of an idea of the world formulated and examined in the works of the Neoplatonic humanists and the Renaissance hermetists. Finally, we can simply consider these paintings as mere "caprices," "fancies" or "bizzarrerie"; that is, the work of an artist who found his main inspiration in the world of the freakish, fantastic, and grotesque.

Each of these interpretations has been more or less popular over the centuries, and Arcimboldo has been seen alternately as a magician and esoteric, as the artist whose allegories expressed the cultural aspect of the Austrian emperors' political schemes, and also as a forerunner of fantastic art (and for this reason he interested the surrealists). It is however clear that even if all these interpretations are considered valid, and although few of his works have survived, he occupies a unique and totally original place in the panorama of the modern figurative arts. And if it is true that the inspiration and ideas behind his very special style must have come not only from a general cultural climate but also from more concrete examples (such as, to mention one of the most likely, certain drawings in Leonardo's *Codice Atlantico*), it is also true that no other artist before him had ever thoroughly explored the possibilities of the subject and composition techniques that were to create his so-called "composed heads." In other words, Arcimboldo was to a large extent the inventor and above all the experimenter of a particular form of portraiture, so much so that it is impossible to look at an "Arcimbolderia" (more or less directly derived from his) without having to think of him as the true, first father of that special way of composing the human face.

He was not only the initiator of a pictorial technique, then, but also the inventor of a form of painting, which starting from his, over time has acquired a sort of an autonomous life—that is to say, like the steps of a cognitive process it can be abstracted from its nature as a simple fact, its existence in this or that painting. There is no

Grandville
*First Dream: Crime and Expiation*
in *Le Magasin Pittoresque*, Paris, 1847
Woodcut, 23.6×15 cm
Cabinet des Estampes
Bibliothèque Nationale, Paris *

other way to explain the success of his idea. Artists from very different periods and cultural backgrounds have been able to find inspiration in it without having to give up their own style, without having to become imitators or followers, without having to separate themselves from their own time, their own culture, and their own personal paths in order to benefit from his example.

The texts reproduced below in a certain sense confirm the persistence of the idea that Arcimboldo launched in his time—drawn from works of varied character and importance, they show the attention that has been given, not only to the historical and artistic personality of the Milanese painter, but also to what still interests us in that particular logic and way of portraying the human face, what we find striking and intriguing, what attracts us in these fascinating and sometimes disturbing transfigurations.

This is not a review with any claims to represent a full anthology. It is rather a series of ideas or suggestions, from the period running from the end of the last century up to the present day. In these extracts Arcimboldo's painting, and above all his idea, are the more or less explicit basis for evocations, analyses, or straightforward descriptions of the physical or intellectual universe. It is as though his idea were a lens or a gauge, a tool suitable for grasping the varied and heterogeneous material of different eras and different works of art. Historical curiosities, aspects of scientific research and bizarre natural phenomena are the subjects discussed in the first three articles that follow. Although they are addressed to a popular audience — or perhaps for that very reason — they clearly reveal the imprint of a positivist attitude, the triumphant "scientific" belief in progress of the end of the last century. It is not unusual, says the first article, to see rock formations recalling the image of the human face; and in fact, says the third, one of these profiles is exactly like King Leopold's (as much as to say that even mountains respect the hierarchy of human social organization).

Grandville and Desperret
*Enigma*
Lithograph, 19.5×14.4 cm
in *Le Charivari*, no. 9, 1834

Certainly, confirms the second writer, because the order of nature and scientific knowledge have nothing to do with the world of the imagination and artistic expression.

1885: Anonymous

Vitruvius relates that the architect Dinocrates proposed to Alexander the Great to carve Mount Athos in such a way as to give it the shape of a man, whose one hand should support an entire city, and whose other should carry a cup which received all the waters from the mountain, and from which they overflowed into the sea.

This gigantic project had doubtless been suggested to the Macedonian architect by the singular forms that certain mountains affect. It is not rare, in fact, to see human profiles delineated upon the sky, and this phenomenon especially happens in countries where

Anonymous
*Enigmatic Landscape*, 1830-40
Lithograph with chalk, 28.4×37.4 cm
Dr. Günther Böhmer Collection, Munich *

the folded limestone strata have been broken up in such a way as to give rise to deep valleys perpendicular to the direction of the chain. If we look at these folds from below in an oblique direction, we shall see them superimposed upon one another in such a way as to recall a human profile.

In the seventeenth century, Father Kircher conceived the idea of taking up Dinocrates' plan upon a small scale. His drawing remained engraved for a long time upon a marble tablet set into the wall of Cardinal Montalte's garden at Rome. [...][1]

1890: Anonymous

Under the heading "Scientific Recreations," the *New York Mechanic* presents this sketch, which in the intention of the artist who conceived and drew it represents the widespread but completely mistaken opinion that a wild medley of ideas runs through the brain of a gifted inventor, a "first-class inventor," as our colleague puts it.

But the *Scientific American*, where we borrowed this sketch, rightly protests against such an opinion. If the brain of an inventor were haunted simultaneously by all the different ideas the drawing suggests, he should be pitied rather than admired and would never be able to come up with anything final and useful. The truth, which in no way detracts from the interest of the sketch, is that the mind of an inventor rarely deals with more than one idea at a time. It becomes his nightmare, his mania, and stays with him until it is replaced by another to which he dedicates himself with the same conviction and exclusive interest.

The fact is that success in this field needs a clear, complete understanding of the subject and requires all the person's energy and mental activity to be concentrated in a single direction. Such a use of the brain is not for everybody.

Woodcut (anonymous)
*Anthropomorphic Landscape*, undated
Royal Library, Windsor Castle

Photograph of a rock in the shape of a human figure
in *La Nature*, Paris, Masson, 1899
Institut Catholique, Paris *

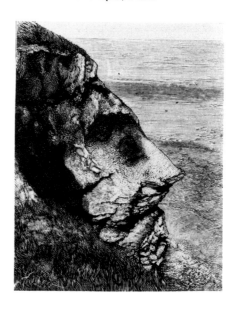

Contrary to what we are often tempted to think, the inventor is a person who is more gifted than his contemporaries and the environment around him, and is capable of thinking differently and more effectively than others about questions that leave the general public indifferent; he generally gets so absorbed in his own thoughts that he is judged mad, or at least lacking in common sense.

If in this particular case the writer's pen has had to contradict the artist's pencil, the denial is completely philosophical and does not affect the admiration due to the design and execution of this mechanical and artistic fantasy.[2]

## 1899: Anonymous

We have often reproduced photographs of gigantic stones that recall an object or an historical character. Change frequently shapes monoliths into forms so distinct that they seem to have been designed and executed by a human hand. In other cases, these natural sculptures are created by the action of air and water; the cliffs of our coasts are particularly subject to stresses — the water strikes their base disaggregating the molecules, there are frequent rock falls, ridges collapse leaving uneven surfaces behind them.

The rock illustrated today belongs to this category of stones. Its bizarre shape shows a strikingly human structure and the exceptional thing about it is the close likeness it presents to the profile of Leopold II, King of Belgium — the sharp nose following the same line as the forehead, the mouth drawn in and the beard that seems very long because the lower part of the head is hidden by the edge of the cliff; finally, the eye seems to be half shut the way it usually appears in photographs of the Belgian sovereign.

Looking at the rock at around 10 or 11 o'clock in the morning, when the sun is striking it directly, the shadows are sharper and the resemblance is increased.

Naturally this curious stone is destined to disappear. Like the whole cliff itself, it is condemned to crumble away gradually; every year chunks detach themselves and fall onto the sand below. We felt it was interesting to reproduce the picture because of its curiosity value and its ephemeral nature.[3]

"It is not really a matter of this or that artist," wrote Dvořák tracing the development of the spirit of late Renaissance and mannerist art. That is to say, it is not important to establish whether a certain painter with his work contributed more than another to dissolving the idea of a world in which an immediate objective relation existed with nature. It is the *Zeitgeist*, the spirit of the time, that now presents us with the wavering, uncertain outline of the Subject, where previously we could perceive the self-contained, full dimension of the indubitable Object.

Odilon Redon
*Eclosion* (*Blossoming*)
In *Dans le rêve*, 1879
Lithograph, 32.8×25.7 cm
Cabinet des Estampes
Bibliothèque Nationale, Paris *

The question of individuality, of subjectivity — which Lomazzo was the first to admit in his treatise on styles of painting — is notoriously one of the crucial points of twentieth-century thought and art. In terms of a unified although multiform vision like Dvořák's, to admit it as the essential basis for any cognitive approach, including the aesthetic one, is the ideological appendix that illuminates the final frontier of positive thought, showing how it already relapses into another form beyond that frontier.

Starting from theoretical formulations of this sort, it is not hard to find the path toward the embodiment of that historical and cultural attitude. Already in Venturi's piece — independently of the fact that one may not agree with his opinion — we can see the critic's eye withdrawing before the temptation of the global, unifying view. On the contrary, he is analytical in the way he describes Arcimboldo's brushstrokes one by one, in concatenation, making a coordinated statement that is content to be partial, a list of fragments that only finally will add up to the picture, the work. And even the appearence of oneness is immediately thrown into doubt, since it occurs in a substance that is "disaggregating, crackling, rotting," that cannot be trusted because it is not knowable.

It is the shadow of Subjectivity that finally, of necessity, becomes the only light, the least dark shadow. And it is actually a personal judgment that marks the shadowy frontier of Venturi's critical examination: in his view, Arcimboldo's is only a "depraved and almost diabolical artistic imagination." Or, as in the case of Nicodemi, is the possibility of establishing a direct relationship, beyond centuries of history, between certain experiments of modern painting and those of an artist who lived in the sixteenth century.

Or again, as in Nezval's poem partially reproduced here, it is the mirror homage that a poet generally defined as "surrealist" can take the liberty of presenting to a man like Arcimboldo, with whom he had in common only a certain frequentation of the streets — those at least still recognizable — of Prague.

## 1924: Max Dvořák

Where art had once been the guide, now suddenly it became guided, and where it had represented the very essence of human values, now it became an instrument in man's spiritual struggle. [...]

Just as awakening after a night of celebration, we find that the cares of the day have returned, so throughout the Christian world the enormous load of unresolved questions, contradictions, and spiritual needs that had been inherited from the Middle Ages and had only been sleeping under the veil of Renaissance culture, came to life again in every sphere. As old forms suddenly became current again and new tendencies arose, the artistic unity of that culture dissolved into a multiplicity of viewpoints and tendencies.

Woodcut (anonymous)
*Alembic Man*, 19th century

These movements were attempts — hard to grasp as a whole, apparently very divergent yet all springing from the same source — to do justice to the complexity of existential questions that the Renaissance had avoided and the reformers had tried to set aside with arbitrary simplifications. The questions now had to be dealt with from every point of view—history and psychology, theory and practice, religiousness and skepticism, the inner domain and the outer world. There have been few periods that, while producing no externally brilliant creations, were nevertheless so filled with transforming energies, destructive and at the same time fertile.

Having lost its dominant role, art found a new orientation in three main respects:

1. In the field of thought: far more than in preceding periods, it became the voice of every intellectual interest and all areas of knowledge. (...)

2. The lack of a unified direction necessarily created a wide variety of possibilities and a series of tensions, ranging from an extreme virtuosity that combined borrowed forms, beautiful line and color, intense sensuality and ideal abstractions into skilful but anaemic images, to the ardent expression of a profound experience of the contents represented or their visible appearance. [...]

3. In its relationship with nature: while in the Renaissance the Ideal was indissolubly linked to its sensory manifestation and physical rules, and a unified vision of nature was its origin and premise, representing the idea of a nature raised to conceptual perfection, now, with the shift of the unity from object to subject, a dualistic viewpoint was created. As in the Middle Ages, we again find co-existing movements — but equally present in a single artist and a single work — in which a perfectly objective and formal realism goes side by side with forms and substances unconnected with any observation of nature — portraits are combined with formulas, genre painting with supernatural meanings, reality with its transcendence.[4]

## 1934: Adolfo Venturi

Among so many outlandish images that perhaps have a distant origin in Leonardo's caricatures and a nearer one in German engravings, we cannot deny the astonishing skill of the hand and the fertility of the pictorial imagination, exceptional in the contemporary Milanese world, of the author of the *Allegoria dell'Inverno* in the Museum of Vienna.

There the bizarre master pours forth his wildest inventions. From a woven mat forming the cloak the neck emerges, made of a barked tree trunk where the roots mark the twisted paths of arteries and veins, and the nodes, the swell of the tendons and curve of the Adam's apple.

Odilon Redon
*Il y eut peut-être une vision première essayée dans la fleur (There was perhaps a first vision attempted in the flower)*, 1883
In *Les origines*
Lithograph, 22.3×17.2 cm
Kunstmuseum, Winterthur *

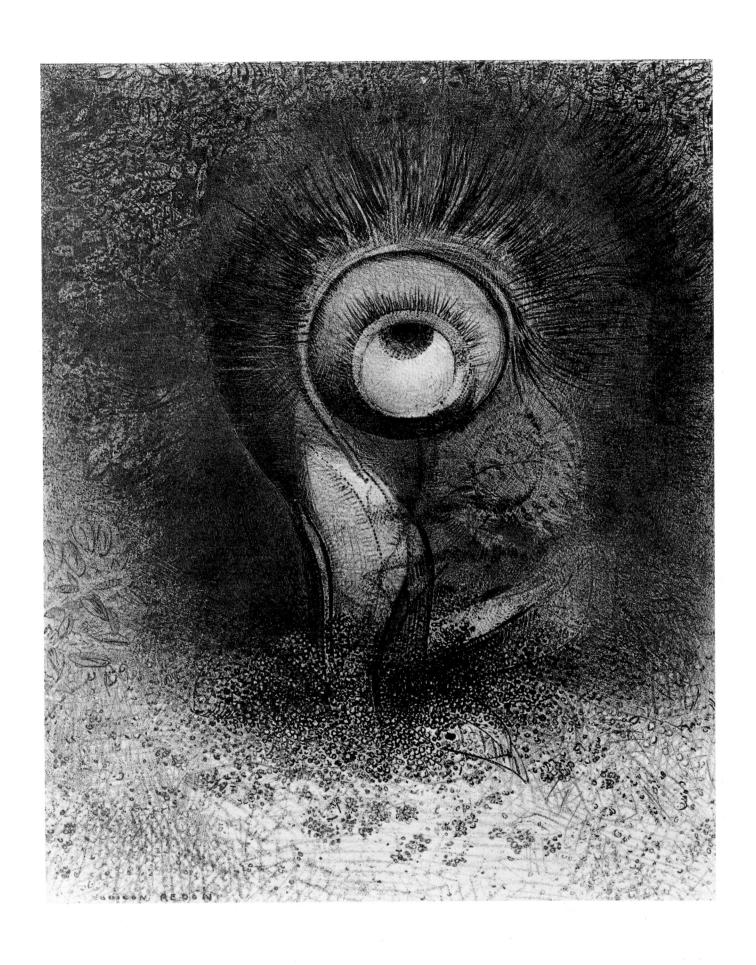

*Il y eut peut-être une vision première essayée dans la fleur*

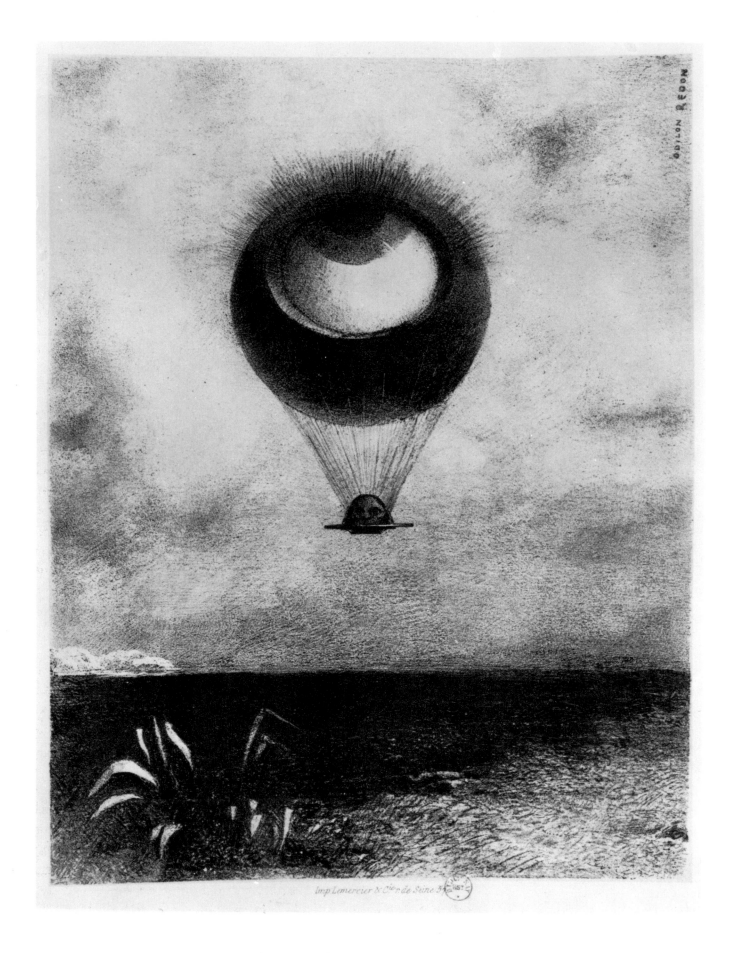

*L'oeil comme un ballon bizarre se dirige vers l'Infini*

The lumps, excrescences, and ramifications of the trunk, the irregularities of the bark also shape the craggy profile, the contorted ear, the great curved nose; from the forehead and skull bare branches emerge and twist to form a cap. Other broken-off twigs create lumps on the chin and forehead; a whirl of grasses forms the hairs of the beard and head; a fungus, the animal grimace of the mouth; dry twiglets, the bristly tufts of beard. Amused by his own clever and childish game, the painter has even decorated the cap of that fatuous brute with slender ivy sprays and given him a showy cravat with two lemons hooked to a twig.

The resulting effect is at once farcical and macabre — the cracks and scales of bark crumbling on the swollen, skinny neck, the sunken, lined cheeks, the great scraped nose of the bestial physiognomy, reveal simultaneously a penetrating observer of nature trained at Leonardo's school; the hand of an extremely skilful draftsman capable of rendering the movement of a substance that is disaggregating, crackling, rotting, and a depraved, almost diabolical, artist's imagination.

The slimy eye, sunk between fringed scales of bark as though between bristling lashes, has a disgusting, porcine look; a corrupt life seems to swarm up the neck, in the hairy ears, in the bristly cheeks, like worms crawling over a corpse; and something in the artificial figure, composed as if for a brutal joke, recalls the torture masks that emerged from Leonardo's pen. The master's tragically merciless spirit becomes a macabre joke in the work of the extravagant Arcimboldo, but none of the direct disciples of the great man showed the ability of this late follower to sense and render the movement of molecules, the inner structure of living forms. [...][5]

1934: Giorgio Nicodemi

Among the innumerable surprises that Lombard painting reserves for anyone who wants to investigate it and discover what a wide variety of attitudes could inspire a series of artists completely imbued with the traditional virtues of balance, unified color, and spaciousness, none is more strikingly modern than that given by painters active at the end of the Cinquecento.

The great theorist who observed their work and tried to formulate its critical rules, Giovanni Paolo Lomazzo, unhesitatingly believed in the real greatness of the movements developing around him. His successor, more cautious and more prudent, being unable to grasp properly either the fanciful expressions of the writer or the paintings that justified them, for a long time abstained from investigating the art that flourished in Lombardy in the second half of the Cinquecento.

Only in modern times was the attempt made to identify the immediate origins of seventeenth century Italian painting in that

Odilon Redon
*L'oeil comme un ballon bizarre se dirige vers l'Infini* (*The eye like a strange balloon moves towards the Infinite*), 1882 dedicated to E.A. Poe
Lithograph, 26.2 × 19.8 cm
Cabinet des Estampes
Bibliothèque Nationale, Paris *

period. To the astonished eyes of the scholars it became apparent that there should be a new attention to the experiments of a painting that with Figino, Simone Peterezzano, the Campi, and Lomazzo himself had prepared the way for the most important and tormented figures of an art that, from Caravaggio to Daniele Crespi, embodied a new, profound order of forms and ideas.

The origins of this art are to be found in the upheavals and experiments in which the concern of abstract painting with volume and form is confusedy present, the interest in fantastic inventions, fanciful images, still life, down to episodes from ordinary life. The master who first and most rightly deserves investigation is probably the painter Giuseppe Arcimboldo. His name comes to us on the wings of the fame attributed to him by his contemporaries. [...][6]

## 1937: Vítězslav Nezval

Once in the office
Of a dental technician
In his mouth he discovered
Two millstones
That were just grinding the glass eye
Of his cannibalistic desires
He dared not move his tongue
Which was the shape of a mole
And was crouching timidly
Unable to say yes or no
When he awoke from the anaesthetic
He saw his own head
In the ten windows of the street opposite
Spit
A cloud of quails
Who flew to rest on the plateau of an omnibus
Which was driving away
A bed strangely taken to pieces
As if it were changing home

At that time
His neck was formed
By a bunch of Havana cigars
Held together
By a simple high collar fairly tight
With big points
Under it instead of a tie he fixed
A tame swallow
Which had its nest in the perfumery
Where in summer
He put away his typewriter

Odilon Redon
*Partout des prunelles flamboient*
(*Everywhere pupils blaze*), 1888
in *Temptation of St. Anthony*
Lithograph, 20.4×15.8 cm
Cabinet des Estampes
Bibliothèque Nationale, Paris *

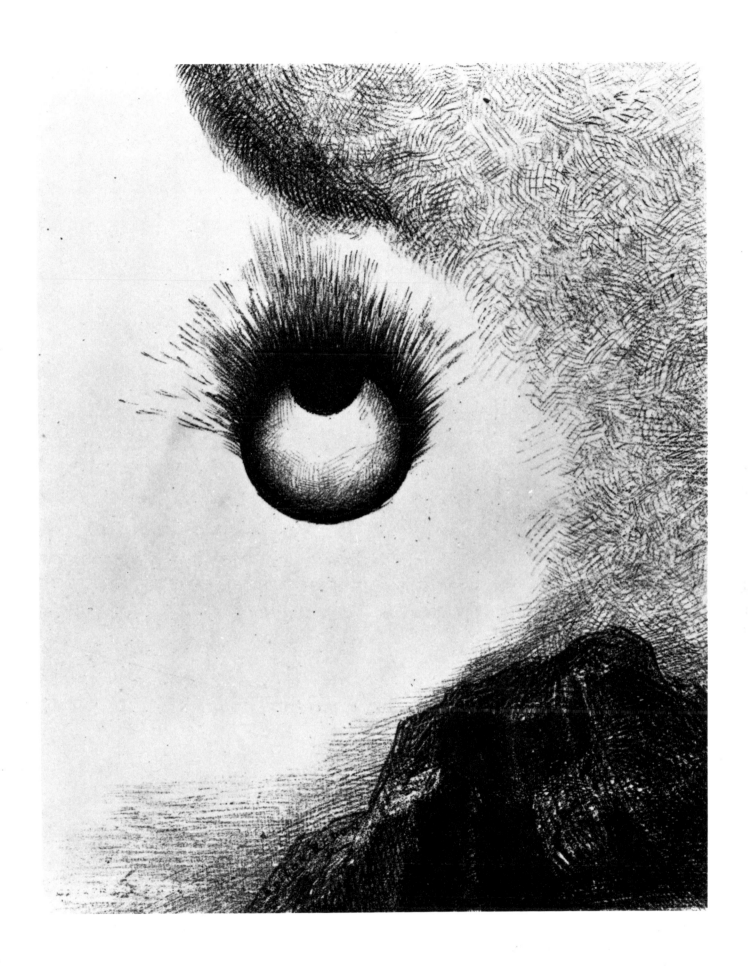

*Partout des prunelles flamboient*

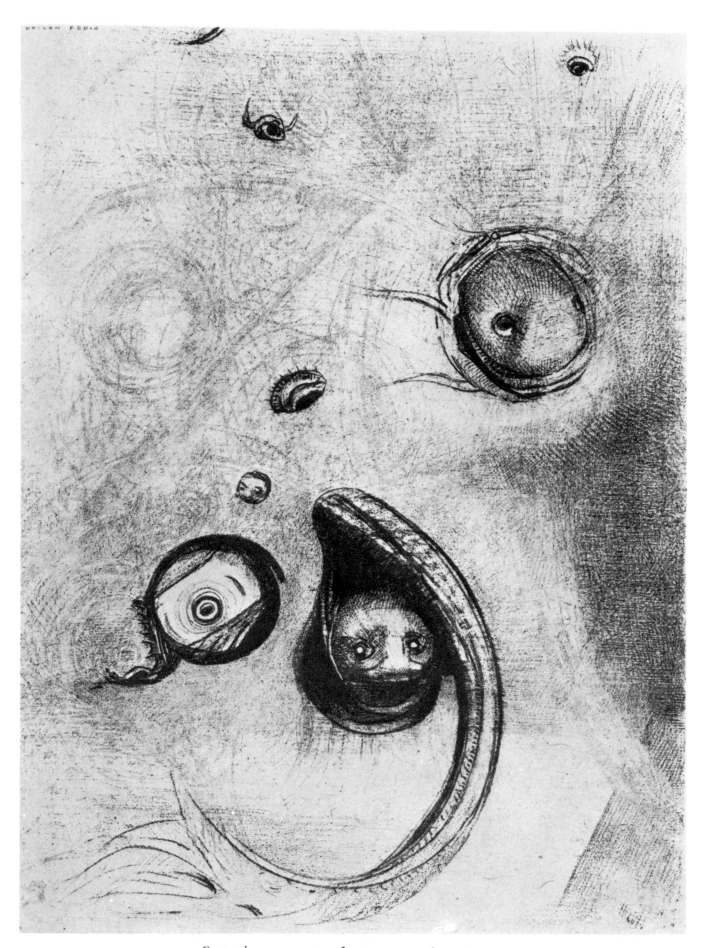

*...Et que des yeux sans tête flottaient comme des mollusques*

On his chest
Covered by a linoleum shirt front
Inlaid with Swiss watches
Rested the blonde head
Of a mermaid
Whose mythological tail had grown
Down to his stomach
And which
From time to time like in a dream
Coiled upward
Seeking
His lips
Covered with cellophane

There were days
When he grew old before his time
So that his hair
Had the appearance
Of white shavings
And fell
Under the merciless strokes of the plane
Of a great self-martyrdom
Which never for a minute stopped chopping up
The top of his skull covered with bumps
And grated
The cabbage-head stuffed with pains
Until the fingers of sleep
Pushed away the terrible hairbrush
He also fell
Into difficult states of mind
During which he changed
Into two rams
Who charged each other head on by surprise
And tried
To destroy all his joy[7]
[...]

One thing is particularly striking in the extracts that follow: generally speaking, the main concern of the writer is not that of an art historian or critic, a "technician" specifically interested in the study of painting and the practice of his own speciality. Interest in Arcimboldo remains constant in the period following the second world war, but the fact that he was above all a painter does not seem to be of primary importance for the authors represented in this brief review.

Is this a merit of Arcimboldo's or a demerit of these modern writers? In other words, is it because their arguments, as though attacked by claustrophobia, refuse to be contained in the limited sphere of a

Odilon Redon
...Et que des yeux sans tête flottaient comme des mollusques (And eyes without a head floated like molluscs), 1896
Lithograph, 31×22.4 cm
Cabinet des Estampes
Bibliothèque Nationale, Paris *

221

*techne*? Or is it because the paintings by the author of the *Seasons* and the *Elements* spontaneously overflow the limits of their own time and specific nature as painted objects, becoming obedient pretexts for argument?

The distinction existing between the "fact" of Arcimboldo's portraits (their objective character as works created under certain conditions — historical, cultural, biographical, etc.) and their peculiar ability to lend themselves to very different approaches without betraying them, creates the modernity of this artist. Through him, contemporary man can finally find himself reflected in his own culture again.

It is true that Arcimboldo's painting marks the critical moment when the unity of Nature disintegrates and the horizon of knowledge breaks up into a series of fragments which cannot be recomposed (Wescher, Baltrušaitis, Legrand and Sluys). What seems to be important, however, is the fact that he gives our modern generation the perfect opportunity to make a statement which ultimately says less about Arcimboldo's personality and art than about our own particular attitude as modern men unable to go beyond the impasse of a culture formulated and experienced as a mirror reflection.

This hindrance, common to the arts and thought of our time, has given rise to opinions like those of Geiger, a consoling representative of "common sense" who resolves the anguish of the impasse by denying modern painting (which he can oppose with particular force precisely while reflecting on Arcimboldo's idea); or like those of Hocke and Barthes, who try to solve the dilemma by shifting and substituting its terms. The former presents an interesting but far-fetched argument suggesting that Arcimboldo's canvases are metaphors to be read as a set of rhetorical devices — since the artist must have been familiar with the principles and rules of rhetoric, he says, the pictures should be seen as a systematic application of this art. Barthes, with an even more fascinating argument, actually supposes that Arcimboldo had an explicit linguistic intention. The Milanese artist is detached from his own immediate reality of the paintbrush and categorized as a mere logotype of the cultural alphabet of the West.

So is it perhaps better to follow Breton or Caillois, who deliberately keep their arguments below this critical limit and even consider Arcimboldo's *mirabilia* with a certain detachment? It is hard to say...

## 1950-51: Paul Wescher

Arcimboldo's double images with their intentional deformations of human monsters express the split which the new natural sciences were producing in traditional conceptions of the period; the old unity was being splintered like a mirror reflecting the universe, and among the remaining fragments appeared the parts of a new reality.

*Composite Head*, 1900 c.
French post-card
Private collection, Paris *

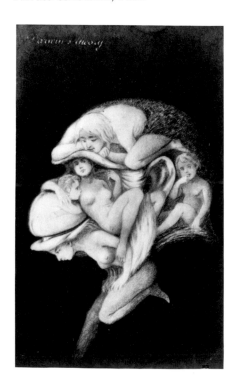

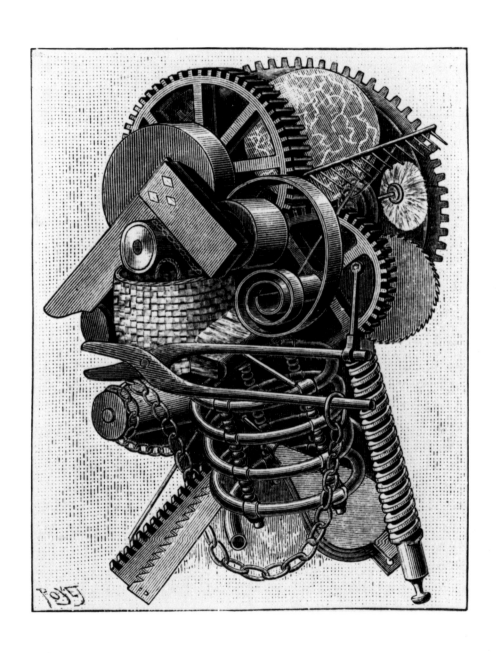

Woodcut by Louis Poyet
*The Head of the Inventor*
in *La Nature*, Paris, Masson, 1890
Institut Catholique, Paris *

Man's mind had been left confused and his image distorted by the schism between these different realities. His capacity to solve the secrets of nature was precisely what distinguished him from nature itself; but he could no longer explain himself in terms of elements of the universe from which his knowledge now definitely separated him. No longer in harmony with the universe, he had subconsciously become a riddle to himself, a distorted caricature of his own speculations. [...] After the long simplifying process of materialism and naturalism, we are again living in a period of transition similar to that of Arcimboldo though in reverse. The idea of the automaton has been revived by De Chirico, Léger, Max Ernst, Dalì, Masson, and many other painters. Tchelitchew's paintings such as *Forest of Four Elements*, *The Golden Leaf*, or *Hide and Seek* bring back the idea of microcosm and macrocosm. Under the influence of Freud and *automatique psychique*, the double image has changed into "chance pictures" or "paranoiac pictures." The ambiguity of Arcimboldo's heads appeals to surrealist artists not only by their irrationalism but also because of the tension, on the one hand between reality and art, and on the other between a picture of fruit that is simultaneously the picture of a head. [...][8]

Woodcut (anonymous)
*Shoemaker*, 19th century

## 1951: Jurgis Baltrušaitis

A collection of different elements, fitted together with extreme precision, makes up a series of human heads in which every detail is exactly in its place. This is a strange form of composition in which the attributes of an allegorical character seem to multiply and penetrate inside the figure in order to construct it. The exchange between a living being and a complex mechanism of objects shows a strange turn of mind. (...)

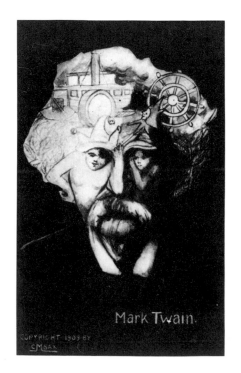

*Composite Head of Mark Twain*, 1900 c.
American post-card
Private collection, Paris *

A Milanese painter, Giuseppe Arcimboldo, excelled in this sort of composition. The face of *Winter* is made up of trees stripped bare by the cold. Summer is a pile of fruit and vegetables: ears of corn decorate the neck, the cheek is an apple, the chin a pear, the head is crowned by a basket of plums and grapes. The splendor and weight of these products of a fertile earth seem to overflow the picture. The image recalls the glory of the gods of antiquity, enhanced by bunches of grapes and leafy fronds. But the system is completely recomposed in an organic unity. The plants cluster together to form a profile like the chaotic medley of beasts inside oriental animals. This is not a flowering on man's head but a skilful construction, against nature. (...)

## 1954: Benno Geiger

If today's painting, or rather the part of it that goes in for acrobatics, wanted to find evidence in past centuries that could support or confirm its practices, Arcimboldo with his *bizzarrie* could provide that

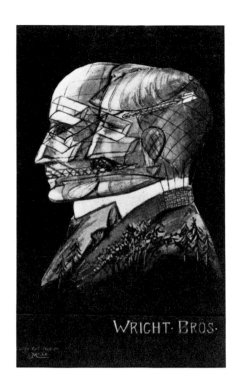

*Composite Heads of the Wright Bros.*
American post-card
Private collection, Paris *

Woodcut (anonymous)
*Hatter*, 19th century

credential. Not that I appreciate the current, very obtrusive art of the abstractionists, surrealists, atomicists or spatialists, as they call themselves in turn: starting from principles that are generally quite bourgeois and normal, and from an education that is nearly always limited, out of pure desire to conform to the taste or distaste of our times they try to distinguish themselves by their extravagances, jumping from one idea to another into the Paradise Lost of the subversive Picasso. It is not because I feel obliged to build a historical pedestal for these practitioners that I am taking up the cause of Arcimboldo. Perhaps I am doing so to prove precisely the contrary. [...][10]

## 1955: Legrand and Sluys

Modern man stops short in astonishment before these terrifying apparitions embodying *Water* or *Fire*, before these images designed to perpetuate the memory of a *Reformer*, a skilful *Cook*, a scholarly *Librarian*. Torn between laughter, fascination, and repulsion, an indefinable feeling of discomfort and even frustration comes over him. An enigma, a mystification, a farce, a challenge, a symbol... he has no idea how to interpret these strange compositions.

Out of a touching human countenance revealing passions, filled with youth and joy or worn by toil, hardship, or vice, Arcimboldo has made a structure that is visually valid — the work is solid, well put together, sometimes even impressive; the drawing is confident, the color restrained and not unrefined — but he has totally mocked like nobody else the idea of the face as "the mirror of the soul." Rather than trying to capture a person in a fleeting moment of intimacy, the painter has deliberately excluded all traces of inner life and banished every emotion. [...]

The surrealists finally rediscovered the shock effect of these visual eccentricities. In the "composed heads" they could see an attempt to create disorientation similar to their own efforts. They appreciated the "black" humor that flouted moral conventions with deliberate cynicism. [...][11]

## 1957: Gustav René Hocke

We have seen that there are several sorts of "transpositions." One of these forms is the "transfer of a quality belonging to a living creature to another living creature" (fox=cunning man); Arcimboldo paints canvases representing people made of animals or flowers. Another form is the "transfer of the inanimate to the animate" ("heart of stone"); Arcimboldo painted a cook composed of cooking utensils. In his work, is there also a transfer of the animate to the inanimate (for example, the "face of a landscape")?

From the technical and formal point of view Arcimboldo's art can be defined as an allegorical metaphorism, in the sense of a pararhet-

225

oric (artistic importance given to everything Aristotle defines as "faults," particularly in the fifth book of his *Rhetoric*). [...]

Unfortunately the knowledge of rhetoric, of the fundamental forms of "elocution" — the Aristotelian tradition — is increasingly disappearing in modern Europe. [...][12]

## 1957: André Breton

Although according to several testimonies, the choice and placement of the allegorical elements used by Arcimboldo to compose his strange portraits were the result of almost esoteric concerns, there is more true magic in the works of his "disciples" than in his, at least in the series of the *Seasons*, mainly of German origin, where a breeze of pantheism blows.

Anthropomorphism, here as elsewhere, plays havoc — the simple analysis of the human face is replaced by its recomposition, and this sort of pre-cubism in reserve never attains the depth of Chinese geomantic paintings where the "azure dragon and white tiger" redistribute the heavenly influence through trees and rocks [...].

Instead of evil hills "looking like a horse's eye, a tortoise or a basket," Arcimboldo only composes portraits. [...][13]

## 1965: Roger Caillois

I admit that the delirious appearance of Arcimboldo's paintings strikes the eye. I agree that it is delightfully imaginative to put together flowers, fruits, and fishes in such a way that faces or personages are created, made up entirely of elements belonging to the same series. But can one deny that this is nothing but a game, a challenge? [...]

I see only an amusing procedure, systematically applied and depending entirely on a well-practiced hand once the rules have been given. To classify such works as fantastic art when their character as sheer conventional, mechanical virtuosity leaps to the eye, seems to me wrong-headed or at least strangely superficial.

Arcimboldo's art is sometimes presented as a miraculous event, created from the void or resulting from mysterious Far Eastern influences. I think the truth is simpler: throughout the fifteenth century miniaturists were engaged in composing initials in the form of plants, animals, or people. The figures were twisted and contorted to make them into readable letters, but each element remains a living creature — a monster, a root, or a tendril, a juggler or an acrobat or even a disjointed skeleton — drawn as faithfully as possible and with abundant detail.

The origin of the procedure is clearly ornamental. Arcimboldo adopts it, drops the alphabet but uses the same device to create faces or landscapes with ingenious combinations of independent forms

l'un après l'autre dans la partie qu'on lui indique. Comme dans tout tableau indicateur une simple pression sur un bouton, placé à portée de la main,

Fig. 2. — Détail de la tête de la silhouette.

permet de faire disparaître les voyants soit après chaque coup, soit en bloc pour recommencer le tir.

Ce système très ingénieux, robuste et pratique, permet de tirer très rapidement puisqu'on n'a jamais à s'occuper de la cible et il a, en outre, le grand avantage d'assurer une sécurité absolue.

B. LEBLOND.

Woodcut by Louis Poyet
*Captain Chevalier's Electric Target*
in *La Nature*, Paris, Masson, 1903 *

belonging to the same series. His aim is to make the eye alternately break up the image and then recompose it. I repeat: I admire the game, but in my opinion to consider it mysterious is going too far. [...][14]

1977: André Pieyre de Mandiargues

In this immense field, Arcimboldo's work stands out to my eyes as a bright, fixed pole of attraction. It is fascinating, exciting, and yet reassuring, because it is the work of an artist who is perfect in his own way as only the greatest masters are.

Fig. 6. — Moulages de la bouche prononçant les voyelles.

la photographie de cette flamme était celle des vibrations. Enfin est intervenu le phonographe, modifié pour ces sortes de recherches. Toutes les causes d'erreurs étant écartées aussi rigoureusement que possible, les tracés obtenus par les trois appareils étaient semblables. C'est ainsi que l'on a constaté que les voyelles parlées ont des tracés très caractéristiques, tandis que le groupement des oscillations de ces mêmes voyelles est assez difficile à retrouver lorsqu'elles ont été chantées. Dès ces premiers travaux il a été reconnu que les voyelles I et OU sont constituées par une vibration unique; E et O sont formées de deux vibrations et enfin A de trois vibrations (fig. 2). Ce résultat ne pouvait être considéré comme acquis qu'après avoir été vérifié par d'autres méthodes. C'est alors que dans le même but sont intervenus les appareils électriques : en premier lieu

l'oscillographe Blondel et ensuite le récepteur téléphonique. L'idée d'utiliser le récepteur téléphonique est venue au docteur Marage à la suite d'une communication faite à la Société de physique sur l'appareil télégraphique extra-rapide Pollak-Virag. Bien que le principe de cet appareil ait déjà été décrit, il nous semble intéressant de le rappeler, au moins en ce qui concerne l'application spéciale qui en a été faite par le docteur Marage.

Le récepteur téléphonique, recevant les courants émis au poste de départ, transmet les vibrations qui agitent sa plaque à un miroir M (fig. 9) placé devant lui auquel il est relié par un support rigide. Ce miroir reçoit en permanence un faisceau lumineux d'une lampe S et le dirige à travers la lentille L sur une bande de papier P située au foyer de la lentille. Un simple point lumineux vient donc

Woodcuts by Louis Poyet for the article by Dr Marage on the photography of the voice in *La Nature*, Paris, Masson, 1908 *

227

I admit that he is a mannerist, because the label applies to his whole century, or nearly, but his paintings never try to tell a story or re-evoke a dream like most of the members of this school. I admit that he is baroque, because of his shock value and his delight in masquerade, but I see nothing convulsive or extravagant in his work. I also admit that he is a pre-Romantic, because of his use of natural elements, but this is only an instrumental use that never touches on a feeling for nature or tends toward lyricism. That he is "fantastic" I also admit, on condition that the formula is merely opposed to that of "artistic" realism, according to Plato's argument in the *Sophist*, taken up by Comanini *à propos* of Arcimboldo in his Neoplatonic dialogue *Figino*; but that he is a pre-surrealist like Hieronymus Bosch (the most genuinely surrealist painter of the past) as has been said too often, I deny, because I cannot find any element having an unconscious, automatic, or dream origin in his work.

The same goes for the accumulations that make up Arcimboldo's "composed figures," where I agree there is a playful, sometimes humorous element, but without imprisoning the painter in the limited vision to which his friends Comanini, Morigi, and Lomazzo confined him, I refuse to consider Arcimboldo's painting a simple collection of emblems.

All these interpretations merely distort or diminish the splendor of the work they claim to explain and which in fact is not at all obscure.

Much more important, it seems to me, is the aspect of anthropomorphic still life present in almost all Arcimboldo's composed figures and almost all his paintings, even the two reversible panels. The fact that the still life gains vitality from the subtle contrivance of his composition seems to me one of the genuine "marvels" produced exclusively by the author's skilful use of palette and brushes. [...]

Moreover, the observation of what I have called the "phenomenon" — and it proves to be one in the most meaningful sense of the term — leads us to discover a third or even a fourth dimension in Arcimboldo's painting. By third dimension, I mean the distance one must step away from the picture so that one no longer sees the still life elements — fruits, flowers, land, or water animals, utensils and materials of various kinds — and instead perceives the charming, majestic, imperious, or ridiculous whole of a human face. And the fourth dimension I consider the minutes or seconds it takes the observer to cross the distance separating him from the point (or moment) when the transformation takes place before his eyes.

Thus the idea of volume, or at least of relief, and a certain idea of time are introduced into the picture plane, which is really exceptional even for the fanciful capital of Bohemia in the sixteenth century!

Louis Ducos du Hauron
*Anamorphic Self Portrait*, 1889
Slide
Société Française de Photographie, Paris *

Self portrait of Frederic Eugene Ives
(detail), 1890 c.
The American inventor of the
half-time printing

And to the question of whether Arcimboldo was aware of how many innovations he was introducing in his art, my answer is that I believe he was, because this profoundly enigmatic man seems to me one of the least limited artists that have ever lived. [...][15]

1978: Roland Barthes

Rhetoric and its figures of speech was the way the West meditated on language for over two thousand years. It never ceased to admire the fact that there could be transformations of meaning in a language (metabola) and that these metabola could be codified, classified, and named. In his way Arcimboldo is also a rhetorician: his *Heads* throw a whole bundle of rhetorical figures into the discourse on the Image — the canvas becomes a laboratory for tropes.

A shell stands for an ear, which is a *Metaphor*. A bunch of fish stands for Water — in which they live — and that is a *Metonymy*. Fire becomes a flaming head, which is an *Allegory*. To enumerate fruits — peaches, pears, cherries, strawberries — and ears of corn to convey the idea of Summer is an *Allusion*. To repeat a fish to make a nose in one place and a mouth in another is an *Antanaclasis* (repeating a word in a different sense). To evoke a name by another that has the same sound is a *Paranomasia* or play on words; to evoke one thing by another that has the same form (a nose by a rabbit's back) is a paranomasia using images, etc. [...]

Now, Arcimboldo's art is an art of fabrication — that is to say, a message to be delivered. When Arcimboldo intends to signify the head of a cook, a peasant, a reformer, of Summer, Water or Fire, he ciphers the message. Ciphering means to hide and not hide simultaneously. The message is hidden because the eye is distracted from the sense of the whole by the sense of the detail. At first we only see that fruits or animals are piled up before us, and then by making the effort to distance ourselves and change the level of perception, we receive another message. This is a hypermetropic apparatus, which like a decoding grille allows us to suddenly grasp the global, "true" sense.

So Arcimboldo imposes a substitution system (an apple substitutes a cheek, just as in a coded message a letter or syllable stands for another letter or syllable), and also a transposition system (the whole picture is in a sense shifted back toward the detail).

However — and this is Arcimboldo's special characteristic — the remarkable thing about his "composed heads" is that the picture hesitates between encipherment and decipherment. In fact, when we have removed the substitution and transposition screens in order to see the composed head as an *effect*, the interlacement of original meanings which served to produce this effect still remains in our eye.

Louis Ducos du Hauron
*Anamorphic Self Portrait*, 1889
Slide
Société Française de Photographie
Paris *

231

In other words, from a linguistic point of view — which is really his — Arcimboldo speaks a double language, simultaneously plain and scrambled; he fabricates gibberish, a nonsense language, but these inventions are perfectly intelligible. Ultimately the only *bizzarreria* that Arcimboldo does not invent is a completely incomprehensible language. His art is not mad. [...][16]

1. "Dinocrate's Project" in *Scientific American*, New York, 1885.
2. In *La Nature*, Paris, 1890.
3. "Un rocher à la figure humaine" in *La Nature*, Paris, 1899.
4. *Kunstgeschichte als Geistesgeschichte*, Munich, 1924.
5. In *Storia dell'Arte Italiana*, Milano, 1934.
6. "Giuseppe Arcimboldo" in *Città di Milano*, Milan, 1934.
7. The Man Who Composes His Own Portrait with Objects, Prague, 1937.
8. "The 'Idea' in Giuseppe Arcimboldo" in *The Magazine of Art*, Washington, D.C., 1950-51.
9. "Tête composée" in *Médicin de France*, Paris, 1951.
10. *I dipinti ghiribizzosi di Giuseppe Arcimboldo*, Florence, 1954.
11. *Arcimbolde et les Arcimboldesques*, Brussels, 1955.
12. *Die Welt als Labyrinth*, Hamburg, 1957.
13. "Crise de la magie" in *L'Art Magique*, Paris, 1957.
14. *Au coeur du fantastique*, Paris, 1965.
15. *Arcimboldo le merveilleux*, Paris, 1977.
16. *Arcimboldo*, Parma, 1978.

Etienne-Jules Marey
*Rotation of the Head on the Cervical Axis*, 1894
Photographical study
Archives du Collège de France
Paris *

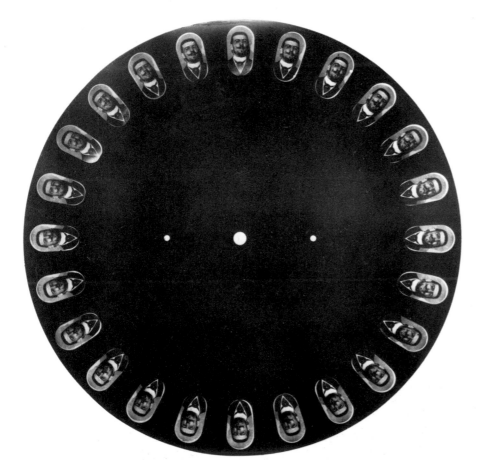

Georges Demeny
*Je vous aime*, 1892
Phonoscope record *

Georges Méliès
Still from the movie
*The Man with a Caoutchouc Head*
1902 *

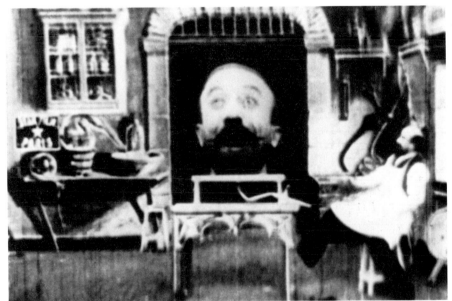

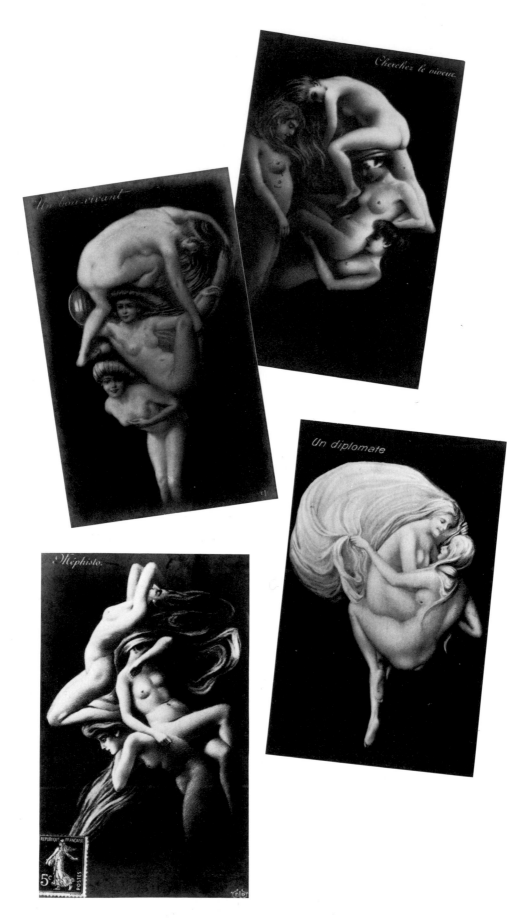

*Composite Heads*, 1900 c.
French post-cards
Private collection, Paris *

# Kao at the Dawn of Modernity

by Aomi Okabe

Utagawa Kuniyoshi
*Composite Head of a Woman*
19th century
Woodcut, 36.5×24.3 cm
Museo d'Arte Orientale
Edoardo Chiossone, Genoa *

Natives of Edo (*edokko*), the *Ukiyo-e* masters Hokusai Katsushika and Hiroshige Andō were active as artists at the time when a subtle crisis was undermining the feudal system of the shogunate, at the close of the Edo period. Another *Ukiyo-e* artist who was their contemporary, the son of a master dyer of Nihonbashi, combined the temperament and cast of mind of a true *edokko* with an understanding of the common people: Kuniyoshi Utagawa (1767-1861).

*The Apparition of Legendary Figures in Yorimitsu Minamoto's House (Minamoto Yorimitsu-ko yakata tsuchigumo yogai a nasu zu)*, a work composed by Kuniyoshi in 1843, made history thanks to the attack of the critics, who saw in the painting a strong vein of sarcasm directed towards the government. The violent controversy affected the artist personally — arrested by shogunal officers, Kuniyosho was subjected to harsh interrogation.

His strange *yokai-ga* painting — as works were called that found their inspiration in the fantastic, bizarre world of ghosts — in reality aimed at rendering the "face" (in Japanese, *kao*) of the Tenpo years (1841-45), during which one of the three great reforms that characterized the Edo period was strongly developed. This was a particularly severe moral reform aimed at consolidating the power of feudal government. Regulations were dictated down to the last detail imposing frugality, sobriety and simplicity, and so forbidding the purchase and sale of luxury clothes and foods. The press was censored and the life of hairdressers and prostitutes became difficult.

*Nishiki-e* (multicolored "brocade print") painting, a variant of *Ukiyo-e*, did not escape the dictates of the reform: bright colors were categorically forbidden and it was not permitted to portray contemporary figures such as actors or *geisha*, courtesans. This was a very severe blow inflicted on the *Ukiyo-e* masters, whose art found its vitality and inspiration precisely in the two great portrait subjects of beautiful ladies and actors.

The term *ukiyo*, "the passing world," from the compound work *Ukiyo-e* (*e* = painting), is linked to the rise of the new merchant class in the towns and the conception of a free, open life that prevailed during the Genroku period (1688-1704).

*Ukiyo-e*, widespread thanks to a large-volume production of woodprints, had become one of the irreplaceable pleasures of the period,

being rooted in ordinary everyday life. It is no exaggeration to say that in the portrayals of female beauties and actors, the common people saw their dreams and desires come alive.

The reform imposed on *Ukiyo-e* ultimately had the effect of an action of self-control. Public awareness, however, reacted with immense vitality, reflected henceforward in the work of Kuniyoshi, where it gave artistic life to caricatures in which an intelligent parody was subtly concealed. In his works we find cats or goldfish personifying actors, for instance, or courtesans portrayed as swallows, depicted with fresh, biting irony and a fantastic and original imagination.

Kuniyoshi's portraits, rather than representing the physical characteristics of a person, aimed at revealing the soul, in a happy artistic synthesis on themes such as "A bully becomes human," "The man who mocks others," "A youth who seems an old man."

Those were the years in which the reform of the Tenpo period was ending, having lost its authority, and 1848 was on the horizon. Taken as a whole, his work from that period reveals a portraiture of faces with ironical expressions containing elements of parody. Kuniyoshi also created puzzle scenes containing a riddle to be solved, the so-called *hanji-e*. Here we find figures with haunted eyes, and a moving head and body joined in ingenious, complex ways, which turn into different images according to how they are looked at. A unique antidote to boredom, they were called "prints of yawn-stopping characters." The origin of this genre of *yoko-zu* painting, "portraits on several levels," probably goes back to the Chinese work *Gotoshi* (*The Five Children*). Kuniyoshi's style, however, differs considerably from the prototype in the dynamic, ludicrous movement of each figure and the way the expressivity of the faces is articulated and changes. Compared with the series of caricature portraits mentioned above, these later works express a greater apparent serenity. Unchanged, however, remains Kuniyoshi's unique interest in the physical appearance of his characters, which is a fundamental element of his portraits. Complementing the curious anomaly of the sinuous, almost contracted lines of the figures, the face becomes the synthesis of a fragile, delicate balance.

Caricature, no longer harmless, provides a reading of the history of a crisis of artists deprived by the will of the state of their freedom to paint the faces of beautiful women or theatre actors as they would have liked, reflects the crisis of a whole period in which the only "face" that could be portrayed was the official one of feudal morality. This meant the loss of true, live portraiture, with its meaning for the common people, to whom it had transmitted something more than an image of the contemporary idea of a full life. The portrait of the countenance defined and imposed from above and from outside could be only an empty reality, with no contents or possible readings.

Utagawa Kuniyoshi
*Composite Head of a Man*,
19th century
Woodcut, 36.5×24.3 cm
Museo d'Arte Orientale
Edoardo Chiossone, Genoa *

236

If one analyzes the style that developed at the end of the eighteenth century during the Kansei years of the Edo period, it becomes clear that the conception of the inner expressive world revealed by the face portrayed is related to the then fashionable *hame-e* painting, which associated various elements of composition; but the play of metamorphosis in the image testifies to the presence of a direct influence of Arcimboldo's art.

The *Biographies of the Ukiyo-e Master Utagawa* tell us that besides European paintings, Kuniyoshi also possessed illustrated reviews of European art. The master himself remarked, "If it is Western art, then it is real painting." The mercantile exchange with Holland of the period made it easy to procure paintings and engravings from overseas. It is therefore by no means improbable that Kuniyoshi had direct knowledge of the work of Arcimboldo, or of paintings by artists who had been strongly influenced by him, since between the sixteenth and seventeenth centuries there was a widespread fashion in Europe for painting in Arcimboldo's manner.

Kuniyoshi's strong interest in European painting was transmitted in a meaningful and stimulating form to numerous disciples. Here we should mention the artistic movement known as "Yokohama *Ukiyo-e*." In 1859, in concomitance with the opening of the port of Yokohama, many *Ukiyo-e* painters took the ways of the newly arrived foreigners as themes for their work. Yoshitora, Kuniyoshi's most talented follower, besides painting the greatest number of "Yokohama *Ukiyo-e*," also created *nishiki-e* on the subject of *fuku-warai*, "the smile that brings happiness," a traditional game particularly among children.

*Fuku-warai* is usually the image of an ugly snub-nosed woman with absurdly round cheeks (*otafuku*). The game goes like this: on a piece of paper showing the profile of a face, a blindfolded player tries to pin cutout paper silhouettes of the eyes, nose and mouth. Finally he is allowed to look at the result and bursts out laughing at the sight of the comic, ugly face he has created.

The origin of this typical New Year pastime has been the subject of various speculations. The most widely accepted explanation is that it was born of the conviction that a game of this sort is always amusing and that laughter in itself produces happiness. Particularly from midway through the Edo period up to the years immediately preceding the second world war, it was an extremely popular and widespread form of amusement. Known to all the Japanese as a traditional New Year's game, it still survives but is disappearing now.

Something in common can be glimpsed between *fuku-warai* and Kuniyoshi's art. Like a blindfolded man who is denied the vision of objective reality but in compensation has the "privilege" of giving form to a face starting from a mere profile on a white sheet, shaping it in a mental vision and then changing and distorting it at random — the game that is the basis of *fuku-warai* — so Kuniyosh's *Ukiyo-e*

*Composite Head of Xantippe*, 1900 c.
French post-card
Private collection, Paris *

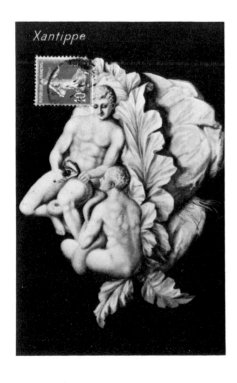

caricatures show the reaction to that face, quite "empty" of any living reality, that was codified and imposed with tragic historical violence by ignorant statesmen cut off from the common people. And just as the game always ended in laughter, significantly the painting of the period became transformed into a sort of delight in portraying the ludicrousness of a blindfolded player trying to "create" a face he cannot see. The *Ukiyo-e* show us how the intrinsic vitality of the common people's spirit, translated into the culture of the time, could react with laughter and sarcasm towards the existing world of values.

The theme of the ear, which dominates the art of Tomio Miki (1937-1978), is also inseparable from the historical context of a crisis. The new postwar generation, often in a theatrical way, destroyed and negated the validity of existing social values. Towards the end of the fifties the young Miki made his entrance into the world of art by burning the canvases of his works with an inflammable substance, leaving only the frames intact. Miki was one of the early leaders of the neodada "anti-art" movement.

In 1960 there was a strong campaign of opposition to the signature of a new security pact between America and Japan, a campaign recalled by many as the moment of greatest crisis for postwar democracy. The government's final decision on the subject closed what had become a highly sensitive issue, but the almost revolutionary attitude on the part of young people no longer prepared to leave everything in the hands of the official government marked a new epoch. The sixties also saw the evolution and increasing competitiveness of the Japanese economy, a great leap forward in industrial production and the beginnings of an interest in controlling town-planning in the large cities.

From 1963 onwards, as the subject of his art Miki took the portrayal of ears, particularly the left one, in innumerable variations. The vital organ that continues to transmit, multiply and integrate non-sensations, although part of a whole in fact symbolizes the capacity of objectifying the degree of "humanity" and completeness of the image of a face. "I chose nothing, it was the ear that chose me," said Miki in reply to a question about the reasons that had led him to focus on the ear as his subject.

The "anti-art" movement in fact aimed at finding a form of total art that would be radical and at the same time dynamic. In this context Miki was attracted by the organ that is most important — the ear — in our ability to communicate, but at the same time he also discovered its negative aspects. With his premature death that looked like suicide, in his last works Miki left a shadow of mysterious doom surrounding "the ear." His works express the negativity of existence and the burden of solitude experienced by modern man, together with the sense of frustration that characterized the crisis of the sixties in Japan.

*Fuku-warai*
*(The Smile that Brings Happiness)*
Japanese game, 19th century *

238

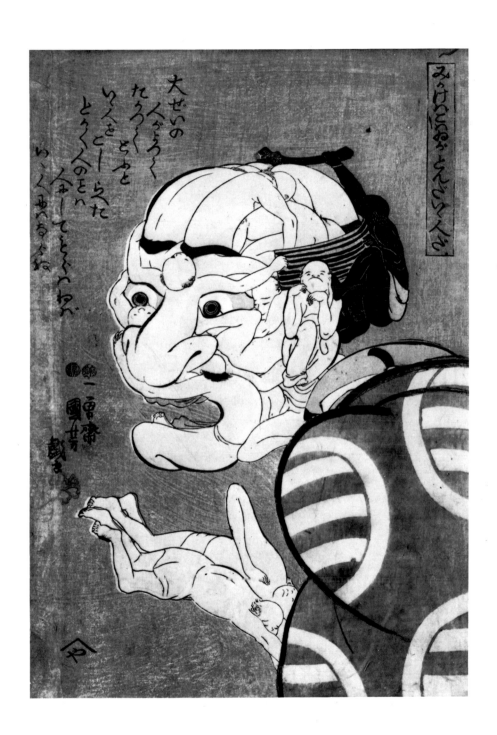

Utagawa Kuniyoshi
*Composite Head of a Man*
19th century
Woodcut, 36.5×24.3 cm
Museo d'Arte Orientale
Edoardo Chiossone, Genoa *

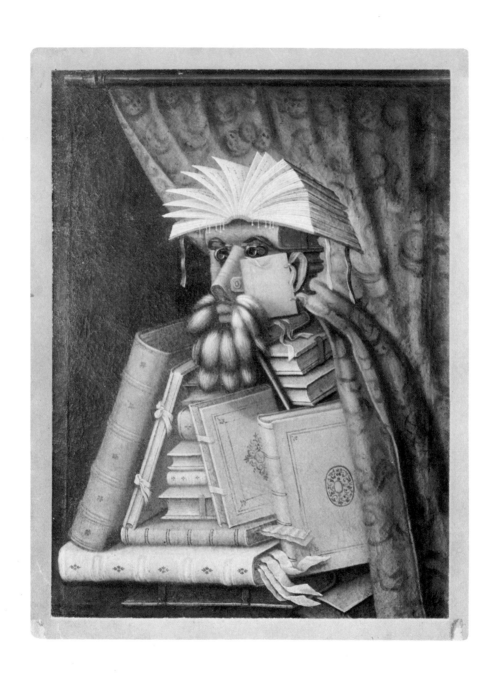

Photographic reproduction of *The Librarian*
by Giuseppe Arcimboldo

The document was catalogued by Olof Granberg
as no. 80 in the General Inventory of Art Treasures in Sweden
and dated by him 1904,
as also appear from the recto reproduced on the opposite page.

# Excerpts from the Inventory of Art Treasures in Sweden[1]

by Olof Granberg

Giuseppe Arcimboldo, Italian painter (portraitist), born in Milan around 1530 and died, also in Milan, 11 July 1593. From 1565 to 1587 court painter and very sought after organizer of entertainments and celebrations for the emperors Ferdinand I, Maximilian II and Rudolf II. He painted primarily portraits and allegorical heads composed of flowers, fruit and roasted birds: works in bad taste, but much appreciated in the past. Today his paintings are extremely rare.

320. *John Calvin* (1509-1564), the Reformer; caricature portrait; bust, turned to the left, wearing a fur-lined cloak and a black cap. The head is made up of fish and birds. Above the neck are some manuscripts and above the stomach two books; on the top one is the inscription *Isernia*. Green background. - Signed: *Giuseppe Arcimboldo F. 1566.*

*Gripsholm*

321. *The Librarian*, portrayed as a bust seen frontally and composed of books piled on top of each other. An open book represents the hair and two key rings the eyes.

322. *The Vegetable Gardener*, portrayed as a bust seen frontally and composed of fruit and vegetables. Apples serve as cheeks, cherries as eyes, two peapods as eyelids, ears of wheat as eyebrows, and a pear as the nose.

*Count Brahe, Skokloster*

323. *The Cook.* The painting shows a silver platter on which some roasted birds are arranged in such a way that, when one turns the painting upside down, they form a life-size bust portrait of a man with a sort of silver helmet on his head.

*Ax. Ekman, Mogärd*

324. *Bust of a Young Lady*, seen frontally and composed of flowers. Inscription: La flora dell'Arcimboldo.

*Pendant of the following painting*

325. *Bust of a Young Lady*, seen frontally and composed of flowers.

*Coll. Hammer, Stockholm*

All six above-mentioned paintings were seized in Prague in 1648. They appear in the Imperial Inventories with the following descriptions:
"Face formed by mixed roast meats, by Arsimboldo. Face formed by birds, by Arsimboldo. Portrait composed of books, by Arsimboldo. Face composed of various fruits, by Arsimboldo Orig.". Etc. Etc.

1. Olof Granberg, *General Inventory of Art Treasures in Sweden*, pages 71-72, Stockholm, 1911.

Like everything else related to Arcimboldo, his reapparance in the art world after four hundred years is rather mysterious.

It seems likely that a photographic reproduction of Arcimboldo's *The Librarian* was an element of inspiration for Picasso when he painted Henry Kahnweiler's portrait in Cadaqués in August 1910. Not only is the general scheme of the composition the same, but details of the hair and the right hand correspond. Picasso's painting is almost monochromatic, as are several of his canvases from this period, but as he would have seen a black and white or sepia-colored photograph of Arcimboldo's painting, this is all the more appropriate. Even more astonishing, the sizes of the two paintings are almost identical.

Using *The Librarian* as an inspiration for Kahnweiler's portrait would have been a sly comment by Picasso, for in 1910 Kahnweiler began his second profession, adding that of publisher to that of art dealer by publishing his first Apollinaire texts. In 1910 there were no published reproductions of Arcimboldo's work. His name had been mentioned in a rather insulting fashion — "the Minister of Public Jokes at Maximilian's court" — by the Swedish art historian Olaf Granberg in two guidebooks for the collections at Skoklosters Castle in Sweden. Several of Arcimboldo's paintings had found a refuge in Skoklosters Castle after the Swedish Army sacked Prague in 1648 during the Thirty Years War. Gustaphus Adolphus's daughter Christina brought many of the paintings taken at Prague with her to Rome when she converted to Catholicism and abdicated as queen of Sweden. But she did not like the "German School," and since she included Arcimboldo in it, his paintings remained in Sweden.

Who would have had access to Skoklosters, a keen interest in art and great curiosity in general, and have been an acquaintance or friend of both Apollinaire and Picasso, living in Paris at the time of analytical cubism? Probably Fredrik Ulrik Wrangel, of the same family, strangely, as the Wrangel who led the Swedish troops against Prague. He had spent the summer of 1876 — an important summer for his evolution as a painter — in Skoklosters, which belonged to his relatives. After many adventures, he decided to abandon painting for writing and to settle in Paris. There he became a central figure in the Swedish artists' colony, and he was greatly appreciated by the painters of Montparnasse as a cultivated and amusing man. He seems to have known both Picasso and Apollinaire. It is not difficult to imagine that Wrangel had a photograph of *The Librarian*. We know that the painting had been photographed in 1904, if not earlier, and in order to impress and amuse his cubist friends, he might have shown them the photo of this strange painting with its remarkable way of constructing the figure. Wrangel was, at this time, hesitating between giving his attention to Picasso or to Matisse, but it is certain that he was strongly intrigued by the cubist method of composing an image.

P.H.

Pablo Picasso
*Portrait of Daniel Henry Kahnweiler*
1910
Oil on canvas, 100.6×72.8 cm
Art Institute, Chicago *

Ingve Berg
*Portrait of the Count Fredrik Ulrik Wrangel*
China ink on paper
Private collection

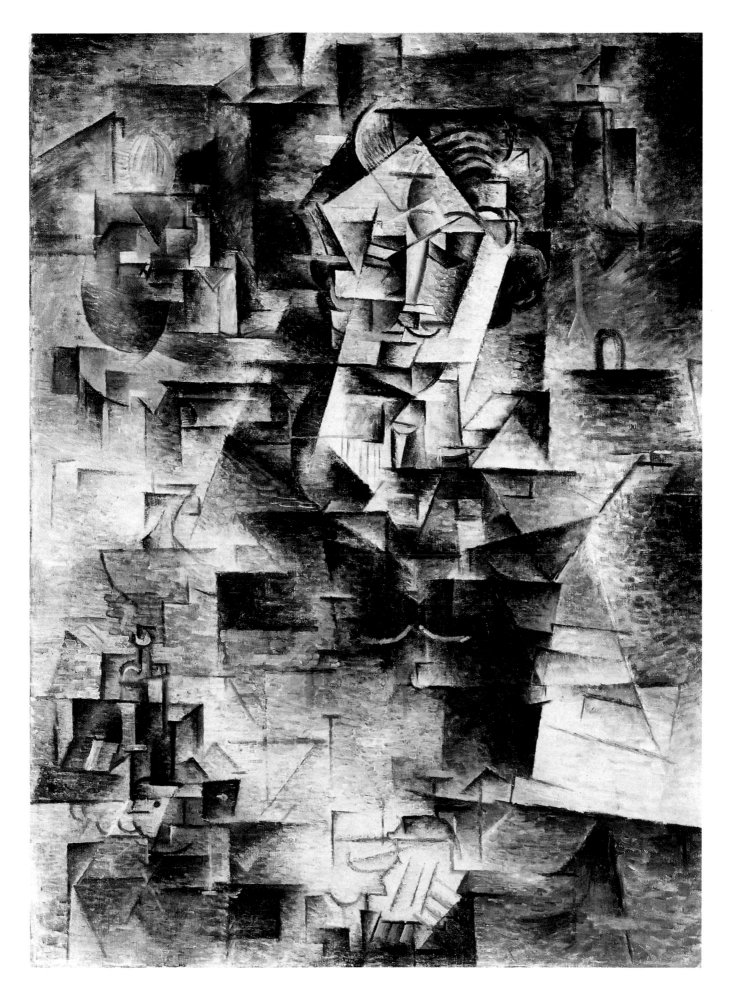

243

Anton Giulio Bragaglia
*A Gesture of the Head, Photodynamics*, 1911
Photograph, 18.5×13.5 cm
A. Vigliani Bragaglia Collection
Centro Studi A. G. Bragaglia, Rome *

# Continental Drifts

by Jean Clair

A provocative but pertinent comparison has been made between Marcel Duchamp's unique procedure and what Paul Valéry called Leonardo da Vinci's "method."[1] To validate such a comparison it is useful to recall singly some intellectual influences behind the strange careers, so far outside the norm, of these two artists separated by four centuries.

Although Duchamp sought a *mathesis universalis* it was not in the company of Luca Pacioli that he lived, but rather in that of the treatises of Henri Poincaré[2] and Elie Jouffret.[3] Although he too was fascinated by the visual pyramid and the rules of the golden section, his concern was not to illustrate a *Divina Proportione* but to apply them to the highly improbable physiology of his *Mariée*, both in the 1912 painting and in the preparatory study for *Etant Donnés* on velvet and parchment from 1948. Again, rather than being interested in the Neoplatonic theories of Marsilio Ficino and participating in discussions about Hermes Trismegistus, Plato, or Christ, he pondered on the uchronias and utopias developed by Hinton[4] and Pawlowski.[5] And finally, in search of a new Aristotelianism he immersed himself in Ouspensky's *Tertium Organum*.[6]

Briefly, in the treatises on perspective, on either side of three horizontals (the lowest marking the horizon line of the lower plane and the highest the frontal line of the plane considered from above) the classical painters developed two heterogeneous spaces, one of geometrical perspective and the other of perspective projection — that is to say, a two-dimensional space and the *appearance* of a three-dimensional space. Heterogeneous spaces, but between which the laws of classical Euclidean geometry allow an exact congruence to be conceived.

Duchamp also used a similar device in his *Grand Verre*, but in this case what is developed at the junction between the three horizontals is the figuration, in the lower plane, of a perspective mechanism, and in the upper plane, the *appearance* of a four-dimensional organization: the body of a bride in four-dimensional extension.

Stated in summary terms, in Duchamp the theory of the fourth dimension, developed in the framework given by the authors mentioned, plays exactly the same role as the theory of the pyramid of

visual rays in Leonardo. As the original dimension, it allows the dimensions of the physical universe to exist, develop, and interconnect. This can perhaps be compared with the way a meta-language stands above a group of languages linking them together, breaking them up, and recomposing them on the basis of distinct units.

In Leonardo the act of seeing, regulated by the mind and having become a theory in the etymological meaning of the term (*theôrein*) invests all phenomena of whatever description and a priori however heterogeneous, with the same equivalence: since they are observable, they are capable of uniting with all other objects observed and by degrees of approximation of substituting one another.

In the same way, in Duchamp the act of seeing — the theory — becomes speculation, not on the phenomena themselves but on the relations between phenomena, or rather the appearances of

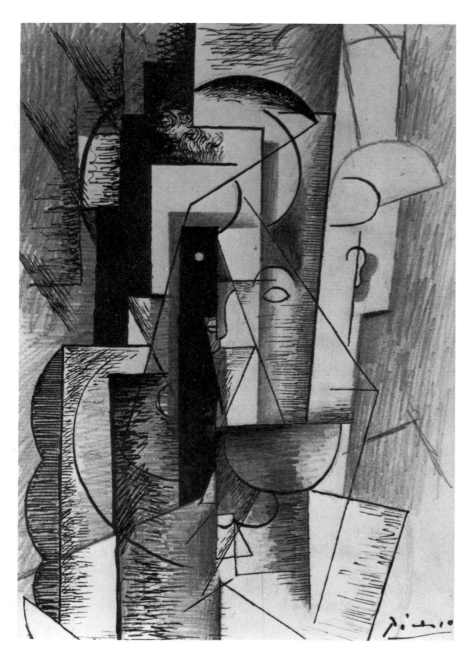

Pablo Picasso
*Portrait of Guillaume Apollinaire*
1913
Frontispiece of *Alcools*
China ink, watercolor and pastel on paper, 21×13 cm
Lionel Praeger Collection, Paris *

246

Arnold Schonberg
*The Red Look*, 1910
Oil on cardboard, 28×22 cm
Arnold Schönberg Institute
The University of Southern California
Los Angeles *

phenomena; on the combinatory system that connects the two-, three-, four-, and *n*-dimensional universes and makes every object the shadow cast by another object of any sort, and every form the projection of another form, in the circular play of anamorphoses governed here by the laws of a multi-dimensional geometry. Until finally, as he wrote in the *Boîte Blanche*, one can no longer distinguish between two similar forms.

Going somewhat beyond the limits of this discussion, it must be mentioned that the theories of multi-dimensional geometry, which were widely popularized at the beginning of the century and, together with the chromatic revolution introduced by fauvism, were instrumental in shattering traditional perspective, influenced a great many other artists besides Duchamp. For Kupka and the painters of the Puteaux group this was an important subject of conversation as it was for Gleizes and Metzinger. Picasso himself, when he painted his *Portrait of Kahnweiler* in 1910, explicitly referred to the construction schemes of four-dimensional figures as illustrated, for example, in Elie Jouffret's work mentioned above, which he had learned about through Princet.[7]

For all these painters, then, the work of art is not a retinal illusion, an insubstantial mirror image claiming to reflect the reality of a phenomenon, but becomes the instrument of a "concrete mental relationship between phenomena," or to be exact, between the images of phenomena.[8]

Better: if "every shift of elements, made to be observed and judged, depends on a number of general laws and on a particular appropriation, defined in advance, for a category of minds to which these elements are particularly addressed, then the work of art becomes a machine designed to stimulate and combine the individual formations of these minds."[9]

Hence the fascination for both artists of complicated machinery designed to produce unexpected effects, monsters or marvels — machines, it must be emphasized, for the most part gratuitous and ineffective: the optical mechanisms of Leonardo's *First Book on Light and Shadow* and Duchamp's small glass *A regarder d'un oeil...*, the machinery for attack in the former's drawing of a war chariot and the latter's drawing of a *Combat de boxe*, and finally the festive machines, such as Leonardo's invention in the Belvedere rooms in the Vatican where he filled a hall with sheep guts blown up by a forge bellows, according to Vasari, "so full that bystanders had to take refuge in a corner," and Duchamp's entrance for visitors at the Surrealist Exhibition of 1938, barred by a network of wires stretched in all directions like a delirious visual pyramid... Fascination with the machine as an iconographic subject because the work itself has become the metaphorization of a machine.

I am quite aware that the machine is not the same in Duchamp as in Leonardo, just as Henri Poincaré's geometry cannot be com-

pared with that of Luca Pacioli. But I see that in both cases it is intended to produce the same effects of whimsical and extravagant invention designed for a particular mind.

When Marsilio Ficino published his *Theologia Platonica* in 1474, he depicted nature as an inexhaustible mine of what he called "hieroglyphs." "What is the final enigma?" he asks himself. "It is the power to transform one thing into another." Aristotele had defined metaphor similarly. The "hieroglyph," like the metaphor, is a sign to designate something else.

Now, what does Duchamp say? "Every form is the projection of another form according to a certain vanishing point and a certain distance." This projection, this transposition of one form into another, is certainly a definition of metaphor. But Duchamp adds, "Every ordinary three-dimensional body — inkpot, house, captive balloon — is the perspective projected by numerous four-dimensional bodies onto the three-dimensional plane."[10]

In fact it hardly matters whether this phenomenon is defined as "metaphor" or as something else: in this endless play of forms, of shadows projected by one universe onto another — the "hieroglyphs" of the Neoplatonists, the "anaglyphs" of the engineer of vision Duchamp, or metamorphoses and anamorphoses — in this mechanism and this incessant generation of glyphic effects, where phenomena, or rather the images of phenomena, continuously replace one another or join with one another, the mechanism capable of producing them remains the same: the sheet of glass, the *parete di vetro*.

This is the scopic machine that enables the form of an object to be transported or metaphorized into any other form. Written on it at the point where it intersects the visual pyramid is a "hieroglyph" perpetually to be decoded, the meaning of which depends on the observer's position — this is "the spectator who makes the picture," the observer who simply projects his own position before the world, in the infinite circularity of *regard regardé/regardant*, the look which both looks and is looked at, the observer observing and observed. Because, as Duchamp says, "the continuum with $n$ dimensions mirrors the continuum with $n-1$ dimensions."[11]

The point, which could define any aesthetic of mannerism, is this: the "same" object, even the simplest such as a straight line, has its properties *metamorphosed* according to whether it is immersed in a 2, 3, 4, or $n$-dimensional space.

The set of properties that define it in a certain continuum is no more "true" than any other set perceived in another continuum.

There no longer exists any ultimate, "absolute" space in which form and being are identified. There is no *quadratura* that can give the construction rule *sub aeternitate* of a given volume, no *regola prospettica*, no single geometrical interpretation that can claim to be an exclusive truth. Everything becomes simultaneously true and false

Marcel Duchamp
*The Bride*, 1912
Oil on canvas, 89.5×55 cm
Collection of Louise and
Walter Arensberg
Philadelphia Museum of Art
Philadelphia *

248

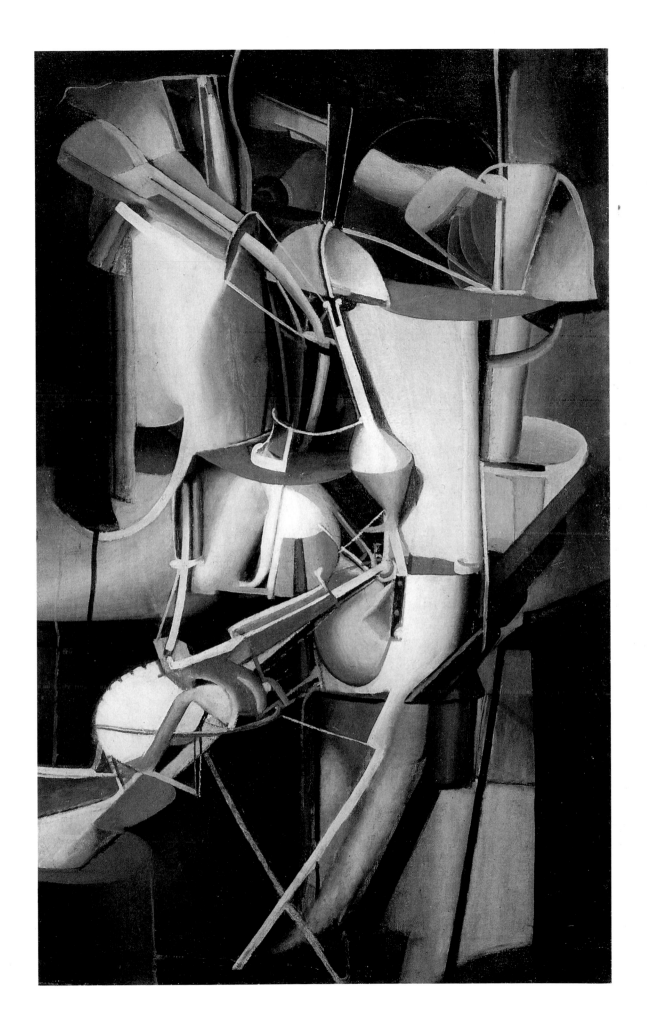

249

because everything becomes a question of viewpoint and of epistemological decision. Every measurement depends on a given reference system and an observer. Nothing is fixed. Great continental drift!

In the same years 1912-1915 when Duchamp was preparing his great work, Alfred Wegener completed his study *Die Entstehung der Kontinente und Ozeane* (The origin of continents and oceans). This sets out a theory as destructive to the "realism" of the natural sciences of his time as Riemann's and Poincaré's theories were to "scientific" positivism at the end of the century. Both also represented another humiliation for human narcissism, to use Freud's phrase, as serious as the discovery at the end of the Middle Ages that the cosmogony did not follow a geocentric system. In fact Wegener demonstrates that Pangea, the primordial land, was originally composed like an Arcimboldesque face of the united fragments of what today we call Europe, Asia, Africa... Unity of meaning, unity of measure, unity of weight, corporeal unity, unity of subject — all shift and have never ceased to shift since time began.

Two years after Wegener, in 1917, Darcy W. Thompson published his famous work *Growth and Form* in Cambridge. There he studied the transformations and permutations of organic forms seen according to different projection systems. Instead of the unitary and almost mystical philosophy of creation expressed in the law of unified

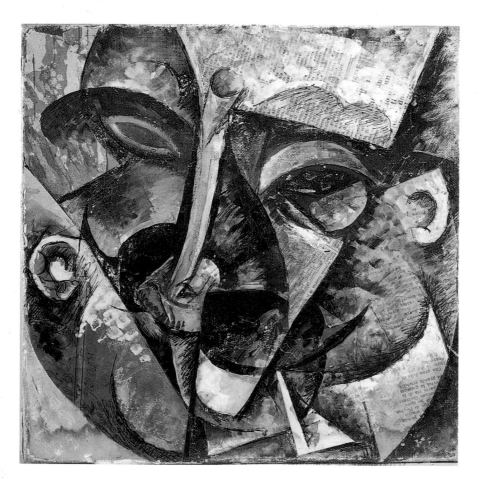

Umberto Boccioni
*Dynamism of a Man's Head*, 1914
Pastel, pen, gouache and newspaper
collage on canvas, 31×31 cm
Civico Museo d'Arte Contemporanea
Palazzo Reale, Milan *

250

Drawings from
*Growth and Form* by Darcy W.
Thompson, Cambridge, 1917

growth of organized beings that fascinated Goethe and the Romantic thinkers, or Fibonacci's search for a series that would include the structure of every living creature, Thompson's study revealed the whims and extravagances of a nature where every form progressively slides into another but the prototype, the *Urbild* that would supply the law, never appears.

In this way he was able to show that the form of a given animal species according to a certain projection system becomes another animal form of a different family according to another system. Thus a fish belonging to the Scarus type in an orthogonal projection turns into the image of a fish of the Pomacantrus genus in a circular co-axial projection. Together with the shape, the color pattern also changes, adapting to the new projection and "presenting" the appearance of another animal. Even more astonishing, fish of the Diontidae family, projected according to a hyperbolic grid, become transformed point for point into moonfish.

Thompson thus verified mathematically that the system of animal forms was the same as that of the anamorphoses that change every manifested object into the possible projection of another object, "according to a certain vanishing point and a certain distance." There is no first form, none is reducible to unity, none is "truer" than another because every reference system has disappeared: every form generates another form, every form is generated by a form. Or to use Duchamp's terms, every *appearance* in a continuum with *n* dimensions is an *apparition* in a continuum with *n-l* dimensions.

So the separate units, the entities, the "beings" that we believe we are recreating at a distance from a certain point of view, and the names we give them — "balloon," "inkpot," "bicycle wheel," "The Gioconda," "God" — with the values we attribute to them and the sensations they give us, are only pure sense effects with no "natural" reality existing to fuse them.

And metamorphism, which exerts its pressure on the universe of forms changing them continuously, endlessly into other figures and other materials, functions in the same way in the world of art. What from a certain point of view appears as cottonwool and gold stars to the observer, when seen at a distance and at a certain angle, in an effect of reverse "continentalization" becomes the profile of George Washington (*Allégorie de genre*) or a map of the United States.

The connaturality which until that moment had seemed to unite forms, names, and meanings, can even disappear in the sphere of more primitive sensations at the level of smell, taste, flavor. Marzipan, a mild, sugary taste representing a fruit or a child's sweet shaped like a fruit — an ambiguity delicious in itself — when "composed" by the imagination of the spectator who is "making the picture" (as one says that a cook "makes" a meal) can become the face of a greedy man, the mannerist *concetto* of a face worked in low relief, where the contours are those of a meal that never comes, a

251

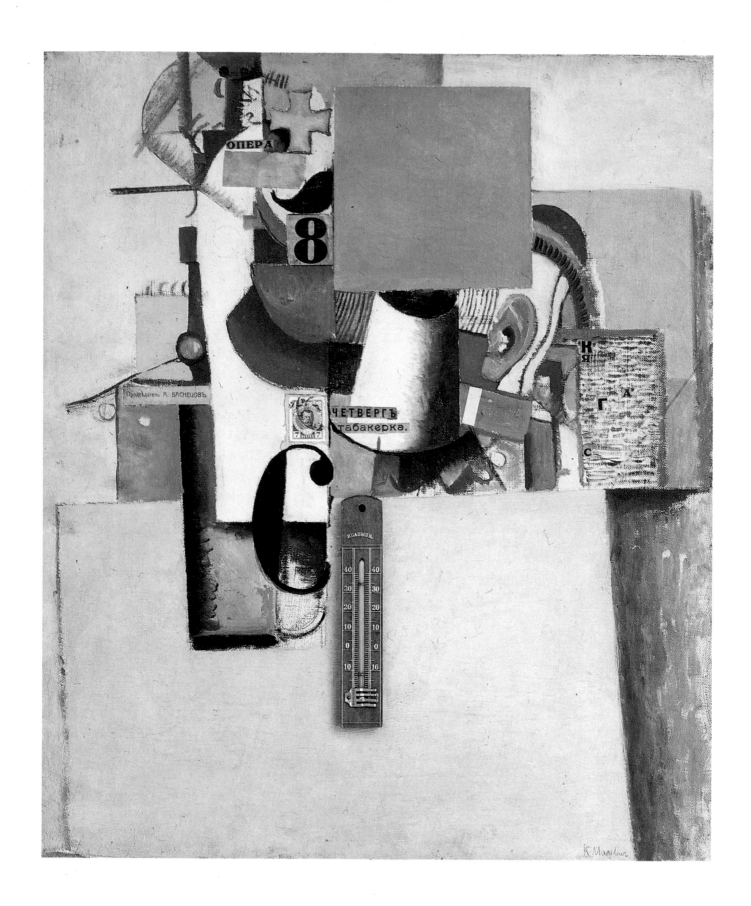

Kasimir Malevich
*Soldier of the 1st Division*, 1914
Oil on canvas and collage
53.7×44.8 cm
Museum of Modern Art, New York

torture of Tantalus, a delight to the eyes that can never get enough, a *Torture-morte...*

Thus in the first decade of this century the mental procedures that changed traditional mathematics into topological analysis (*analysis situs* or position analysis) and the physical sciences into methods for understanding the phenomena of indeterminacy, provoked a vast shake-up of knowledge that can be compared only with that experienced by the Renaissance, when it also fell into crisis at the threshold of the modern age, around 1520.

In the same way, in the visual arts the realism of the nineteenth century — which taken to the extremes of naturalism and then of empiriocriticism of the senses with impressionism, assumed a complicity of mind and body with a *natural* place — in Marcel Duchamp and his companions was succeeded by a pure artificialism.

This latest embodiment of mannerism, whose methods corresponded to a pure nominalism of thought — "a sort of pictorial nominalism," Duchamp was to say — lastingly undermined the idea that the mind can be anchored to a truth, the body to a form, the subject to a definition, history to a meaning.

At this point every statement can only set into motion machinery for producing effects that are momentary and hence all the more marvellous or disconcerting — machines of seduction and deceit, theatrical machines like those made by Nicola Sabbatini, machines for country fairs and "gardens of illusions," *apparati* and *monstra* designed to evoke *appearances.*

The world no longer has any reality in itself, it is only a vast *Kunstkammer* in constant movement, subject to endless changes before our eyes. The act of creation is no longer only the search for a truth of being, guaranteed by a strict axiomatic system, but rather a particular *manner*, deceptive and fanciful, of evoking appearances.

Man Ray
*Transmutation*, 1916
Collage, 46.8×61 cm
Moderna Museet, Stockholm

To conclude, I would like to evoke a late figure of mannerism, the extravagant heir to Leonardo's speculations on perspective, but undoubtedly also the remote inspirer, with Nicéron, of Duchamp's phantasmagoria — Athanasius Kircher.[12] In 1624 he published his *Physiologia* with the recipes for his innumerable "experiments". What does he present there? Every imaginable curiosity, the "Spectacula paradoxa rerum," the universal theater of paradoxes. And the machines are described like paradoxical images, *concetti a concordia discors* of nature and the imaginary, of alogical metaphors.

This ambition, as Hocke says, to *technologize* metaphorism was already present in Leonardo when, fascinated by the game of mirror images and having fallen under the influence in the Belvedere of a mirror-maker known as Giovanni degli Specchi, he conceived the idea of constructing an octagonal catoptric chamber, a perfect optical labyrinth in which man and his nature would be trapped in a non-naturalistic perspective.

This was the same ambition that inspired Marcel Duchamp when he broke with the whole evolution of the painting of his time, which from Manet to Matisse's monochrome studios was rejecting the teaching of perspective, its conceptual games and investment in the fantastic, and turned precisely to this tradition as the only source capable of restoring to art the intelligence it had lost and making its practice the repeated test of the mechanism of fascination.

Duchamp's aim of course was not to restore canonical status to the *prospettiva pingendi* — on the contrary, he was preparing to make use of its potential for perverse effects, its mechanical trickery, its suitability for making intricately twisted statements, in order to play with the aberrations and "sharpen," as he put it later, the spectator's gaze, deceiving his eyes so as to open them wider.

Giorgio de Chirico, it should be recalled, followed the same route in 1911, the year that Duchamp went back to the teaching of Nicéron and Kircher, when he too rediscovered the classic perspective tradition, not in order to restore it but rather to use its infinite possibilities for distortion. A last consideration on this "self-contained system" — the phrase used by Paul Valéry to define Leonardo's method and that could also be applied to Duchamp's. Far from referring to a truth outside the object and therefore available for ontological investigation, it envelops the object in a network of contradictory significations that cancel its meaning — where there was being there will now be "nothing, perhaps", Because this is the circularity in which the look is the object looked at, this reversibility of structure between the retina and the glass wall that indifferently places at the summit of the visual pyramid the observer's eye or the illuminated sex of the figure observed, in a complicity that links the spectator to the picture.

Duchamp, it will be remembered, among his panoply of idle knick-knacks had recommended "the tap that stops running when it is not

Giorgio de Chirico
*The Jewish Angel*, 1916
Oil on canvas, 67.3×43.8 cm
Private collection*

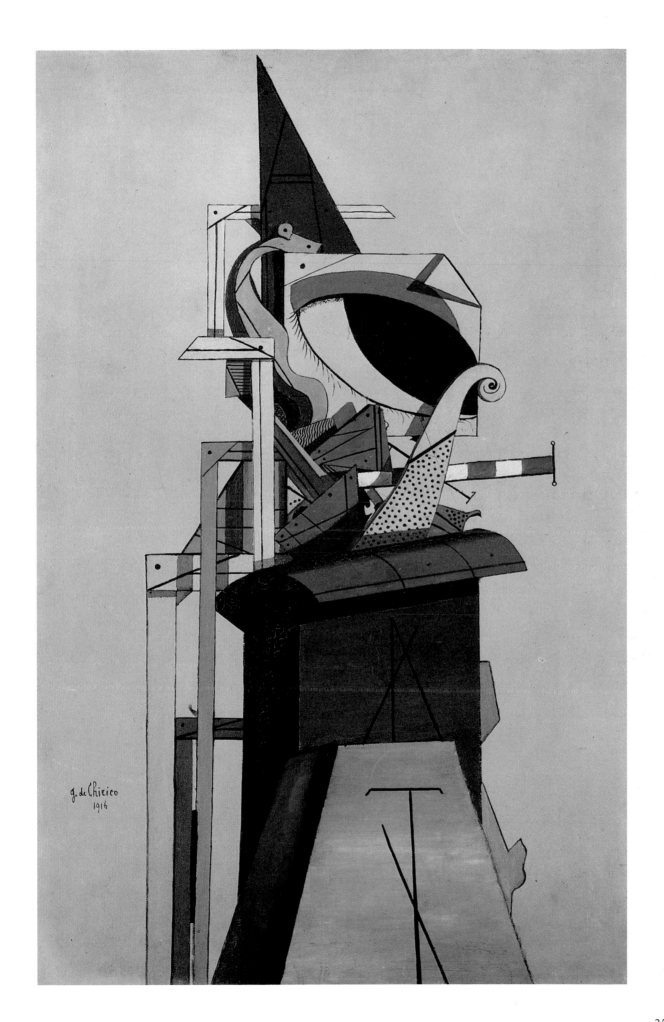

being listened to." Well, it occurs to me that this intermittent tap might well be the one that supplies the water of the Philadelphia cascade. Because *Etant donnés...* is probably the first work that stops being "art" when it is not being looked at. It is the first intermittent work of art: it no longer affects us according to the unchanging laws of delight but "functions" only when solicited, like those secret drawers for which one needs to know the combination or system of springs to reveal the treasures and hidden mirrors. It is the first work to create the same effects of anamorphosis in three dimensions that the mannerists of the past tried to obtain in two dimensions.

It is a mechanism for projection — the moment the spectator's gaze penetrates its working he is taken into the sphere of the unknowable and marvellous. It is the absolute artifice that, for the brief moment we allow it to take hold of us, appears as the substitute or enchanting lure of the search for an absolute of being and knowing that modern man has understood is impossible.

For the modern artist it is also the exact counterpoise to that attitude on the part of the public — the "spectators who make the picture" — which has made a work of Leonardo's into "The Gioconda": much more than a picture, a myth, the very embodiment of the deceptive seduction of the painter's artifice, effective even when we are no longer looking at it; its smile, like that of Lewis Carroll's cat, remains with us even after the painting has disappeared.

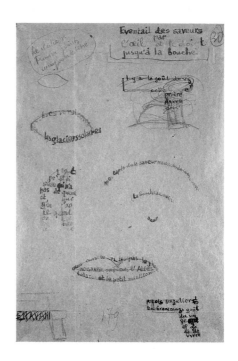

Guillaume Apollinaire
*Revolver*, 1917-18
Calligramme
Ink on paper, 24.5×16 cm
Collections Arthur A. and Elaine
Lustig Cohen, New York *

1. Cfr. André Chastel, "Léonard: la fable et la forme," in *Fables, Formes, Figures*, Paris, 1978, vol. II, pp. 249 ff.; Jean Clair, "Duchamp, Léonard et la tradition maniériste" in *Duchamp, Colloque de Cerisy*, Paris, 1979, pp. 117 ff.
2. H. Poincaré, *Analysis Situs*, Paris, 1895; *La Science et L'Hypothèse*, Paris, 1902.
3. E. Jouffret, *Traité élémentaire de Géométrie à quatre dimensions*, Paris, 1903.
4. Howard Hinton, *A New Era of Thought*, London, 1910; *The Fourth Dimension*, London, 1910.
5. G. de Pawlowski, *Voyage au Pays de la quatrième dimension*, Paris, 1912.
6. P. D. Ouspensky, *Tertium Organum, A Key to the Enigmas of the World*, published in Russian in 1912 and in English (London) in 1921.
7. V. Henderson and Linda Dalrymple, *The Fourth Dimension and Non-Euclidean Geometry in Modern Art*, Princeton, 1983.
8. Paul Valéry, *Introduction à la méthode de Léonard de Vinci*, Paris, 1894, *passim*.
9. *Ibid.*, p. 255.
10. M. Duchamp, Notes for *La Boîte Blanche* (A l'Infinitif).
11. Notes for *La Boîte Blanche*.
12. Although Duchamp does not specifically refer to Athanasius Kircher, in the notes to *La Boîte Blanche* there is this mention, under the heading "Perspective": "See Bibliothèque S.te Geneviève catalogue *all* the section Perspective: Nicéron (Father J., Fr.), Thaumaturgus opticus." If he consulted "all" this section, as is probable, he also found Father Kircher's works there.

Naum Gabo
*Constructed Head No. 2*, 1916
Phosphorous bronze, h. 45 cm
Private collection

256

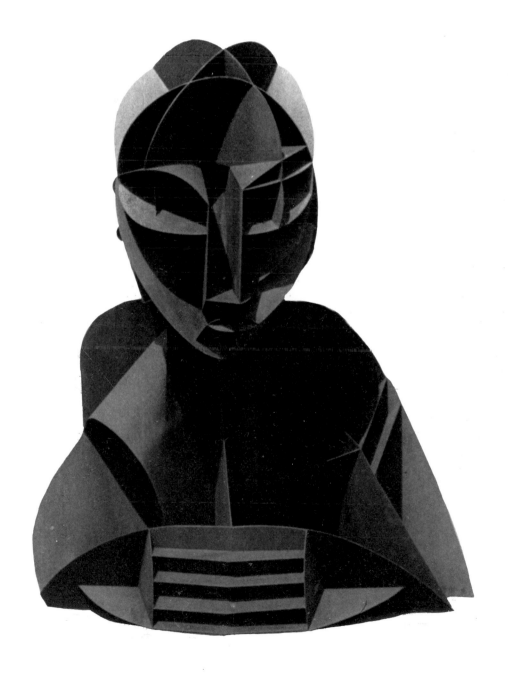

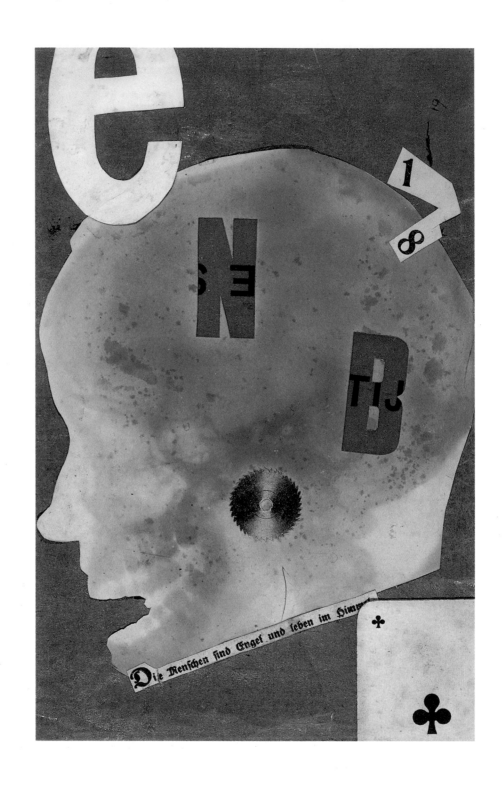

Raoul Hausmann
*Human Beings Are Angels and Live in Heaven*, 1918
Collage and photomontage, 31×20.5 cm
Berlinische Galerie, Berlin *

# The Passion of the Face

by Paolo Fabbri

"Suddenly I see the solution of a puzzle figure. Where previously there were branches now there is a human form."[1]

Galileo advised against practicing philosophy the way Arcimboldo painted. For this scientist, a lover of painting, the disparate centos of quotations from Aristotle were like the works of "capricious painters who want to represent a human face by assembling only agricultural tools, or fruits or flowers from one season or another, *bizzarrerie* which proposed as a game, are beautiful and pleasing and show the talent of the artist, but should not be proposed as a universal criterion of painting." If there are signs of nature (and the human face), Galileo advised that they be read like a book written in alphabetical or geometrical characters, as phrases or formulas from a combinatorial system of minimal elements.

I shall return to this opposition to resolve it, but first let me outline the rebus of the representation of the face in Arcimboldo's painting.

It is not Della Porta's ciphered, metaphysical physiognomic system, nor the heraldic system of blazons on the body. His "capricious and bizarre" arrangement of objects creates a hieroglyph that goes beyond the language of devices. Arcimboldo's faces are unique parables running like an underground seam (or fault) through the history of the figurative arts in general and of portrait painting in particular.

It is therefore impossible to reduce them to the memory of the time when they were composed. Their poetic density continues to allow new readings, in which we extract more from the memory than he inscribed in it. Let us try to follow a thread — a labyrinth is a sagaciously tied thread — or rather a double thread: expression and passion.

"Meaning: a physiognomy"[2]

We know that a portrait is there not only to represent (refer back to a referent) and signify (construct a meaning and communicate it), but also to express emotion (and provoke it). It is the incessant concern of art to inscribe passions (states of mind, feelings, emotions),

to codify them in systems of signs, to stage the place (unsayable? unrepresentable?) where sensations and perceptions are transformed into meaning and affects, in order to direct us toward acting and understanding. Leonardo's phrase, "so the figure is not praiseworthy unless there appear in it an act expressing the passion of the soul," reverberates up to the nineteenth century.

But although the whole body cites and excites affects and effects of meaning, it is the face that has the privilege, endlessly observed, of expressing itself on its own expression. The minute play of the facial actors (eyes, mouth, brows, chin, nose) makes the meaning and states it. Theoretical thought and descriptive curiosity — from Aristotle to Lavater, from Lombroso to Buhler — has never ceased to inquire about this meta-linguistic privilege, this expression to the second power.

The conclusions are well known: the face makes sense through a code that is physiognomic (the facial forms are fixed signs of faculty) and pathognomic (the positions and processes are signs of passion). These codes, historically (slightly) variable, are autonomous structures, immanent and arbitrary, that allow characters to be read; quasi-languages similar to cartomancy and astrology. The face thus inscribed refers back to a stable typology of passions. Against its backdrop are concentrated the divisions (often ternary) of the faculties-modalities of knowing, being able and wanting, of the conceptual, physical, and affective life. The divisions are reapplied to each actor of the face: forehead and nose are further subdivided into features and parts whose combinatory system produces complex layers of emotive significations. The nose, for example, can be divided into root, bridge and tip, and the articulation of its features (long/short, convex/straight/average, thin/fleshy) allows up to 81 types to be identified, corresponding, it seems, to inclinations, vices, and defined virtues. By the same method up to 58 foreheads can be distinguished, 43 eyes, 50 chins, and 18 mouths!

To this typology of expression corresponds a varied passional typology: from indifference to sincerity, from love to patience, from hope to anger, often organized in binary fashion in opposing pairs with intermediate terms and variations of intensity (a dictionary cites up to 50 types of anger).

The reduction of the passions to simple elements (desire/aversion, joy/sadness etc.) and their categorical or fluctuating combinatorial system has been an absorbing concern for philosophy (from the Stoics to Descartes, from Spinoza to Hume and Scheler); here I prefer to behave as a linguist. As is well known, passion is revealed by the tongue, and language is not sparing of "capricious and bizarre" metaphors: mouths may be loose or tongues tied, hair lost in temper or let down in intimacy, teeth set and upper lips stiffened, noses poked, snapped off, put out of joint, or paid through.

According to the (Italian) dictionary, some actors of the face are

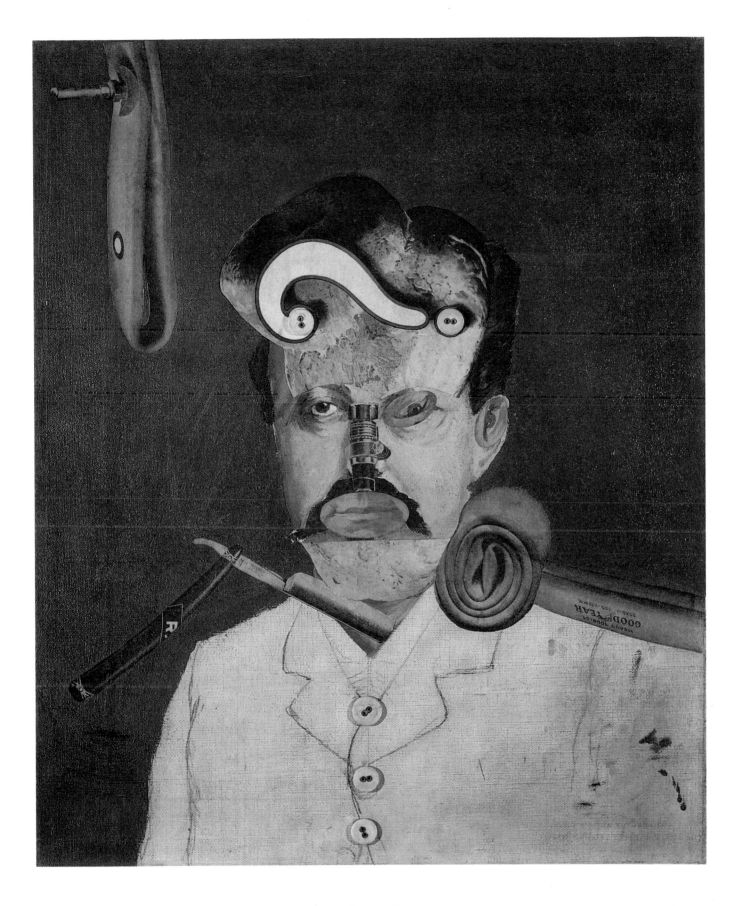

George Grosz
*Remember Uncle August, the Unhappy Inventor*, 1919
Oil, pencil and collage on canvas, 49×39 cm
Musée National d'Art Moderne, Centre Georges Pompidou, Paris *

specialized in communicating special passions: the teeth, revenge, resentment, and threat; the hair, horror and excitement; the eyebrows, severity and haughtiness; the nose, a cleverness that may become indiscretion or turn up in disgust. On the other hand, the same passions — hostility or understanding, aggressiveness and benevolence, for instance — can be shown by the face, eyes, or lips indifferently (is the forehead the most aggressive?)

To enable us to catch in a word (in its lemmas) the trace of the emotion signified, the *states* of the actors (open/closed, complete/incomplete, colored/colorless, damp/dry) are not enough. *Movements* are needed: opening and closing, lengthening and shortening, raising and lowering (but also curling, squeezing, and twisting), striking and breaking, entering, exiting, and penetrating, gaining and losing. According to Louis XIV's court painter Le Brun, a theorist of physiognomies, all the passions could be represented by the movement of the eyebrows alone, and all affective characters reconstructed with only these two facial characters. And everybody knows, in the common sense of language, how the ear, for example,

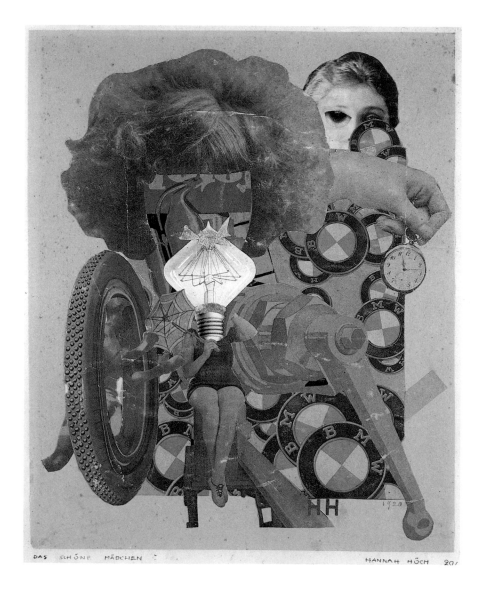

Hannah Höch
*The Beautiful Girl*, 1919-20
Collage on paper, 35×29.5 cm
Private collection *

262

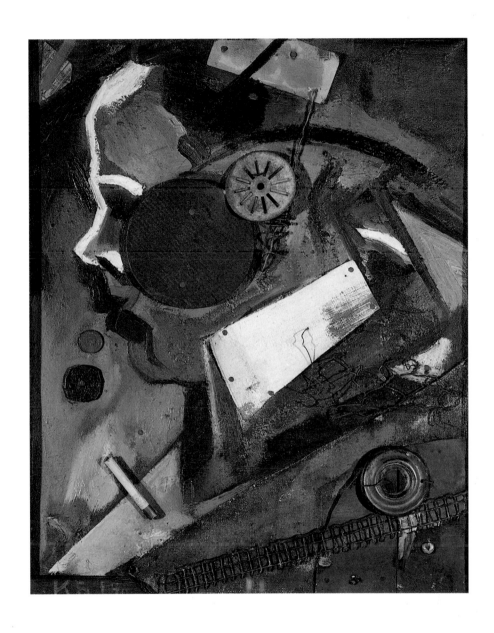

Kurt Schwitters
*Merzbild 1 A (The Physician)*, 1919
Assemblage and oil on canvas, 48.5×38.5 cm
Thyssen-Bornemisza Collection, Lugano *

is pricked up in attention; how the neck — an object of precious and high-risk value — lengthens in curiosity or expectation, and bends in fear and oppressed dependence. And so forth.

But we must think further and state this stereotypy of traits differently. Lying below the inscription surface of passional marks there is a "deeper" face, an abstract likeness and an appearance process that is the real condition for recognizability of the "features." Raising and lowering are correlated to euphoria and dysphoria, turning the head away is a logical negation but also a refusal or distaste for communication. These correlations are independent of the single actors: the movement of the eyebrows, for instance, toward the median line of the face, expresses the same perplexity as the shoulders shrugged or moved toward the median of the body.

The semblance becomes the site of elementary operations made up of dilations and contractions, tensions and relaxations, the site of metamorphoses between substances and tints, where there is movement and exchange between the operators of veridiction (sincerity, perplexity, and pretence) and the operators of judgment (agreements and reprobations, admissions and reservations).

Our culture never stops reflecting and being reflected in these two faces: the one of superficial traits and pre-established emotions, the other of the unconscious symbolic system, categorical and intensive. We use the first face to conceal the second, covering it with make-up and masks, or uncovering it (with happy euthanasia?) to show the mechanisms under the skin (flayed bodies) or to rediscover the deep underface, or the common mask of the skull. Our culture prints types, surveys *cartes du tendre*, maps of love, suggests dominant passions and thus, with a direction (individual and collective) of the self, exercizes an art or technique of control over the deep expression and emotion. The resulting face is a form of politics, as is its combinatorial rewriting.

"Sometimes we hang proverbs on the walls. But not treatises on mechanics."[3]

What thought echoes in the portrait as deviated by Arcimboldo? The paradigms of objects that make a face there, are not only exercises of talent or didactic stratagems, whims or art of memory techniques. First of all they are portraits that we see as dumb (or we can lend them a mechanical word, minus its proper physiognomy). While the portrait (ideally) always speaks, if only to say its last words, the *Jurist* or the *Librarian* say nothing, or say, "Nothing." The "person" (*persona*) — which is a mask and etymologically, the activity of speech — is all in the figurative *fabula*. Then — and this is the *punctum*, the sharp revelation — the affective communication of the face is replaced by the exhibition of the objects. The subjective intent gives way to the portent of things, if portent it is, "not

Francis Picabia
*La femme aux allumettes*, 1920-25
Oil on canvas, matchsticks, hairpins
coins, 92×73 cm
Private collection *

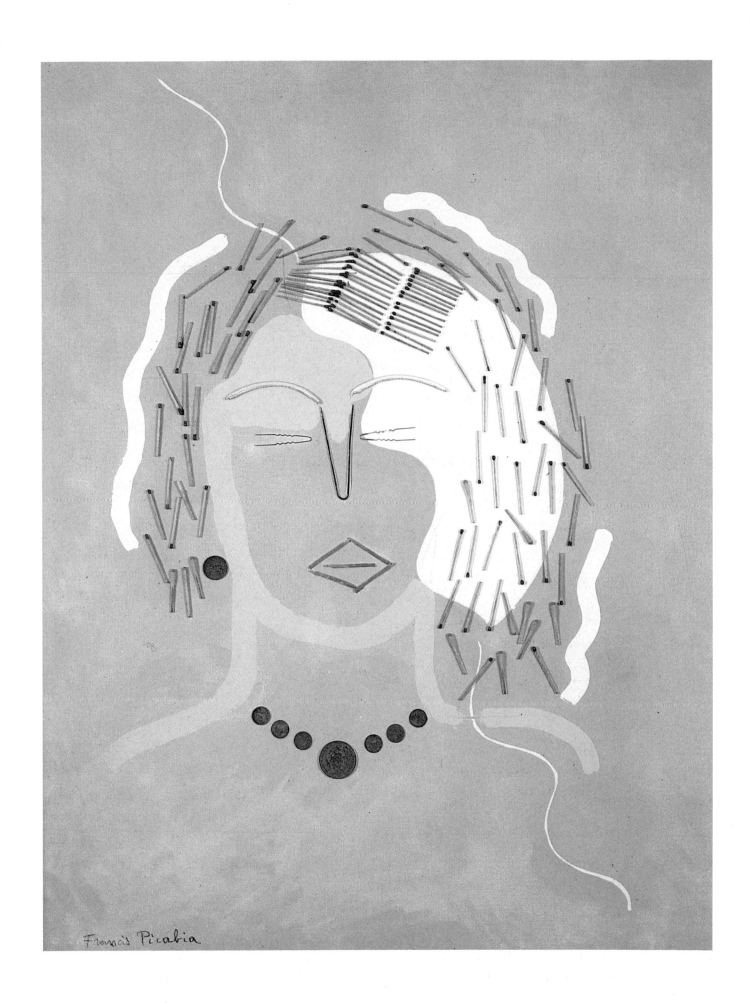

the annunciation of a single event, but a whole panorama and almost a continuous perspective'' (Benveniste). Flowers and instruments, plants and animals impose their characteristics on the characters of the face. Mushrooms or fishes are preferred because they can reformulate the facial organs/traits. Maintained in its semblance, the face is radically transformed — in its signification (no longer the only and certain face, but only a certain face) and most of all, in its passional expression. The emotive subject drops the connotations of his "personification."

In a culture that recognizes the subject and its meaning in every whisper and rustle of nature, where every object has a physiognomy, what happens when it is the objects that make the face or distort it? When the object becomes a portrait — that mirror of poses and grimaces we hold out to others and which never reflects them enough — what happens to the subject that enunciates itself there? What is left of the *sprezzatura*, the concern-disdain of the Renaissance portrait?

One of the disturbing effects of Arcimboldo's painting is the way the objects expose themselves in *portraits* (in the French and Italian meaning), leaning toward us. In fact, while the pre-verb *por*+ implies the idea of extension, a full spread (cfr. "*por*+ is a presence that projects itself in continuous outwardness," Benveniste), the subjective instance is suspended, becomes virtualized and as it were revokes itself. It is its *ritratto* [= "portrait" and also "retracted"] in the Italian and Spanish sense of the word.

"Bizarre" position of the human image in Arcimboldo — term (first or second?) of the object metaphor, its enunciative pose is in the mode of a free indirect style. Ritratto/portrait, the transitional subject allows two passional interpretations. Either a subject is still in exile behind the things that have deposed him (then the melancholy of the *ritratto* will be his dominant passion) or an embryonic subject is appearing behind the things (and this glimpse will be the curiosity and hope of the *portrait*). But there is still another solution.

"When somebody says, 'To me this is a face,' we ask him, 'What transformation are you alluding to?' "[4]

In the *portrait*, the face offers itself to the sight of the other; the subjectivity of the aspect is perceived socially and is subjected to a composition and a composedness. Half of our face is ours and half is given to us by the gods, but the whole is imposed (or denied) by our culture. An abstract "facifying" machine, as Deleuze and Guattari would say, an inscription surface with fissures imposed on every part of the earth and sky and on the head and body of human beings. It is this social definition that imprints the outlines of the passional features. The most intimate emotions become labels for a collective ceremonial: the face format is a political con-formation, a semiotic

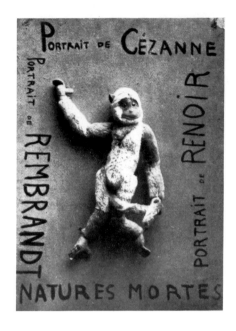

Francis Picabia
*Dada Picture*
In *Cannibale*, no. 1, Paris, 1920
24×15.5 cm
Bibliothèque Littéraire Jacques Doucet, Paris *

266

screen for the network of subjectivity of which the face is the representative.

But this dogmatic figure is constantly in doubt. Its distinctive traits are threatened with distortion by the same passional forces they should fix. Through the abstract diagram of relations erupts the defacing force of tics (convulsive, spasmodic). Invisible deviating forces transform the valences of sensation and feeling into ambivalences. The actors of the face become decomposed, change direction and speed, aspect and tense: they become new tracer elements. They are not only isolated partial objects reacquiring their autonomy, but the anticipation of others' points of view in the same face that is facing others. This mutant and metamorphic aspect is surely a plausible reading of Arcimboldo, and a *basso continuo* of modern painting.

Certainly it is one of the effects of meaning produced by the still or animate life that replaces the facial actors. Before, instruments

Francis Picabia
*The Holy Virgin*, 1920
China ink on paper, 32.6×24 cm
Bibliothèque Littéraire
Jacques Doucet, Paris *

267

Marcel Duchamp
*L.H.O.O.Q.*, 1919
Pencil on photographic reproduction
19.7×12.4 cm
Private collection *

ANNA BLUME

Kurt Schwitters.

Kurt Schwitters
*Anna Blume*, 1921
Collage, 13.9×8.9 cm
Galerie Gmurzynska, Cologne *

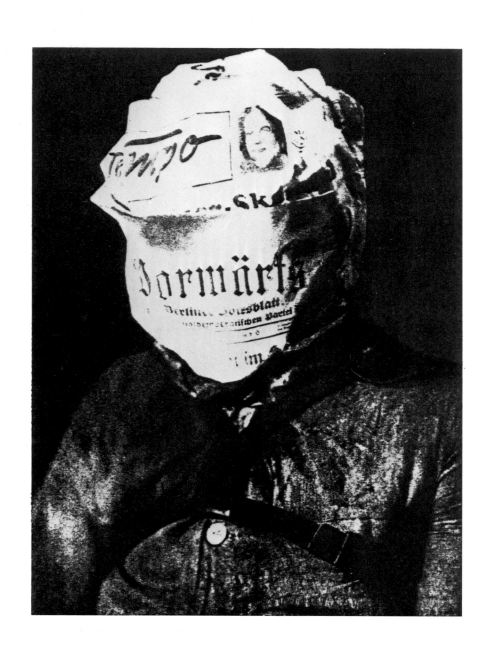

Photomontage by John Heartfield
for the review *A.I.Z.*, no. 2
Dresden, 1930

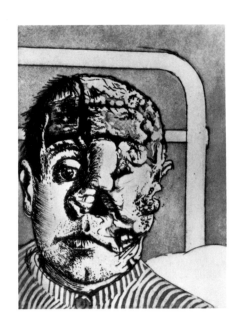

Otto Dix
*Transplantation*, 1924
Aquatint, 19.8×14.9 cm
Private collection

and animals and plants were recognizable by their indirect effects on the face that perceived or consumed them (papers and vegetables, books, furnishing and game birds). Now that the face is deposed, its features are those of a witticism (a chicken with wings/moustaches and legs/eyebrows, while the mouths are pomegranates or hedgehogs or mushrooms, fish or birds' heads, pots or lamps or plates). And what if this facetiae-face, this border-line face began to wink, became a victim of object tic? For if the things composing it began to move, each with its own speed of wear and use, then man's false identity would dissolve.

In this principle of disappearance lies the seduction of Arcimboldo's work: each object returns to its place outside the calculated scheme!

The language of the objects — little encyclopedia shows — hints at a radical adventure of the subject that art in fact never ceases to narrate. Things are no longer diminished persons, but if anything the subject is the alienated part of the object, as Baudrillard would say. Behind objects there is no longer a subjectivity requiring psychology, which a subcutaneous scanner would discover as the portrait of a flayed man. In their reversibility, things transform every gesture into a transitory hieroglyph and charm us precisely by their absence of desire and aversion, of pain and pity. There is no sign of fetishism in these countenances that are ultimately talismans — the appearance is ready to disappear with every rhetorical variation of the reading (the face becomes still life and vice versa). Any physiognomic impulse is justifiably absent.

To this pure mosaic game we can vainly attempt to apply an appearance of consistency (the regulation distance of the portrait, the inclusion of the viewpoint) and an imaginary passional interpretation (the melancholy of the flayed man). But the meta-linguistic privilege of the face — to speak for the body — is revoked. From a semi-motivated sign, the *portrait* becomes pure artifice, a game of non-interchangeable appearances, its only destiny to appear and disappear. In this ceremonial morphology, which goes well beyond court practice, forms display all the resources of their charm: the intensity of the game is no longer of the order of an affect or of a moral law guaranteed by a transcendent sender or receiver.

This is Arcimboldo's modernity — the liberation of the objects allows a proliferation of the visual combinatorial system, of the sensible effects. The emotion will be in the topological inscription, volumetric and chromatic, not in a fixed pathognomic reading of the world and humanity.

Emotion turns into sensation and vice versa, in the autonomy of the artistic practice. A deep passion, polymorphous and multi-sensitive, preceding any figurative investment, is inscribed in the substances and forms, in the processes and rhythms.

Arcimboldo's "special effects," by dislocating the face — the locus

of the inner personality (Simmel) — open space for the values of sensation, for the perception of the intense ambiguities of feeling. Other signs, other modes were needed to refer the changing face of modernity, other purports and other forms (of content and expression) to inscribe and cancel the new regimes of aspect and presence. It is not easy to invent new passions (Fourier tried) and new expressions. Arcimboldo is the forerunner — this is the parable, the magician's portent of this "strange painter." Galileo's ostracism should be lifted: ultimately the difference of abstraction is only a question of levels of interpretation. Modern art is well aware of this, having turned to Arcimboldo to take the baton in the race.

1. Wittgenstein, *Philosophische Bemerkungen*, § 259, Vienna, 1964
2. Ibid., § 258
3. Ibid., § 280
4. Ibid., § 259

Man Ray
*Marcel Duchamp*, 1924
Photograph

Raoul Hausmann
*The Spirit of Our Times*, 1919
Wood, leather, metal and cardboard
32.5×21×20 cm
Musée National d'Art Moderne
Centre Georges Pompidou, Paris *

272

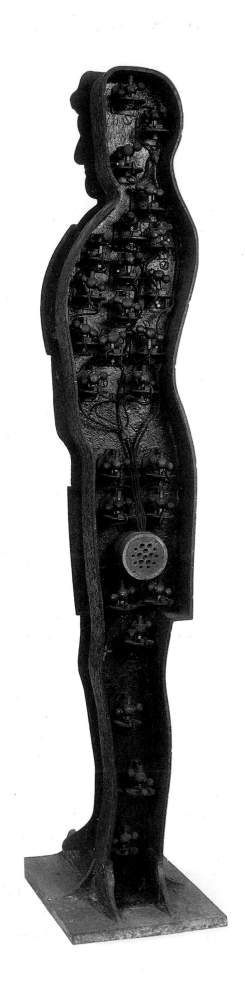

274

# Animarum Venator

by Massimo Cacciari

Roland Barthes has devoted a masterly essay to the secrets of Arcimboldo's language, ("Retore e Mago," *Arcimboldo*, Parma-Milan 1978). While the sequence of discourse can be broken down into units endowed with meaning (words), the "discourse" of a painting seems to have only one possibile subdivision, for its components (lines and points), if they are abstracted from the whole, have no meaning whatever. Now, on the contrary, the various parts of Arcimboldo's figures do have a meaning, and are in themselves "lexicographical units" taken from a dictionary of images. And they are completely intelligible images, nothing like those in children's books (as Barthes misinterprets them), but closer to the genre of scientific illustration: "bear in mind that there is no fruit or flower that is not drawn from nature and imitated with the greatest possibile diligence" (G. Comanini, *Il Figino*, 1591).

Arcimboldo has direct experience of the elements that make up his figures, for he can study pictures of them in the imperial collections. And in similar terms Lomazzo praises the "naturalistic" mastery of Arcimboldo's extraordinary figures. Indeed, his painting is capable of representing "to our eyes all the forms of things, with which this world is filled and embellished, in the manner of another Nature, or at least as an imitator with the intellect, and by emulating her succeeds in so many respects in letting us know the diversity of the said forms in the most beautiful and delightful way" (G.P. Lomazzo, *L'Idea del tempio della pittura*, 1590).

Thus Arcimboldo imitates with the intellect, and for this reason he delights us, because the elements that he imitates with such supreme care are valuable only as metaphors; they are in some way projected into what is beyond themselves and most often projected in their entirety. For we can find no resemblance between a hare and the protruberance of a nose, or between a wolf's fangs and a human eye. Any analogy in the play of metaphor is pure chance. The dominant factor is the compositional invention — a reckless mania to which we will return later, akin to throwing a bridge across to an invisible bank.

But what is the "message" of this game? What is hidden and at the same time not hidden in its "code"? Does the application of the structure of speech to painting amount only to a "marvel"? But, first

Captain Chevalier
*Electric Target*, 1900
Iron, 160×30×43 cm
Maison Gastinne Renette, Paris *

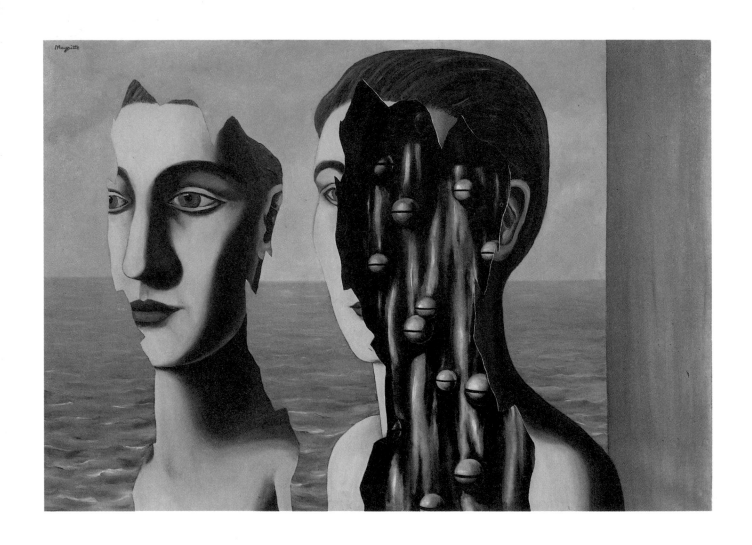

René Magritte
*The Double Secret*, 1927
Oil on canvas, 114×162.5 cm
Musée National D'Art Moderne
Centre Georges Pompidou, Paris *

and foremost, to what extent can those animals, those flowers, those pieces of fruit, all of them perfectly distinct, really have a meaning in themselves? Arcimboldo's finest works evoke nothing less than the notion of a tangle, a disorderly muddle. What is striking about them is the force, the perfectly measured power of the *complexio*. The latter, as such, constitutes the problem of this method of representation. How can what is perfectly distinct be equally perfectly inseparable? And more: how can figures apparently so contrary to one another appear and take on definition according to a rhythm that composes them so indissolubly? Because, in the various possible treatments of Arcimboldo's "metamorphic vertigo," this is the very problem that risks being overlooked: the formidable compositional clarity of the works, the "beingfinishedness" of the labyrinth that they invent. At one and the same time a *Terminus* embraces the forms and a *Nomos* arranges the complex internal relationships. *Nomos*, moreover, as in that Pythagorean musical science that is at the heart of the reflections of both Lomazzo and Comanini. Even the "monstrous" bodies of Arcimboldo are made on the basis of a "musical concert," according to the proportions of harmony. And not only do their elements fit together without the violent effects of caricature, but their chromatic tonalities are also in accord, or intended to be in accord with each other, on the basis of a precise system of correspondences between sound (or better: musical intervals) and color. Comanini declared that Arcimboldo "has found the tones and semitones and the diatessaron and the diapente and the diapason and all the other musical consonance in colors, with that very art with which Pythagoras invented these same harmonic proportions." The harmonic system of the figure, therefore, is the aim of his work — an aim pursued with all possible art — and certainly not the abstract extolling of the single element. The more precision and singularity the latter displays, the more forcefully it is subsumed into the whole, appears as a part of it, and therefore signifies it. Every relationship, every particular *complexio* between different elements, must be perfect in order that the figure as a whole becomes a perfect chord, perfectly resolved.

Arcimboldo's inventiveness astonishes us by the systematic way in which it pursues such ideas; or rather, by the systematic exclusion of all "eccentricities" from his discourse. The word "harmony" comes from the Greek *harmózein*, and "art" is connected with the same root. The verb means to join, to put together parts that fit each other. Birds do not go together with fishes, nor the kingdom of Fire with that of Water; nor do the phlegmatic colors of Winter fit with the heartening colors of Spring. During the sixteenth century there were cases of metamorphosis from one kingdom to another, dissonant confusions of the orders of creation (in Bosch, for example). There is no trace of this in Arcimboldo. Each realm finds its harmonious balance, sounds its purest chord. Nor does any really

monstrous vision or species disturb it, any fantastic creature disquiet it: even the Ocean, sacred dwelling-place of the most tremendous nightmares since time immemorial, is "scientifically" described.

Once again, we are at the antipodes of the hellish fantasies of a Bosch or a Breughel. In Arcimboldo the disquieting, the *Unheimliches*, does not at all consist in the representation of the extraordinary and unheard-of as such, but in the representation of what is extraordinary and "miraculous" in ordinary things — what is, or can be, the daily object of direct, precise experience — in "hallucinating" the experience we normally have when we view the human body. It is *magia naturalis*. Magic because, whereas elements offer themselves to ordinary observation *singulatim*, in the form of discordant, inhospitable differences, here they reach their accord and establish their kingdom. But it is magic that concerns the elements as they actually exist, that produces nothing which departs from the natural system of creation, nothing that is *dia-bolic* with respect to that system. The magician, far from violating the *Nomos*, is the one who expresses it, who displays it. His art could be defined as a maieutic system of the harmony latent in the various orders of the world and in the world as a whole. Its production is a discovery, an illumination of that harmony. This light, in point of fact, dazzles normal sight: the eye that arranges things in a-rhytmical sequences is disconcerted before the *Rythmòs* that composes them and is now made visible. But this *Rythmòs* is not imposed on nature, does not appear as a tyrannical order extraneous to her, but rather as the immanent law of her own heartbeat. It is, therefore, the hermetic-alchemistic tradition of the Renaissance that supervises the structure of Arcimboldo's language, his double division, and inspires it with an internal logic. A *Terminus* embraces the coming into being of these figures. He does not appear at once — he is the last to show himself. The last fruit of creation: *nativitas perfecta*. Only by departing from the composition, looking at it from a distance, can he be grasped. All the faces constitute a face, *the* Face. To the *Nomos* who ordains the relationships between the elements there is a corresponding *Terminus* who defines their harmony. The whole of creation flowers in the face of man; every order of his achieves full maturity, manifests its own idea, within the limits of this mark. The various signs, we can say, here reveal their own significance. They harmonize reciprocally insofar as they are elements of the different *facies* of man. Once again, that *Terminus* is not tyrannical or inhospitable: the faces of the animals and things "respect" it without any apparent trouble, without becoming contorted by it. Nor do they have the appearance of a dead list of names, a collection of stuffed animals: the germination of the fishes is *natura viva*, while a true symbol of imperishable physis is the cow which, regally stretched on her side, supports the Hunter garlanded with stags, elk, and ibex. They seem at home in his face; the cow seems like the fertile

Stills from the movie
*Strike*
by Sergej Eisenstein, 1924 *

Stills from the movie
*Hat Games*
by Hans Richter
1927-28 *

278

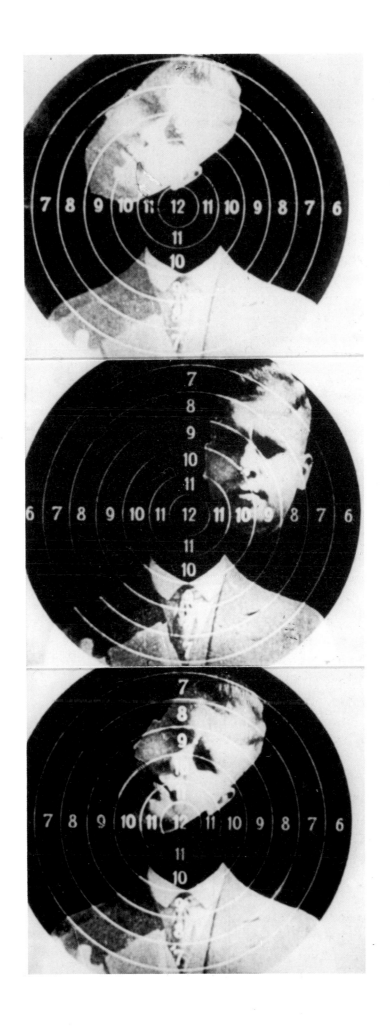

humus of this flourishing creation. An extraordinary representation, the magical expression of the great theme of *dignitas hominis*. On the other hand, the extent to which Florentine Neo-Platonic hermeticism was active in the Lombard culture surrounding Arcimboldo, in Lomazzo, in Comanini, and more decisively still in the scene par excellence for our painter — the courts of Vienna and Prague — is a well-known phenomenon thanks to the analyses of Klein, the Panofskys, and Yates. Lo, man is a prodigy, worthy of veneration and honor, because his facies is a compendium of the whole of creation. The words of the *Asclepius* reported in the oratio of Pico della Mirandola, "an epigraph worthy of the whole age" (Garin), are thus, literally, re-invented by Arcimboldo. The sign of man binds to itself all others. "He is at the same time all things and he is at the same time everywhere" (*Asclepius*, 6). He is free from the hierarchies of the various orders, not because he exists as an abstract world in itself, outside them, but because he bestows form and measure on them all. The *commodatio* of the various orders is always a *commodatio ad hominem*. A diabolic inversion of this harmony would occur if a flower, an animal, or a stone were to be composed of human faces. Alchemical transformation has a pre-determined and irreversible direction: it passes from the apparently chaotic multiplicity of natural forms to the true Aurum (gold) of the sages, which one attains *intus*, by plunging into oneself, returning radically within oneself, which is to say realizing one's own humanity to perfection. The Ministers of Sleep lead Arcimboldo from the images of "animals and birds and snakes and knotty branches and flowers and fruits and fishes and vegetables and leaves and ears of grain and straws and grapes" to those of men and the "vestments of men," of women and the "ornaments of women."

Outside of this meaning, magic becomes sinister, and marvel degenerates into fantastic eccentricity. From this point of view, Arcimboldo's mania appears far more rooted in the groove of tradition than "heroically and furiously" experimental and avant-garde, as was thought by so many of his twentieth-century rediscoverers, who were obsessed with "actualizations."

And yet, the harmonic picture so far described is far from being satisfactory. There are too many poisons stirring up the aura. With creators like Arcimboldo, it seems necessary to reflect more problematically on the tradition to which he most certainly belongs. The theme of *dignitas hominis* — of this mankind that, in Arcimboldo, seems to be almost the humus and *Terminus* of creation — undergoes decisive changes as it passes from the hermetic texts translated by Ficino to Ficino himself, to Pico, and gradually through the intricate web of Renaissance and mannerist hermeticism. Here we cannot even sketch a summary outline of the evolution of this theme, but only attempt to define its direction as regards the aspects relevant to Arcimboldo's work. Signs of adult disenchantment inexorably creep

André Breton, Paul Eluard
Valentine Hugo
*Exquisite Corpse*, 1930 c.
Pastels on black paper
28×22 cm
Private collection

André Breton and Frédéric
Migret-Anon
*Exquisite Corpse*, 1930 c.
Pastel on black paper
31.8×23.8 cm
Robert A. Baird Collection
California *

Still from the movie
*Un Chien Andalou* by Salvador Dalí and Luis Buñuel, 1928 *

Stills from the movie
*Un Chien Andalou*
by Salvador Dalí and Luis Buñuel,
1928

into the almost triumphant hymn of the beginnings. It is not the *foelicitas* that supposedly pours forth on man from the supreme generosity of the Father that is dwelt upon, but that other aspect: "nec certam sedem nec propriam faciem nec munus ullum peculiare tibi dedimus, o Adam." The eye falls on this expression and little by little abstracts it from its context. It no longer succeeds in accepting it as a "natural" statement of that idea of *foelicitas*. Only an imperceptible shift is needed to bring about a decisive catastrophe, for seen in a different light the same thing becomes unrecognizable. In the *Asclepius* the mixed nature of man appears as the most fortunate, because it is allowed to retain everything and therefore to bind everything, and bind everything to itself. And the theme of *medietas* as measure, proportion, and temperance was to be propounded by Ficino in all its political, ethical, and religious consequences. But we only have to sense what this *medietas* cannot be for its triumph to begin to decay: no certain place, no character belongs to it exclusively. And no face.

The capacity of man consists in his being nothing but *in-capacity*; nothing belongs properly to him except capability of being. No foundation, no present, establish his being. His facies pullulates with every seed, with all the *semina rerum*. Enormous freedom, which "indetermines," which is a condemnation to infinite nostalgia: man's appetite is infinite, says Campanella later, and he is not satisfied with power nor cities nor kingdoms. Not even a world could satisfy him, as Alexander demonstrated when he grieved at not being able to subjugate all the worlds of Democritus. *Homo ille melancholicus* springs from this: it is not a question of a rupture or a reversal of the discourse on the dignity and uniqueness of man, but rather a penetration of him, a radical process of interiorization. This same uniqueness is now reflected according to his mournful facies, grasped according to his essential wretchedness, that of not being other than what we want, that is, not being except what we "plan" to be. Not being and not living except in the image of what we might be and live. The face that is free to assume any likeness therefore becomes unreal, a dream never completely grasped, undecipherable. Like dreams it grows pale, and its colors lose any naturalistic correspondence to those of things which are, of those things and those animals that have been given a certain place, a certain face and a certain character. The late Renaissance and mannerist periods have a vision of man as being *ek-static*. This vision seduces, bewitches, terrifies. It is in this sense that the late-Renaissance "magician" revives the grand themes of hermetic and Neo-Platonic humanism — according to a yardstick of suffering, we have to say, and of a decay that was immanent within it from the beginning, but that now displayed itself as the basic and inescapable tonality. Again the universe is treated as an ordered system of correspondences, in which the soul can "fabulieren" (as Paracelsus puts it) with the invisible entity of

283

the *astrum*. Everything bears within it the indelible signature of the original unity; everything still recognizes that it is an expression of that unity, the word or *logos* of God, and therefore since the beginning of time included in it and destined for it. Throughout the whole century we still hear the mighty sound of the symphony of Plotinus, in which every determined entity, every *logos*, every *dynamis*, is a member of the choir. Outside of the notion that everything is *sympathès* and that this cosmos does not contain a single fragment of matter that is *apsychon*, absolutely without *psyche*, that is, of the principle of life and movement — outside of the idea of the universally symbolic nature of being, it is impossible to understand the basic motifs of that religious and scientific, artistic and philosophical culture that extends from the "rebirth" of Plotinus to Giordano Bruno. And yet this vision presents a radical change of tone. In the *Liber de vita coelitus comparanda*, which is a real and proper commentary on Treatises II and IV of the *Fourth Ennead*, the value of the symbol is finite, the entire universe appears to be perfectly finalized, and therefore embraceable according to the idea of a single End. The works of nature proceed in an orderly manner, like the works of a wise man. It was still in the Thomist-scholastic (and Aristotelian) universe that there emerged the problem of that prodigy, that monstruum: man being at the center of things. But this centrality was still in harmony with the *uni*-versal nature of the cosmos ending at man. Now it is this very *uni*-versality and this finalization which that prodigy, that *monstruum*, questions pitilessly. The "heroic fury" of man without a place of his own, without a face, without an enduring character, completely breaks the finite character of the symbol, and he seems at home only in the infinity of forms. His world, as Montaigne was to say, "all runs on wheels." "I do not depict being; I depict passing."

What gradually fails between Ficino and Bruno, and renders any philological analogy sterile, is the image of man as fixed within a finished, perfected cosmos. What does not in any way diminish is the notion of a cosmic *sympatheia*, of a cosmic web of bonds which it is up to the "magician" to decipher and, to some extent, to provoke. Indeed, this notion can become more emphatic, charged with an even more decisive value, for just because the ratio of things can no longer be forced into finite horizons there must be greater intensity in the mania which investigates it, moving out on its "hunt" from that ratio. It is the new flight of Giordano Bruno that soars beyond our globe, wings its way through the immensity of space, a flight that no prejudice and no tradition are able to arrest at the *Terminus* of the celestial spheres. These spheres have become a fictitious prison, and the "magician" becomes precisely the one who, in dissolving the image, also dissolves the ancient, ancestral fear of it.

The profound melancholy of this interminable flight. This flight does not overcome, but confirms the terrible character of that

Salvador Dalí
*Paranoiac Metamorphosis of Gala's Face*, 1932
China ink on paper, 29×21 cm
Boris Kochno Collection, Paris *

284

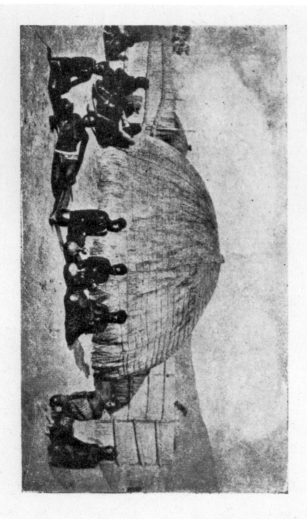 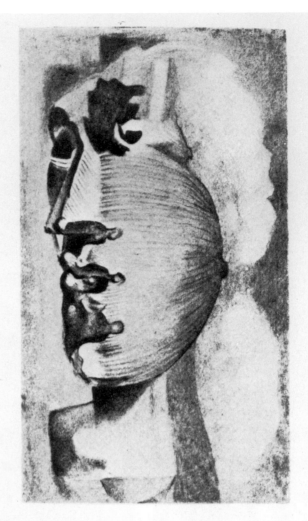

COMMUNICATION : Visage paranoïaque.

A la suite d'une étude, au cours de laquelle m'avait obsédé une longue réflexion sur les visages de Picasso et particulièrement ceux de l'époque noire, je cherche une adresse dans un tas de papiers et suis soudain frappé par la reproduction d'un visage que je crois de Picasso, visage absolument inconnu.

Tout à coup, ce visage s'efface et je me rends compte de l'illusion (?) L'analyse de l'image paranoïaque en question me vaut de retrouver, par une interprétation symbolique, toutes les idées qui avaient précédé la vision du visage.

André Breton avait interprété ce visage comme étant celui de Sade, ce qui correspondait à une toute particulière préoccupation de Breton quant à Sade.

Dans les cheveux du visage en question Breton voyait une perruque poudrée, alors que moi je voyais un fragment de toile non peinte, comme il est fréquent dans le style picassien.

Salvador DALI

freedom, which already resounds in the words of Pico's *Oratio*. No flight has ever seemed less triumphal, further from superhumanistic stereotypes. Thus the art of binding became infinitely more laborious and complex. The *ratio vincolorum* did not become clarified with the heroic progress of that flight, but on the contrary its occult nature emerged with increasing "clarity."

What binds is *latens*, even if we have to conceive of it as absolutely determined, because it is evident that every thing is at the same time binding and bindable, as the *vinculum* belongs to the *sensus* of each thing, as the shadow belongs to the body. Absolutely determined in its effects, the *vinculum* eludes every categorical definition concerned with what belongs to it in itself. In the bond par excellence (the bond of love) this dialectic of what is determined and what is occult emerges with the greatest possible force: it is impossible to comprehend it as a "something" and impossible to escape its power; impossibile to liberate oneself from its being-hiddenness.

The words of Bruno, who spent some time in the "magical Prague" of Rudolf II a few months after Arcimboldo's return to Milan, might in my belief constitute the best commentary on Arcimboldo's art. They were pronounced in the very year in which Arcimboldo's masterpiece, the *Vertumnus*, was produced. Certainly, as we have already stressed, he continues to operate within the perspective of a hieratically ordered universe: Bruno's formidable *Ent-ortung* finds in him nothing but a definite and particular echo. But on the basic problem of the *vinculum* it distinctly makes its presence felt. In forms that are absolutely determined, according to precisely "constructive" logical procedures, all the beings hold together, though what holds them together remains totally mysterious. The binding power is *spiritus*, not definable as an entity; it is non-entity. But this *non-being* or *no-thing* is absolutely determined; in fact it is *the* determined thing, since every fiber of the universe bodies it forth as its own meaning, "that" which permits both vision and discourse, "that" which permits an intuition and a communication of many: we are able to perceive the multiple and discuss it because it is not *disiecta membra*, but ratios, relationships, correspondences, links... in fact a truly wonderful system of influences, an extraordinary and inexhaustible polyphony.

And the *Nomos* itself (in the original Pythagorean musical sense) according to which all souls are composed, 'et vinciens ipse a vincto revinciatur'' (Bruno, *De vinculis*), now becomes an unfathomable problem. The perfected circular rhythm of the Neo-Platonic *vinculum*, that "circulus amorosus" spoken of by Leo the Jew, is deformed into a whirl of ellipses: the perfect symbol is replaced by the dramatic interplay of analogy and resemblance. Are the faces of things and terrestrial animals all brought to a conclusion in that of *Homo victor*? Or is this very face a no-thing, nothing? Is it possible that of this face, which ought to constitute the very end-all of crea-

Salvador Dalí
*Paranoiac Visage*
in *Le surréalisme au service de la révolution*, Vol. XII, no. 3
Paris, 1931
Musée National d'Art Moderne
Centre Georges Pompidou, Paris *

Communication: Paranoid Face

Following a period of study during which I had been obsessed by a long reflexion on Picasso's faces, in particular those of his black period, I was looking for an address in a pile of papers when suddenly I was struck by the reproduction of a face I thought was by Picasso, an absolutely unknown one.

Suddenly the face disappeared and I realized my illusion (?). The analysis of his paranoid image allowed me to discover, with a symbolical interpretation, all the ideas that had preceded the vision.

André Breton interpreted that face as belonging to de Sade, which corresponded to a very particular interest of Breton's in de Sade. In the hair of the face Breton saw a powdered wig, while I saw a fragment of unpainted canvas such as often occurs in Picasso's work.

*Salvador Dalí*

tion, we can affirm nothing but in terms of resemblances? Is it the face that comprises all faces, or are we compelled to have recourse to the other faces, which firmly and solidly are, which *know how to be*, in order to attempt an approximate definition of it? From afar, and only from afar, "something" appears that seems to be the face of a man; but if we observe carefully from close up we discover that it is nothing but the myriad of others: indeed, the myriad of the Other. And man *is* wild boar and wolf and fox, horse and stag and bird, as in the kaleidoscopic interlocking play of Della Porta's magic physiognomy. To define him in some way it is necessary to have recourse to that which is other than him, since he does not subsist in any place or in any form. To define him therefore means to construct him artificially. The line we have followed so far perhaps helps us to understand the basic reasons for that term "artifice," which everyone uses when dealing with Arcimboldo. His works are far from being a gratuitous game, nor is the astonishment that is intentionally provoked confined simply to the figurative invention. It is necessary, inevitable artifice: only artificially, at this point, is it possible to represent that bond which is the very meaning of things; only artificially, at this point, is it possible to represent that face which seemed to constitute its express End. The bond has no "ubi consistam," therefore to imagine it requires trouble, work, *inventio*. It appears marvellous just because it is no longer imaginable as "natural": an extraordinary product of the imaginative *vis*, which succeeds in discerning the play of the *sympatheia* between all the souls of the worldsoul even though it no longer has any determined or finite support, even outside the circle of the ancient symbolic cosmos. We are on a fine dividing line between on the one hand the Neo-Platonism (of a hermetic and Pythagorean flavor) of humanism and the early Renaissance, and on the other the baroque *ingenium*

"Alfred and I were in Paris in 1931, going around to the galleries. We went to the Pierre Colle Gallery in the rue de la Boétie where there was a show of Dalí's. Dalí came in poor and emaciated. He had no suit jacket and wore a raincoat over his shirt. We all went into the back room and saw a big painting with an opalescent sky — *The Masturbator*. Dalí showed us a postcard of one of the colonies in Africa. Natives in front of a big white tent, leaning, sitting, lying, etc. It was a horizontal photo. When he turned it vertically, what we saw was the large head of a woman — the tent was her chin, the figures her features. The double image. This is how Alfred and I got the idea of the double image.
We then went to Bad Gastein in Austria. In this little town we saw an Art Shop, a cheap tourist shop with a lot of bright flashy tourist pictures — flowers and fruit — just awful. In one corner of the room was a dark picture. We went over, and saw it was a horizontal landscape. We could see it was old. The dealer turned it vertically and we saw it was a hunter with a cap. Trees made the cap and bushes the chin. The ears were the target. We bought it.
Back in New York we showed the picture to Panofsky and he said it was of the 'School of Arcimboldo.'
When Alfred did the Surrealism show, he put in a lot of peculiar and enigmatic pictures from previous centuries to accelerate the public's acceptance of Surrealism."

*Margaret Barr*

Photograph of a rock at Cap Creus taken by Robert Descharnes and entitled by Salvador Dalí *Idée que la géologie dor sans someil*
Artist's collection *

that leads to the "intense" figure, the "grotesque conceit" of metaphor and allegory, the hieroglyphic in which nothing is ever denoted. That is, we are not yet by any means in the theatre "full of wonders," which is the metaphor for a thesaurus. Here astonishment is still directed at a *thaumastòn* that possesses ontological determination: the *vinculum* is *rei sensus*. And yet this very ontological basis now appears as the occult. Its pathos is nostalgia. The discourse, the *logos* that attempts to name it is inevitably transformed into such pathos. Arcimboldo in fact states it with perfect clarity, but nothing of what he states represents the bond that he wishes to state. Perfect determination and perfect latency. The bond does not appear. What appears is the naming that "means" it, that is its sign. Signs appear as if in them there could be a representation of the *Realissimum*: the power of the bond itself. And precisely this constitutes the essence of artifice. In this sense we should read the eulogy of artifice in the treatises of Lomazzo and Comanini, and not simply in the orthodox Aristotelian sense of the coupling of verisimilitude and marvel, the "credible wonder." In opposition to more classical aesthetics, Lomazzo's *Trattato* goes so far as to start out by exalting "this artificial and admirable painting," capable of forms of "flame," of figures that have "the tortuosity of a live serpent," and a "force of coloring" that is absolutely against the rules. And Agrippa (one of the sources of Lomazzo, as also of the "magic" of Bruno) had already spoken of the effectiveness of pictorial "deception," of the unnatural and the "monstrous" that pictorial ingenuity can produce (resulting in its greater excellence with respect to sculpture, as well as the fact that it can even be considered *ut poiesis*). But it is to Michelangelo that Lomazzo is intending to refer, and it is therefore not possible to take his words in a sense that would be no less than late baroque! Here the problem of artifice springs from the magic artifice of the *anima mundi*. Here the marvellous arises from the fact that the bond can still be imagined (in the literal sense of the word: put-into-images), in a case where everything seems to appear as transience and metamorphosis. It is a marvel that transience and metamorphosis can be signs of that Anima. A marvel that in the very *vanitas* of the signs one can imagine that Anima; that is, that images of it can construct themselves.

There emerges a painful awareness of the essential skepticism of the hermetic hymn to man. To confront the power of his magic there arises ever more clearly the idea of the elusiveness of that primal source, that unity that was never lost, that might have guaranteed its foundations. The bonds and the effectiveness of binding itself seem *artificial*. Bruno is aware of how "monstrous" Arcimboldo's work is. The melancholy facies becomes that of the magician himself. And according to this facies Arcimboldo depicts himself in his *Self-portrait*. (But is not the portrait of the *homo ille melancholicus* the portrait of the

sixteenth century itself? — an image of the coincidence between the imaginative *vis* and the unattainability of his End, between the cosmic power of the *vinculum* that links all things and the "wretchedness" of the manifold bonds that emerge in time, that come and go, that run on wheels like the figure of Fortune; a coincidence, moreover, between the force of the *logos* that ventures beyond the very circles of the ancient universe, and the pathos that strikes it as soon as it recognizes that "wretchedness." From Dürer's enigma to the portraits of Arcimboldo, the century is mirrored in this image).

The magician is he who binds and connects artificially. By linking things that seemed dispersed, he creates marvellous images. But at this point — and here is the "critical" situation of Arcimboldo — are what his imagination connects really and truly *things*? Is his image really a potent talisman that draws to itself and gathers in itself the powers of what it represents? Or are these powers at this point nothing but simple names? Is naming here not already on the point of changing into a mere interplay of signs, deprived of all evocative force? The magician is he who possesses the power of the name, but of the name as bound "by nature" to the thing. Now, on the contrary, it is another form of naming that arises, or rather, what emerges is the aporia of naming itself. One cannot name the "thing" except through something other than itself. This is no game, but harsh necessity. In the name lives the desperate attempt to grasp the "thing" by means of that which is not the thing itself. We cannot say "the earth" by means of "the earth"; we cannot describe "man" or even his characteristics by means of these characteristics themselves. We do not know the "thing." Names can only ceaselessly circle round it. Each name represents only an evanescent metaphor of it. An aware, mature metaphoricality of naming: that is Arcimboldo's way, and his philosophy. One of Bruno's great teachers, Nikolas of Cusa, had already said it, while dwelling on the great themes of apophatic theology before any humanistic enthusiasms cropped up: we know absolutely nothing about man, or about a stone or any single thing, but we *believe* that we know. If we ask ourselves about its *quidditas*, about the intrinsic, inalienable properties that make it *this* thing and no other, we can say nothing at all. We only know that the genus man is not the genus stone, and this we know from the differences in their shapes and operations, not because we know what a man is or what a stone is. What we have to say is never a positive *scientia* of the thing, but a matter of putting things in relation to each other, of establishing differences. Really and truly to know a thing would mean knowing it through the thing itself, its *quidditas*, its selfness, which is a perfect, divine *tauto-logy* impossible to man. Man is the creature who turns all to metaphor. This is expressed by Arcimboldo with perfect clarity. It does not follow, as is repeatedly said by those who misunderstand the tremendous seriousness of his game, that the face

René Magritte
*Le viol*, 1935
Chalk on paper, 36.5×25 cm
The Menil Foundation, Houston *

292

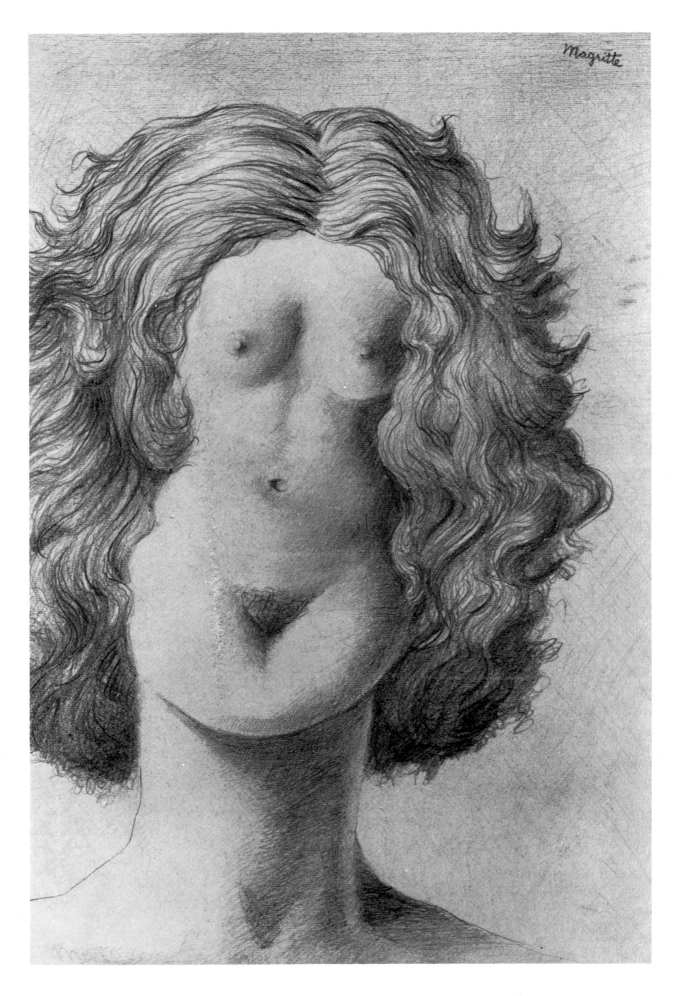

of a man is "replaced" by a composite of elements or animals (and this critical approach is no less vulgar when it explains what these elements or animals represent). No, it follows that the face of anything cannot be named except with something other than itself; that no face has, for us, a proper name; that our discoursing is nothing but a composing by means of differences and relationships, by increasingly artful links, by the *industry* of a process of binding, of which the fleeting and ephemeral nature and the melancholy key emerge with ever greater clarity.

Nothing is immediately expressible any more; every "natural" appearance is in reality a result, a product. Naming no longer touches anything, but is instead transformed into a pathos of distance. A long, adventurous metaphorical construction: that the marvellous

Carl-August Ehrensvärd
*Grotesque Portrait*, 1795
Pencil on paper, 32×20.5 cm
National museum, Stockholm *

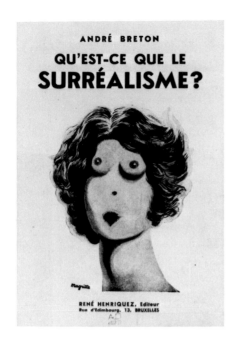

Cover by René Magritte for
André Breton's *Qu'est-ce que le
surréalisme?*
Brussels, René Henriquez, 1934
Bibliothèque Littéraire
Jacques Doucet, Paris *

pictorial artifice is able to express. And never a characteristic in itself. This seems to be the crisis that Arcimboldo represents. His portraiture (and that we have to speak of portraiture has been recognized by critics for some time) no longer has anything psychological about it. The great Renaissance and mannerist portraits were entirely inspired by the search for the inwardness of the sitter, for the unique, distinctive character. Arcimboldo's "monstrous" art renounces this very thing. Naming is incapable of grasping any *quidditas*, and proceeds purely by *genera*, by types. Pure temperaments can be represented, the highly generalized specifications of the creature, but never those subtle links, those impalpable filaments that connect the individual person with his own *astrum* or place him *singulatim* within the immense chorus of the cosmos. The psyche, the principle of motion, the *fons et origo* of the gestures and thoughts of this individual person, is a "thing" that of necessity escapes the net of naming. And therefore reality itself, in its own being, is for us ineffable. In Arcimboldo the "extraordinary," with respect to the preceding tradition, to which as we have seen he does in many ways belong, consists in no longer trying to achieve it. It is as if he forbade himself to expect it any more. He stations himself where it is impossible to discover the root: in the interminable play of metaphor. He wants to be where it is impossible to be: he gives the appearance of being there, and with this he produces astonishment and wonder.

A portrait of pure temperaments, of abstract ideal types, is a portrait of names, of signs. The name *is* the person, and each and every property of the latter is dissolved in it. The person is dissolved into the metaphor that indicates him. All that is celebrated in this is metaphor. The baroque court, the court of baroque drama, is already wholly implicit in this "drifting" of Arcimboldo's portraiture. The game of naming already expressed itself here in the form of grand ceremony. Nothing in it is worth anything on its own account, nothing has its own face. The only things of value are the rites of the rapport, of the relationship, and the parts that have been bestowed on each of them. No face as such, but masks. And the mask expressed the type, the genus, the temperament. In the great drama of the court, which is a metaphor of the world, the name of each person is the name of the role that he must play, and this name has a meaning only in its functional relationship to that of all the others. The psyche of each one is precisely what one has to be able to renounce, if the form of this game is to be preserved. And Arcimboldo is the perfect courtier.

The basis of the allegorical celebration is therefore the same as that of the most acute melancholy. The very names that exalt the type, the mask of sovereign power, declare its infinite distance from "psychology" in the proper sense of the word. The utterly real representation of this humor, as a universal experience, simul-

taneously shows its own introspective impotence and its own intuitive "wretchedness." Not even the frontal vivacity of *Vertumnus* subverts the framework of this drama. The "strange and deformed image" with a smile on its lips, the "regia imago" of Rudolf II, who raises a head made of fruit and ripe ears of grain above a bust of flowers and vegetables (as described by Comanini, and by Lomazzo in his *Idea*), is only apparently free from the weight of the mask, of the abstract, single part, of the established role. The king is every mask and every name. His power consists in having the extraordinary ability to "convert" himself into any semblance: therefore Vertumnus. But not even the king can exceed the game of names and masks. He is the actor par excellence, the one who knows all the parts. He is the prisoner of the drama in all its entirety and complexity: he encloses it all in himself, he always remembers it all, far from surpassing it, far from being free of it, far from being able to have an existence of his own outside the scene where it is being played out. The king is Spring and Winter, Summer and Autumn, Fire and Water, Earth and Air; he embraces within himself the drama of the humors and of the elements, he is phlegmatic and choleric, sanguine and melancholy. He is the power of the drama itself, the expression of its inexorability.

It also used to be called *Il cacciatore* (The Hunter), and the title is exact, if we take it in the sense of *animarum venator*; for the hunter is he who attempts to bind within himself the great concert of living beings. But his face is both that of he who binds and of that which is bound. The symphony of the animals, in all the variety of their heraldic functions, becomes the mask that conceals the psyche of the hunter. Or better, the regal image is here nothing other than the type of the hunter. And since the hunter will never touch the essence of his elements, the elements of which his only apparent facies is composed, he will re-echo the colors of autumn, of the melancholy earth that will soon be at rest.

The *signum triciput* of Saturn is indeed concealed in this regal profile. The eye is composed of the jaws of a wolf, facing backwards, an emblem of the memory turned toward the past. The dog, emblem of the *providentia* that looks into the future, is shown in the very middle of the head. The lion of Bohemia, the lion of present intelligence, majestically supports the entire figure, along with the ram, symbol of the Golden Fleece. Saturn, in his three aspects, dominates this figure; this face is his triple facies. An "imago regia," but only insofar as it is an image of the king, an image that alludes to the king, to Saturn. Not regal in itself, but only insofar as it is an image of the king, who "con-verts" all semblances, this image rules over the mournful magic, the ceremonies, the artifices, the inventions and the drama of Arcimboldo, a painter who was "in all things a philosopher."

*Composite Head*, 1900 c.
Post-card
Private collection, Paris *

# Honor to the Object!

by Salvador Dalí

When Plato writes: "Let none enter who do not know geometry," we are all quite aware that this is intended in the teasing, humorous way typical of the playful, conversational style of this philosopher, because in reality nobody took less notice of geometry than he. In fact Plato, far from maintaining a perimetric strictness, in his time was a character very like the *Dame aux camélias*. He was the true Lady of the Camelias of Mediterranean philosophy, because like her he lived silently, beyond the confines of geometry, with the materialist sex-appeal already possessed in that period by the statues of "sculptural thought," of a perfectly anti-geometrical morphological type, thus brilliantly inaugurating without knowing it the first great official brothel of aesthetics.(...)

So this philosopher, after having insulted the anti-geometrical bodies of sculpture, after having written on the door of the brothel of art the well-known "Let none enter who do not know geometry" (to gain more profit for himself from the anti-geometry of the soft structures he delighted in), as a reaction chose to immerse his head in the clouds of an abstract, spiritual, languid love, undoing with his head what he had really done with his hands, with his sex, by attenuating everything behind this vague intellectual feeling of elevation, finally even confusing the paths of meteors with the movements of his own mind.

So meteors and the most twinkling stars were for him just like camelias for the Lady. As Plato adored his stars, so the Lady worshipped her flowers, seeing in them the incarnation, or if one prefers, the flowering of her own spirit.(...)

If Plato, Anaxogoras, Socrates, the Pythagoreans and a few others, with their spiritual ideas about meteors, marked on the clock of culture the time of the "sculptural thought" which we shall see flowering again later, with all the aquatic, labiate camelias, all the waterlilies of the ideal cosmogony of the Modern Style, which as Salvador Dalí misses no occasion to repeat is nothing but the sublime flowering, the apotheosis of Greco-Roman culture reaching heights of truculence thanks to the here miraculous pepper of Nordic materialism, if Plato, as I have said and repeat so that my readers shall not lose the thread of my thought in this overlong sentence, struck the exact hour of "sculptural thought," Epicurus, that first great rational-

Salvador Dalí
*Birth of Paranoiac Furnishing,*
1937 c.
Black chalk and gouache on paper
62.2×47 cm
Private collection*

ist as Marx call him — and Lucretius, too, sang his materialist merits as sweetly as a nightingale — Epicurus, I was saying, although going against the ideas of the Greek people, ended "aesthetic sculptural thought" and attained a new level of moral conscience that laid the foundations for the Nordic appreciation of the "object," as Feuerbach was later to conceive it (but historically, for the object to achieve an autonomous consistency, it was necessary to await the new moral and intellectual barbarism of Christianity). If for Plato the "beloved woman" is still only a sculpture, with Christianity this same "beloved woman," the libido, by sublimation becomes the object of love, the "beloved object," and this loved object finally becomes the concise, categorical and fetichistic object of the cross itself, which definitively closes the "sculptural period."

Jesus Christ, as far as I know, does not say, "Let none enter who do not know arithmetic," but he could have said it, and if he had, it would have been right to take the prohibition seriously, because it is with Christianity that the moment for proper political accounting really arrives. It is the arithmetical cross of Christianity that demands an accounting for the state of aphrodisiac promiscuity in which (under the symbol of Leda and the swan) the right-and left-wings were living in mingled chaos, and it is certainly arithmetic that for the first time are divided right and left with the cross between them, decapitating the manhood of the Roman eagle above the imperial banner, removing all its feathers and turning it into the clear, bald cross it already had in its bones. The imperialist eagle which was already nothing but the powerful triumph and definitive erection of this winged phallus: Leda's swan, since in the case of Leda (personification of the right-wing) and her swan (personification of the left), the latter was still very far from realizing its possibilities as a rapacious, dominating eagle, since it was aphrodisiacally stunned by the sex-appeal of the right (Leda) and did not really know what it was doing, which in the circumstances seems very natural.

But this cross, this object, a political and arithmetical symbol which will allow us no more rest (because it begins as the sign of addition and becomes that of multiplication, of five-year plans, when it turns into a "hammer and sickle"), is more or less destined to be a hooked cross, a swastika, returning to the shape it had at the time of the anti-Platonic conceptions of meteors and, above all, of the sun.

And it is precisely the philosophy of the brilliant little Chinese which as I write this article in front of my window open to the Spring, sings with the sweetest and most appropriate voice of a canary sitting on my table in the form of the book *La Pensée Chinoise* by Marcel Granet. Currently the book claims all my attention. There I find arithmetical swastikas which give me great joy by proving that the Mediterranean and Plato in particular had no knowledge of such combinations. If Plato had known them, he

Salvador Dalí
*Être-Objet* (*Being-object*)
In *Minotaure*, 1935, no. 6

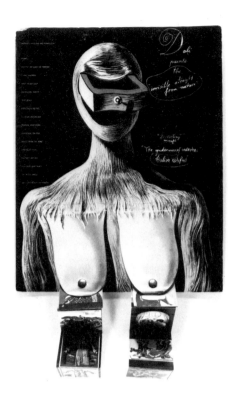

Salvador Dalí
Jacket of the Catalogue for the
Artist's Exhibition at the Julien
Levy Gallery, New York, 1936 *

would immediately have conceived "dialetical materialism" simply to annoy the Germans.

The swastika is the emblem of action, antisculptural, showing even in its morphology its unmistakable intention of really destroying everything for the sake of the object, which in the case of the swastika is the sun, a very important object which however leaves us Surrealists perfectly cold.(...)

This supremely irrational sign, sprung from the regions of octagonal civilization, appears above all as the amalgam (here the word is perhaps too ambitious) of antagonistic tendencies and movements. In fact its motion, tending simultaneously to the right and to the left, is the perfect symbol of the "squaring of the circle" derived from the octagon. This Wheel, although nobody knows whether it turns, is at all events destined to make men march.(...)

This paradoxical coming and going, this reaction and revolution is also explained by the fact that if the aim is on the one hand to square the circle, an eminently static idea, on the other it is nothing less than perpetual motion, which since our desire is always to make extremes meet, is embodied by the paradox of static dynamism, so that we see the right-wings of the swastika turning desperately to catch the left-wings by the tail, a sight that fills us with delight since it constitutes a magnificent biological impulse of narcissistic cannibalism, violently delirious and as fresh as a rose.

To conclude these few ideas timidly sketched out, I declare that the real, phenomenological swastika, the swastika as old as a Chinese sun, claims the honor of the object.

The surrealist object is inflexibly determined not to allow itself to be manipulated further. The surrealist object claims and will successfully impose its paranoiac-critical hegemony.

The surrealist object is impracticable, its only use is to make man march, to exhaust and cretinize him. The surrealist object is there only for honor, it exists only for the honor of thought.

In place of the banners and trophies, and dishevelled and furious cavalcades of octagonal-type civilization, surrealists and paranoiac-critics will pass under the hysterical triumphal arch of soft structures, surmounted by aphrodisiac, arithmetical jackets glittering with urine and emeralds.(...)

The aphrodisiac jacket belongs to the category of "thinking machines." It can be worn during certain extremely nocturnal excursions, in very powerful cars running very slowly (so as not to spill the liqueur in the glasses) during certain very calm nights of intense sentimental compromise.

Rayographe by Man Ray *

# Journey to the End of the Face

by Vittorio Sgarbi

*The Arcimboldo images in the exhibition that Alfred Barr mounted at the end of 1936, "Fantastic Art, Dada, Surrealism," were not originals but enlarged photographs. However, Barr's initiative launched into the mainstream of the larger public the art that was first discovered and appreciated by the cubists. That great interest in Arcimboldo's work continues to grow.*

Cover by Max Ernst for
*A Brief Guide to the Exhibition of Fantastic Art, Dada, Surrealism*
7th Dec. 1936 - 17th Jan. 1937
Museum of Modern Art, New York *

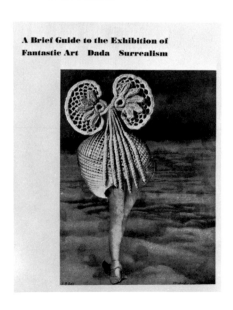

There are painters who are fundamentally philosophical, constantly seeking to escape the image they are depicting. What interests them is not to illustrate, but to penetrate, to see inside and beyond things. Their vision of reality is not reproductive but deeply interpretative. They open passages into the most secret corners, into the hiding places of obsession, into the depths of the psyche; they explore dark zones, perceive anxieties and mysteries, following a path that, starting in the late Quattrocento, reaches its point of arrival in the theories and work of the surrealists.

It is in fact possible to trace a subterranean path of surrealism in certain fundamental episodes of modern art, primarily in the sixteenth and nineteenth centuries. Indeed we can see as gravitating around veritable pivot-points important expressions of prototypes, germinal cells that lend form to ideas because what always gives substance to the history of forms is a shift from a given culture to a given image, from a concept to its representation. Now, when we read a profound unity of nature into Leonardo what we mean is that man enjoys a keen organic relation to things, represents their synthesis and completion, and above all contains in himself the structure of the whole world. Stone and flesh, water and eyes, plant life and clothes, are linked in one and the same rhythm, one and the same breath, one and the same dimension. That is how we must interpret paintings like the *Virgin of the Rocks* or the *Mona Lisa*, if it is true that culture is reflected in the *system* of forms. For Leonardo, man is the model of the world. And the life of nature is set up as a relationship between matter and energy that is identical in the macrocosm of the natural world and in the microcosm of man. In the *Codice Atlantico* we read: "Man is called miniature world by the ancients, and certainly the wording is well put. Inasmuch as man is composed of earth, water, air, fire, this body is the likeness of earth."[1]

Or: "The body is of the nature of grampus fish, or sperm whale, because it blows water instead of air."[2] And in fact rocks are its skeleton, loam its flesh, water its blood, flowing from the heart, which is the ocean, to the veins which are the rivers, whereas the "heat of the world's soul is the fire that permeates the earth."[3] And it is precisely in the *Codice Atlantico* that we find that famous

303

incunabulum of anamorphosis with which Leonardo provides graphic proof of the theories set forth in the *Treatise of Painting*, where he describes the foreshortenings of slanting views and the uneven proportional intervals.[4]

The elongated drawings of Leonardo, the face of a baby and an eye, are rendered by means of "barely visible tracings of the gradually outspreading projection lines," as Jurgis Baltrušaitis has pointed out.[5]

But the rediscovery of man in nature, the assignation of a face to the constantly changing formations of ground and rocks, has an even deeper significance in Giorgione. At this crossroads between Lombardy and the Veneto, between Leonardo and Giorgione, everything seems to happen simultaneously, as if in the stars, through mysterious influences of distant things. And yet there had also been a real opportunity: Leonardo's visit to Venice at the dawn of the new century, in 1500, while young Giorgione, only a little over twenty, was delineating his new vision of nature, of a *Natura naturans*, along the lines that were still being defined by the superb mind of Giovanni Bellini.

In some of Giorgione's most famous paintings, like *The Three Philosophers* of the Kunsthistorisches Museum in Vienna or *The Sunset* of the National Gallery in London, clearly shadowed forth, dissembled in the rock formations and traced by the clefts and ravines, are great human faces, all of whose features can be made out, from the slits of the eyes to the nose with its nostrils, to the mouth and the bearded chin. A similar anthropomorphic formation of rocks is to be found in *Pan and Syrinx*, a painting by Giovanni Agostino da Lodi, known as Pseudo-Boccaccino, in the Thyssen Collection in Lugano. The artist, who lived a long time in the Veneto, may be considered the intermediary between Leonardo's ideas and Venetian painters. And the Thyssen painting seems very closely related, in its idea of nature, to the poetic principles of Giorgione. The conception of space is similar, and the relationships between the figures and the landscapes, and similar, however different in stylistic terms, are the complex structures of the rocks and, in them, the concealed faces.

Most likely Giorgione's real Leonardo, in those very first years of the century, was no other than Pseudo-Boccaccino. Certainly the animation of nature, the endowing of it with condensed but perfectly recognizable human features, appears to be common to the two cultural areas of Lombardy and the Veneto, which at a certain moment seem to overlap. And since everything seems to be subject to that supreme logic of a preordained destiny, an appointed hour, a combination of events, one fundamental element must not be overlooked among the formative elements probably introduced into the Veneto area by Pseudo-Boccaccino, namely the Northern element. And however different in plan, with its distinctly realistic lay-

*Salvador Dalí*
*The Face of the Huge Cretinous Cyclops*, 1939
(Decomposition of a subject from *The Endless Enigma*)
Pencil and China ink on tracing paper, 21.5×20 cm
Gala-Salvador Dalí Foundation
Teatro-Museo Dalí, Figueres *

Salvador Dalí
*Mythological Beast*, 1930
(Decomposition of a subject from *The Endless Enigma*)
Pencil and China ink on plaster, 21.5×20 cm
Gala-Salvador Dalí Foundation
Teatro-Museo Dalí, Figueres *

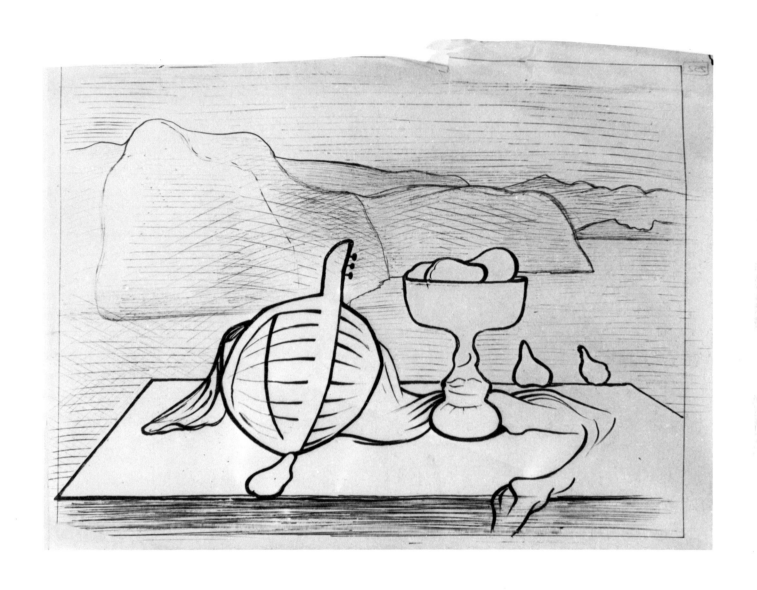

Salvador Dalí
*Mandolin and Fruitbowl*, 1930
(Decomposition of a subject from *The Endless Enigma*)
Pencil and China ink on tracing paper, 21.5×20 cm
Gala-Salvador Dalí Foundation
Teatro-Museo Dalí, Figueres *

out, based, unlike Giorgione and Pseudo-Boccaccino, on real seeing, one must not forget as a document the extraordinary watercolor, *View of Arco*, painted by Albrecht Dürer on his way to Trent from Verona in 1495. Clearly distinct in the rock formation beneath the stronghold on the cliff overlooking the Sarca valley, is the profile of a scowling man, perfectly decipherable, from the hair to the broad wrinkled brow to the eye socket, the long pointed nose, the mouth and chin. So this is one more link, at the end of the century, between the *Virgin of the Rocks* and the philosophical idylls of Giorgione, in the tracing of a human face in the natural world.

These are the first signs, the first formal representations of the principle that inspired the quest of Giuseppe Arcimboldo. And these precious works of the past take on a more complete and virtually preordained significance if compared, in particular, to an extremely revealing work by Arcimboldo unfortunately lost, but extant in a contemporary print. This is a woodcut by Hans Meyer who worked in Vienna around 1565 for Maximilian II, at the same time that Arcimboldo appeared in the records of the royal family as the official portrait painter to the court. The painting which inspired the woodcut probably dates from the period between the *Four Seasons* (1563) and the *Four Elements* (1566), but it could be a work seen several years earlier, possibly even the first of Arcimboldo's strange inventions. In fact, there is something less bold about it, as if it were still bound to the face-in-nature ambiguity in the spirit of the Giorgione and Dürer models.

A faithful copy of it (as the image from the same side of the woodcut seems to indicate) belongs to a private collection, where it is attributed to Josse de Momper and conserved in a series inappropriately called *The Four Seasons*. The Arcimboldo trademark is certified in the woodcut by a stone in the lower right hand corner bearing the inscription, "Inventio Arcimboldi," further confirmed by the couplet under the illustration: "Me into mountain didst form and onto paper didst impart / Nature by accident, Arcimboldo by art."

Obviously and clumsily copied after the woodcut, claiming a similar plan and a rather free rendition (two elements that would also lead one to suppose a direct derivation from the lost original), the painting was mentioned by Geiger (the former owner), who recklessly attributed it to Arcimboldo.[6] The woodcut in particular, but also the painting are very obviously descended from the Pseudo-Boccaccino and Giorgione works mentioned above. Going back, more specifically, to the Giorgione cliff, we notice that Arcimboldo has endowed the scene with architectural elements, bridge, houses, tower, and a waterfall corresponding to mouth, eyes, nose, and beard, but complying perfectly with the rhythmic patterns and contours of nature, dissembled but nonetheless visible in Giorgione.

In Arcimboldo there is amusement in the composition, a spirit of whimsy, a suggestion of the conflict between nature and civilization,

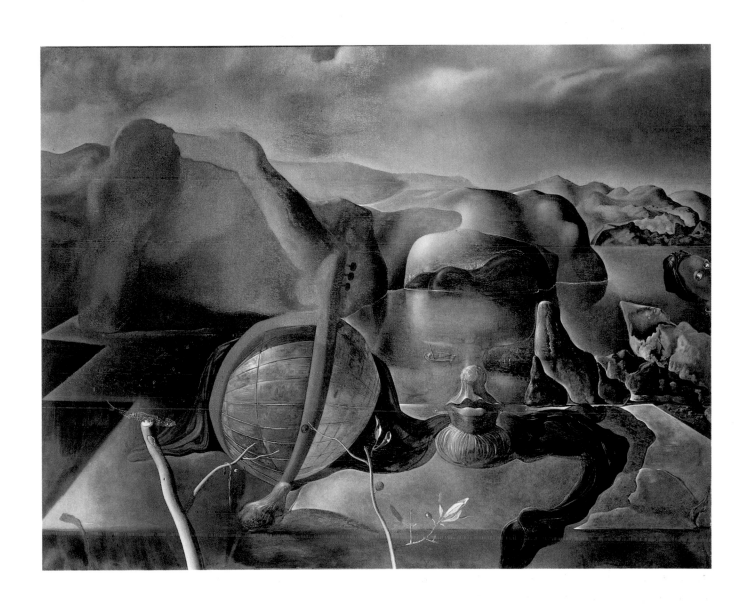

Salvador Dali
*The Endless Enigma*, 1938
Oil on canvas, 114.3×144 cm
Artist's collection
Gala-Salvador Dalí Foundation
Teatro Museo Dalí, Figueres *

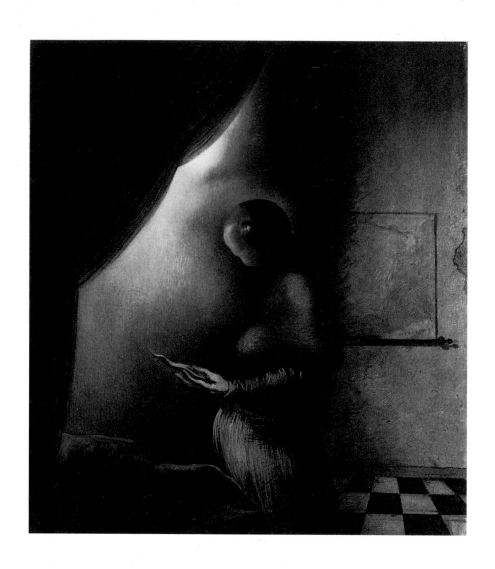

Salvador Dalí
*The Image Disappears*, 1938
Oil on canvas, 55.9×50.8 cm
Gala-Salvador Dalí Foundation
Teatro-Museo Dalí, Figueres *

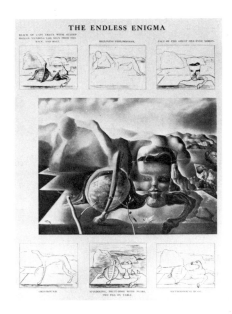

Salvador Dalí
Jacket of the Catalogue for the
Artist's Exhibition at the Julien
Levy Gallery, New York, 1939 *

between architecture and rock formations, amalgamated into an image that is something else, a complex synthesis (not house, not rock-formation, but face), which is not found in Giorgione, for whom the boundary between human face and nature is much more vague and subtle. Yet, upon closer examination, the cadence is the same; and it is that trademark, that tinge, that embryo, suggested by Giorgione, which seems to have inspired Arcimboldo. In the two painters, the rhythm of the parts is absolutely identical: note the turned-down mouth, as was also the case in Pseudo-Boccaccino, and beneath the chin the flounce that slopes down to the plain, like a riverbank, corresponding to the cascades of Arcimboldo that surge in tiny billows like the curls of a beard. Add to this an element not mentioned in the description of the Pseudo-Boccaccino and Giorgione paintings, that Arcimboldo also borrows from them the wooded area growing on the hill like a lock of hair.

Certainly, as is eloquently proved by a comparison with the copy mentioned by Geiger, *Homo omnis creatura*[7] (encumbered by mechanical architectural insertions into the excessively anthropomorphic tissue of forehead, cheeks, teeth), in Arcimboldo there are bold and spectacular inventions (though, going by the engraving, based on elements by Giulio Campagnola, hence still in the Giorgione area), such as the plume of smoke corresponding to the eyebrow. So after this comparative examination, maybe "Inventio Zorzoni" should be superimposed over the inscription "Inventio Arcimboldi."

Proceeding with the discussion of certain Arcimboldo predecessors, we shall remain in the same area of Giorgione in identifying a reference point for the fundamentally important *Four Seasons*, signed and dated 1563, in several works by Dosso and Battista Dossi. It is difficult to establish, in this case, if the influence was direct or stemmed from those philosophical focalizations that seem to link Arcimboldo-Leonardo-Giorgione, but surely some suspicion of formal relationships or of borrowed ideas is suggested by the grotesque faces and their virtual identification with flowers, fruits, and birds, arranged with perfect naturalness, in the so-called *Bambocciata* by Dosso Dossi in the Uffizi, dating from around 1535. In particular, the extraordinary syntagma of the breasts of the female figure on the left with the apples and citrons on the tray she is holding may well have been an element that caught Arcimboldo's eye. On the other hand, the Dosso Dossi painting dates from the period when Dossi was seeking an out-and-out inter-identification of the human body with plant life in the frescoes in the Hall of the Caryatids in the Villa Imperiale in Pesaro.

The same interest, in an even more Arcimboldesque key, reappears around the mid 1550s in the allegories *Justice* and *Peace* by Battista Dosso, now in the Gemäldegalerie of Dresden. In these huge figures, one also gets the impression of an identity, if not a reversal

of values, between the conventionality of the faces and the extraordinary realistic cast given the flowers, fruits, and vegetables. From these monumental, however overcharged, figures to Arcimboldo was but a short step. For him it was a matter of combining what was still distinct and separate in the Dossi brothers.

## The eye-planet

Moving into the sphere of modern art in search of parallel frequencies for phenomena that, like those that led up to Arcimboldo, precede surrealism, the name that stands out among all others is certainly that of Odilon Redon. His position as an inventor of new images, creator of moods, begetter of unexpected auras, is very similar to Giorgione's. With Odilon Redon a new world opens up, where everything refers to something else and contains in itself an endless network of relations with everything else, with the stated purpose of "making unreal beings live human lives, in keeping with the laws of realism, and placing as far as possible the logic of the visible at the disposal of the invisible."[8] Redon carries to the highest degree the principle of Kaspar David Frederich: "the painter must paint not only what he sees before him but also what he sees in himself. But if he sees nothing in himself, let him leave off painting what he sees before him."[9] In an ideal and wholly independent prolongation of Leonardo and Arcimboldo, Redon pictures eyeballs big as planets, as suns, as balloons. The moon has a gaze: "On the horizon the angel of certainties and in the dark sky a questioning gaze."[10] The lashes of an eye turned upward in a state of ecstasy are like sunbeams: "The eye, like some strange balloon, makes for the infinite."[11]

The eye is Redon's real obsession: it is an independent entity, dwells in space, indeed describes a space different from everyday reality. In our body it is the eye that provides the perceptions for establishing our position in space, which appears essentially static. If the eye is left free to float in empty space, all spatial references, related to terrestrial gravitation, necessarily undergo a change. This is what Redon means, discovering a new physical law, when he attaches the following caption to one of his lithographs: "And let the headless eyes float like mollusks."[12] We are no longer on the verge of dreams but inside dreams, as is symbolically shown in *Dans la rêve*, where a radiant planet-eye appears to a fleeing couple between two large columns of a temple.[13] This almost apocalyptic image (of an Apocalypse Now, as well) does not so much conjure up solitude, fear, and abandon as represent the figurative rendition of Baudelaire's symbolist manifesto, *Correspondances*: "La Nature est un temple ou de vivants piliers / laissent parfois sortir de confuses paroles; / l'homme passe à travers des forêts de symboles qui l'observent avec des regards familiers. / Comme de long échos qui de loin

Cover of *Match*, 12th October 1939
Drawing by Salvador Dalí
War scene
in Lieutenant Deschanel's face

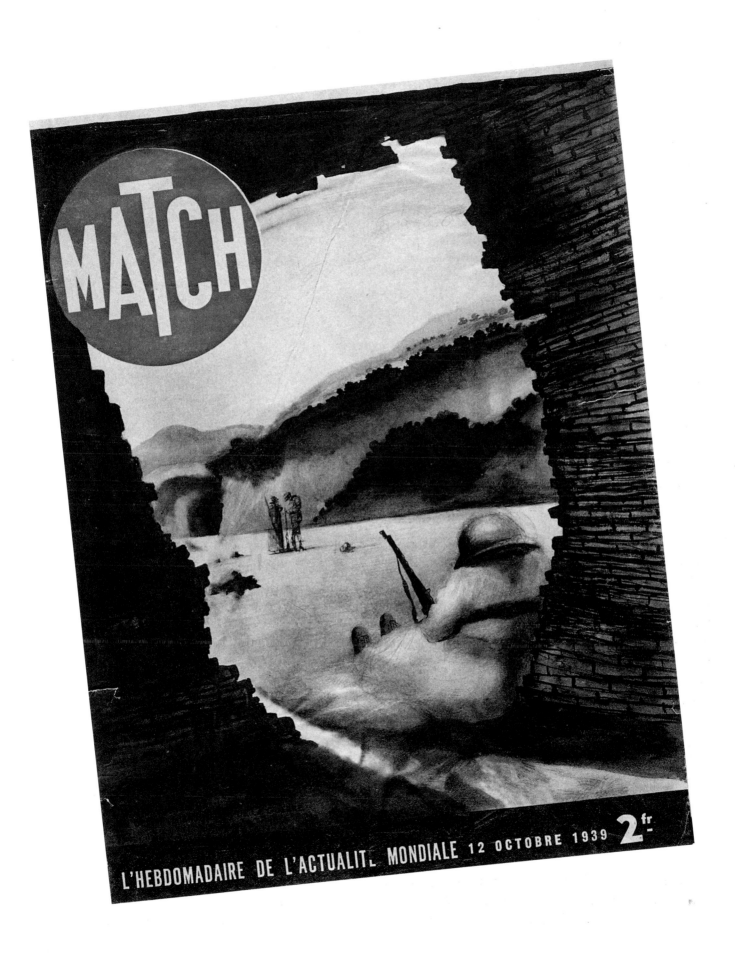

MATCH

L'HEBDOMADAIRE DE L'ACTUALITÉ MONDIALE 12 OCTOBRE 1939 2 fr.-

Hans Bellmer
*Céphalopode irisé*, 1939
Oil on cardboard, 49×44 cm
André François Petit Collection, Paris *

se confondent / dans une ténébreuse et profonde unité, / vaste comme la nuit et comme la clarté, / les parfums, les couleurs et les sons se répondent. / Il est des parfums frais comme des chairs d'enfants, / doux comme les hautbois, verts comme les prairies, / et d'autres, corrompus, riches et triomphants, / ayant l'espansion des choses infinies, comme l'ambre, le musque, le benjoin et l'encense / qui chante les transports de l'esprit et des sens."[14]

But Redon goes further because along with the relations, he studies and analyzes the transformations. He captures all the echoes of things, both "in a dark and profound unity, vast as the night and light," and in their disembodiment, in their passing from one substance to another, from being to being-other, without disintegrating, indeed re-forming into new and unexpected unities. Because each thing is also another thing, has two, three, infinite aspects, and each image is also another image, just as Arcimboldo had shown. But while Arcimboldo's approach presumes a twofold truth (we can see a face, but also a simple arrangement of fruit or vegetables), Redon's art envisages, in its extreme ambiguity, a single truth: the truth of the deep mystery of things. So ambiguity becomes law, the key to the interpretation of nature. The sun-eye is also the flower-eye, the mollusk, the egg, the balloon, the Baptist's head, and is still an eye.

In his journal, A soi-même, Redon wrote in 1902: "The sense of mystery lies in abiding at all times in ambiguity, in double, triple appearance, shadows of appearance (images in images), forms that seek-to-be or that will be, depending on the viewer's frame of mind. In the appearance of things lies then great suggestion."[15]

"Images in images": Redon was aware that here lay the taproot of his quest, in which oppositions are reconciled to reach a synthesis that was to be shattered anew by the surrealists (we feel that nothing remained for Magritte to explore but a play on words and images).

Redon's vision is Manichaean. From the black of his charcoal drawings and lithographs — always set off by the light of the eyes, an aspiration to the heights — by the last decade of the century Redon had already moved on to bright pastel and oil paintings, in which he transformed the themes already treated in his drawings. He slowly emerged from the dark, from doubt, anguish, and obsession, without sacrificing the revelatory power of mystery. As he had already foreseen in commenting on the first version of his *Pegasus Flying to the Sun*: "It is the triumph of light over darkness. It is the joy of broad daylight opposed to the sadness of night and the shadows. It is like the joy of relief after anguish."[16] In this constant duality of light and darkness one of the fundamental experiences of the modern spirit is resolved, providing psychoanalytical profundity and an extraordinary and surprising solution to the riddle propounded more than 300 years earlier by Arcimboldo.

Hans Bellmer
*The Dream of Mr. Quetzalcoatl*, 1938
Watercolor
Private collection

## The Face changes Face

Among the indirect outgrowths of the explorations of Arcimboldo, grafted onto the trunk of Odilon Redon, certainly one of the most unforeseeable and anomalous is represented by Alberto Martini. Starting with *Yellow Butterfly* and *Moth*, followed by the lithographs of the 1915 butterfly series,[17] and possibly even earlier, in his explicit allusions to eyes as sources of light, Martini conceals human or feline faces in multicolored butterfly wings already arranged anthropomorphically. After a period of quieter subject matter, during which he painted a number of intense portraits, an interest in faces returned around 1928, expressed in more schematic geometrical compositions. I am thinking particularly of works like *Plastic Metempsychosis - Triptych of Love*,[18] where surreal forms float in a vague space studded with flashing eyes that take shape in superimposed faces. As Marco Lorandi has pointed out, "In the central panel, perhaps the most complex in this painted parable of 'psychic transmigration,' the elements of the other two panels are brought together and blended: the mountainous landscape at the bottom, the great tree-flower that holds in its bloom the meeting of faces and mouths, the rosette of the great pearl-valves lying open to reveal the sealed crucible of the multitude of feelings."[19]

Alberto Martini's explorations overlap those of Magritte in works like *The Smoker* and *The Mathematician*, both dating from 1930, constantly returning to the prevailing motif of the eye, emerging protagonist of these images, up to the extreme limit of *Human Gaze*, painted in Paris in 1932. This is a rarefied and effete homage to Odilon Redon,[20] already belonging to the world of Duchamp and Picabia. Martini is a rare case of an extraordinary technician, as emerges clearly in his flawless engravings, who relinquishes virtuoso flights in favor of ideas, attempting to reduce forms to nothing, to direct psychic emanations without the hand as go-between. It seems impossible that the same artist could have come up in 1905-1910 with the wonderful series of illustrations for the short stories of Edgar Allan Poe and twenty years later with works so sloppily drawn and repellently painted as the series that Martini himself called "peinture téléplastique."[21] Arcimboldo's example had an indirect influence on Martini too, was transformed into a methodological principle, into a conceptual stimulus whose outcome removes all ambiguity. Dreams and obsessions, eye-obsessions, are stamped directly on the canvas and the resulting images. In them the "journey to the end of the face" really seems to have run its course.

Alberto Martini
*Invention of the Movement of the Glance*, 1935
Drawing

1. Leonardo da Vinci, *Codice Atlantico*, fol. 55, v.
2. *Ibid.*, fol. 203, r.b.
3. Leonardo da Vinci, *Codice dell'Anatomia*, fol. B.
4. *Trattato della Pittura di Leonardo da Vinci nuovamente dato in luce con la vita dello stesso autore scritta da Raffaele du Fresne.* Paris: Langlois, 1651, p. 79.
5. J. Baltrušaitis, *Anamorfosi*. Milan, 1978, p. 43.

Marcel Jean
*Specter of the Gardenia*, 1936
Plaster covered with fabric, zip fastener and roll of film
28.2×20×25 cm
Museum of Modern Art, New York *

6. B. Geiger, *I dipinti ghiribizzosi di Giuseppe Arcimboldi*, p. 42, pl. 22. The painting was republished in R. Barthes, *Arcimboldo*, pp. 72-73, with the indication that it now belongs to a private collection in Turin.

7. The inscription "Homo omnis creatura" appears on a scroll in the upper part of the painting.

8. O. Redon, *A soi-même, Journal (1867-1915). Notes sur la vie, l'art et les artistes.* Paris, 1922, p. 18.

9. K.D. Friedrich, *Bekenntnissen*, ed. K.K. Eberlein. Leipzig, 1924.

10. The lithograph, dated 1882, belongs to the series dedicated "A Edgar Poe," whose power of suggestion also stimulated the imagination of Alberto Martini.

11. The lithograph of the Edgar Poe series dates from 1882.

12. The lithograph, for *La Tentation de Saint-Antoine*, dates from 1896.

13. The lithograph, entitled *Vision*, from the "Dans le rêve" series, is dated 1879.

14. C. Baudelaire, *Les Fleurs du Mal*, 1857.

15. O. Redon, *A soi-même*, p. 97.

16. In R. Negri, *Redon*. Milan, 1967, p. 6.

17. These works were published in the catalogue in the retrospective exhibition of *Alberto Martini*, ed. M. Lorandi. Milan, 1985, pp. 102-103, pls. 87-90.

18. *Ibid.*, pp. 142-143, pls. 135-137.

19. *Ibid.*, p. 143.

20. Cf. the vague spatial definition in Redon's lithograph, "Et que des yeux sans tête flottaient comme des mollusques."

21. Published in Lorandi, *Alberto Martini*, p. 159, pl. 157.

# The Question of the Fragment

by René Thom

Does it make sense — as has for instance been done in the case of Catastrophism — to seek parallels for certain artistic movements in the world of contemporary science? Clearly, the object is to discover a common origin shared by the disciplines of artist and scientist which goes beyond the obvious *a priori* differences their respective activities impose. And where is this more likely to be found than in a common fount of imagination inspiring and directing the respective development of both? But then, are such parallels really justifiable?

Such questions, however, call for great circumspection. Nonetheless it is just such a bridge between Science and the Arts I would here attempt to construct. There are two approaches, namely from Arts to Science or from Science to Arts. Of the former I have come across several examples: it is usually a case of a creative artist who has found a personal "recipe" for creating a particular kind of work of art, using particular materials, in a particular style and with a particular range of chosen forms... At a later stage he is tempted to illustrate, or rather justify, his creative processes by recourse to the great images of modern science. Here there is no lack of large-scale themes that are rich in evocative power: an example is the Big Bang theory of the beginning of the universe with the flight of the galaxies. On a smaller scale there are others that are also very suggestive, such as plasma confinement (for controlled nuclear fusion), or the confinement of quarks often held to be responsible for the stability of matter. Catastrophism is also influential from a terminological point of view (to which, incidentally, its much discussed fame is due)... However, what strikes me in all the cases I have come across is that the artist discovers his creative process(es) as a result of his own artistic growth, and the attempt to discover in the world of science a rationalization for his creative expression, which in his own eyes as in those of the public may be its justification, always takes place *a posteriori*. When he does this though, is the artist not falling (at times even willfully) into the trap of a forced assimilation? Art, after all, has no need of Science. Beauty comes of itself, and is not bound to any cultural or rationalizing field of reference. It is for this reason that I, quite unlike those artists who seek a parallel for their creative processes in the world of science, have chosen to

Rayographe by Man Ray *

319

approach the bridge from the opposite direction with the intention of revealing the scientist's perplexity when confronted with the enigma of Beauty. Can one construct, could one even imagine, a "scientific" theory of aesthetics? Now, it happens that Catastrophism (in its most general, philosophic sense) can throw some light on the question of the genesis of art. And from this point of view I am tempted (not a little imperialistically) to declare there exists no catastrophist art as opposed to, let us say, a "continuist" or "Apollonian" art, but instead that all art is catastrophist in its very essence!

What is catastrophism in the most general acceptance of the word? Fundamentally it is a theory of universal dynamism: each thing only exists as a unique and separate entity insofar as it is able to withstand the passing of time. All existence is the expression of a conflict between the erosive, destructive effects of time — everything passes, says Heraclitus — and an abstract principle of permanence (or genesis) that ensures stability in things. This latter I (after Heraclitus) call *logos*. The most stable and permanent entities are of a material and spatial nature: protons, according to the most recent theories, last for something in the order of $10^{50}$ years — much longer than the $10^{14}$ years attributed to the existence of the universe. The geometry of our space-time is also considered permanent, notwithstanding that the entities that make it up are unknown. Time is endowed with the peculiarity (making it perhaps unique among all the forms of space considered by science) that it is the support both of a geometry (defined in terms of "length" of time and equal measures of duration) and of an "axiological" space basically conceived of as a past-time $\rightarrow$ future-time movement marked by the discontinuity of present-time. In highly anthropomorphic terms — allowing nonetheless of a precise mathematical interpretation — every "logos" is defined by a system of "values" producing an axiological space that can be defined in terms of local space — a substratum of an (at least relatively) geometrical nature, such as space-time. A typical example occurs in linguistics, when a meaningful phrase is endowed with morphological unity by means of establishing data — the result of a system of values — for its signification, through the use of a logos that ensures the relationship between *signifié* and the syntactic (syntagmatic) structure of the phonemes in the temporal sound-structure. Clearly, less stable entities must rely for their existence on those which are more stable. While it is true that in a certain sense all entities are located in a substratum as the minimum expression of a *potential* that "axiologizes" it (cf. Aristotle's explanation of gravity by the theory of natural place), this substratum can often be non-spatio-temporal, and thus defined by duly topologized abstract qualities. The corresponding objects, being extended entities, are not circumscribed: in the same way as "physical fields," they are ubiquitous entities propagated in real space (for example, energy, which in its lowest

Ben Shahn
*This is Nazi Brutality*, 1943
Lithograph, 102×72 cm
Museum of Modern Art, New York

Marcel Duchamp
*Allégorie de genre (George Washington)*, 1943
Assemblage: cardboard, nails and gilded stars, 52.2×40.5 cm
Private collection, Paris *

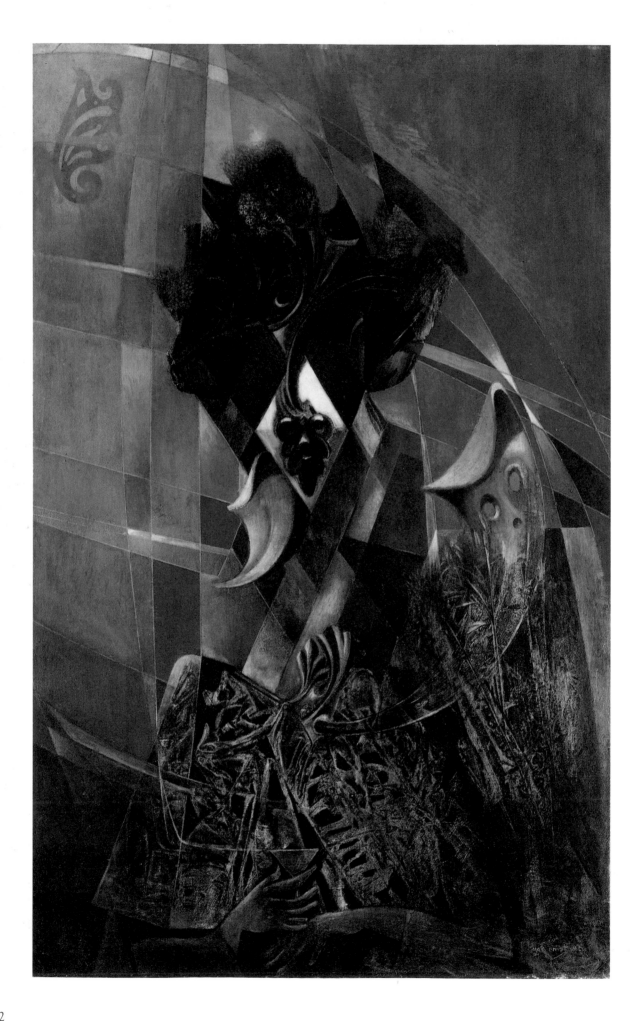

322

form is propagated as heat). In the sphere of subjective qualities, analogous active qualities exist. These I have proposed to call *pregnances*. These pregnances are initially the "fundamental values" of biological regulation (hunger, fear, love) and they take on spatial forms (known as *salient* forms) which are then propagated through spatio-temporal contiguity. According to Frazer, propagation through contact and propagation through resemblance are the two principal means by which magic is manifested... (Here we should call to mind Pavlov's classic experiment where the alimentary pregnance of meat took on the salient form of a bell that the dog heard each time it was fed.) When these biological pregnances manifest themselves in an animal, they take on a visible form known as "figurative effects." These effects can make another animal of the same species, on perceiving them, undergo this same pregnance: the cry of alarm an animal makes at the approach of a predator propagates a "fear" pregnance throughout the community. These pregnances extend even to the subjective pregnances manifested by inanimate objects perceived by a subject (for a starving man, anything resembling food becomes food...).

To determine explicitly the "logoi" that ensure stability in living beings is an immense problem. The theory of elemental catastrophism (the seven kinds of spatio-temporal catastrophies) names only the simplest articulations which structure stable space-time conflicts... But reference to axiological space, to "potentials," gives a finalist's view of the nature of regulatory reactions. Catastrophism in its most advanced form — which is, it should be pointed out, not accepted in present-day scientific circles — sets out to define at least the most general traits of the epigenesis (embryology) of living beings and the stability of their metabolism. Further, according to Kant's Third Critique, the unity of a work of art is, like the organic unity of a living being, teleological by nature and may be judged by the same mental processes (reflective judgment). Now, if the claims of catastrophism in the field of biology are well-founded and if Kant's analysis is right, it should be possible to approach the question of unity in works of art with the methods laid down by catastrophism... It is this that I will be doing here, though unfortunately without being able to give much more than a brief outline. In one basic point aesthetics suits catastrophist methodology perfectly: aesthetics is a morphology, dealing as it does with spatio-temporal objects taking either a material form as is the case with the plastic arts (painting, sculpture), or a purely temporal one (music, poetry) (and here aesthetics has an advantage over many of the human sciences like psychology or sociology, unable as they are to spatialize their objects). But if one is dealing with Beauty abstractly, one cannot but recognize two problems that are fundamental to the construction of a work of art: the problem of the contour, and the problem of the fragment.

Max Ernst
*Cocktail Drinker*, 1945
Oil on canvas, 116×72.5 cm
Kunstsammlung Nordrhein-
Westfalen, Düsseldorf

There is a point — an essential one — where aesthetics ceases to be a morphological scientific discipline: it evinces a systematic and thorough-going rejection of any notion of repetition. All objects proper to aesthetics are *hapax*, and any copy is immediately eliminated from the field of study. To wish to take repetition as the criterion for "structural stability" (essential in catastrophism) would only lead to the discovery that such a criterion for stability is purely and simply not pertinent. The playfulness and dream-quality so recurrent in art are related to a desire for originality at all costs — perhaps in all the history of mankind no two dreams have been strictly identical.

This deep-seated obstacle to approaching works of art from a cata-strophist bias can be partially obviated if one notes, a) that unity in a work of art is less manifest as an exigence of stability than as an exigence of what is optimum: the fact that great aesthetic effects can come of the smallest variations of form shows that "robustness" is not what is at stake here; b) that repetition is perfectly permissible as regards detail, as regards the infra-subject... Some arts — like music — have a morphology that, in what is essential, is a discrete combinatory extending over a finite number of elements (the note in classical music).

When one sets out to observe a painting (or any product of the plastic arts), the mind first grows aware of the contour of the work, and then, in an effort at analysis, one tries within its centers to discern subjects imbued with some kind of pregnance. The overall extent of the work thus becomes divided into sections: areas spreading out from a central point (or, more generally, a circumscribed configuration of details accepted as an individual entity). It is possible to think of this sectioning process as springing from a sort of pro-liferation of the contour (where it is most rapid since there are no details to arrest one's attention) toward the interior... It is essentially the conflict of these pregnances directed by the logos of a "catastrophe" (perhaps indeed more than elemental!) that guarantees the unity of a work of art. Its aesthetic impact, its "beauty," is due to the more or less perfect accordance of this sec-tioning process with an ideal model, which results from subjecting the entire painting to an abstract partitioning dictated by a structure of an algebraic nature, a catastrophist logos. One may, from this point of view, well ask if its beauty springs from the overall nature of a work of art or if it is of necessity already present in fragments or details of the whole: a question not unlike seeking a definition of life — that holistic property of the organism, which is nonetheless present in the least of the cells that compose it. The answer is affir-mative, yet needs clarifying: if the overall "logos" of a work of art calls for a negative (repellant) pregnance in a particular area, then a faithful representation of this circumscribed pregnance, while re-maining unsightly within its own limits, becomes beautiful in the

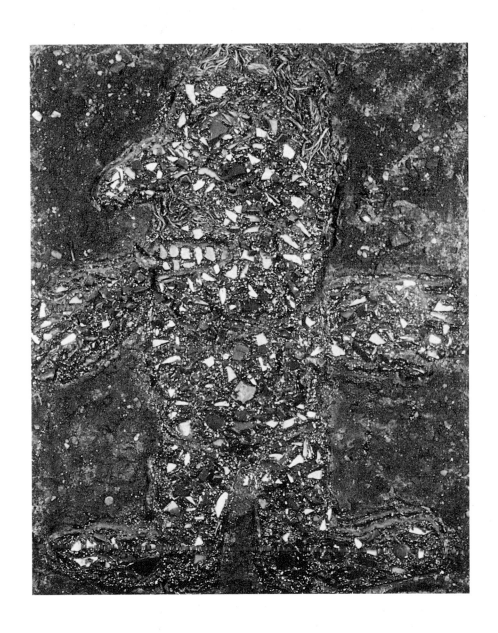

Jean Dubuffet
*The Cellarer*, 1946
Oil and other materials on canvas, 46×38 cm
Private collection, Geneva *

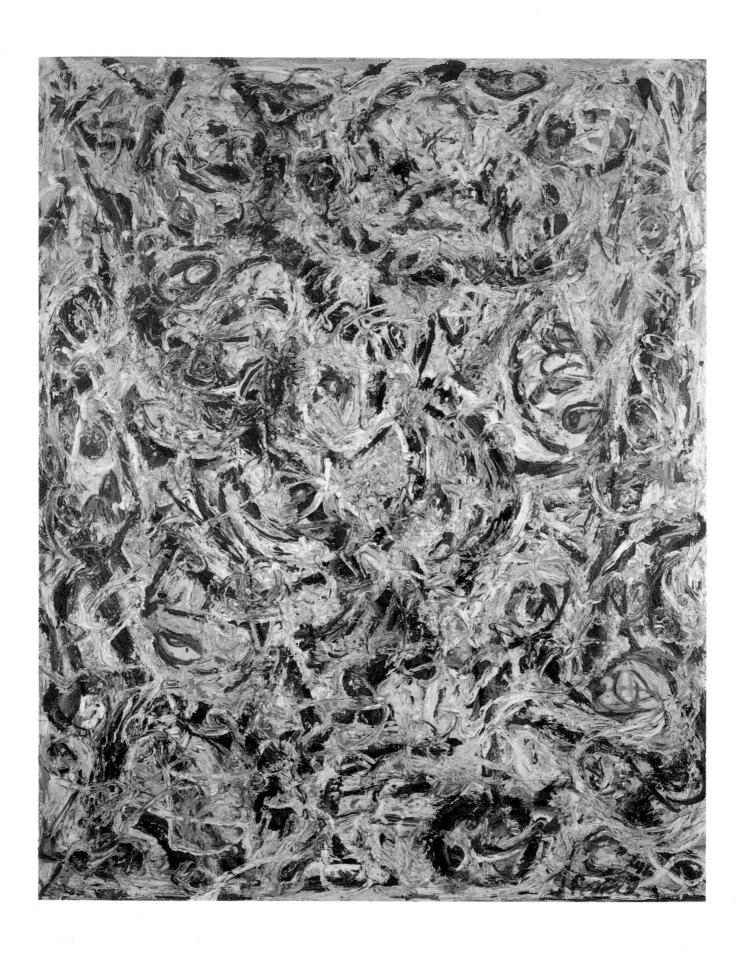

overall view. It is worth examining the term "fragment" as used here. One must not confuse that "center" or "infra-subject" isolated in the process of a perceptive analysis of a painting with a fragment such as might result (like the fragments of an ancient statue) from an act of catastrophic fragmentation, and which, rather than a sectioning process, would take the form of a purely arbitrary and accidental break-up. And yet, even in this case, the overall beauty of a work may often still be felt. Theoretically, one may think of a painting as comparable to the mathematician's analytical function, whose whole can be reconstructed from its least parts. Indeed, given a fragment, the expert should be able to reconstruct a good deal if not the whole of the original painting, rather as paleontologists like Cuvier were able to reconstruct the whole skeleton of a fossilized animal from a single bone. It is that accordance, that compatability between various extrapolations based on fragments, that presents one of the most explicit criteria for Beauty.

This theory of aesthetic effects in a work of art undoubtedly gives rise to some points for discussion.

I am tempted to state that just such an analysis — one which allows a pertinent interpretation of the morphological organization — is possible for any work of art. (An anthropological problem: does art precede language, or language art, in the evolution of the hominidae?) From this point of view, "stochastic" art does not exist. Not even the products of "action painting" are arbitrary, as all material action must needs undergo the laws of physics and mechanics. Nor can art exist in a (totally) abstract form, that is to say, completely devoid of the figurative element — save perhaps music, being the only one to have a discrete notation. Even music, however, has subjects and themes. The most naively representative paintings are of the Lives of the Saints (St. George slaying the Dragon, St. Denis bearing his own head): here subject is grammatical in the same way as a nuclear phrase. Even Marcel Duchamp gives his paintings a grammatically perfective title: "Bride stripped by bachelors, even..." In these pictures with a nuclear-phrase-type title, there are less than four *actants* that can be recognized as circumscribed centers in the painting. Can a zero-value painting exist, a painting without any identifiable *actant*? This is of course possible when what is portrayed is, for instance, a medley spreading out almost indefinitely (Pollock). Here the superficial critic persists in speaking of "chaos." But one well knows that, in terms of qualitative dynamics, these chaotic structures are sometimes engendered by very simple deterministic mechanisms, and I, naive mathematician that I am, am tempted to feel that their aesthetic effect is bound up with the laws of generation in all their intrinsic simplicity. Aesthetic sensibility can, therefore, be seen as a "detector of laws" — a function whose biological importance for the survival of mankind is quite evident. It remains to mention crowd-

Jackson Pollock
*Eyes in the Heat*, 1946
Oil on canvas, 137×109 cm
(The Solomon R. Guggenheim Foundation)
Peggy Guggenheim Collection
Venice *

paintings (processions, drinking scenes): that is to say paintings with a large number of presumed *actants*. Here, one can find a hierarchical organization into competing groups, or, in the case of abstract figurations, a symmetry that multiplies the same configurations. I would add that one can also find competition between propagations and pregnances, even if the pregnances are not individuated into *actant* elements, but are represented by interlaced ramified graphs like capillaries in the circulatory system. Or further, a struggle between a pregnance anthropomorphized in the form of a figure and a non-individuated physical pregnance like fire or water... To sum up, the *actant* character of any representation seems to me to be a necessary postulate for the intelligibility of art.

Most of the great pictorial styles may be seen as varied couplings of subjective and objective pregnances. So it was that impressionism endowed the propagation of light with superphysical aspects bor-

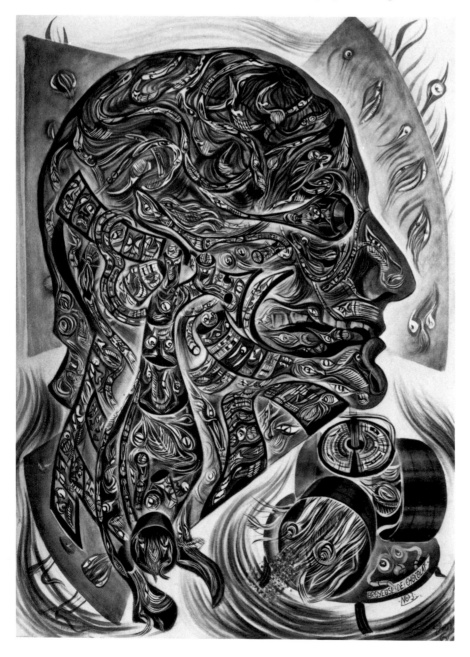

Errò
*Portrait of Robert Lebel*, 1961
Oil on canvas, 92.4×65.4 cm
Jean-Jacques Lebel Collection, Paris

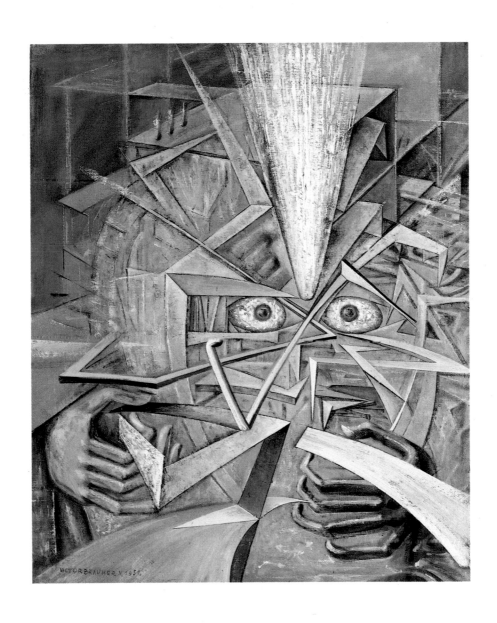

Victor Brauner
*Breakdown of Subjectivity*, 1951
Oil on canvas, 73×60 cm
The Menil Foundation, Houston *

rowed from the psychological diffusion of emotion. Cubism, on the other hand, by transforming the most impregnated beings ("Les Demoiselles d'Avignon") into aggregates of cylinders and cones, tried to "contain" this pregnance to the full, or rather to efface it. This modern age has again brought up the question of the naturalness of the figurative effects of a pregnance. *Traumdeutung* psychoanalysis has imbued many objects (umbrellas, mushrooms, etc.) with a sexual pregnance quite lacking in the object itself. Here we may note that playful, dream-like quality in art (above all in modern art): every picture is an enigma, just as is every dream, and solving the enigma is part of the aesthetic pleasure it gives. Yet one should not forget that painting has made use of ambiguous figures since the Renaissance (Arcimboldo). Much could be said on the theme of stylistic variations of figurative effects.

Jean Dubuffet
*L'Amphigourique*, 1954
Scum, h. 41 cm
Private collection *

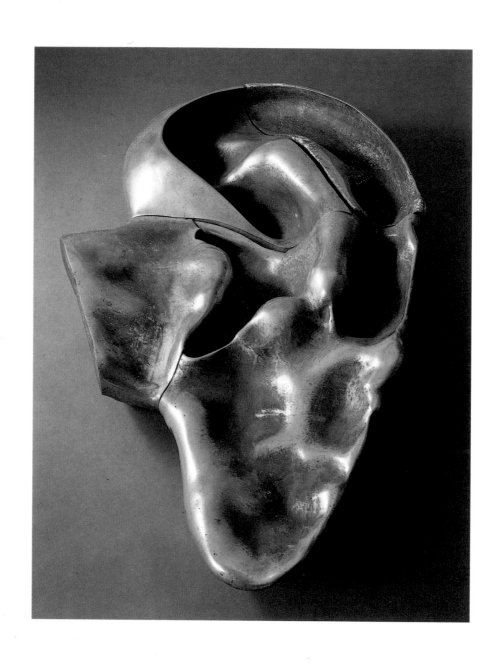

Tomio Miki
*Ear*, 1960
Relief in molded aluminum, 104×173×28 cm
Kenji Misawa Collection, Tokyo *

# Capturing the Ephemeral

by Ilya Prigogine

The first question that will doubtless be asked here is: how on earth does a physicist come to be interested in the work of Giuseppe Arcimboldo? I think that the best answer is to be found in a dialogue between Albert Einstein and Rabindranath Tagore, which took place in 1930 and was subsequently published under the title of "The Nature of Reality".[1]

EINSTEIN: There are two concepts regarding the nature of the Universe: the world as a unity dependent on humanity, and the world as a reality independent of the human factor.

TAGORE: When our universe is in harmony with man, the eternal, we know it as truth, we feel it as beauty.

EINSTEIN: This is the purely human concept of the universe.

TAGORE: There can be no other conception. This world is a human world — the scientific view of it is also that of the scientific man. Therefore, the world apart from us does not exist; it is a relative world, depending for its reality upon our consciousness. There is some standard of reason and enjoyment which gives it truth, the standard of the Eternal Man whose experiences are through our experiences.

EINSTEIN: This is a realization of the human entity.

TAGORE: Yes, one eternal entity. We have to realize it through our emotions and activities. We realized the Supreme Man who has no individual limitations through our limitations. Science is concerned with that which is not confined to individuals; it is the impersonal human world of truth. Religion realizes these truths and links them up with our deepest needs; our individual consciousness of truth gains universal significance. Religion applies values to truth, and we know truth as good through our own harmony with it.

EINSTEIN: Truth, then, or Beauty is not independent of Man?

TAGORE: No.

EINSTEIN: If there were no human beings any more, the Apollo of Belvedere would no longer be beautiful.

TAGORE: No!

EINSTEIN: I agree with regards to this conception of Beauty, but not with regard to Truth.

TAGORE: Why not? Truth is realized through man.

EINSTEIN: I cannot prove that my conception is right, but that is my

religion. Einstein here presents himself as the defender of the classic scientific viewpoint, the one that prevailed from Newton down to himself.[2] If we take his word for it, reality is transparent and yields itself unequivocally. It in no way depends on the man who describes it.

But after 1930, physics entered a phase of transformation. Long-neglected questions returned in force: "What is reality?," "What part is played by construction in our description of the world?" It is not that we are moving toward a subjectivistic physics, but we are today led to recognize that man is a part of the nature he describes. Even in the sphere of the natural sciences, the eminently active part played by construction, which we surprise at work in the patterns of human understanding, is by this time fundamental.

Now, the pictures of Arcimboldo offer us constructions whose ambivalence provokes astonishment: where does one find the reality? In the human appearance, or in the abnormal elements that compose it?

The questions that these compositions pose to us entered a number of twentieth-century currents of thought, in particular surrealism. In a brief note on the relationships between art and time,[3] I had occasion to approach the "anti-scientific" aspects of so-called abstract art, and some of the solutions that various aesthetic traditions brought to the problem of the relationship between description and construction.

The difference between these sets of problems and the one suggested to us by the works of Arcimboldo, a difference that without doubt partly explains the spell they exercise over us, consists in the fact that their author lived before — and not after — the formation of mathematical physics, which is overwhelmingly predominant in the seventeenth and eighteenth centuries.

Shortly before his death Giuseppe Arcimboldo received from the emperor Rudolf II the title of Count Palatine. His work, that is to say, is to be placed within the ferment of events and ideas that preceded the appearance of the first manifestations of classic science, in the work of Galileo and René Descartes.

However we choose to divide culture into periods, it is apparent that neither Arcimboldo nor our modern surrealists would have had a recognized place in the realm of those scientific points of view that triumphed during the great century of Laplace and Lagrange, the age of the Enlightenment.

One of the basic effects of classic science, we all know, is the compulsory identification of the rational with the real, which was destined to bring about a restriction of mental space. When an object travels through a field from point A to point B, its "real" trajectory corresponds to an extremum; that is to say, it maximizes a function, in this case action. Mechanics, justly defined as rational, are based on the existence of such an extremum, and here the real and the rational merge. An important corollary of this assumption is that the

Alfonso Ossorio
*EGO DNS 3*, 1965
Plastic and other materials on wood
106.7×81.3 cm
Robert U. Ossorio Collection
New York *

334

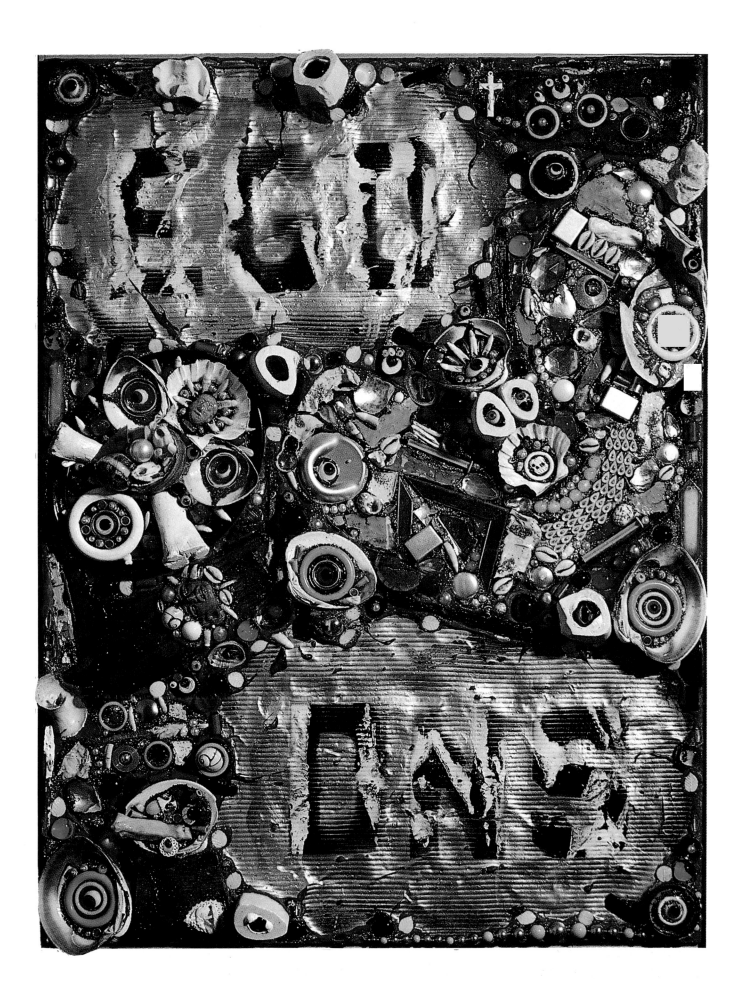

335

imaginary is forced toward the irrational. But today we know that we live in a non-linear world, a world that presents a variety of solutions. The innumerable forms that a snowflake can assume correspond to the different bifurcations encountered during the process of formation. The real opens out into the multiple, and shows the choices made or waiting to be made from among all those possible.

Now, the multiple solutions of non-linear branches can exist only because we live in a world subject to certain constraints of non-equilibrium, a world whose motor is time. It is in fact non-equilibrium that leads to the mechanisms of coherence responsible for the forms and rhythms displayed by nature. It is that very temporal dynamic in the formation of beings and things that the inspired intuition of Arcimboldo was able to grasp.

Let us consider the allegorical series dealing with the four elements, Air, Fire, Earth and Water. According to the classic vision, the elemental is synonymous with permanence. But Arcimboldo's elements exist in privileged moments. It is, so to speak, by miracle that the birds of the Air are placed there to produce that unity which we are able to decipher. An instant later we may find them dispersed, without leaving the least trace of their passing this way. The head depicting Fire composes under our very eyes the equivalent of a snapshot: soon there will be nothing left of it but some scraps of metal. The same happens in the series of portraits: the fruit will rot, the leaves and the flowers will wilt away.

These works do not speak to us of eternity, and make no attempt to transfer to canvas some monument that will defy the passing of time. Their basic plan, as I understand it, is to evoke a dazzling moment destined for immediate disappearance. Our century, a century of transition anguished by the unpredictability of the time, cannot but feel solidarity with the evanescence caught by the paintbrush of Arcimboldo.

1. "The Nature of Reality. A conversation between Rabindranath Tagore and Albert Einstein, on the afternoon of July 14th, 1930, at Professor Einstein's residence in Kaputh"; Calcutta, *Modern Review* XLVI (1931); quoted in an appendix to a lecture I gave at the Jawaharlal Nehru University on 18 December 1982, published under the title of "Only an Illusion" by the Oxford University Press (1983) in the series of the *Tanner Lectures on Human Values*.
2. The reader will find further details in the essay I published (1979) with Isabelle Stengers for Gallimard, under the title of "La Nouvelle Alliance."
3. Prigogine and Pahaut, "Redécouvrir le Temps," note for the catalogue of the exhibition "L'art et le Temps. Regards sur la quatrième dimension"; Brussels, Société des Expositions du Palais des Beaux-Arts, 1984.

Natsuyuki Nakanishi
*Compact Object*, 1962
Assemblage of natural and manufactured objects in a polyester egg, 14.3×21.3 cm
Frank Crowninshield Fund
Museum of Modern Art, New York *

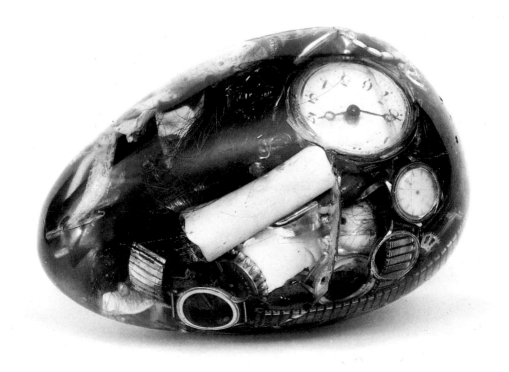

338

Andy Warhol
*Marilyn Monroe's Lips*, 1962
Silk screen, acrylic and pencil on canvas
above: 210.7×204.9, opposite page: 210.7×209.7 cm
Hirshhorn Museum and Sculpture
Garden, Smithsonian Institution
Washington D.C. *

Roy Lichtenstein
*Mirror*, 1970
Oil and magna on canvas, diam 91.5 cm
Artist's collection *

Jasper Johns
*The Critic Smiles*, 1959
Metal sculpture on plaster, 4.4×19.7×3.8 cm
Private collection *

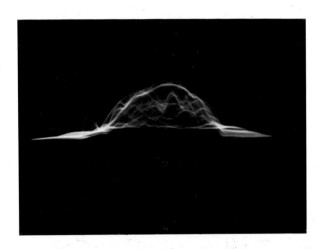

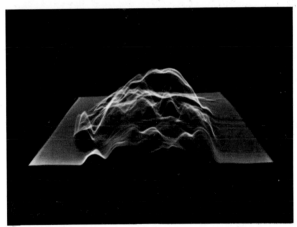

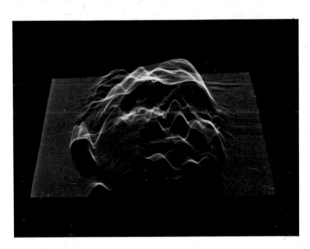

Woody and Steina Vasulkas
*Transformations*, 1974
R/E scan processor

Heinz Kroehl
*Johann Gutenberg*, 1968
Poster

343

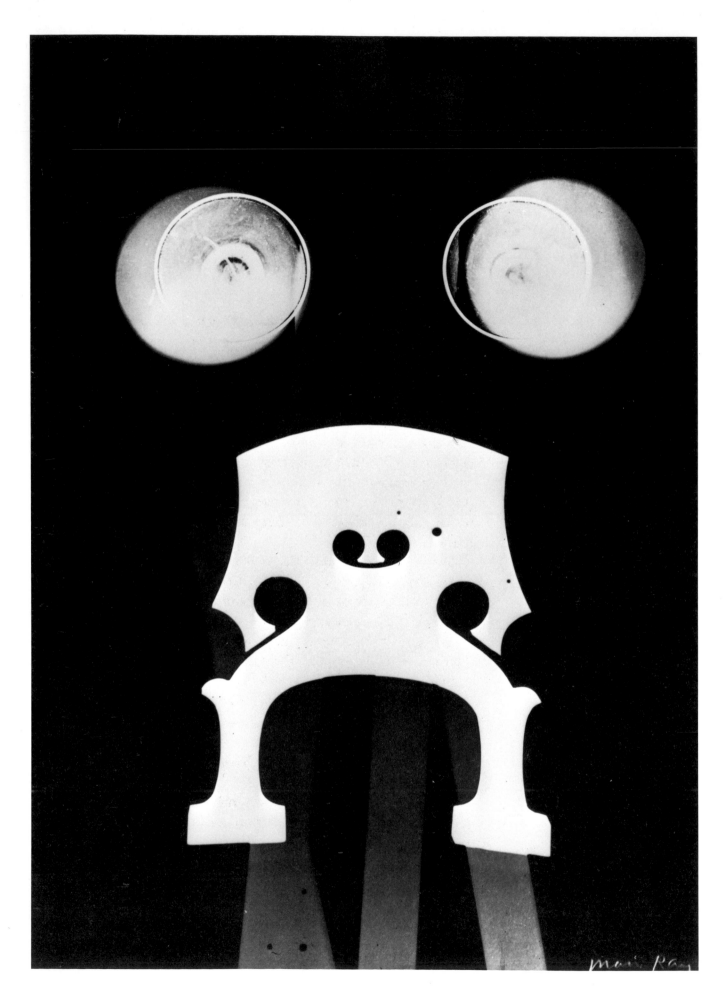

344

# Music for Eyes

by Tonino Tornitore

"Imagine a piano having seventy-five thousand different sounds. This is the situation of painters."
*Salvador Dalí*

In addition to his bizarre *Elements*, fanciful *Seasons* and whimsical portraits, Arcimboldo is also known as the first to have thought of retransposing the harmonic criteria of pictorial chromatics to music. He is considered to be the founder of the *music of colors*, a study still alive although subordinate, suspended between disbelief in paradoxes and attraction toward curiosities.

Such an artist could not be simply a painter; he had to be both a painter and Milanese, in other words educated in an environment strongly imbued with esotericism and where the debate between the arts was still very lively — the environment created by the work and reputation of artists and scientists such as Leonardo and Luca Pacioli.

Besides the well-known theory of *ut pictura poesis* ("as painting, so poetry"), a similar one was developed of *ut ars musica pictura* ("as the art of music, so painting"). Its first and most complete expression occurred in the Lombard environment and was represented by Comanini, who also uses Macrobius's interpretation of the *Somnium*,[1] as Barocchi has pointed out. Tea had already suggested forty years ago that Arcimboldo's experiment in making music with colors was inspired by Leonardo's example and by the master's suggestive comparisons between music and painting.

The only text documenting the existence of what is often — and mistakenly — called the "color harpsichord" is second-hand, but fortunately it is a reliable source in many respects: *Il Figino*, one of the many Cinquecento treatises on art in dialogue form, written by Comanini, who together with Lomazzo was close to Arcimboldo during his last years in Milan.

In my opinion there are three reasons for considering this short dialogue on the music of colors a reliable document:

1) First, the date: the dialogue was originally published in Mantua in 1591 and it is unthinkable that Comanini would have given it to the printers without Arcimboldo's previous consent;

2) Comanini refers to *Vertumnus* as the allegory of the emperor,

345

immediately pointing out the meaning of the painting without having seen it, much less being familiar with Fonteo's poem: who but the artist himself could have revealed it to him?

3) The authoritative confidence and very precise detail of the discussion on chromatic music, considering the freshness of the discovery, strongly indicates that Comanini's source must have been a direct one: who could have been more so than its inventor?

To possible objections as to why there is no further confirmation, two answers exist (without considering the success enjoyed by Arcimboldo and this dialogue in the following centuries): a) Comanini's description and argument are ambiguous (as proven by the different interpretations of the crucial part, which we will discuss later); b) this discussion is moreover eccentric, a sort of enormous exemplification with respect to the main direction of the argument. In fact in the text as a whole — a late and unexciting example of "comparison between the arts" — Comanini makes a parallel analysis of the different parts in tragedy and in painting, comparing the literary poetics and the aesthetics of the visual arts that had become fashionable after being revived by B. Daniello.[2] And this is the final part: "Concerning the sixth and last part of a tragedy, that is to say harmony, you know that this is not the task of the poetic faculty but of music, and has nothing to do with painting either. But nevertheless here painting comes close to music, as sometimes poetry does. For this I take the proof given by Arcimboldo, who has discovered tones and semitones."

So it is clear that from Comanini's point of view, Arcimboldo's experiment is the crowning seal of his argument for establishing a circular equivalence between the arts. In fact he says that so far, painting has demonstrated its close affinity with poetry; and in the sixth part, painting is linked to music. The affinity existing between music and poetry required no proof, but here, to demonstrate the interchangeability between music and painting, which are different "yet sisters," the author describes Arcimboldo's invention.

Poetry = Painting = Music — these are in fact the main steps taken over the bridge of the sixth part of tragedy.

So the setting for what may be considered a parasynaesthetic jewel (not so much for its intrinsic value as for its rarity) is the well-known equation *ut pictura poesis*. As I examine this jewel, I will also describe the controversies concerning its interpretation. "Arcimboldo... discovered tones and semitones and the *diatesseron* and *diapente* and all the other musical consonances within colors, using the art by which Pythagoras invented the same harmonic proportions." And just as Pythagoras transformed lengths and weights into harmonic proportions, "in the same way, by taking an extremely white color and darkening it slightly, part by part, with black, he drew from it the sesquioctave proportion. In this he surpasses Pythagoras."

A comparison follows between the increasing degree of darkness

of the colors from white to tan, which is the inverse function of the progressive pitch of voices (so, oddly, the color corresponding to the treble or "white" voice is in fact dark).

And then comes the clue: "Having learned this order, Mauro Cremonese della Viuola, musician to Emperor Rudolf II, found on the harpsichord all the consonances that had been marked by Arcimboldo with colors on paper. So you see, O Guazzo, how the arts of painting and of poetry walk side by side and follow the same laws in shaping their forms."

The last sentence reconfirms the parenthetic character of the Arcimboldo episode, since it is a second-degree corollary with respect to the first (painting-music), in its turn subordinated to the axiom *pictura ut poesis*. In reality the ingenuous Comanini does not realize (hence neither did Arcimboldo?) that this musichromatic transposition is simply one more innocuous proof of an aesthetic argument already completely taken for granted. (Is this the reason for the oblivion that overtook it — the author's inability to see the potential intersensory scope of his own discovery?)

Here we have a further proof of a synaesthesia *in re, sed non in intellectu*, of the absence of a mentality able to imagine the interchangeability of the data of vision with those of hearing, much less of the faculties themselves. This is a civilization still stuck at the metaphor, not daring to eclipse the *ut*, with a synaesthetically empty mental world.

This is not so, however, in the eyes of certain contemporary critics, who have been rather hasty in their eagerness to discover ancestors and archetypes — in this case, of the ocular harpsichord. Living in a ripe synaesthetic civilization, they attributed to Arcimboldo something he could in reality never imagine — for the Milanese painter, colors are *like* sounds but they are not sounds.

Arcimboldo is therefore *not* the forerunner of the Père Castel who invented the *clavecin oculaire* in the first third of the eighteenth century, neither in theory nor in practice. Theoretically, Castel is following Newton, who had assumed a physical-mathematical identity between the seven notes and the seven colors of the spectrum; in Arcimboldo's case, not only is there no exact numerical correspondence between notes and colors, but the link is an external, arbitrary comparison. And in practical terms, Castel constructed a sort of harpsichord that would emit colors instead of sounds, while Arcimboldo did not build any musichromatic machine (see note 3).

More than from Comanini's dialogue, this misunderstanding has perhaps derived from the quotation of the anonymous author who in 1621 prepared the catalogue of the surviving treasures of the Prague imperial residence at Hradschin, listing a "perspective lute" (*Perspektivlaute*) once belonging to or bought by Arcimboldo. Levi mentions this object but without adding anything, nor have I been able to find it mentioned in any dictionary, musical or otherwise;

evidently it is destined to remain a mystery. I can only suggest two ideas with different degrees of certainty: 1) Certainly this is not an audiocolor instrument (a lute that creates colors is too much even for Arcimboldo's imagination); 2) possibly it was not a real musical instrument, but a lute in a perspective drawing, perhaps the Dürer engraving entitled *The Painter Studies the Laws of Perspective* (from *Unterweisung der Messung*, published in Nuremberg in 1525), an original or a copy made by Arcimboldo, or belonging to him, which had remained in Rudolf's *Wunderkammer* (the emperor had a passion for Dürer's work).

But according to Geiger, the harmonic degrees of color were secret codes that could be deciphered only by using the *Perspektivlaute*. This idea is based on a statement by Lomazzo that "Arcimboldo was an inventor of codes that could not be understood without his instruments";[3] the German critic, however, concludes frankly that this is not a matter in which he is competent and refers the reader back to Levi's article.

This long-lasting misunderstanding concerning the mysterious instrument was in fact probably the result of the link frequently assumed between Arcimboldo and Castel;[4] Levi however had immediately intuited what was probably the chief purpose (and perhaps the only one, besides the improbable secret code) of Arcimboldo's invention; very simply, a new form of musical notation.

"A sheet of paper with colors, then, took the place of the ordinary manuscript or printed notation in use at the time, giving the performer the possibility of interpreting the music according to clearly differentiated colors."[5]

Taking this chromatic score, the court musician Mauro Cremonese della Viuola tested it on the harpsichord, the instrument with the keyboard having the widest range, and that test was suc-

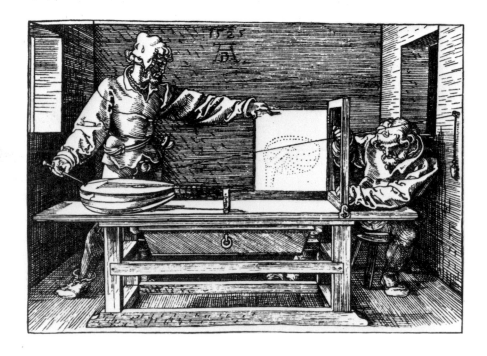

Woodcut by Albrecht Dürer
*A Lute Seen in Perspective*, 1525

cessful because every note corresponded to a precise color nuance, so that "the system seems to have worked, to the immense delight of Rudolf II."[6]

What in brief is Arcimboldo's chief synaesthetic contribution? I do not believe that his mind, however esoteric and "marvellous," could ever have conceived that sounds could be transubstantiated into colors. There is nothing and nobody to authorize such an inference. Objectively, his contribution is to have created "an extraordinary way of representing musical thought with the scale of colors." It could be called a cipher in which the relationship between the chromatic and harmonic scales is purely arbitrary (not considering the reciprocal proportionalities); in other words, there is no reason why C should be white or black: neither a subjective cause (inside Arcimboldo's head), nor an objective one deriving from a presumed law of intrinsic correspondence between sounds and colors applied by the painter. That is the fundamental difference between Arcimboldo and Newton (Castel): for the former the primary link between note/color is casual, for the latter it is causal; for the painter it is extrinsic (as it is in a cipher or any system of signs) while for the scientist it is intrinsic. And why did this theory sink into oblivion? First, for technical reasons: compared with the great innovations of Gaffurio and Zarlino, for example, this musical writing with superimposed layers of color "indicating only the pitch of the notes, but not their duration nor even how to play them," in fact "marks a backward step in notational practice, almost a return to the approximation of the medieval neumae, when the tendency of the intervals had to be laboriously sought to establish the structure of the melody. So this is a small chapter that has rightly been relegated to oblivion, partly because of the lack of autograph documentation."[7]

The same concept is also emphasized by Legrand and Sluys and by Tea. "The attempt at coloristic transcription, condemned by Mengs as impossible, was taken up again on the basis of the complementaries by Cicognara, who established a succession of chromatic fifths. The moderns have also tried,"[8] but without appreciable results. Some of them however certainly remembered the "early Italian painters" who according to tradition had made a very important contribution to developing musical theory "with the semipartite variety of the colors of the rainbow." And here the writer (Doctor Lussana, one of the founders of *udizione colorata* in Italy) refers back to Brücke. In reality, the German physicist does allude to the tradition of Italian painters, but only to stigmatize it for having originated the bad modern habit of correlating sounds and colors; more peremptorily, he in fact says that all the theories of analogy between harmonies of sounds and colors are wrong, "and tend to subordinate the science of colors to the science of music. The tradition of the importance attached by the early Italian painters to perfecting the theory of music, together with Newton's theory, has

INVERNO

Anonymous
*Winter*, undated
Etching, 17.3×23.5 cm
Nationalmuseum, Stockholm *

Man Ray
*After Arcimboldo*, 1942
Oil on canvas, 68.6×55.9 cm
Former Max Ernst Collection

Man Ray
*Waiting*, 1942
Oil on canvas, 40.6×30.5 cm
Private collection, Chicago

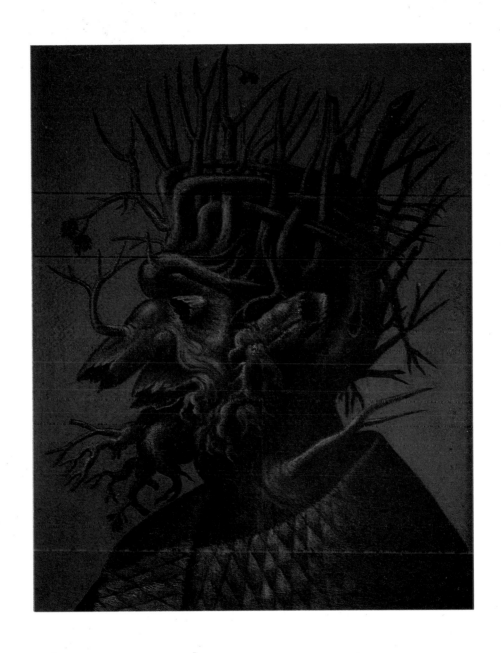

Anonymous (after Giuseppe Arcimboldo)
*Winter*, undated
Oil on canvas, 63×47.7 cm
Private collection, Paris *

Bernard Loginbühl
*Ear*, 1976
Element sculpture in *Monstrum*
by Jean Tinguely

Niki de Saint-Phalle
Project for a sculpture in *Monstrum*
by Jean Tinguely

perpetuated similar erroneous beliefs up to the present day." The allusion to "early Italian painters" is rather vague (probably he was referring to Leonardo rather than to the then obscure Arcimboldo), but I believe that the German scientist has basically hit the mark (leaving aside value judgments on the interest of comparing sounds and colors). Arcimboldo has been seen in turn as the forerunner of Baudelaire and Debussy ("a predecessor of modern symbolism, who gave Baudelaire the *correspondance* and Delacroix the admirable aesthetic result of sound-color"[9]); or of Rimbaud ("he was the starting point for later literary applications to novels and poetry — see Rimbaud"[10]); the surrealists and abstractionists have claimed him;[11] he has been considered the ancestor of improbable machines; and finally, with gratitude or irritation, certain scientists have glimpsed the beginning of modern synaesthetic research in his cultural environment.

Seen through all these facets Arcimboldo himself seems to turn into one of his own nightmare creatures, his hieratic and melancholy magician's face dissolving and becoming sardonically confused in a thicket of contradictions. Is there also a truth here, an implied allegory awaiting a palimpsest, a key to decipher the mysterious hieroglyphs of this "learned Egyptian"?

Anything is possible, of course; but for once it is to be hoped that nothing will be added because the truth, at least as it appears from the *Figino,* has such a Spartan simplicity in contrast with the polished mannerisms of the painting as to hardly require any exegesis. Brücke is right. Perhaps he himself does not know how right he is in asserting that the early Italian painters gave great importance to musical theory. Tea is also right, in a complementary fashion, when she asserts that Arcimboldo fits perfectly into Leonardo's wake. The lively Prague of Rudolf did the rest.

In practice the same model is valid for Arcimboldo's "experiment" as the one used by Chaunu to explain why America was discovered: America could be discovered only by a Genoese setting sail from a mid-Atlantic coast. The very simple secret consists in the causal transplant of a seed of the Italian aesthetic school (the theory of harmonic proportions and the affinity of the arts) into an esoteric environment that exaggerated its basic Pythagoreanism. This is the very general picture.

Specifically, I would not consider Arcimboldo's chromatic notation a contribution to the general revival of musical practice, nor a variant of secret codes; and "it would also be wrong to reduce these attempts to the single aspect — which however does exist — of bizarre experiments in synaesthesics, artificial fantasies of the sort that his era, so enamoured of everything rare, curious, and precious — robots and monsters, paintings and antiques — produced in great quantity."[12]

Undoubtedly we are face to face with exceptional personal gifts of

353

"hypermetaphorization" (or "metabolization") but these never even approach the abysses of the perdition/perversion of the senses.

Arcimboldo's not very recondite intention was probably something akin to the *idée fixe* of his contemporaries and artistic forebears: to surpass music. And here I completely agree with Ciardi when he writes that these attempts "were rather the symptom of a violent liberation process demanding that figurative art be freed from the role of handmaiden to writing," or music, which was the same thing: in both cases, the comparison ennobled painting and provided a strict fixed rule.

Arcimboldo could thus demonstrate that painting had nothing to borrow from its sister, music (although the formal recognition of the kinship occurred in Prague only two years after his death).

On the contrary, painting could even allow itself the luxury of reversing the relationship with dethroned music, and from a hand-maiden in search of harmonic know-how become instead the exporter of methodologies.

The "experiment" had basically shown that well-tempered colors could perfectly well substitute the approximate and by now osbolete traditional notations. But this "experiment" proves something even more important for us: that Arcimboldo simply placed himself in perfect assonance with Leonardo's dictum, taking it to its extreme consequences or — which comes to the same thing — saturating its last valency.

This Leonardesque-Arcimboldian vein (so defined for the sake of brevity, though its roots and ramifications are obviously much wider) can be summarized as follows: a perspective distance, like any motion, implies a progressive inversion, a decreasing proportionality, which in the aesthetic field is also harmonic. So color=music.

In fact if color can be used to symbolize a fictitious spatial mathematical progression, i.e. to pretend a distance, a space, then logically it can also represent another scansion both abstract and rhythmical: harmonic time.

This is how painting as the creditor of music pays its account. Or better, tries to pay it off, since in reality the attempt failed (too complex? too rash?) because it had no consequences.

Finally, it was simply yet another application, extreme and reversed (extreme because reversed) of the magical theory of harmonic proportions.[13]

And if it can be taken only for what it is meant to be — a comparison to illustrate a point — I would like to put forward a final equation: harmonic proportions are to musical chromatic notations as perspective is to anamorphosis.

1. Giampaolo Lomazzo, *Scritti sulle arti*, ed. Ciardi, 1973, p. xxxii.
2. P. Barocchi, ed., *Scritti d'arte del Cinquecento*, p. 444, note 4.
3. Casati quotes the same remark correctly attributing it to Lomazzo, who in fact

wrote it in his *Idea*, p. 373. According to Ferrari in *Arcimboldo*, p. 157, Lomazzo's sentence "refers to Arcimboldo's invention of a colormetric method of musical transcription using an instrument called 'Perspektivlaute,' which applied the Pythagorean theory of harmony between numbers and sounds extending it to the proportion and consonance between musical tones and color gradations." Here the *Perspektivlaute* becomes the equivalent of the *clavecin oculaire*! It is hard to imagine how Ferrari conceived such an amazing idea except for the fact that (almost) everybody attributed the construction of this famous musichromatic instrument to Arcimboldo, and since it is not clear what a "perspective lute" might be, by combining two misapprehensions, à la Arcimboldo another aberration arose, a "lute" that distributes colors harmonically — if I have correctly understood what the writer means in this passage. Ferrari's statement is one of the many modern examples of error and truth combined, as I shall exemplify more clearly farther on. For the moment I will only rehearse the crucial point.

Of the four contrivances attributed to Arcimboldo (chromatic harpsichord, chromatic lute, cryptic lute, some sort of deciphering instrument), probably only the last can be ascribed to him with certainty; the others are fantasies of the moderns, who in this matter have surpassed the ancients:

a) It is perfectly possible that Arcimboldo invented a code, something perfectly in tune with the interests of his time and of his sovereign (Leonardo himself regularly wrote "in code," with his mirror-writing) and it is also possible that an instrument was needed to decipher that code (possibly optical, as a mirror is);

b) I am not an expert on code systems and instruments, but it seems to me unlikely that a "perspective lute" could perform such a function (and the only source, Geiger, is not explicit and has proved unreliable at times); and to a gratuitous supposition I prefer the hypothesis of a Dürer picture, since the emperor's love for the German artist is also well known;

c) It is certain that Arcimboldo did not construct a harpsichord, lute or any other instrument, musical or otherwise, designed to emit colors (I base this statement, obviously, on the only existing evidence, in Comanini and Lomazzo), as almost all the Arcimboldologists wrongly think, from Schlosser onward. In the 70s the imaginary harpsichord was subjected to a dual interpretation, simultaneously wrong and right, without the writers (e.g. Ciardi, Porzio) noting the contradiction.

4. In reality, the misapprehension has a long history. Already in 1885 Casati, although understanding clearly that Arcimboldo's "invention" consisted in the harmonic gradation of colors, "to which he applied the laws of music," and that Cremonese simply used it as a score, concludes that from all this "there came little or no benefit to music; nevertheless, in a period like ours when natural inventions are much prized, it is only fair to return to Italy and to Arcimboldo this invention usurped, or at least invented much later, by the French Jesuit Castel" (C. Casati, "G. Arcimboldi pittore milanese" in Archivio Storico Lombardo XII, p. 91). In reality, neither painting nor Castel have anything to do with Casati's chauvinistic outburst, which was to infect later studies on Arcimboldo (e.g. Nicodemi, 1929 and 1934).

Only in 1955 did Legrand & Sluys set the record straight by pointing out that according to the entry on Castel in the *Biog. Univ. des Music* by F-J. Fatis, he knew nothing of Arcimboldo's attempt.

But human errors die hard: from Kokoschka to Di Paolo, from Praz ("words become color, color music... finally, toward Synaesthesia," in *Mnemosine*, p. 37), to Porzio who considered Arcimboldo the forerunner "by over a century of the unfortunate attempt by L. B. Castel, the French Jesuit who exhausted his own fortune to construct the 'ocular harpsichord,' a device intended to make sounds visible by relating musical scales to the seven basic colors." Castel's attempt is in fact the polar opposite of Arcimboldo's. The painter, by means of a score written in colors instead of the usual notation, enabled music to be made on any ordinary harpsichord. The French abbot moved in the other direction, aiming to make the performance of a normal score produce colors instead of sounds; this entailed the need to build a special instrument which in fact only casually had the appearance of a harpsichord; but in reality the attempt failed, while Porzio himself

says that Arcimboldo's system seemed to work, which is another major difference. The only affinity between Arcimboldo and Castel seems to lie in the fact that for both of them, a sound corresponded to a certain color, but the vast difference between them is that whereas Arcimboldo replaced notes with colors, Castel wanted to replace sounds with color.

5. Levi, quoted in Geiger, *I dipinti ghiribizzosi* p. 91. The printed characters of musical notations are also a relatively recent invention, necessarily following the progress of printing in general. There is a further implication here: with the invention of printing, musical notation was going through a fluid, transitional stage, open to new ideas, perhaps even to solutions as extravagant as Arcimboldo's.

6. Porzio, *Universo illusorio*, p. 27. This musician is another nightmare for the Arcimboldo experts. He is not mentioned in any dictionary of musicians, nor in an early repertory of Cremonese celebrities (Lancetti). I do not know whether this is due to a sort of curse that has archetypically obscured everything touching the perverse Arcimboldo, or whether more prosaically there have been spelling mistakes that make the name unrecognizable and therefore unfindable. This Mauro Cremonese della Viuola (or Vivola?) variously rechristened by the Arcimboldologists Monzo, De Monte, and Marco, risks remaining a figure "no longer identified by musicologists" (Levi, quoted in Geiger, p. 82).

7. Levi, quoted in Geiger, pp. 92, 93.

8. This first attempt "had no echo, having no very serious technical and scientific basis," Legrand & Sluys, *Arcimboldo et les Arcimboldistes*, p. 37 and Tea, *La proporzione nelle arti figurative*, p. 130.

9. Levi himself (quoted in Geiger, p. 85) goes a long way: "Nevertheless, in his color tables of sounds, rather than an innovative system to be opposed to the existing notation, the Milanese painter (I suppose) was concerned also with musical problems and tried something new and phantasmagorical, glimpsing the mystery of expressive relations existing between sounds and colors and capable of evoking a corresponding sensation in the human faculty of perception. This would create an opening toward the ghosts of poetry and give us... a very distant foreshadowing of Baudelaire's lines: 'Les parfums etc.'..." Arcimboldo as the forerunner of symbolism (not to mention the rest) is credible and true in the same way that it is credible and true to state that these artists are all children of the *harmonia mundi*, or that they are all mystic Neo-Platonists, or even merely that they are all white Westerners.

10. Di Paolo in Schlosser, *Die Kunst- und Wunderkammer*, p. 171.

11. The painter Micheli from Lucca, announcing in 1963 the death of painting and the birth of a new art, "synchromia," claimed to be the last link in a complex chain starting from Arcimboldo. And more recently, Luigi Veronesi, in a publication on the connection between sound and color (*Proposta per una ricerca sui rapporti fra suono e colore*) also, and not very surprisingly considering the precedents, claims Arcimboldo as the putative father of this new, total art-science.

12. Ciardi, ed., introduction to *Scritti sulle arti*, p. xxxii.

13. I think that this is what Klein (R. Klein, *La forma e l'intelligibile*, pp. 157-158) means when he says that "almost synaesthetic experimental curiosity and extrapolation on the basis of a blind theoretical postulate, also mingled in Arcimboldo's invention of a 'color harpsichord' and Giacomo Soldati's pursuit of an ideal 'sixth order'." Ignoring yet another slip-up on the "harpsichord," this equivalence between Arcimboldo's experiment and the search for a sixth type of harmonic proportion, which in addition was to provide the proportion *par excellence*, the synthesis and origin of all the others, seems to me the most correct view of the ideal origin of Arcimboldo's experiment as described by Comanini.

Salvador Dalí
*The Sixtine Madonna*, 1958
Oil on canvas, 233×190 cm
Museum of Modern Art, New York

358

# Vertumnus Laid Bare

by František Makeš

Until recently this picture was in very poor condition. We have no written information regarding previous restoration. The most recent restoration revealed the authentic aspect of the painting and allowed the painter's technique to be examined. Because the present aspect of the painting is a vital factor in assessing it, a brief account of the restoration procedures involved is necessary.[1]

The restoration of the portrait provided a welcome opportunity to examine the color structure and the technical aspects of the painter's work. Only small parts, taken from the damaged areas of the pictures, were used to study the various color layers and to identify the pigments and size used. As always happens, it was not possible to take samples from all parts of the picture. Although incomplete, this examination is both comprehensible and sufficient for restoration purposes.

The following layers were revealed in the course of restoration: yellow oleoresin varnish, overpainting of the background, overpainting of the lower part, and traces of old albuminous brown varnish with unsuitable mastic. Because the overpainting and traces were not soluble in organic solvents, the enzymatic hydrolysis process was used.

The enzyme used was Antarctic krill (*Euphausia superba*). The enzyme had no lipolytic function and therefore could not damage the original color layer. The pH effect was measured at 30° C. Enzyme activity was measured at between pH 4 and pH 9, with a peak between pH 6.5 and 8.0. The effect of temperature on the activity of the purified enzyme was measured at pH 7.5. Proteolysis was carried out on the old albuminous varnish. The ideal temperature was determined at 50° C. The result of heating was reached in thirty minutes of incubation. The enzyme was then further studied in the conditions likely during restoration (pH 7.5, temperature 20° C). Enzymatic activity was expressed as the quantity of old varnish hydrolyzed in magnesium per minute. Dark brown albuminous varnish: pH 7.5, activity 0.019.

The oak board is 11 mm thick; its dimensions are 705 × 575 mm. The wooden fiber was studied under the microscope with regard to the structure and shape of the cells.

The initial preparation of the board is clearly visible in the color

X-ray of the central part of *Vertumnus*

X-ray of the vertical section of the oak stand of panel

layers. After the board was primed, a base of two layers with approximately the same composition was applied. Both layers contain white lead, chalk, and charcoal slack. The painting is separated from the board by a layer of white lead, in part indistinguishable. That its consistency varies considerably can also be se under X-ray.

The drawing was not visible even with the use of infra-red rays. The sample taken from the damaged part near the pear led us to hope that information about the drawing could be obtained. On the board, traces of drawing can be seen, above which is a thin layer of white lead. The next layer is modelled in brown. The top layer is in skin-color tones.

X-ray of transversal section of the oak stand of panel

Over the base and the drawing the color appears in thin, uniform layers. The selection prepared with some samples contains a larger number of layers than those taken from *The Librarian*, painted on canvas. This may be explained by the fact that the picture is particularly rich in details: carefully painted flowers, vegetables, and fruit. Furthermore, the samples allow us to study the artist's technique. One can see that the artist did not change his mind while he was working because this would be seen in the color layers. The greens have two to three layers that contain a green copper pigment, mixed with others and applied over a dark green transparent color, which in turn is found in all the light and dark greens of the painting. This, similar to a green varnish, may have been the cause of the poor adhesion of the other colors. This can be seen in the lower part of the painting. One can say, therefore, that this poor adhesion is produced by the reaction of the transparent green layer with the substances of the layer of the colored base.

The mid-blue plums in the upper section of the painting suggest a simple color layer composed of azurite mixed with white lead and dark red. The top layer is of a very thin dark red. In the shadowed areas it is thicker, thus giving the shadows a deep purple color. Red varnish and vermilion were found among the various reds in the painting. In the cross-sections of the color layers we can see that the red varnish covers an entire layer of vermilion. This varnish has the function of giving dark, transparent shadows to the objects painted, but often also adds depth and beauty to the colors. When using the enzyme lipase to study the kinetics of the reds in the original, it was found that there was slowing-down of enzymatic reaction due to the effect of the inhibitor (mercury). The check on these mercury salts was effected by amygdaline hydrolysis. The concentration of mercury ions in the size used in *Rudolf II* and *The Librarian* was calculated by the calibration vector. It was not possible to demonstrate whether the different results of the analysis were due to the restoration of *The Librarian*, which is painted on canvas, or to the different composition of the size itself.

The sample from the white lily showed two white layers of equal thickness, but different composition. The first was most probably

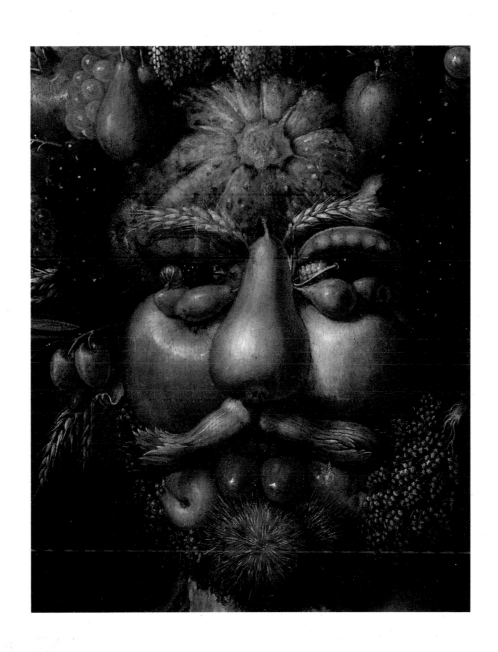

Giuseppe Arcimboldo
*Vertumnus-Rudolf II* (detail), 1590 c.
Oil on panel, 70.5×57.5 cm
Skoklosters Slott, Sweden *

painted with egg-based tempera and oil. We did not find any proteins in the second layer, which is a mixture of pigment and oil. The two layers are separated in turn by another containing lipids. The lily is the area of greatest luminosity in the painting; closer study shows that where the upper leaf ends in shadow the consistency of the white layer diminishes and a gray base appears.

*Photographed in reflected light - Enlargement x 200*

*White lily*
1. Yellow-white base containing crushed charcoal, white lead, and clay.
2. Second base coat. Similar composition, greater quantity of oil.
3. Thin coat of white lead.
4. Traces of drawing using brown color.
5. Layer of paint with white lead content.
6. Primer.
7. White lead.
8. Resinous varnish.

*Pear*
1. First base coat.
2. Second base coat.
3. Layer of white lead.
4. Umber, white lead, vermilion, black.
5. White lead, vermilion, black.
6. Umber, white lead, vermilion, black.
7. White lead, yellow lead, vermilion, black.
8. Resinous varnish.

*Blue plums*
The sample of size was studied using the enzyme lipase.
Temperature 30° C, pH 9.
1. Between the board and the first layer of the base coat there was a coat of primer that was hydrolyzed by the enzyme.
2. The base coats were hydrolyzed very little by the enzyme: the original color layer was completely hydrolyzed. The resinous varnishes were not damaged.

*Green leaf*
1. First base coat.
2. Second base coat.
3. Green layer containing copper salts, white lead, and black.
4. Yellow lead, malachite.
5. Varnish.

The results of the analysis show that the overpainting was in egg-based tempera, siccative oil, and resin. The original color layer con-

Detail of *Vertumnus*

Detail of *Vertumnus*

Detail of *Vertumnus*

tained oil. Glue and lipids were found on the base. The results indicate that the lipid and protein components were found mainly in the base coats. Among the pigments used in the painting are azurite, white lead, yellow lead, malachite, vermilion, red varnish, and black. The pigments used in the overpainting are zinc, cinnabar, green chrome oxide, red varnish, cadmium yellow, black, and ochre. There are traces of old albuminous varnish and of resinous varnish.

For restoration purposes it is important that the enzyme used to remove the overpainting (krill) does not reach the base coat, as this would result in hydrolysis of the size. Before the enzymatic hydrolysis of the painting, a layer of wax was applied that filled in all the cracks. The enzyme was absorbed and the unwanted layer was then removed in the form of paste.

Only after the removal of the old layer was it possible to judge the real state of the original picture. It showed that the main damage consisted in the fact that the color layer had fallen from the lower part of the painting. Underneath, the original was more vivid and colorful. The greatest difference was seen in the red-purple flowers, which had been repainted in brown-yellow.

A general retouching of the painting and of the damaged parts was then carried out.

1. The restoration procedures will be illustrated and published on the occasion of the International ICOM Conference in Sidney in 1987.

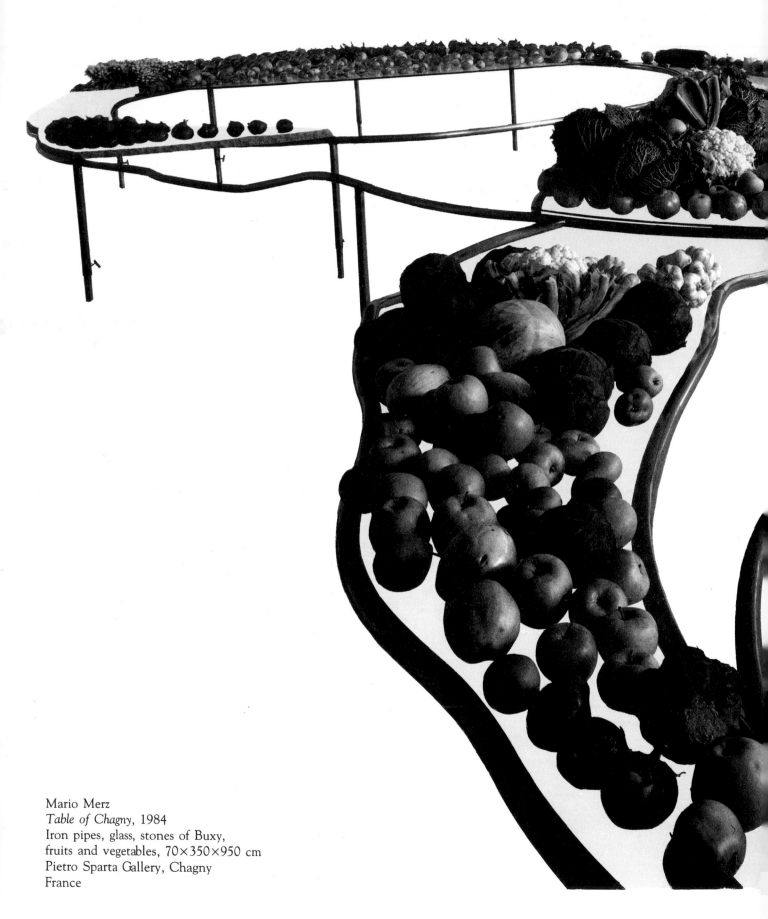

Mario Merz
*Table of Chagny*, 1984
Iron pipes, glass, stones of Buxy,
fruits and vegetables, 70×350×950 cm
Pietro Sparta Gallery, Chagny
France

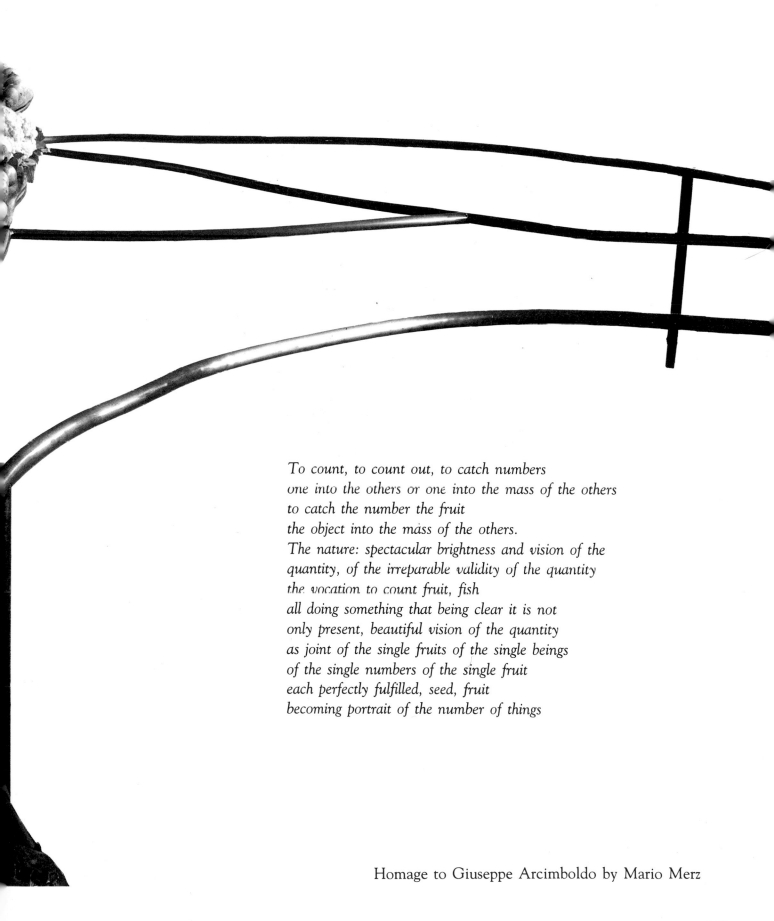

To count, to count out, to catch numbers
one into the others or one into the mass of the others
to catch the number the fruit
the object into the mass of the others.
The nature: spectacular brightness and vision of the
quantity, of the irreparable validity of the quantity
the vocation to count fruit, fish
all doing something that being clear it is not
only present, beautiful vision of the quantity
as joint of the single fruits of the single beings
of the single numbers of the single fruit
each perfectly fulfilled, seed, fruit
becoming portrait of the number of things

Homage to Giuseppe Arcimboldo by Mario Merz

Pol Bury
*Mirror*, 1984
Stainless steel, diam 50 cm
Artist's collection *

# Acknowledgments

*Our gratitude goes to all the persons and institutes who collaborated with us and made the realisation of this project possible by giving their advice and support, and kindly lending their works. To them and to all those who preferred to remain anonymous, goes our warmest thanks for their generous help.*

Austria

*Kunsthistorisches Museum, Vienna*
Rotraud Bauer, Christian Beaufort, Klaus Demus, Rudolf Distelberger, Hermann Fillitz, Herbert Haupt, Helmut Jungwirth, Bernhard Koch, Georg Kügler, Manfred Leithe-Jasper, Wolfgang Prohaska, Karl Schütz, Helmut Trnek

*Sammlungen Schloß Ambras, Innsbruck*
Alfred Auer, Elisabeth Scheicher

*Österreichische Nationalbibliothek, Vienna*
Eva Irblich, Otto Mazal

*Österreichisches Staatsarchiv, Vienna*
Rudolf Neck, Christian Sapper, Elisabeth Springer

*Graphische Sammlung Albertina, Vienna*
Richard Bosel, Fritz Koreny, Walter Koschatzky

*Sigmund Freud Gesellschaft, Vienna*
Harald-Leupold Löwenthal

*Tiroler Landesmuseum Ferdinandeum, Innsbruck*
Gert Amman, Erich Egg

Belgium

*Musées Royaux des Beaux-Arts de Belgique, Bruxelles*
Emma Pacco, Henry Pauwels, Françoise Roberts-Jones

*Bibliothèque Royale Albert Ier, Bruxelles*
Georges Colin, Anne Rouzet, Nicole Walch, Martin Wittek

*Musée Royal des Beaux-Arts, Anversa*
Lydia Schoonbaert

Czechoslovakia

*Národní Galerie, Praga*
Jiří Kotalík

*Národní Muzeum, Praga*
Adolf Čejchan, Jarmila Hasková

*Uměleckoprůmyslové Muzeum, Praga*
Alena Adlerová, Dagmar Hejdová

*Slovácké Muzeum, Uherském Hradišti*
Jiří Deml

Denmarke

*Det Danske Kunstindustrimuseum, Copenhagen*
Kristian Jakobsen, Vibeke Woldbye

*Det Kongelige Bibliotek, Copenhagen*
Nils Henning Jeppesen, Steen Bille Larsen

France

*Musée du Louvre, Parigi*
Roseline Bacou, Michel Laclotte

*Musée de la Renaissance, Château d'Ecouen*
Alain Erlande Brandenburg
Madame Malai-Perrier

*Bibliothèque Nationale, Parigi*
Laure Beaumont-Maillet, Marie-Louise Bossuat, Dominique Coq, Françoise Jestaz, André Miquel, Andrée Pouderoux, Jean Toulet, Madame Veljovic

*Bibliothèque de l'Arsenal, Parigi*
Jean-Claude Garreta

*Musée National d'Art Moderne, Centre Georges Pompidou, Parigi*
Daniel Abadie, Bernard Ceysson, Isabelle Monod-Fontaine, Gérard Régnier

*Musée Carnavalet*
Jean-Marie Bruson, Bernard de Montgolfier

*Bibliothèque de l'Ecole nationale Supérieure des Beaux-Arts, Parigi*
Emmanuelle Brugerolles, Annie Jacques

# Acknowledgments

*Bibliothèque Littéraire Jacques Doucet,
Parigi*
François Chapon

*Institut Néerlandais, Fondation
Custodia, Parigi*
Carlos van Hasselt
Maria van Berge-Gerband
Anneck van Leeuwen

*Institut Catholique, Parigi*
Claudine Lehmann

*Société Française de Photographie,
Parigi*
Christiane Roger

German Democratic Republic

*Staatliche Museen zu Berlin*
Günther Schade, Werner Schade

*Staatliche Kunstsammlungen, Dresden*
Manfred Bachmann,
Joachim Menzhausen

German Federal Republic

*Deutsches Literaturarchiv, Marbach*
Ludwig Greve, Ulrich Ott

*Bayerische Staatsbibliothek, Monaco*
Franz Georg Kaltwasser,
Dieter Kudorfer

*Städtische Galerie im Lenbachhaus,
München*
Armin Zweite

*Germanisches Nationalmuseum,
Norimberga*
Gerard Bott, Rainer Schoch

*Städtische Kunstsammlungen, Augsburg*
Tilman Falk

*Staatsbibliothek, Bamberga*
Bernhard Schemmel

*Berlinische Galerie*
Ursula Prinz, Eberhard Roters

*Herzog Anton Ulrich-Museum,
Braunschweig*
Christian v. Heusinger,
Johanna Lessmann

*Kunstsammlungen der Veste, Coburg*
Susanne Netzer

*Universitätsbibliothek Freiburg in
Breisgau*
Wolfgang Kehr, Vera Sack

Great Britain

*Ashmolean Museum of Art and
Archeology, Oxford*
Nicholas Penny

*Royal Library, Windsor Castle*
Julia Baxter, Theresa-Mary Morton

*Courtauld Institute, London*
Sarah Wilson

Hungary

*Magyar Nemzeti Muzeum, Budapest*
Ferenc Fulep, Jozsef Korek

Israel

*The Israel Museum, Gerusalemme*
Izzika Gaon, Stephanie Rachum,
Martin Weyl

Italy

*Gabinetto Disegni e Stampe degli
Uffizi, Firenze*
Giovanni Cerbara,
Gianvittorio Dillon,
Annamaria Petrioli Tofani

*Biblioteca Nazionale Marciana, Venezia*
Laura Sitran Gasparrini,
Gian Albino Ravalli Modoni

*Museo degli Argenti, Palazzo Pitti,
Firenze*
Stefano Francolini, Cristina Piacenti

*Civiche Raccolte d'Arte, Castello
Sforzesco, Milano*
Ermanno A. Arslan,
Maria Teresa Fiorio,
Mercedes Garberi

*Archivio della Veneranda Fabbrica del
Duomo di Milano*
Ernesto Brivio, Arduino Gasperi

# Acknowledgments

Anonymous
*Allegorical Statue*, 17th century
Stone, h. 210 cm
Private collection, Milan

Adriaen de Vries
*Bust of Rudolf II*, 1603
Bronze
Obrazárna präzkého hradu, Prague *

*Duomo di Como*
Mons. Angelo Cattaneo,
Mons. Giuliano Signorelli

*Civici Musei d'Arte e Storia, Brescia*
Bruno Passamani, Vincenzo Pialorsi

*Museo Civico Ala Ponzone,
Cremona*
Ardea Ebani, Renzo Zaffanella

*Fondazione Giorgio Cini, Venezia*
Alessandro Bettagno, Vittore Branca,
Silvano de Tuoni

*Congregazione Armena Mechitarista,
Isola di San Lazzaro degli Armeni,
Venezia*
Padre Nerses Der Nersessian

*Peggy Guggenheim Collection, The
Solomon R. Guggenheim Foundation,
Venezia*
Thomas Messer, Renata Rossani,
Philip Rylands

*Museo d'Arte Orientale Edoardo
Chiossone, Genova*
Giuliano Frabetti,
Gustavo Gamalero,
Adriano Vantaggio

*Museo Biblioteca e Archivio di Bassano
del Grappa*
Rita Bizzotto

Japan

*The National Museum of Art, Osaka*
Masaharu Ono

Spain

*Biblioteca Nacional, Madrid*
Pablo Fernandez,
Juan Pablo Fuzi Aizpurua,
Jeronimo Martinez Gonzáles,
Elena Santiago Paez

*Real Academia de Bellas Artes de San
Fernando, Madrid*
Jose Ma de Azcarate Ristori,
Blanca Piquero, Blanco Soler

*Fundacion Gala-Salvador Dalí, Figueres*
Francisco Berges,

Maria Teresa Brugues,
Robert Descharnes, Antonio Pitxot

Sweden

*Kungl. Husgerådskammaren, Stoccolma*
Stig Fogelmarck, Bo Vahlne

*Moderna Museet, Stoccolma*
Olle Granath

*Nationalmuseum, Stoccolma
Statens Konstmuseer,
Gripsholmssamlingen*
Per Bjurström, Ulf G. Johnsson,
Lena Löfstrand Granath

*Kungl. Livrustkammaren, Stoccolma
Skoklosters Slott, Bålsta*
Arne Losman, Agneta Lundström,
Karin Skeri, František Makeš

Switzerland

*Historisches Museum, Basilea*
Hans Christophe Ackermann,
Burkard v. Roda

*Thyssen-Bornemisza Collection, Lugano*
Baron Hans Heinrich von Thyssen
Bornemisza, Susanne Thesing

*Kunstverein Winterthur*
Rudolf Koella, Doris Kruschwitz

*Collection de l'Art Brut, Lausanne*
Geneviève Roulin, Michel Thévoz

USA

*Metropolitan Museum of Art,
New York*
Suzanne Boorsch, Colta Ives,
William S. Liebermann,
Philippe de Montebello,
John Pope-Hennessy

*Museum of Modern Art, New York*
Richard E. Oldenburg, Clive Phillpot,
Rona Roob, Cora Rosevear,
William S. Rubin, Richard L. Tooke

*Museum of Fine Arts, Boston*
Sue Reed, Clifford S. Ackley

# Acknowledgments

*The Art Institute of Chicago*
Neal Benezra, James N. Wood
*Denver Art Museum, Denver*
Lewis W. Story
*The Menil Collection, Houston*
Julie A. Addison, Elsian Cozens,
Walter Hopps, James Hou,
Dominique de Menil
*Arnold Schönberg Institute, University
of Southern California, Los Angeles*
Wayne Schoaf, Lawrence Schönberg
*Philadelphia Museum of Art, Filadelfia*
Anne d'Harnoncourt, Nancy S. Quaile
*Hirshhorn Museum and Sculpture
Garden Smithsonian Institution,
Washington D.C.*
James T. Demetrion,
Phillis Rosenzweig,
Douglas J. Robinson
*National Museum of American Art,
Washington*
Andrew Connors, Charles C. Eldridge

Claude Acaei, Hélène Ahrweiller,
Rudolf Peter Altmüller
Robert A. Baird, Monique Barbier,
Guido Barbini, Barthelèmy,
Timothy Baum,
Gloria Fernández Bayton,
Umberto Beliazzi, Anne Bérat,
Pierre Berès, Ana Beristain,
Anthony Besse, Monique Beudert,
Gottfried Biedermann, Noël Blotti
Lionello Boccia, Günther Böhmer,
Antonella Vigliani Bragaglia,
Jean-Michel Bouhours,
Sylvine Bouvet-Delanoy,
Elisa Breton, Philippe Briet,
M.me Alain Brieux, Harry Brooks,
Nathalie Brunet, Yvonne Brunhammer
John Cage, Angelo Calmarini,
Carlo de Carlo, Fernando Caruso,
Leo Castelli,
Cercle des Bibliophiles de France,
Gérard Chiron,
M.me A. Cischi, Jana Claverie,

Bernard Clerc-Renaud, Allan Clark,
Arthur Cohen, Elaine Cohen,
Sergio Corduas
Slavoj David, Michel Decaudin,
Jean Depêche, Robert Descharnes,
Franca Donini
Umberto Eco, Bo Enarsson,
Jacques Faujour, Sidney Felsen,
Daniel Filipacchi, Karl Flinker,
Jeanne Foly, André François-Petit,
Michel Frizot
Myriam Gabo, Elsa Geiger-Arié,
Heinrich Geissler, Natascia Gelman,
Ida Gianelli, Noël Girieux, Giuliani,
Krystyna Gmurzynska, Bscher
Jerôme Gold, Ernst Gombrich,
Monique Gontcharova,
Hans Guggenheim
Roman Hersig, Robert Hersig,
Jan Hoet, Hans Hollein,
Eva Hökerberg, Rebecca Horn
Masaaki Iseki
Guy Jenning, Mimi Johnson
Jean-Paul Kanh, Dieter Kaeppelin,
Samy Kinge, Jitka Klingerberg,
Boris Kochno, Petr Král, Ludvík Kunz
Guy Ladrière, Claude Lalanne,
Patrick Lallour, Helene Lamech,
David Landeau, Jean-Jacques Lebel,
Baudoin Lebon
Madame Max Lerner, Erich Lessing,
Jack Levinovitz, Věra Linhartová,
Amalia Litta Modignani,
Pietro Lorenzelli, Thomas Lovit
Giulio Macchi,
André Pieyre de Mandiargues,
Giorgio Marconi, Tina Marengo,
Manuela B. Mena Marqués
Augusto Marinoni, MaryJo Marks,
Johann Marte, Julie Martin,
Gabriele Mazzotta, Kenji Misawa,
Jean-Yves Mock, Jackie Monnier,
Marco Morin
Pierre Noël, Nuria Nono
Alfonso Ossorio, Robert U. Ossorio
Prokop Paul, Madame A. Perisson,
Vladimír Peška, Evelyne Pomey,

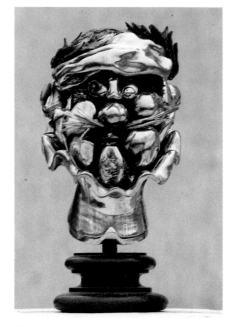

Miguel Berrocal
*Arcimboldo Big*, 1976
Bronze, 44×22×22 cm
(Sculpture composed of 20 elements)
Artist's collection, Verona *

Claude Lalanne
*Crocodile Armchair*, 1972
Galvanized copper on natural
elements, bronze, h. 80 cm
Private collection *

# Acknowledgments

Sophie Pabst,
Gunilla Palmstjerna-Weiss,
Michael Prechtl, Serge Pahaut
Anuska Palme Sanavio,
Carlo de Poortere
André Raffray, Jean Renaud,
André Rieupeyreux, Xavier Rio,
Jean Ristat, Dieter Ronte,
Jacques Roissart,
Marie-Pierre Romand-Douillet,
Adam Rzepka
Janine Sator, Marc Sator,
Wolfgang Schallenberg, Ethel Scull

Zbyněk Sekal, Françoise Serre,
Sotheby, Darthea Speyer,
Gian Enzo Sperone, Cecile Starr,
Jacques Sternberg, David Sylvester,
František Šmejkal
Jaroslav Tabor, Lucien Treillard,
Armande de Trintinian, Eric Turquin
Woody and Steina Vasulkas,
Françoise Viatte, Germain Viatte,
Karl Vocelka
A. Weisman, Angela Westwater,
Anna Lena Wibom, Nina Williams,
Hubert Wolfrum Stanislas Zadora

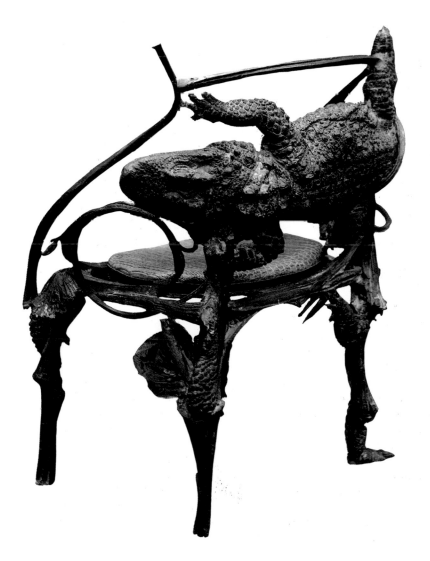

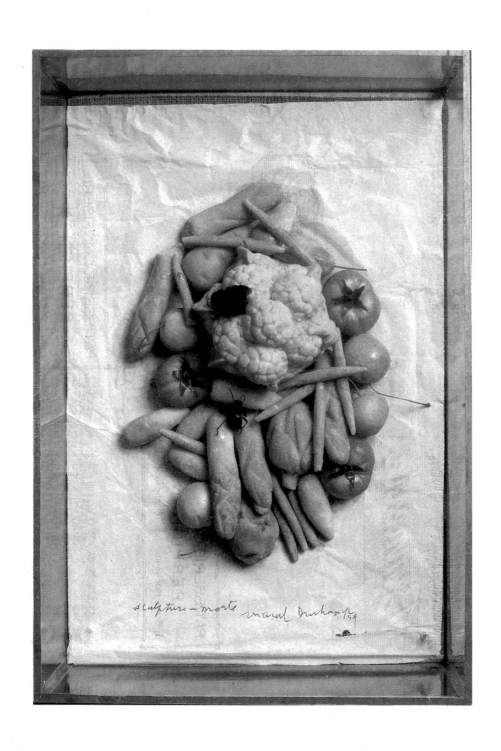

Marcel Duchamp
*Still Sculpture*, 1959
Marzipan and insects on paper
mounted on masonite
33.5×22.5×5.5 cm
Jean-Jacques Lebel Collection, Paris *

# Bibliography

Agricola, Georg Bauer. *De re metallica.* 1556.

Alciati, Andrea. *Emblematum libellus.* Venetiis, 1532.

Alfons, Gunnar Sven. "Giuseppe Arcimboldo," in *Symbolister.* Malmö: Allhems, 1957.

Apollinaire, Guillaume. *Alcools*ı Paris: Mercure de France, 1913.

Apollinaire, Guillaume. *Calligrames, poèmes de la paix et de la guerre.* Paris: Mercure de France, 1918.

Apollo, Horus. *Hieroglyphica.* Paris: Kerver, 1543.

Argelati, Filippo. "*Bibliotheca Scriptorum Mediolanensium*". Mediolanum: In *Aedibus Palatinis*, 1745.

Baltrušaitis, Jurgis. "Têtes composées", in *Médicine de France*, XIX 1951.

Baltrušaitis, Jurgis. *Aberrations.* Paris: Perrin, 1957.

Baltrušaitis, Jurgis. *Anamorphoses ou magie artificielle des effets merveilleux.* Paris: Perrin, 1969.

Barrocchi, Paola. *Scritti d'arte del Cinquecento.* Milan-Naples, 1971-1977.

Barr, Alfred. H. Jr. *Fantastic Art Dada Surrealism.* Exhibition catalogue. New York: Museum of Modern Art, 1936.

Barthes, Roland. *Arcimboldo.* Parma: Franco Maria Ricci, 1978.

Battisti, Eugenio. *L'Antirinascimento.* Milano: Feltrinelli, 1962.

Baudelaire, Charles. *Fleurs du mal.* Alençon: Poulet-Malassis, 1857.

Baudrillard, J. *Les Stratégies Fatales.* Paris: Grasset, 1983.

Baumgart, Fritz. *Renaissance und Kunst des Manierismus.* Cologne: DuMont, 1963.

Baxandall, Michael. *Giotto and the Orators.* Oxford, 1971.

Benezit, B. *Dictionnaire (...) des peintres, sculpteurs...* (entry on *Arcimboldo*, ed. P.A. Touttain). Paris: Gründ, 1976.

Benveniste, E. *Vocabulaire des institutions indoeuropéennes*, vol. II.

Berengario da Carpi, Jacopo. *Isagogae breves perlucidae ac uberrimae in anatomiam humani corporis.* Bologna: Hectoris, 1523.

Bergmans, H.B. *La musique et le musiciens.* Paris: Fischbacher, 1901.

Bettini, M. *Apiarium.* Bologna 1642.

Beyer, Andreas. *Giuseppe Arcimboldo Figurinen Kostüme und Entwürfe für Höfische Feste.* Frankfurt: Insel, 1983.

Borgogni, Gherardo. *Nuova Scielta di Rime.* Bergamo: 1592.

Borromeo, Carlo. "Memoriale al suo diletto popolo della Città e Diocese di Milano," 1579, in Ferdinando Taviani, *La fascinazione del teatro.* Rome: Bulzoni, 1970.

Borromeo, Carlo. "Omelia per il battesimo del figlio del legato veneziano Bonifacio Antelmo," in Ferdinando Taviani, *La fascinazione del teatro.* Rome: Bulzoni, 1970.

Bousquet, Jacques. "Der Mensch als Sammelsurium. Aus der Porträtgalerie des kaiserlichen 'Hofconterfeters' Giuseppe Arcimboldo," in *Die Kunst und das Schöne Heim*, 1963.

Bousquet, Jacques. *Mannerism.* New York, 1964.

Bohr, Niels. *Theory of spectra and atomic constitution*, 1913.

Bracelli, Giovanni Battista. *Bizzarrie.* Florence, 1624.

Brahe, Tycho. *Astronomiae instauratae progymnasmata*, 1588.

Breton, André. *Premier Manifeste du Surréalisme.* Paris, 1924.

Breton, André. "Crise de la magie," in *L'Art Magique.* Paris: Club Français du Livre, 1957.

Brion, Marcel. *L'Art fantastique.* Paris: Albin Michel, 1961.

Browne, Alice. "Dreams and Picture-

# Bibliography

Writing: Some Examples of this Comparison from the Sixteenth to the Eighteenth Century," in *Journal of the Warburg and Courtauld Institutes* 44, 1981.

Brücke, E.B. *Les couleurs au point de vue physique, physiologique, artistique et industriel*. Paris: Baillière, 1866.

Bruno, Giordano. *De la causa, principio e uno*. London, 1584.

Bruno, Giordano. *De l'infinito, universo e mondi*. London, 1584.

Bruno, Giordano. *De immenso et innumerabilibus seu De universo et mundis*. Frankfurt, 1591.

Busch, Renate von. *Studien zu Deutschen Antikensammlungen des 16. Jahrhunderts*. Diss. Tübingen, 1973.

Bundy, Murray Wright. *The Theory of Imagination in Classical and Medieval Thought*. Urbana, Illinois, 1927.

Caillois, Roger. *Au coeur du fantastique*. Paris: Gallimard, 1965.

Casati, G. "Giuseppe Arcimboldi pittore milanese," in *Archivio Storico Lombardo* XII, 31 March 1885.

Castel, L.B. "Clavecin pour les yeux, avec l'art de peindre les sons, et toutes sortes de pièces de musique," in *Mercure de France* XI, 1725.

Chaunu, P. *L'expansion européenne du XIIIe au XIVe siècle*. Paris: PUF, 1969.

Comanini, Gregorio. *Il Figino, overo del fine della Pittura, Dialogo*, Mantua Francesco Osanna, 1591, in *Trattati d'Arte del Cinquecento* (ed. Paola Barocchi), vol. III. Bari, 1962.

Comanini, Gregorio. *Canzoniere*. Mantua, 1609.

Conger, S. *Theories of Macrocosms and Microcosms in the History of Philosophy*. London, 1951.

Copernicus, Nicolas. *Nicolai Copernici thorunensis de revolutionibus orbium coelestium libri VI*. Nuremberg: Johan Petreium, 1543.

Casati, Carlo. "Giuseppe Arcimboldi, pittore milanese", in *Archivio Storico Lombardo*, vol. II, series II. Milan, 1885.

Dacos, Nicole. *La Découverte de la Domus Aurea et la Formation des Grotesques à la Renaissance*. London and Leiden, 1969.

Dalí, Salvador. "Honneur à l'objet!," in *Les Cahiers d'art*. Paris, 1936.

Dalton, John. *A New System of Chemical Philosophy*. London, 1808.

Damish, H. "L'alphabet des masques," in *Nouvelle Revue de Psychanalyse* (La Passion), n. 21, 1980.

David, P. Ioannes. *Veridicus Christianus*. Antwerp: Plantiniana, 1601.

Deleuze, G. and F. Guattari. *1000 Plateaux, Année zéro: la visagéité*. Paris: Minuit, 1980.

Deleuze, G. *F. Bacon: logique de la sensation*, vol. I. Paris: Ed. de la différence, 1981.

Della Porta, Giambattista. *Magia naturalis, sive de miraculis rerum naturalium libri IV*. Naples: apud Mathiam Cancer, 1558.

Della Porta, Giambattista. *De i miracoli et meravigliosi effetti dalla natura prodotti libri IIII*. Venice: Avanzi, 1560.

Della Porta, Giambattista. *De humana physiognomia libri IIII*. Vici Aequensis: apud Josephum Cachium, 1586.

De Pisis, Filippo. "L'Arcimboldi italiano e i surrealisti parigini," in *L'italiano*, 14 January 1934.

Diakov, L. "Tableaux de Giuseppe Arcimboldo," in *Panorama des Arts*, Moscow, 1980.

"Dinocrates' Project," in *Scientific American Supplement* 488, New York, 1885.

Duchamp, Marcel. Exhibition catalogue. Paris: Centre Georges Pompidou, 1977.

Dürer, Albrecht. *Vier Bücher von menschlicher Proportion*. Nuremberg,

# Bibliography

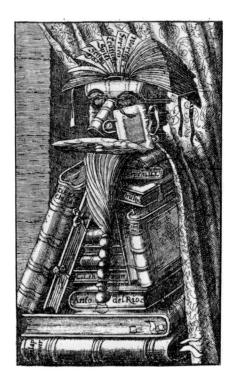

Woodcut by C. Lehman
*The Librarian*
in *Frauenzimmer Gesprächsspiele*
Nuremberg, Wolfgang Endter
1644-57

1528.

Dvořák, Max. *Kunstgeschichte als Geistesgeschichte.* Munich: R. Piper & Co. Verlag, 1924.

Einstein, Albert. *Die formale Grundlage der allgemeinen Relativitätstheorie,* 1915.

Ekman, P. et al. *Emotion in the Human Face.* New York: Pergamon Press, 1972.

Erlanger, Philippe. *L'empereur insolite.* Paris: Albin Michel, 1971.

Evans, R.J.W. *Rudolf II and his World, A Study in Intellectual History 1576-1612.* Oxford: Oxford University Press, 1973.

Evans, R.J.W. *The making of the Habsburg Monarchy 1550-1700.* Oxford: Oxford University Press, 1979.

Fabbri. P., and M. Sbisà. "Appunti per una semiotica delle passioni," in *Aut-Aut,* 1985.

Ferrari, M. "Biografia di Giuseppe Arcimboldo," in Barthes, *Arcimboldo.*

Fracastoro, Girolamo. *Syphilis, sive de morbo gallico.* Verona, 1530.

Freedberg, Sydney J. *Painting in Italy. 1500 to 1600.* Harmondsworth: Penguin Books, 1971.

Fresne, Raffaele du. *Trattato della Pittura di Leonardo da Vinci nuovamente dato in luce con la vita dello stesso autore scritta da Raffaele du Fresne.* Paris: Langlois, 1651.

Freud, Sigmund. *Eine Kindheitserinnerung des Leonardo da Vinci,* 1910.

Friedrich, K.D. *Bekenntnissen,* ed. K. Eberlein, Leipzig, 1924.

Fučiková, Eliška. *Die Kunstkammer und Galerie Kaiser Rudolfs II als eine Studiensammlung.* XXV. Internationaler Kongress für Kunstgeschichte, Vienna, 4 October 1983, 4, Zugang zum Kunstwerk: Schatzkammer, Salon, Austellung, Museum, Vienna, 1986.

Fučiková, Eliška. "Umění a umělci na dvoře Rudolfa II: vztahy K Itálii," in *Umění* 34. (Art and Artists at the Court of Rudolf II: Links with Italy, in *Arte* 34), 1986.

Galilei, Galileo. *Sidereus Nuncius magna longeque admirabilia spectacula pandens...,* 1610.

Galilei, Galileo. *Dialogo sopra i due massimi sistemi del mondo, tolemaico e copernicano,* 1632.

Geiger, Benno. *I dipinti ghiribizzosi di Giuseppe Arcimboldi.* Florence, Vallecchi, 1954.

Geisberg, Max. *Der Deutsche Einblatt-Holzschnitt in der Ersten Hälfte des 16. Jahrhunderts.* Munich: Hugo Schmidt, 1930.

Geissler, Heinrich. *Zeichnung in Deutschland, Deutsche Zeichner 1540-1640.* Stuttgart, 1979.

Gherardini, Filippo. "Madrigale per Ninfa Flora," in G.P. Lomazzo, *Idea del Tempio della Pittura.* Milan, 1590.

Gilli Pirina, Caterina. "L'Arcimboldi non 'Ghiribizzoso',", in *Comentari* 15, 1964.

Gombrich, E.H. "Icones Symbolicae: Philosophies of Symbolism and their Bearing on Art," in *Symbolic Images. Studies in the Art of the Renaissance.* London: Phaidon, 1972.

Granberg, Olof. *La Galleria di quadri della Regina Cristina di Svezia, prima appartenuta all'imperatore Rodolfo II, più tardi ai Duchi d'Orléans.* Stockholm: Haeggstrom, 1897.

Granberg, Olof. *Keisar Rudolf II's Kunstkammare och dess svenska oeden.* Stockholm: 1902.

Granberg, Olof. *Inventario generale dei tesori d'arte in Svezia,* vol. I. Stockholm, 1911.

Guiraud, P. *Le langage du corps.* Paris: PUF, 1982.

Hegel, Friedrich. *Die Phänomenologie des Geistes,* 1807.

# Bibliography

Hocke, Gustav R. *Die Welt als Labyrinth*. Hamburg: Rowolt, 1957.

Husserl, Edmund. *Allgemeine Einführung in die reine Phänomenologie*, in *Ideen*, 1913.

Jacobson, R. "Le oui et le non mimiques," in *Essais de linguistique générale*, vol. II. Paris: Minuit, 1973.

Jamnitzer, Wenzel. *Perspectiva Corporum Regularium*. Nuremberg: Burgen und Goldschmidt, 1568.

Jansen, Dirk Jacob. "Jacopo Strada (1515-1588): Antiquario della Sacra Cesarea Maestà," in *Leids Kunsthistorisch Jaarboek*, 1982.

Joyce, James. *Ulysses*. Paris, 1922.

Kafka, Franz. *Die Verwandlung*. Leipzig: Kurt Wolff, 1916.

Kaufmann, DaCosta Thomas. "The Perspective of Shadows; The History of the Theory of Shadow Projection," in *Journal of the Warburg and Courtauld Institutes* 38, 1975.

Kaufmann, DaCosta Thomas. "Arcimboldo's Imperial Allegories. G.B. Fonteo and the Interpretation of Arcimboldo's Painting," in *Zeitschrift für Kunstgeschichte* XXXIX, IV 1976. Munich/Berlin: Deutscher Kunstverlag 1976.

Kaufmann, DaCosta Thomas. "Arcimboldo au Louvre," in *La Revue du Louvre et des Musées de France* XXVII, nn. 5-6, 1977.

Kaufmann, DaCosta Thomas. *Variation of the Imperial Theme in the Age of Maximilian II and Rudolf II*. New York and London, 1978.

Kaufmann, DaCosta Thomas. "The Kunstkammer as a Form of Representation: Remarks on the Collections of Rudolf II," in *Art Journal* 38, 1978.

Kaufmann, DaCosta Thomas. "Ancients and Moderns in Prague: Arcimboldo's Drawings of the Silk Industry," in *Leids Kunsthistorisch Jaarbock* 2, 1983.

Kaufmann, DaCosta Thomas. *L'Ecole de Prague*. Paris: Flammarion, 1985.

Kaufmann, DaCosta Thomas. "Arcimboldo and Propertius. A Classical Source for Rudolf II as Vertumnus," in *Zeitschrift für Kunstgeschichte*, n. 1, 1985.

Kaufmann, DaCosta Thomas. "Éros et poesia: la peinture à la cour de Rodolphe II," in *Revue de l'art* 18, 1985.

Kaufmann, DaCosta Thomas. *The School of Prague. Painting at the Court of Rudolf II*. Chicago, 1987 (in preparation).

Kayser, Wolfgang. *The Grotesque in Art and Literature*. Trans. by Ulrich Weisstein. New York, 1981.

Kemp, Martin. "From Mimesis to Fantasia: The Quattrocento Vocabulary of Creation, Inspiration and Genius in the Visual Arts," in *Viator* 8, 1977.

Kepler, Johannes. *Astronomia nova, seu physica coelestis*. Prague, 1609.

Kepler, Johannes. *Dissertatio cum "Nuncio Sidereo,"* Prague, 1610.

Kepler, Johannes. *Tabulae Rudolphinae*. Prague, 1627.

Kircher, Athanasius. *Ars Magna, Lucis & Umbrae*. Rome, 1646.

Klein, Robert. *La forma e l'intelligibile*. Turin: Einaudi, 1975.

Kokoschka, Oskar. *Schriften 1907-1955*. Munich: 1956.

Kris, Ernst. *Psychoanalytic Exploration in Art*. International Universities Press, 1952.

Lancetti, V. *Biografia cremonese... dai tempi più remoti fino all'età nostra*. Milan: Borsani, 1819.

Lebel, Robert. *Léonard de Vinci ou la fin de l'humilité*. Paris: Presses du Livre Français, 1952.

Legrand, F.C., and F. Sluys. "Giuseppe Arcimboldo. Joyaux des Cabinets de Curiosité," in *Les Arts Pla-*

Cover of *Dipinti ghiribizzosi di Giuseppe Arcimboldi*

# Bibliography

*stiques*. Brussels, 1953.

Legrand, F.C., and F. Sluys. "Découverte en Suède des Oeuvres de Arcimboldo," in *Les Beaux Arts*. Brussels, 13 February 1953.

Legrand, F.C., and F. Sluys. "Arcimboldo, le meneur de jeu dans le cortège de son temps," in *Les Beaux Arts*. Brussels, 25 March 1953.

Legrand, F.C., and F. Sluys. "Découverte inattendue à Bruxelles d'une tête composée à la manière de Arcimboldo," in *Les Beaux Arts*. Brussels, 3 April 1953.

Legrand, F.C., and F. Sluys. "Têtes composées du XIVe siècle à nos jours," in *Les Beaux Arts*. Brussels, 19 June 1953.

Legrand, F.C., and F. Sluys. *Giuseppe Arcimboldo et les Arcimboldesques*. Brussels, La Nef de Paris, 1955.

*Le Larousse du XIXe siècle*, entry on "Coleres".

Lietzmann, H. "Das Neugebäude zu Wien," in *Internationaler Kongress für Kunstgeschichte* 3, Vienna, 1985.

Litta, Pompeo. *Milano nobilissima: Famiglie celebri d'Italia*, vol. I. Milan: Giusti, 1819.

Lomazzo, Giovanni Paolo. *Trattato dell'Arte della Pittura*. Milan: Pontio, 1584.

Lomazzo, Giovanni Paolo. *Groteschi*, Milan, 1587.

Lomazzo, Giovanni Paolo. *L'Idea del Tempio della Pittura*. Milan: Pontio, 1590.

Longhi, Roberto. "Quesiti caravaggeschi", in *Pinacotheca*, 1928-29.

Lussana, F. *Fisiologia dei colori*. Padua, 1873.

Machiavelli, Nicolò. *De Principatibus*. Florence, 1532.

Marinelli, Sergio. "The Author of the Codex Huygens," in *Journal of the Warburg and Courtauld Institutes* 44, 1981.

Mazzeo, Joseph Antony. "Metaphysical Poetry and the Poetic of Correspondence," in *Journal of the History of Ideas* 14, 1952.

Mendel, Gregor. *Versuche über Planzenhybriden*, 1865.

Micheli, G.A. *Sincromia. L'analogia suono-colore e la fine della pittura*. Lucca: Libreria E. Baroni, 1963.

Montaigne, Michel Eyquem de. *Les Essais*, 1560-1595.

More, Thomas. *De optimo reipublicae statu deque nova insula Utopia*. Louvain, 1516.

Morigia, Paolo. *Historia dell'Antichità di Milano*. Venice: Guerra, 1592.

Morigia, Paolo. *Della Nobiltà di Milano*. Milan: Pontio, 1595.

Morigia, Paolo. *La Nobiltà di Milano*. Milan: Bidelli, 1615; reprint Bologna: Forni, 1979.

Muraro, Luisa. *Giambattista della Porta, mago e scienziato*. Milan: Feltrinelli, 1978.

Münster, Sebastian. *Weltbeschreibung*. Basel, 1543.

Negri, R. *Odilon Redon*. Milan: Fabbri, 1967.

Neumann, Jaromír. "Rudolfínské umění, I," in *Umění* XXV, 1977.

Neumann, Jaromír. "Rudolfínské umění," in *Umění*, XXVI, 1978.

Neumann, Jaromír. "Die Kunst am Hofe Rudolf II," in *Renaissance Art in Bohemia*. London, New York, 1979.

Nezval, V. *L'uomo che compone con oggetti il proprio ritratto*. Prague, 1934.

Nicodemi, Giorgio. "Giuseppe Arcimboldo, 1560," in *Problemi dell'Arte attuale*, Milan, Jan./Febr. 1929.

Nicodemi, Giorgio. "Giuseppe Arcimboldo," in *Il Poligono*, January/February 1929.

Nicodemi, Giorgio. V.O. *Pittori minori liguri lombardi e piemontesi del Seicento e del Settecento*. Venice: Zanetti,

Cover of
*Hermit of Peking*

# Bibliography

1931.

Nicodemi, Giorgio. "Giuseppe Arcimboldi," in *Milano*, Milan, August 1934.

Nietzsche, Friedrich. *Also sprach Zarathustra: ein Buch für Alle und Keine*, 1883.

Nietzsche, Friedrich. *Ecce Homo. Wie man wird was man ist*, 1888.

Orlandi Pellegrino, Antonio. *L'Abecedario Pittorico*. Bologna, 1719.

Orso, Steven. *Philip IV and the Decoration of the Alcázar of Madrid*. Princeton, 1986.

Ovid. *The Metamorphoses*, trans. by Horace Gregory. New York: Viking Press, 1958.

Palatino, Giovanni Battista. *Sonetto figurato*. Rome, 1561.

Panofsky, Erwin. *Galileo as a Critic of the Arts*. The Hague: Martinus Nijhoff, 1954.

Panofsky, Erwin. *Idea, A Concept in Art Theory*, trans. by Joseph J.S. Peake. Columbia, South Carolina, 1968.

Paracelsus, *Opus paragranum*. Frankfurt, 1565.

Paracelsus, *Opus paramirum*, 1575.

Pedretti, Carlo. *Studi Vinciani. Documenti, analisi e inediti leonardeschi*. Geneva, 1957.

Perez Sanchez, Alfonso E. "La Primavera de Arcimboldo en la Academia de San Fernando," in *Archivio Español de Arte* 37, Madrid, 1984.

Pieyre de Mandiargues, André, and David, Yasha. *Arcimboldo the Marvellous*. New York: Abrams, 1978.

Porzio, Francesco. *L'universo illusorio di Arcimboldi*. Milan: Fabbri, 1979.

Praz, Mario. *Mnémosyne*. Paris: Gérard-Julien Salvy, 1986.

Preiss, Pavel. "Prager Marginalien zu Giuseppe Arcimboldo," in *Alte und Moderne Kunst* IX: 77, 1964.

Preiss, Pavel. "Dvě arcimboldovy kresby Rudolfa II," in *Časopis Národního Musea* CXXVI, Prague, 1957.

Preiss, Pavel. *Giuseppe Arcimboldo*. Prague: Nŏvu, 1967.

Prigogine, Ilya. *La Nouvelle Alliance*. Paris: Gallimard, 1979.

Prigogine, Ilya. "The Nature of Reality," in *Modern Review* XLIV, 1931.

Prigogine, Ilya. "Redécouvrir le Temps," in *L'Art et le Temps*. Exhibition catalogue Brussels, 1984.

Rabelais, François. *Grandes et inestimables chronicques du grand et enorme géant Gargantua*. Lyons, 1532.

Rabelais, François. *Gargantua et Pantagruel*, 1532-1564.

Redon, Odilon. *A Soi-Même, Journal (1867-1915). Notes sur la vie, l'art et les artistes*. Paris: Fleury, 1922.

Redondi, Pietro. *Galileo Eretico*. Turin: Einaudi, 1983.

Rietstap, J.B. *Armorial Général...*, Gouda: Van Goor Zonen, 1884.

Ripellino, Angelo Maria. *Praga Magica*. Turin: Einaudi, 1973.

"Una roccia antropomorfa," in *La Nature*. Paris: Masson, 1899.

Rosci, Marco. "Leonardo 'filosofo'. Lomazzo e Borghini 1584: due linee di tradizione dei pensieri e precetti di Leonardo sull'arte", in *Scritti di Storia dell' Arte in memoria di Anna Maria Brizio*. Florence, C. Marani, 1984.

Roy, Claude. *Arts fantastiques*. Paris: Encyclopédie Essentielle, 1960.

Sambucus, Johannes. *Emblemata et aliquot*. Antwerp, 1569.

Savio, Fedele. "Giovanni Battista Fontana o Fonteio", in *Archivio Storico Lombardo* 4, 1905.

Schedel, Hartmann, *Weltchronik* (*Liber Chronicum*). Nuremberg: Anton Koberger, 1493.

Scheicher, Elisabeth. *Die Kunst- und Wunderkammern der Habsburger*. Vienna: Molden, 1979.

Zdeněk Sklenář
*Homage to Arcimboldo*
in the revue *Mlada Fronta*
Prague, 1969

# Bibliography

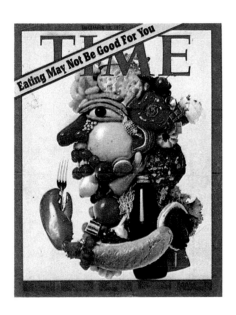

Cover of *Time*, 18th Dec. 1972

Schlosser, Julius von. *Die Kunst- und Wunderkammer der Spätrenaissance*, Leipzig, 1908.

Schön, Erhart. *Das Kunst und Lere - Unterweysung der Proportion und Stellung der Bossen*. Frankfurt: Christian Egenolff, 1543.

Sluys, Félix. "Mon Diagnostique: l'art fantastique est l'exutoire des époques intelligeantes et inquietes", in *Connaissance des Arts*, 68, 1957.

Sterling, Charles. *La nature morte de l'antiquité à nos jours*. Exhibition catalogue. Paris: Tisné, 1952.

Stoer, Lorenz. *Geometria et Perspectiva*. 1555.

Summers, David. *Michelangelo and the Language of Art*. Princeton, 1981.

Tasso, Torquato. *La Gerusalemme Liberata*, 1580.

Tea, Eva. *La proporzione nelle arti figurative*. Milan, 1945.

Teilhard de Chardin, Pierre. *Le phénomène humain*, 1955.

Thieme, U. and F. Becker. Entry on "Arcimboldo G.", in *Allgemeine Lexikon der Bildenden Kunstler*, vol. II, 1908.

Thom, René. *Stabilité structurelle et morphogenèse: essai d'une théorie générale des modèles*. Reading, Mass.: W.A. Benjamin, Inc., 1972.

Töppfer, Rodolphe. *Essai de physionomie*. Geneva: Albert Skira, 1945.

Tornitore, Tonino. "Giuseppe Arcimboldo e il suo presunto clavicembalo oculare", in *Revue des études italiennes*, XXXI, 1985.

Tory, Geoffroy. *Champ fleury*. Paris, 1529.

Trevor-Roper, Hugh. *Princes and Artists*. London: Thames & Hudson, 1976.

Trunz, Erich. *Pansophie und Manierismus in Kreise Kaiser Rudolfs II. Die österreichische Literatur. Ihr Profil von den Anfangen im Mittelalter bis ins 18. Jahrundert. (1050-1750)*. Graz, 1986.

Tzara, Tristan. "Propos sur Bracelli", in *Aventure d'un livre et notes bibliographiques*. Paris: Alain Brieux, 1963.

Tzara, Tristan. "Le fantastique comme déformation du temps", in *Cahiers d'Art*, 1937.

Valverde de Hamusco, Juan. *Anatomia del corpo humano*. Rome: A. Salamanca & A. Lafrery, 1556.

Venturi, Adolfo. "Giuseppe Arcimboldi", in *Storia dell'Arte Italiana*, vol. IX, part VII, Milan, 1934.

Veronesi, L. *Proposta per una ricerca sui rapporti fra suono e colore*. Milan: Siemens Data, 1977.

Vesalio, Andrea. *De humani corporis fabrica*, 1543.

Vocelka, Karl. *Habsburgische Hochzeiten 1500-1600*. Vienna/Cologne/Graz: Göhlau, 1976.

Vogtherr, Heinrich. *Livre artificieux et très proffitable pour pointres....* Antwerp: Jehan Richard, 1551.

Wegener, Alfred Lothar. *Entstehung der Kontinente und Ozeane*, 1912.

Wescher, Paul. "The 'Idea' in Giuseppe Arcimboldo's Art", in *Magazine of Art* XLII, Washington, January 1950.

Wirrich, Heinrich. *Ordentliche Beschreibung des Christlichen Hochlöblichen und Fürstlichen Beylags... den XXVI Augusti in der Kayserlichen Statt Wien... in Teutsche Carmina gestelt*. Vienna 1571.

Wittkower, Rudolf. *Principi architettonici nell'età dell'Umanesimo*. Turin, 1964.

Zimmermann, Heinrich. "Das Inventar der Prager Schatz- und Kunstkammer", 1621, in *Jahrbuch der Kunsthistorischen Sammlungen des Allerhöchsten Kaiserhauses*, vol. XXV, Vienna 1905.

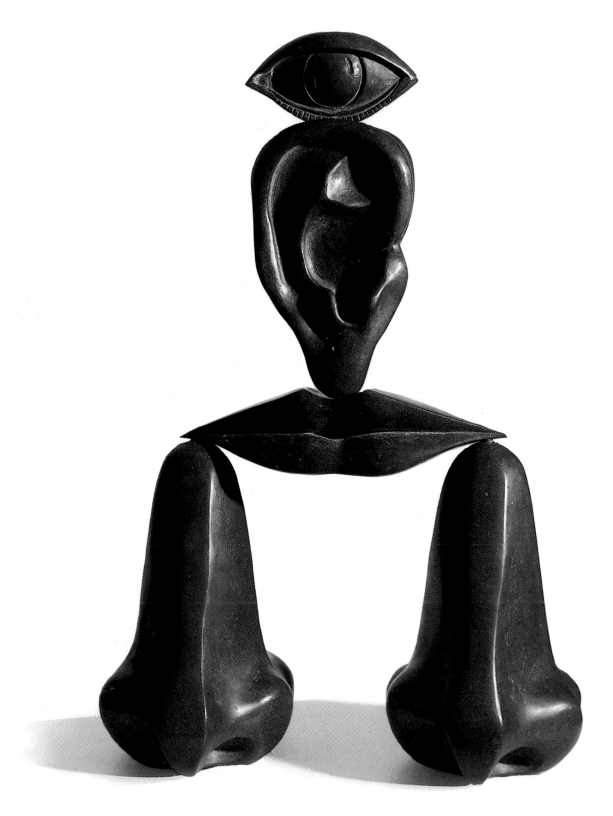

# Index

René Magritte
*The White Race*, 1967
Bronze, 52.5×34.5×17 cm
Serena Fine Arts, Milan *

# Index

Anonymous
Round bowl, 1536
Faïence, diam 23 cm
Private collection *

# Index

# Index

Peter Weiss
*The One-day Calif*, 1956
Collage, 30×21 cm
Private collection, Stockholm

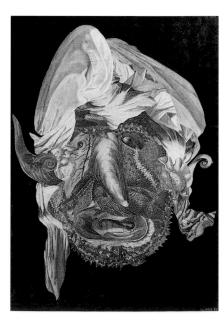

# Index

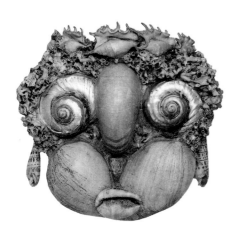

Pascal Maisonneuve
*Queen Victoria*
Assemblage of shells, h. 42 cm
Collection de l'Art Brut, Lausanne

Michael Druks
*Druksland*, 1974 *

# Index

Pol Bury
*Baudelaire*, 1962
Kinetic photograph, 16×11 cm
Private collection

Index

# Index

Franciszek Starowieyski
*Iluminacja*, 1973
Poster, 81×57.6 cm
Museum of Modern Art, New York

# Index

Roman Cieslewicz
*La Joconde*, 1974
Photomontage, 65×50 cm
Private collection, Paris

# Index

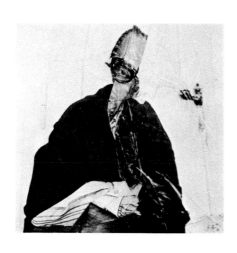

Jiří Kolář
*The Self Portrait*, 1980
Collage
Private collection

# Index

Record sleeve
Archiv Production, 1978

# Index

Tapestry after Giuseppe Arcimboldo's *Spring*, woven in Micheline Henry's workshop Aubusson, 1977, 152×135 cm Private collection *

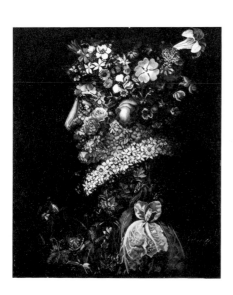

# Index

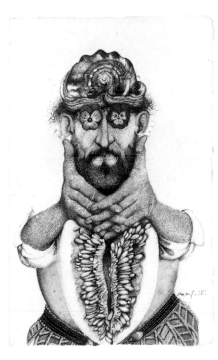

Michael Mathias Prechtl
*Giuseppe Arcimboldo*, 1980
Watercolor and sepia on handmade
paper, 34×21.6 cm
Private collection

# Index

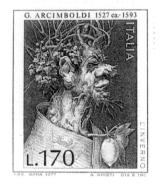

Homage to G. Arcimboldi
Stamp issued by the Italian Postal
Service, 1977

# Index

143. Cette poule n'a pas de queue.

144. Cet arbre n'a pas de feuilles.

145. Une plume.

146. Une montre.

147. Une clef.

148. Un encrier.

147. Une clef.

Salvador Dalí
*Erotic Metamorphosis*, 1969
Lithograph, Paris

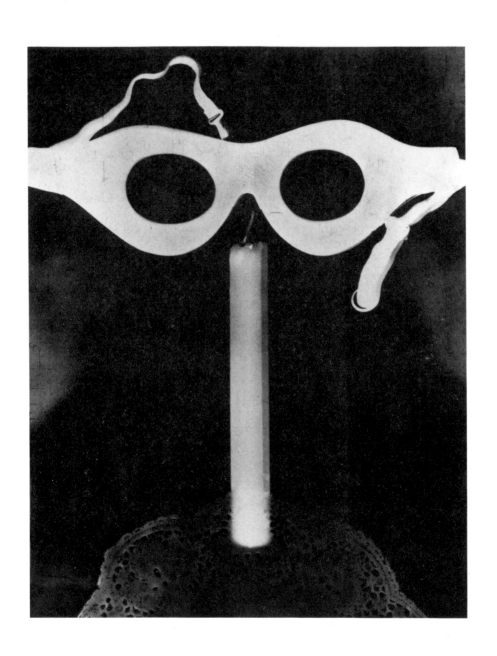

Rayograph by Man Ray *

# Photographic Credits

Albrecht, 62, 132
Piero Baguzzi, 177, 357
Alberto Bertoldi, 22, 140
Leonard Bezzola, 352, 353
Rudolph Burkhart, 341
James Dee, 202
Robert Descharnes, 288, 297, 298, 309, 310, 313
Roberto Esposito, 250
Fine Arts, 380
Jacques Faujour, 285, 321, 351
Fondation Custodia, 195
Fondation Dubuffet, 331
Giraudon, 59, 63, 134, 135
Grünke, 262
Marianne Haller, 53, 62, 69, 134, 160, 186
Hinz, 173
Institut Courthaud, 325
Steven Kasher, 256
Kissling, 258
Eric Lessing, 41, 61, 66, 76, 78, 91, 95, 101, 102, 105, 106, 133, 137, 140
František Makeš, coperta, 361, 362, 363
Mario Matteucci, 54, 145, 146, 148, 149, 150, 151, 152, 153, 154, 155, 156, 157, 369, 382
Meyer, 81, 162
Allen Mewbourne, 290, 293
Eric Mitchell, 249
Musée National d'Art Moderne Centre Georges Pompidou, 261, 268, 273, 276, 305, 306, 307, 398, 399
Nodo, 57
Yasuyukio Ogura, 332
Carlo Pisa, 47
Prokop Paul, 116, 119, 127, 131, 138, 139
Milan Posselt, 71
Ritter, 92
Adam Rzepka, 4ª di coperta, 8, 10, 80, 82, 140, 191, 192, 272, 274, 314, 328
Göran Schmidt, 8, 116, 119
Services Photographiques de la

Réunion des Musées Nationaux, 24, 25, 50
Société Française de Photographie, 229, 230, 234
Mark Smith, 326
Gabriel Urbánek, 131, 138
Romano Vada, 30
Peter Willy, 94, 175

*It has been impossible to identify the source of a number of documents. We apologize to the authors for any omissions.*

*Translators*

Lisa Clark
Robert Mann
Patrick Creagh
Anthony Shugaar
Maria Rees
Margaret Kunzle
Crispin Mason

*Editing*

Jane Chapman
Carol Rathman
Jaime Roberts